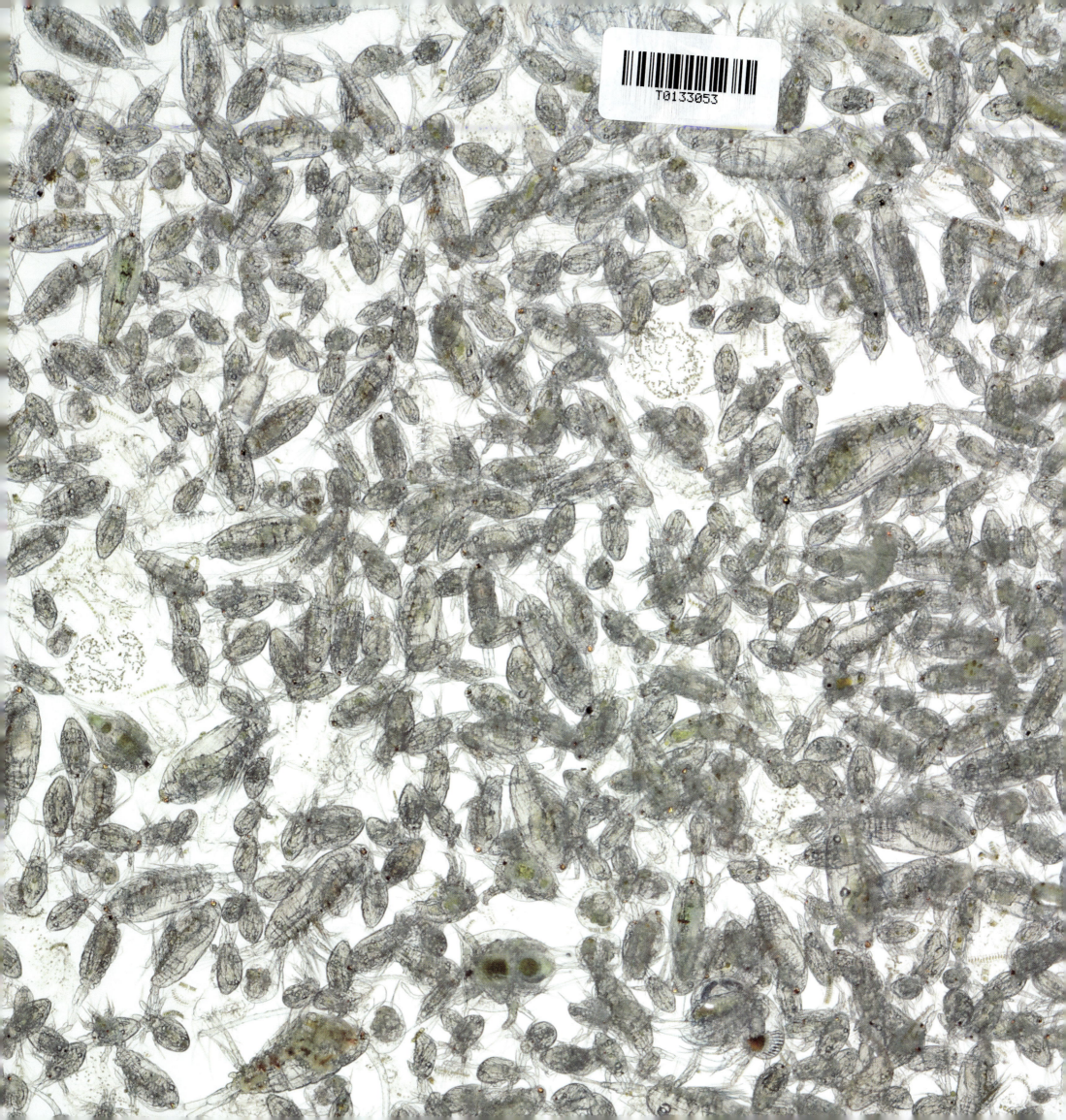

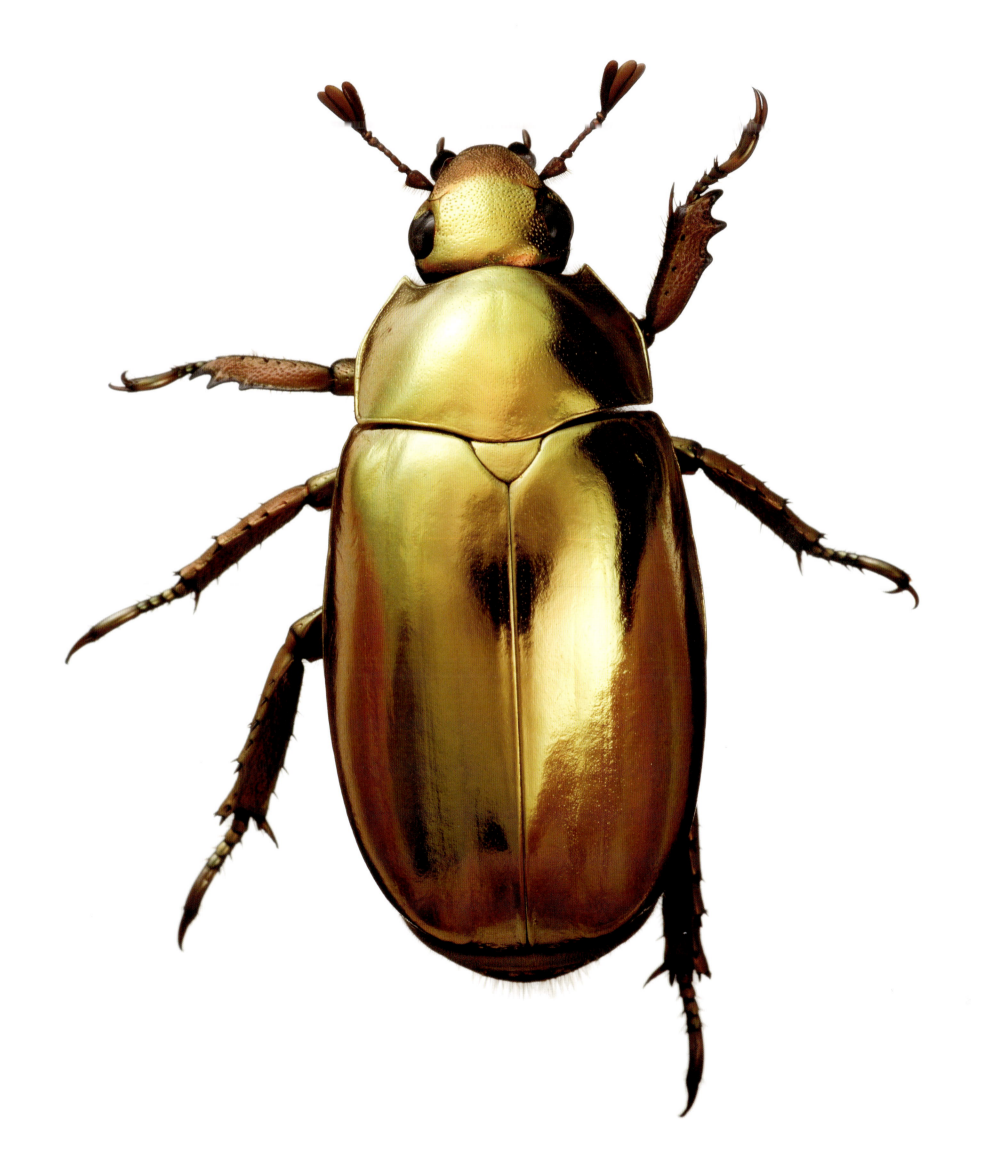

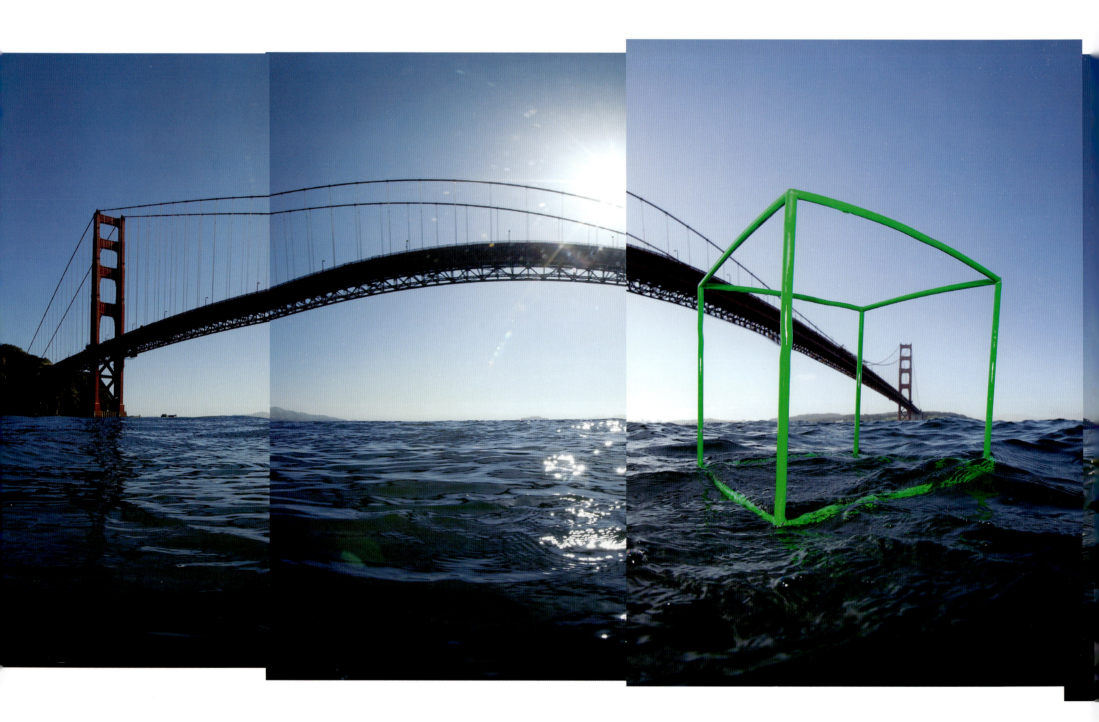

Half-title: Jewel scarab, *Chrysina resplendens,* 1.2″ (3.1 cm)

This page: The cube's location in San Francisco Bay, just to the west of
the Golden Gate Bridge. To get a sample here, fine mesh nets were towed
behind the *Argo* (right) and worked by David's assistant, Anand Varma.

A WORLD IN

ONE CUBIC FOOT

PORTRAITS OF BIODIVERSITY

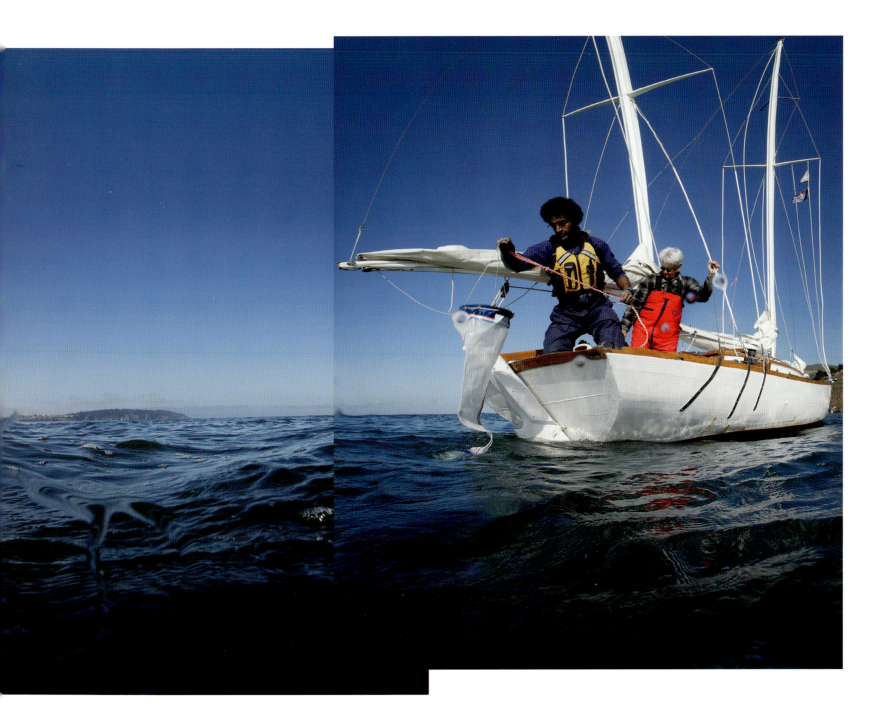

DAVID LIITTSCHWAGER

FOREWORD BY E. O. WILSON

THE UNIVERSITY OF CHICAGO PRESS
CHICAGO AND LONDON

Spotted boxfish

Ostracion meleagris

3.5" (8.9 cm)

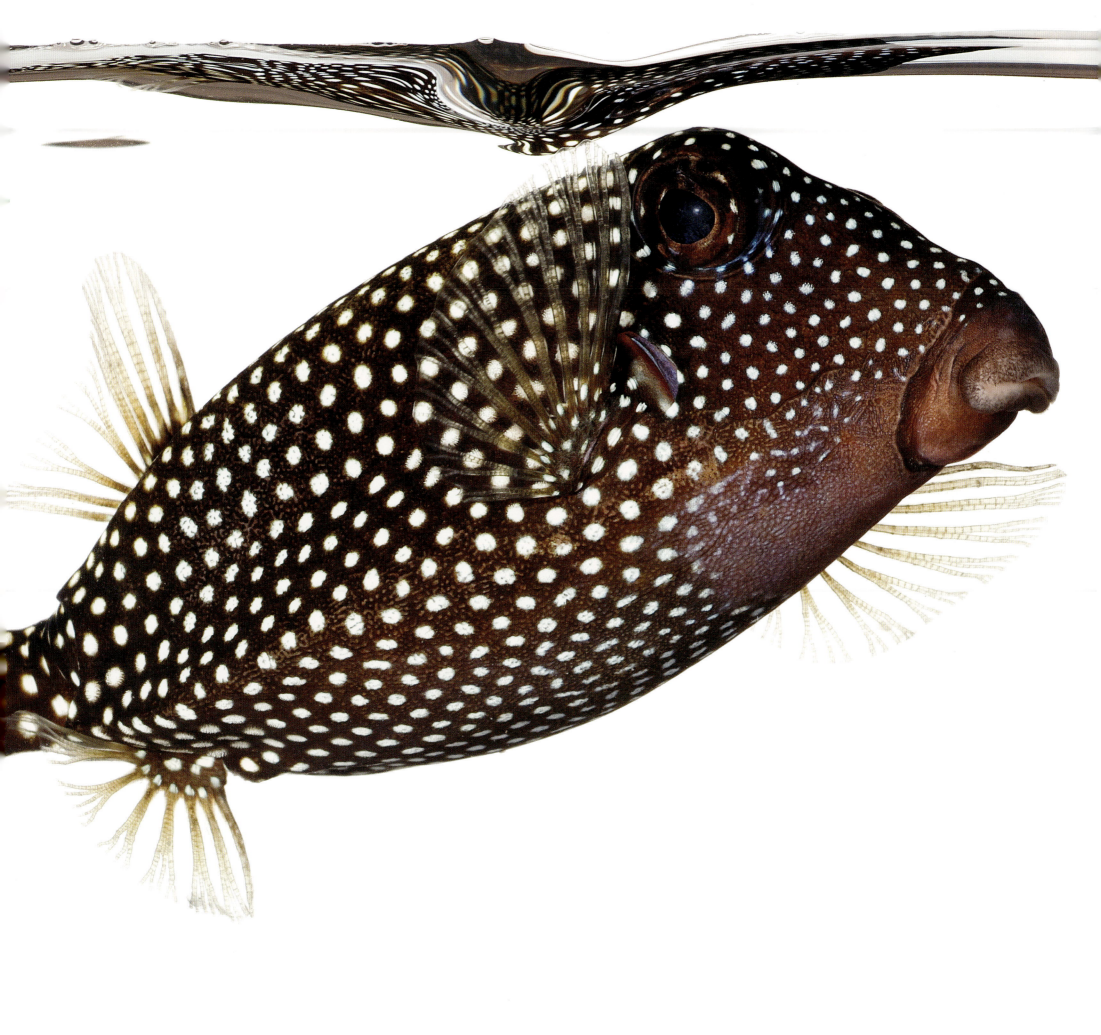

CONTENTS

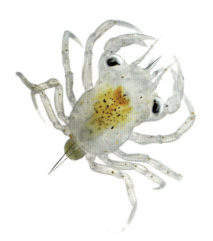
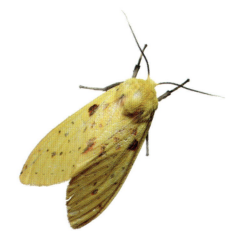
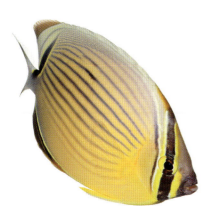

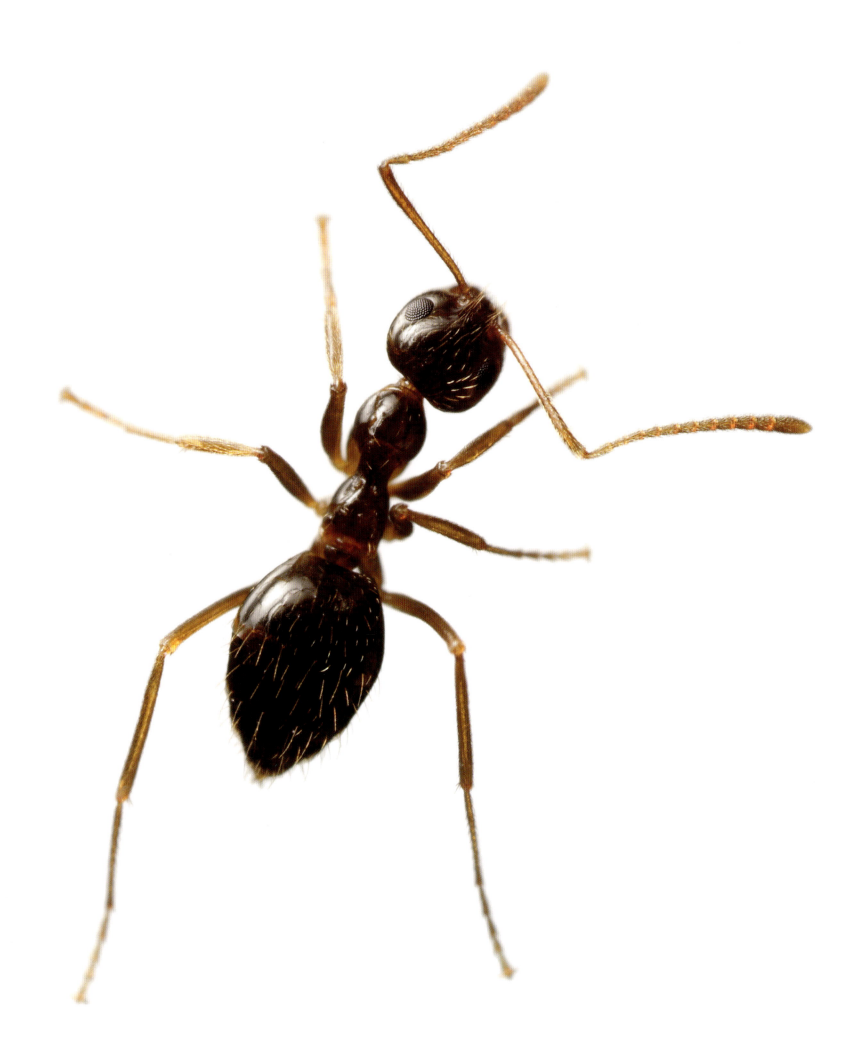

A Shovelful of Soil

WHEN YOU THRUST a shovel into the soil or tear off a piece of coral, you are, godlike, cutting through an entire world. You have crossed a hidden frontier known to very few. Immediately close at hand, around and beneath our feet, lies the least explored part of the planet's surface. It is also the most vital place on Earth for human existence.

In any habitat, on the ground, in the forest canopy, or in the water, your eye is first caught by the big animals—birds, mammals, fish, butterflies. But gradually the smaller inhabitants, far more numerous, begin to eclipse them. There are the insect myriads creeping and buzzing among the weeds, the worms and unnameable creatures that squirm or scuttle for cover when you turn garden soil for planting. There are those annoying ants that swarm out when their nest is accidentally cut open and the pesky beetle grubs exposed at yellowed grass roots. When you flip a rock over, there are even more: You see spiderlings and sundry pale unknowns of diverse form slinking through mats of fungus strands. Tiny beetles hide from the sudden light, and pill bugs curl their bodies into defensive balls. Centipedes and millipedes, the armored snakes of their size class, squeeze into the nearest crevices and wormholes.

It may seem that the whole icky lot of them, and the miniature realms they inhabit, are unrelated to human concerns. But scientists have found the exact opposite to be true. Together with the bacteria and other invisible microorganisms swimming and settled around the mineral grains of the soil, the ground dwellers are the heart of life on Earth.

The terrain they inhabit is not just a matrix of dirt and rubble. The entire ground habitat is alive. Living forms create virtually all of the substances that flow around the inert grains.

If all the organisms were to disappear from any one of the cubic spaces depicted in these photographs, the environment in it would soon shift to a radical new state. The molecules of the soil or streambed would become smaller and simpler. The ratios of oxygen, carbon dioxide, and other gases in the air would change. Altogether, a new physical equilibrium would be approached, at which the cubic foot would resemble that on some distant, sterile planet.

Earth is the only planet we know that has a biosphere. This thin, membranous layer of life is our only home. It alone is able to maintain the exact environment we ourselves need to stay alive.

False honey ant
Prenolepis imparis
0.2″ (4 mm)

Most of the organisms of the biosphere, and the vast number of its species, can be found at the surface or just below it. Through their bodies pass the cycles of chemical reactions upon which all of life depends. With precision exceeding anything our technology can match, some of the species break down the dead plant and animal material falling from above. Specialized predators and parasites feed on these scavengers, and higher level specialists feed on them in turn. The whole, working together in a constant turnover of birth and death, returns to the plants the nutrients needed to continue photosynthesis. Without the smooth working of all this linkage, the biosphere would cease to exist.

Thus, we need all of this biomass and biodiversity, including all of the creepy-crawlies. Yet in spite of its vital role, life at the ground level remains relatively unknown, even to scientists. About 60,000 species of fungi have been discovered and studied, for example, including mushrooms, rusts, and molds, but specialists estimate that more than 1.5 million species actually exist on Earth. Along with them in the soil thrive some of the most abundant animals in the world, the nematodes, also known as roundworms. These include, among other forms, the barely visible white wigglers that can be found everywhere just underground. Tens of thousands of roundworm species are known, and the true number could be in the millions. Both fungi and roundworms are outdone dramatically in turn by still smaller organisms. In a pinch of garden soil, about a gram in weight, live millions of bacteria, representing several thousand species. Most of them are unknown to science.

Ants, with more than 12,000 described species in the world (and the group on which I specialize as a naturalist), are among the better studied insects. Yet it's a good guess that the actual number is double or even triple that. In 2003 I completed a study of the "big-headed ants" of the Western Hemisphere, a genus (*Pheidole*) that has the largest number of known species and is among the most abundant of all the ants. At the end of my study, after 18 years of off-and-on effort, I had distinguished 624 species. A majority, 337, were new to science.

Only a dozen or so of the species have been closely studied. One of the smallest, I discovered, feeds on oribatid mites, which are usually much smaller than the letter *o* on this page and resemble a cross between a spider and a turtle. Oribatids are among the most abundant creatures of their size in the soil. A cubic foot might contain thousands of individuals. Yet I found that their diversity and habits remain largely unknown, much more than in the case of ants.

Life at the ground level is not just a random mix of species, not an interspersion of fungi, bacteria, worms, ants, and all the rest. The species of each group are strictly stratified by depth. In passing from just above the surface on down, the conditions of the microenvironment change gradually but dramatically. Inch by inch there are shifts in light and temperature, the size of the cavities, the chemistry of the air, soil, or water, the kind of food available, and the species of organisms. The combination of these properties, down to a microscopic level, defines the surface ecosystem. Each species is specialized to survive and reproduce best in its particular niche.

Soil studies, and especially the biology of the ground level, is growing rapidly into a major branch of science. Now bacteria and other microscopic forms of life can be identified quickly by the decoding of their DNA. The life cycles of increasing numbers of insects and other invertebrate animals, many entirely unknown to science, are being explored in the field and laboratory. Their physical and nutritional needs are coming clear, species by species. The Encyclopedia of Life, available in a single address (eol.org), is gathering all known information on each species and making it available free throughout the world.

A small world awaits exploration. As the floras and faunas of the surface are examined more closely, the interlocking mechanisms of life are emerging in ever greater and more surprising detail. In time we will come fully to appreciate the magnificent little ecosystems that have fallen under our stewardship.

— *E. O. Wilson*

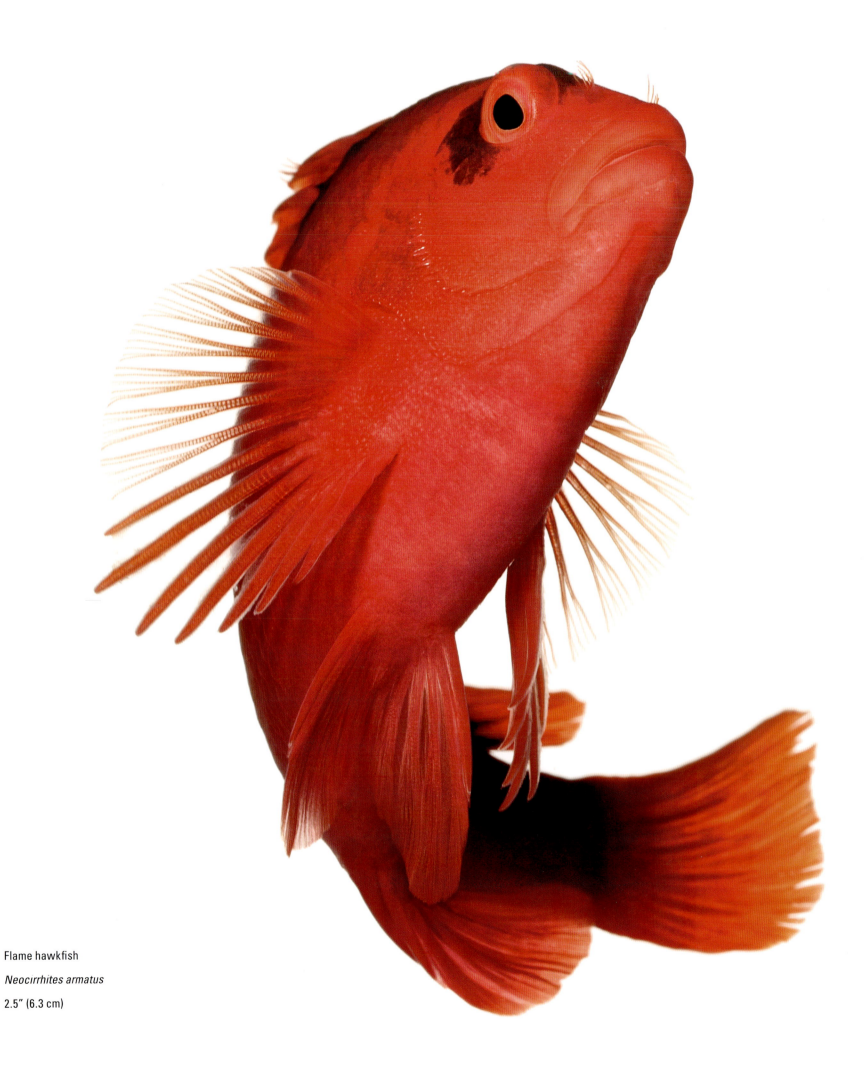

Flame hawkfish

Neocirrhites armatus

2.5" (6.3 cm)

A Lap-Size Sample

"A lifetime can be spent in a Magellanic voyage around the trunk of a single tree."

—E. O. WILSON

THIS BOOK STARTED WITH A QUESTION: How much life can be found in a small piece of the world, in just one cubic foot, over the course of a normal day? A cube seemed the right size and shape—you could hold it in your lap or get your arms around it. If you examined and photographed the complex life it held, what would that life look like?

The imagined cube became a frame made of quarter-inch stainless steel rod. The design had to be simple but adaptable. I also used a miniature photo studio that I could travel with and set up in very dissimilar terrains. I wanted to photograph, as precisely and faithfully as possible, every creature I found in the cube.

The poet Wendell Berry wrote in his foreword to my first co-authored book, on vanishing species, *Here Today*: "This intense concentration upon the appearance of the creature itself is, to begin with, a plea. It is a way of saying, Look! Look! See how fearfully and wonderfully this creature is made. See how beautifully the feathers, or the scales, or the short smooth hairs are laid together. See the gloss of live intelligence in this eye, and in this one.... If it did not exist, you could not imagine it. Since it does exist, please do not neglect to imagine it."

This time, I wanted viewers to see the microcosm the cube revealed in faraway locales, then imagine a similar universe in one cubic foot of their own backyard, a nearby park, or creek. I wanted very diverse habitats, so I consulted with marine biologists, evolutionary biologists, and botanists, and we decided finally on five: a coral reef, a freshwater river, forest leaf litter, a cloud forest canopy, and shrubland. The photographic work, generously supported by *National Geographic* magazine, occupied me from October 2007 to September 2008.

My first location was a forest leaf litter habitat in the middle of New York City—in Central Park. The second was shrubland, and for that I chose South Africa's Mountain Fynbos, a bush area that Frank Almeda, a botanist at the California Academy of Sciences, had told me about years before. Sit on the ground, he told me, and you can reach out and touch 50 species of plants. The forest canopy habitat was the most logistically challenging, so the connection

I made with Nalini Nadkarni was critical: Her study site in Costa Rica's Monteverde cloud forest was a jewel of diversity. Moorea, French Polynesia, my preferred coral reef location, already had the Biocode Project, a collaboration between the University of California Berkeley and the Smithsonian Institution to characterize the biological diversity of the island and its surrounding waters; the project coordinator, Chris Meyer, kindly agreed to help with cube specimen IDs. The other aquatic setting on my list—a freshwater habitat—was an easy choice: My friend Paul Hartfield, an aquatic biologist for the U.S. Fish and Wildlife Service, said that Tennessee's Duck River was the place to go.

When I set the cube on leaf litter in Central Park, I was testing the entire concept and didn't know what to expect. I knew I wanted maximum diversity, so I had to find a spot that was a little wild and unmanicured. My assistant, Anand Varma, and I spent a couple of days looking at locations throughout the park with Regina Alvarez, Director of Horticulture and Woodland Management for the Central Park Conservancy. We settled on the Hallett Nature Sanctuary, just northwest of the Pond at Fifth Avenue and Central Park South—a very busy part of the world, but the Hallett has been fenced in since 1939 and remains mostly undisturbed. Leaf litter there still has the kind of loft that allows for more life.

After we decided on the general location, we had to choose where to put the cube. This part of my project was sometimes the hardest part. Whatever the habitat, the cube's placement determined the species list. Move the frame a little to the right or left and you get a different selection of plants. Different plants mean different pollinators and different herbivores. Move the frame up or down a hillside, and the average temperature, rainfall, and hydrology change, as do things inside the cube. It sometimes took days to find the right spot, but once I planted the cube, there it stayed.

In the Hallett, we put the cube in our chosen spot then backed away and sat down to watch. A gray squirrel wandered in. Song birds foraged about. The light changed. After days of observing and photographing the cube in situ, we began collecting specimens from it—motile creatures like midges, flies, spiders, ants. The crawlers were easy to catch, the fliers we caught in a net. We brought the creatures to our field studio, where I photographed them against a white background, which allows for the sharpest, best-lit likeness. Nature loves to hide, but I wanted to show everything. I love classic scientific illustrations, particularly 18th-century European natural history drawings, and I wanted to get that same clarity and fidelity. Certain samples were easy to photograph. Millipedes seemed to pose politely for the camera. Whirligig

mites, on the other hand, measure less than a millimeter and accelerate scarily fast (a defense mechanism), so photographing them at five times life size was a sizable task.

After photographing a creature, I released it to its habitat or passed it on to the American Museum of Natural History for a scientific ID. One hitch at the Hallett site was that I wasn't allowed to handle larger animals. We made a species list of the vertebrates that moved through the cube but had to find another way to photograph them. At the suggestion of my assistant, Anand, we went to his home state of Georgia and there photographed a squirrel from an animal rescue shelter, a raccoon used as a "wildlife ambassador" in schools, and bird species that were being banded by Audubon crews in the field. My Central Park shoot, including the Georgia trip, took 16 days and entailed 6,000 exposures to record 121 living specimens. That would turn out to be one of the most compressed times. Two other locations, Moorea and the Monteverde cloud forest, because of logistics and their tropical density, took twice as long.

In 2011, supported by the David Brower Center in Berkeley, California, I added a sixth habitat to this book. I wanted to "localize" my experience, to find a habitat that was close to home, essentially part of my neighborhood. Early on in the habitat quest, one consultant had suggested an open-water habitat, and since I live in San Francisco, the Bay seemed ideal. The cube would go under the Golden Gate Bridge, where the confluence of ocean currents and terrestrial run-offs creates a rich marine stew. I can't now drive across the bridge without imagining what the cube revealed.

Of all the locales, however, Central Park's leaf litter holds a special place in my consciousness. Just outside the Hallett were paved paths, huge lawns, city streets, and high rises, but in that spot, across just one, unstepped-on leaf, hundreds of creatures were coming and going. It's a world like the "tangled bank" Darwin described in the last paragraph of *On the Origin of Species by Means of Natural Selection*:

"It is interesting to contemplate a tangled bank, clothed with many plants of many kinds, with birds singing on the bushes, with various insects flitting about, and with worms crawling through the damp earth, and to reflect that these elaborately constructed forms, so different from each other, and dependent upon each other in so complex a manner, have all been produced by laws acting around us.... There is grandeur in this view of life, with its several powers, having been originally breathed by the Creator into a few forms or into one; and that, whilst this planet has gone circling on according to the fixed law of gravity, from so simple a beginning endless forms most beautiful and most wonderful have been, and are being evolved."

— *David Liittschwager*

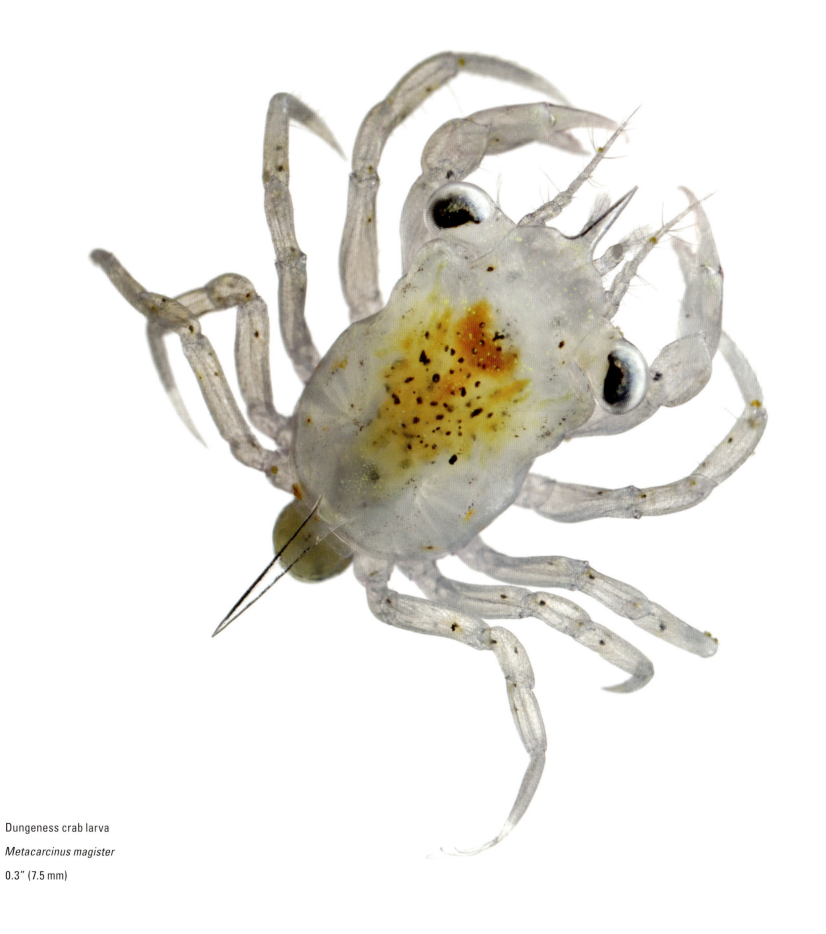

Dungeness crab larva

Metacarcinus magister

0.3" (7.5 mm)

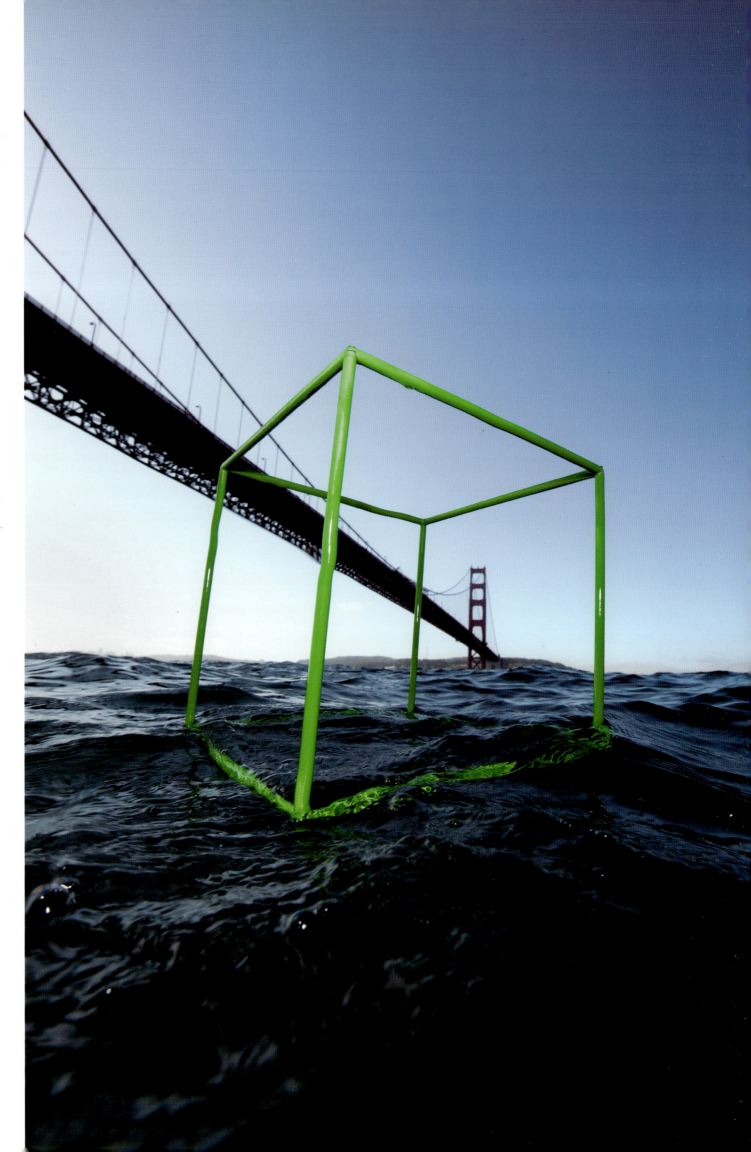

Argo *and the* One Cubic Foot *project voyaged 16 times into the Golden Gate, and in all weathers. Twice a day, a great deal of the Pacific Ocean attempts to enter San Francisco Bay; twice daily again, supplemented by the two vast riparian systems that flow into it, that same water changes its mind. Ebb or flood, a tide there can run four, five, and even six knots. Many locals and not a few tourists have watched from the beach as a perfectly lovely vessel, all sails set and full of wind, proceeds backward out the Golden Gate. A few locals have watched it from much closer up. Truth be told, these waters are reliably wild. We tasked* Argo *to navigate them delicately, at one to two knots, to facilitate trolling the fine mesh by which David captured and studied creatures all but invisible to mariners. This parameter necessitated easing and hardening sheets, feathering and reefing and even dousing sails, tacking west for one set of the net, jibing east for the next. If stemming the tide at a knot or two was the ideal, staying aboard, despite a good soaking, was occasionally the real deal. And always we stayed alert to drying rocks, deadheads, and mats of kelp—and to red-eyed grebes, harbor porpoises, bottlenose dolphins, sea lions, fog, 900-foot freighters, and the Canada bull goose, puffing his breast, flaring his wings, and honking, most truculent to see* Argo *close to his promontory.* —Captain Windrow

UNDER THE GOLDEN GATE BRIDGE, SAN FRANCISCO, CALIFORNIA

"What do you think, Subhuti? Are there many particles of dust in the 3,000 chiliocosms?"

 — The Buddha

"Very many, World-Honored One."

 — Subhuti

 From the *Vajracchedika Prajnaparamita—or Diamond—Sutra*

A couple of turkey vultures, wings unfurled like spinnakers, dry and groom themselves in the late morning sun atop Yellow Bluff.

Below them to the south the deck of the Golden Gate Bridge vibrates with automobile traffic: sedans, hatchbacks, El Caminos, Pintos, Cabriolets, blue, red, white, gray, black, countless variations thereof—40 million a year, nowadays, and around 2 billion total since the bridge went up in April 1937.

Inside the metal and plastic vehicle housings are "sentient beings," in whose housings of bone and tissue imaginings, dreams, and phantom conversations are being played and replayed, as all the while their senses are taking in the spectacle of the Bay, its headlands, its islands—billions of neurons squirting, firing, making their passage through dark archways and into adjacent realms.

"Subhuti, if there was as many Ganges Rivers as the number of grains of sand in the Ganges, would you say that the number of grains in all these Ganges Rivers is very many?"

 — The Buddha

"Very many, indeed, World-Honored One."

 — Subhuti

On the day before the summer solstice, the weather unseasonably warm and still, the 28-foot ketch *Argo* makes its way out of Pelican Harbor, past the houseboat modeled on the Taj Mahal at the harbor's mouth, and into the channel. It's quiet out there. That neuronal buzz on the bridge is gone here. We're caught up in another element, or elements, wind and water, and it's the sails and tiller that preside—and, of course, Captain Windrow, who, though vigilant, seems none too concerned, especially on a sweet morning like this.

It's not always sweet out here, as the American writer Jack London knew well. He had been an oyster pirate on the Bay in his early years, and later chased after the same pirates as part of the state's fish patrol. "San Francisco Bay is so large," he wrote, "that often its storms are more disastrous to ocean-going craft than is the ocean itself in its violent moments."

The Bay is very large indeed: With a surface area of some 400 square miles and 2 trillion gallons of volume, it is the biggest estuary in the western Americas, draining over 40 percent of the land area of California. On each day's tide more than seven times the amount of water flows through the Golden Gate than flows out of the Mississippi watershed. And instead of opening to the sea like the Chesapeake and other great estuaries, it is funneled through a narrow, mile-wide passage at the Golden Gate, where it meets the ocean. "It really blows on San Francisco Bay," London wrote in 1912.

It starts blowing now as we make for what the mariners call The Slot and the shadow under the bridge, the wind picking up fetch as it travels across the open water. The water moving out of the Bay toward the open sea has been there for six hours. We head out on the tail end of a big ebb, throw the nets out just off Kirby Cove, near the north tower of the bridge, at the shank end of ebb. The nets are 330-micron mesh for the zooplankton, 80-micron for the phytoplankton. The water is flowing freely off the cove, very little sediment, unlike in the channel. A helicopter swoops under the bridge and back over it.

We pull up a sample, brown-colored, dense with life. Here, at the eastern edge of the northern Pacific, is one of the richest, if not the richest, near-shore habitats on the planet: 550,000 creatures in the sample, 2.6 billion creatures passing through one cubic foot over the course of 24 hours ... just a tad busier than the Golden Gate Bridge over the course of 74 years. Saltwater mites, barnacle and worm larva, diatoms, porcelain

crab larva, tiny jellyfish, pteropod eggs, possum shrimp, marine gastropods, hydrozoans, snails, amphipods, gyroscope-shaped whatnots. What passes for "consciousness" in an isopod? Dream life in a marsupial shrimp?

We reverse course and return to harbor on flood tide. A container ship heads east, off our starboard. No telling what's in its containers—diatom-powered toaster-ovens?

A whole lot of salt water is displacing estuarial water underneath us. Dolphins get busy in the midst of it. The sky is cloudless. Which should facilitate stargazing later in the evening.

There are some 2,500 stars visible at any given time in the Milky Way, and about 200 to 400 million that we can't see. A mariner like Captain Windrow might not know the particular numbers, but he'd have a ballpark notion. I have known the captain for many years and can well imagine him stretched out on his back above deck gazing at the stars. He could, no doubt, steer by them if he chose to, but it's my guess he likes to just kick back and stare at them for no good reason now and again. And because he's no stranger to these phyto- and zooplankton junkets, it probably doesn't elude him that all that blinking and whatnot happening above is happening underneath his hull as well, in its own fashion. I suspect it's a great comfort to the captain knowing of so much going on around him, above and below, and none of it having anything to do with him.

> "Where there is every single sort of being—whether womb-born, whether egg-born, whether water-born, or born of transformation; whether possessing form or whether without form; whether possessing thought or whether without thought; whether neither possessing thought nor without thought—I will cause all to enter the non-residual nirvana, liberating them."
> — *The Buddha*

It's all a bit much to try to digest, the wiggling, living sutra of a drop of the Bay. Just about one drop of water from out there by Kirby Cove would seem enough to give most anyone pause, a rather long pause.

— *August Kleinzahler*

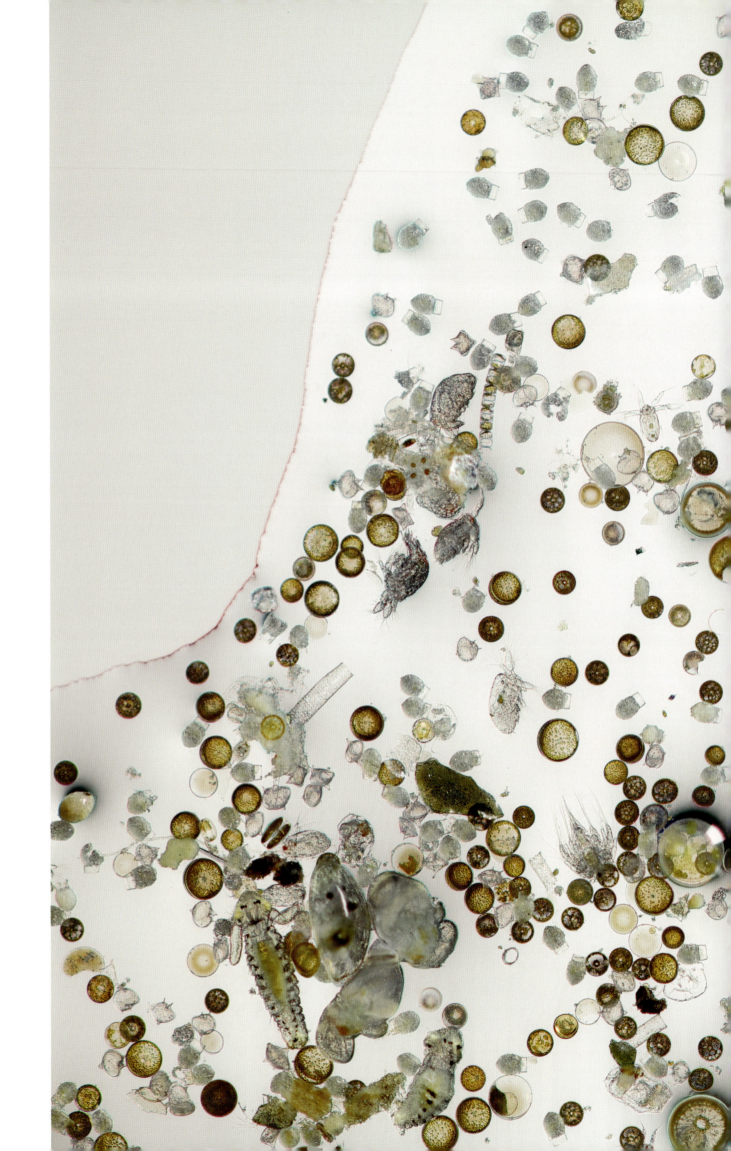

A DROP OF WATER FROM A PLANKTON SAMPLE
BELOW THE GOLDEN GATE BRIDGE, SAN FRANCISCO.

*Roughly 9,000 creatures, measuring .08
mm (.003") and greater, occupy one cubic
foot of water below the Golden Gate Bridge
at any one moment. During the course of
a typical day, about 2.6 billion creatures
will pass through that one cubic foot.*

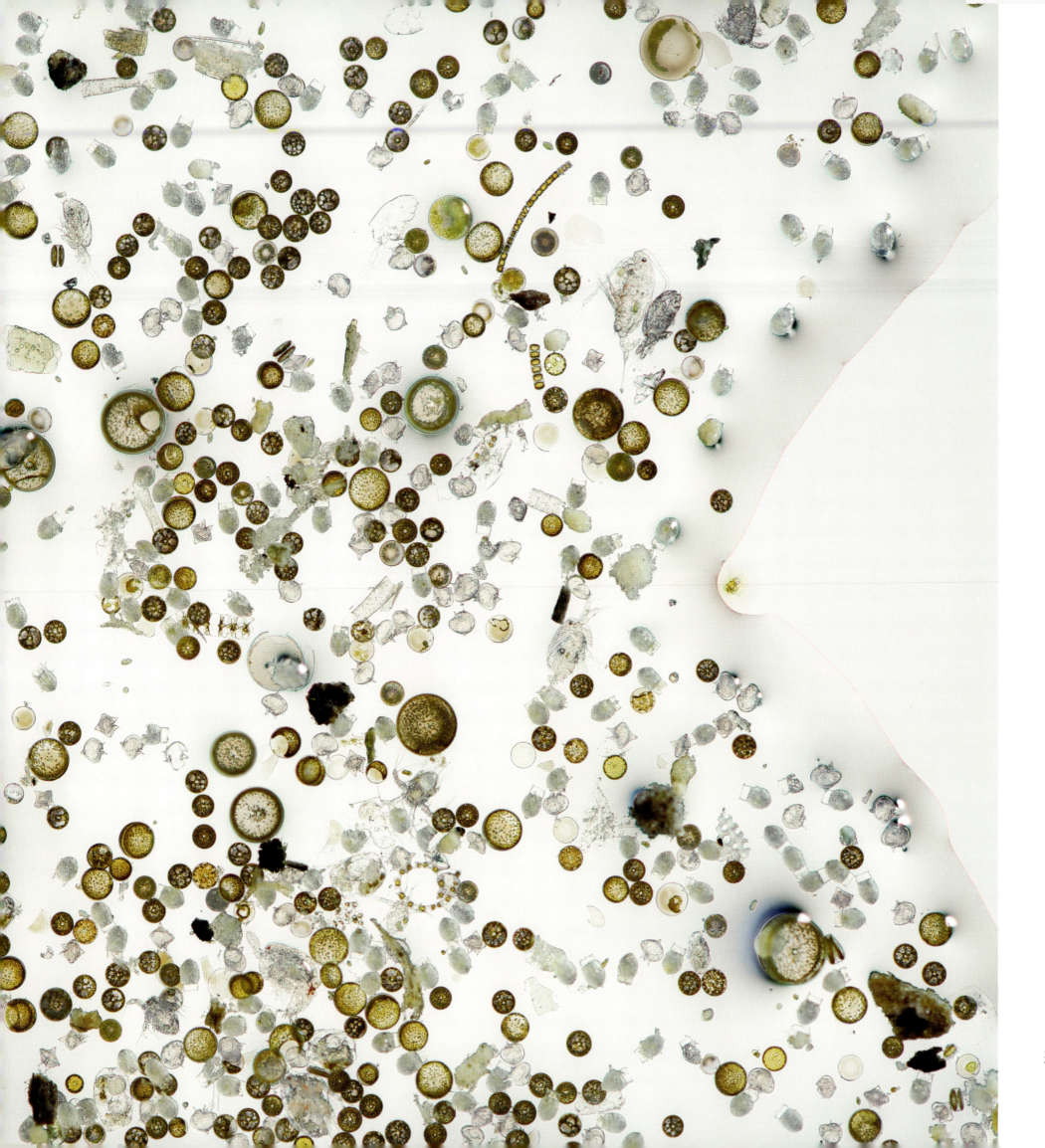

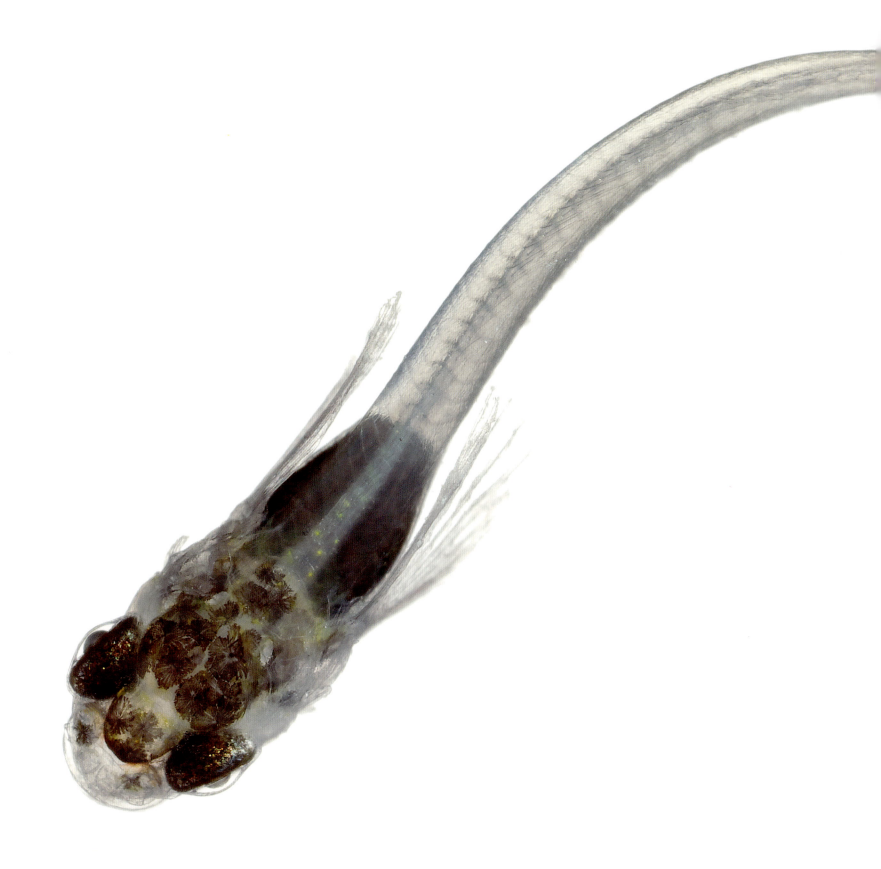

Fish larva
class Actinopterygii
0.47" (1.2 cm)

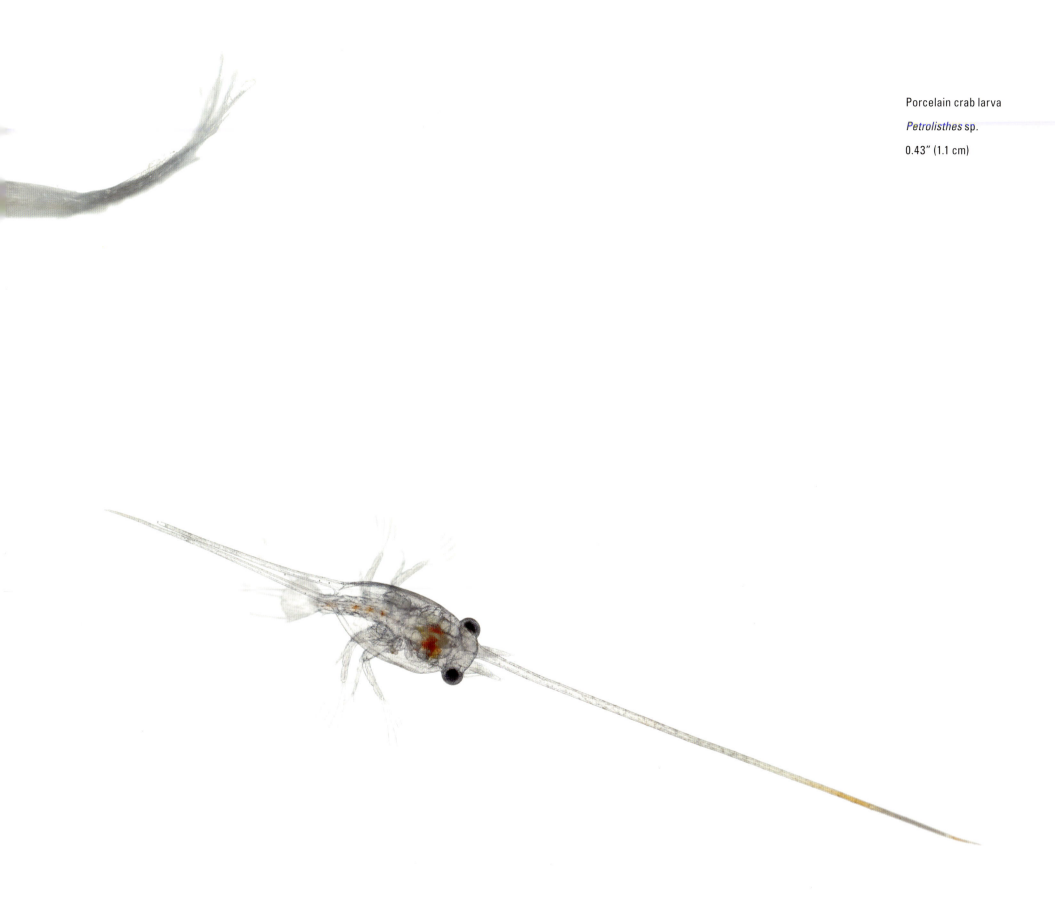

Porcelain crab larva
Petrolisthes sp.
0.43" (1.1 cm)

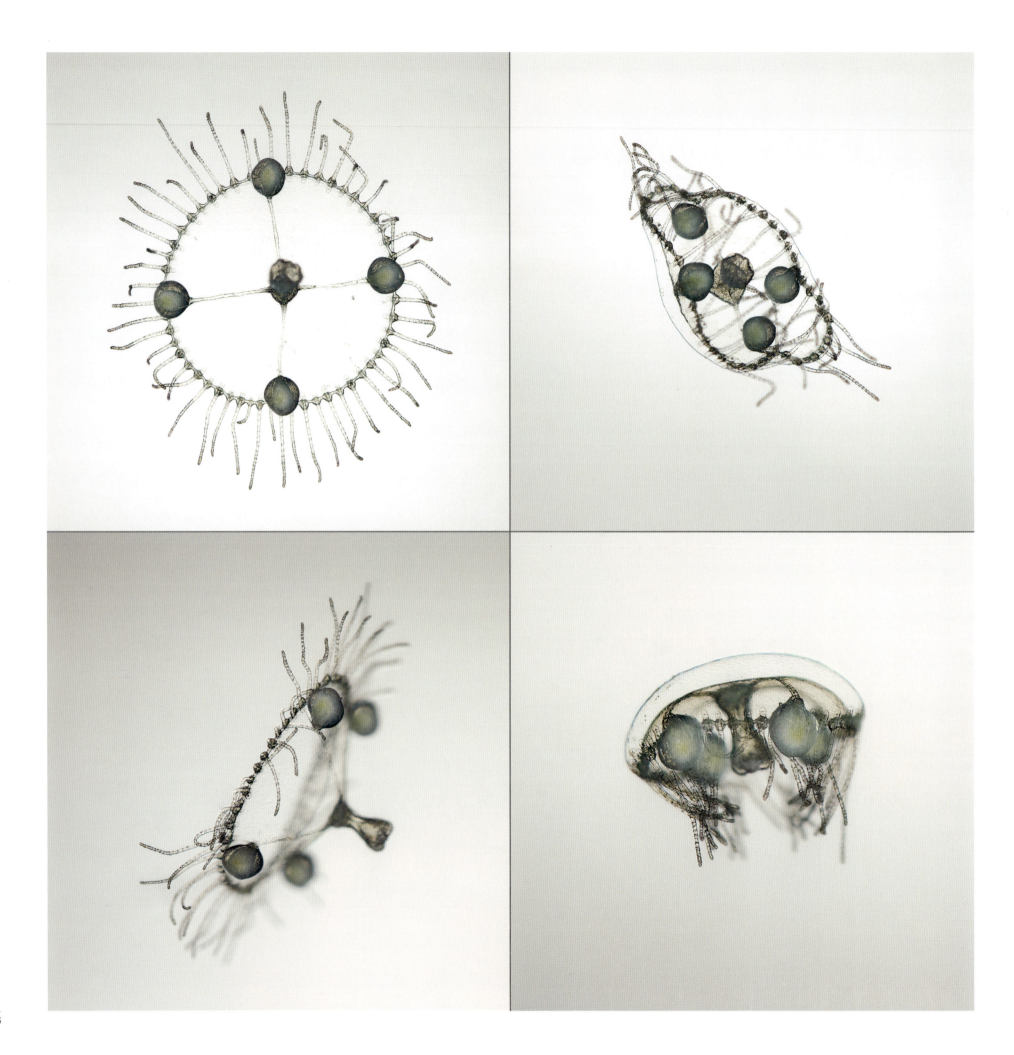

Hydrozoan jellyfish *(left, all)*

Obelia sp.

0.1" (2.5 mm)

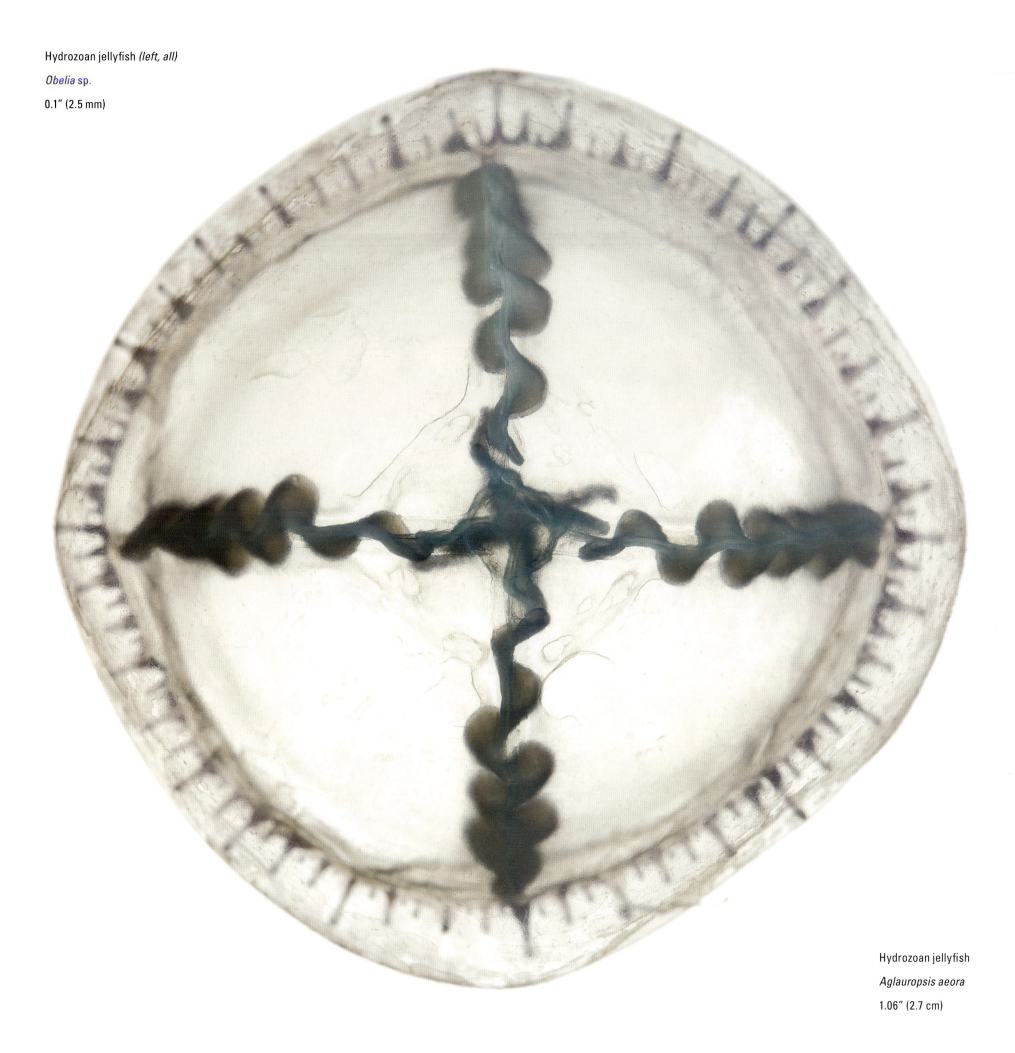

Hydrozoan jellyfish

Aglauropsis aeora

1.06" (2.7 cm)

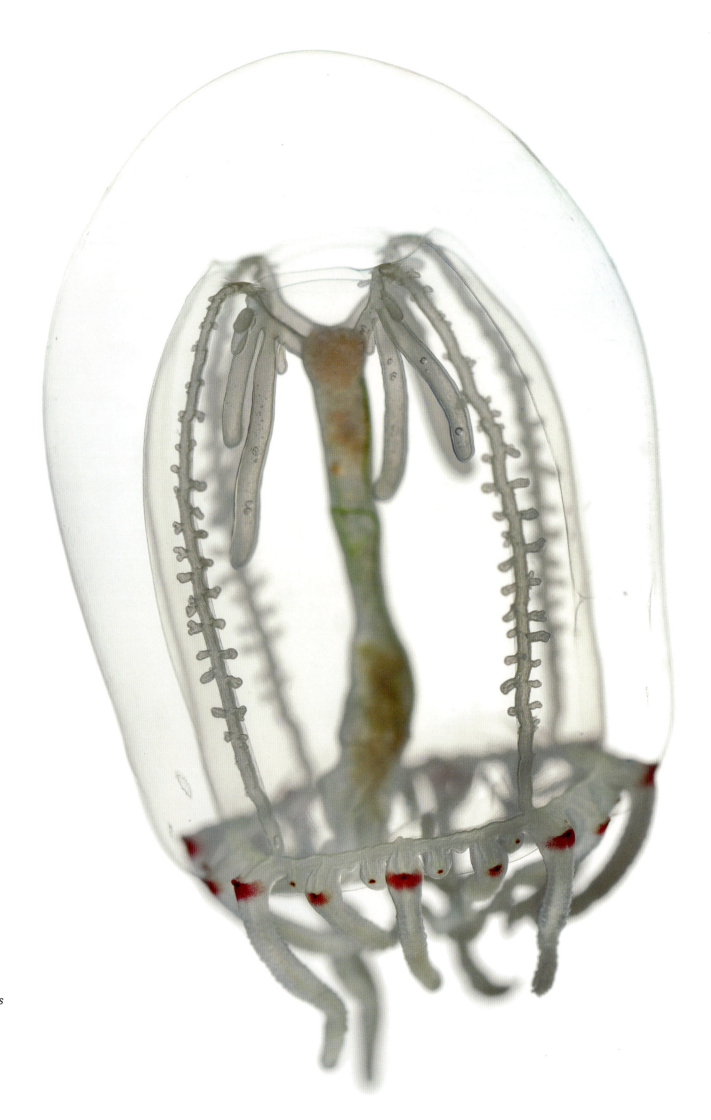

Hydrozoan jellyfish

Polyorchis penicillatus

0.83" (2.1 cm)

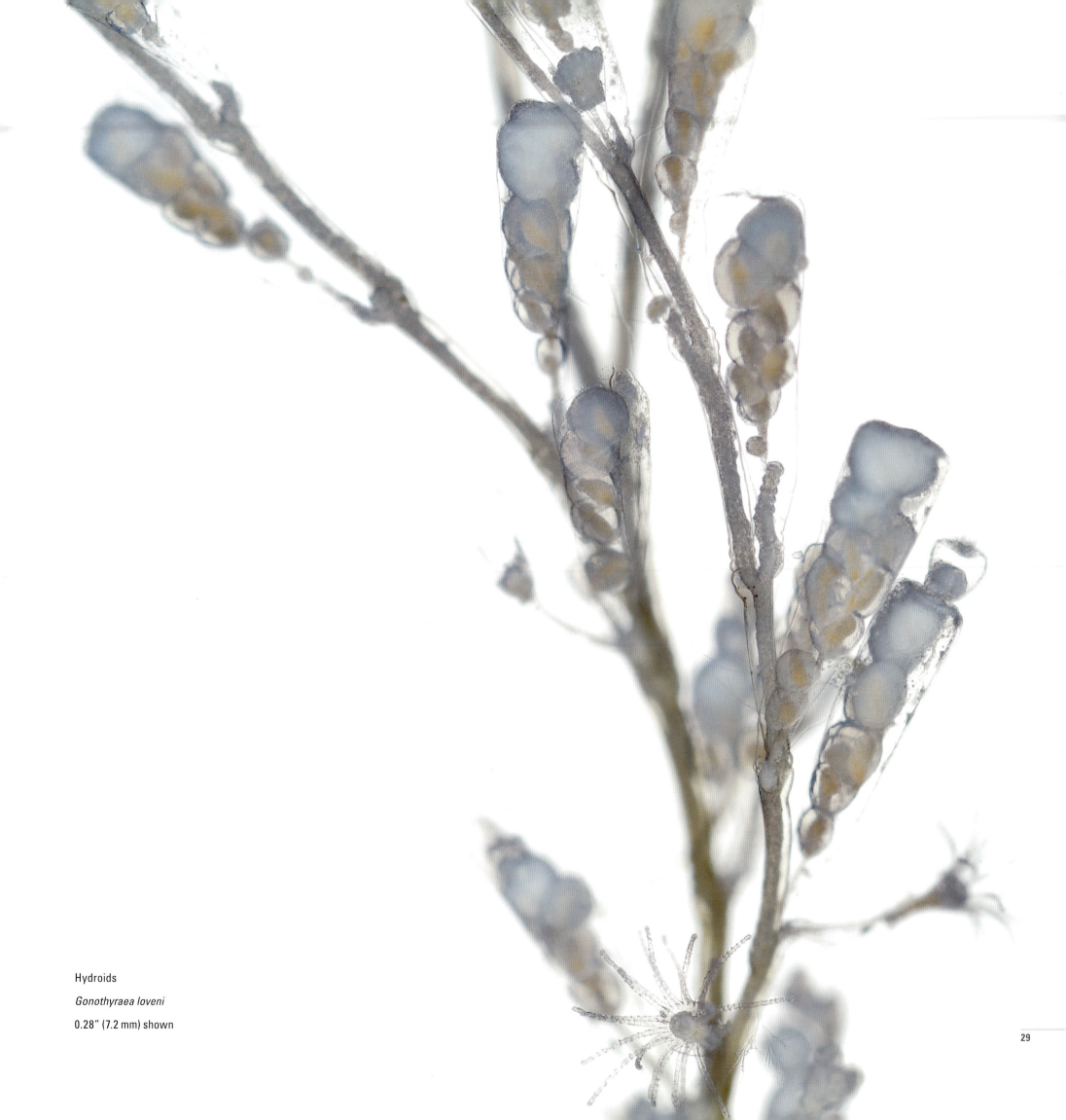

Hydroids
Gonothyraea loveni
0.28″ (7.2 mm) shown

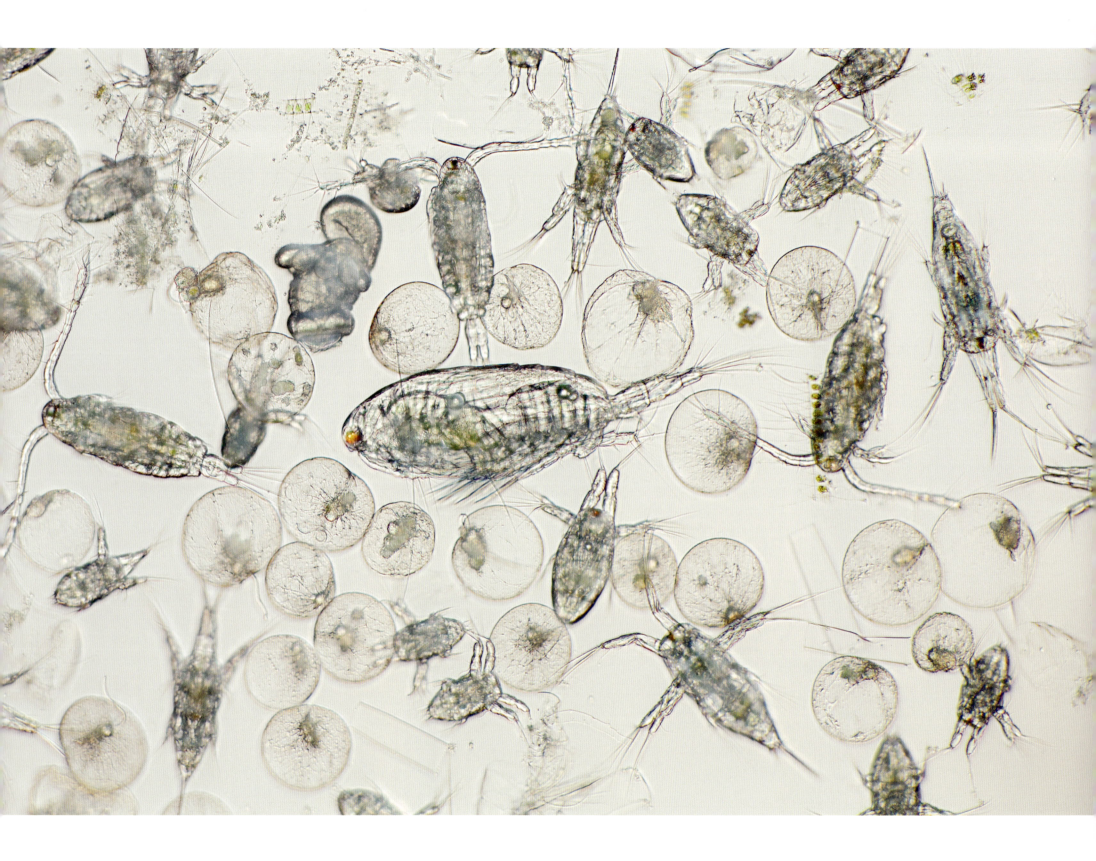

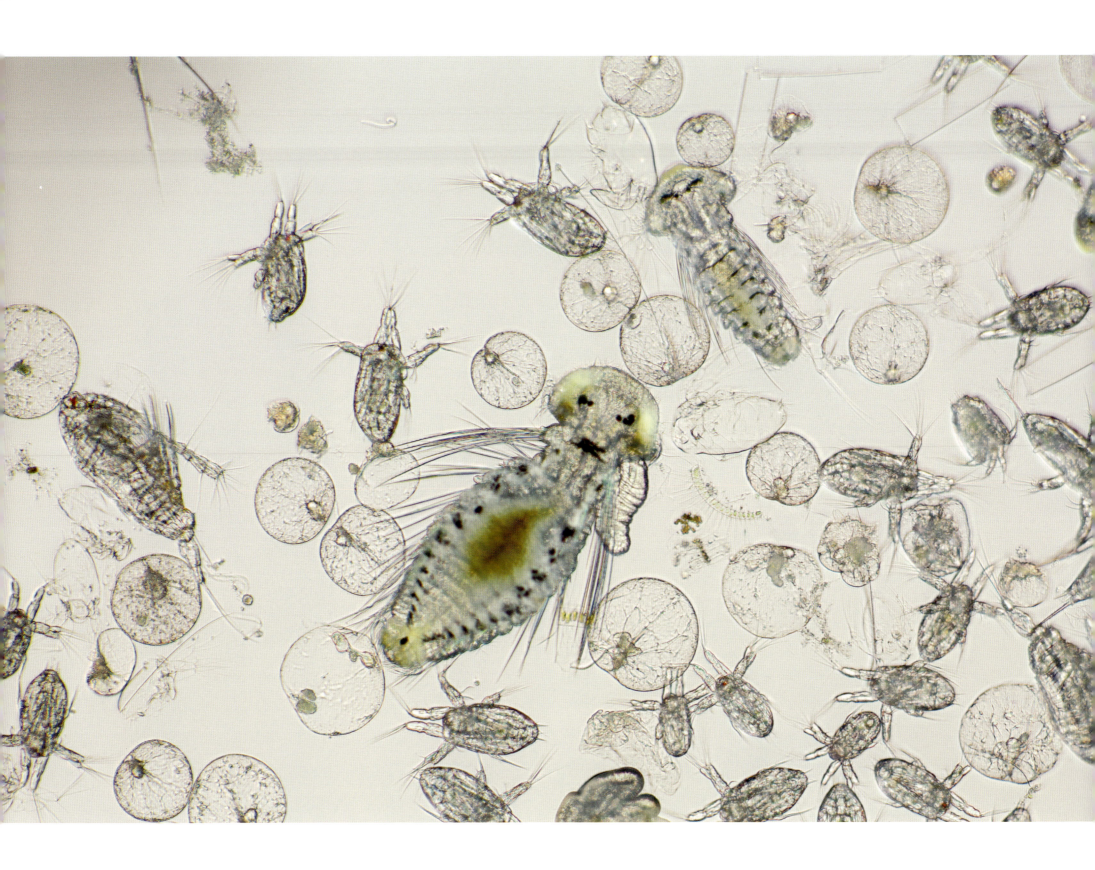

Worm larvae, copepod larvae, and diatoms

.003"–.03" (.08–.8 mm)

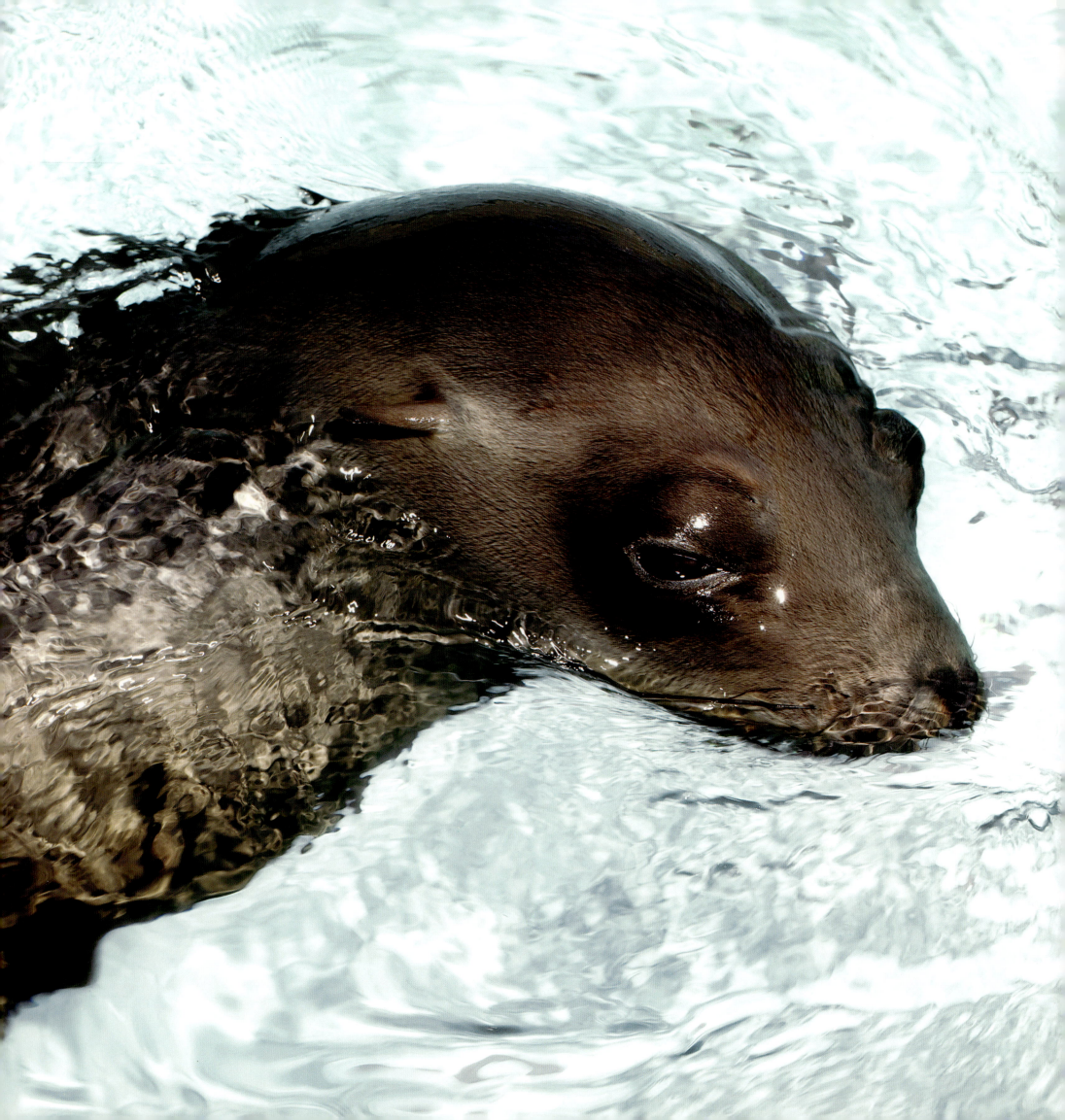

California sea lion pup *(left)*

Zalophus californianus

52″ (1.3 meters) long

Pacific harbor seal pup

Phoca vitulina

31.5″ (0.8 mctcrs) long

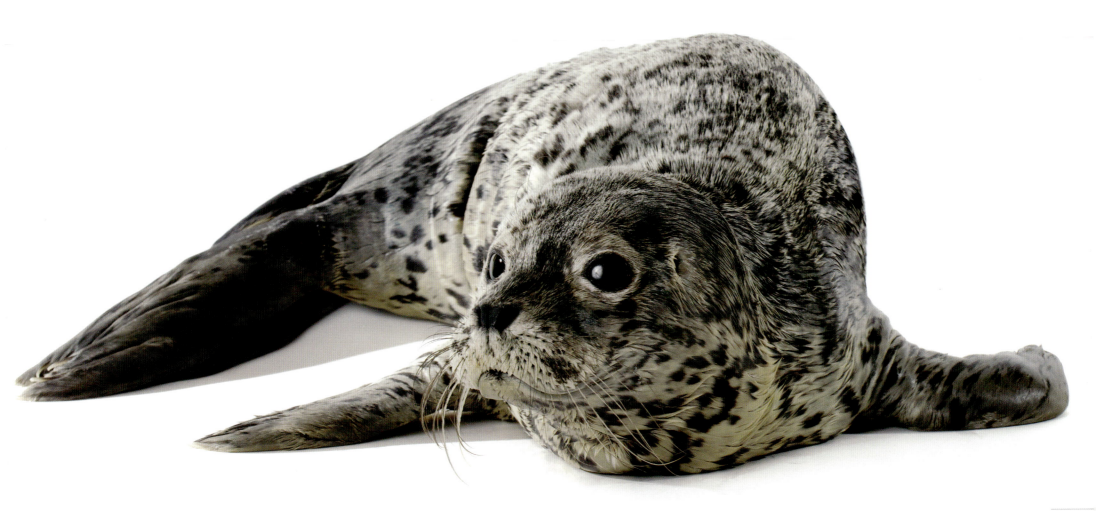

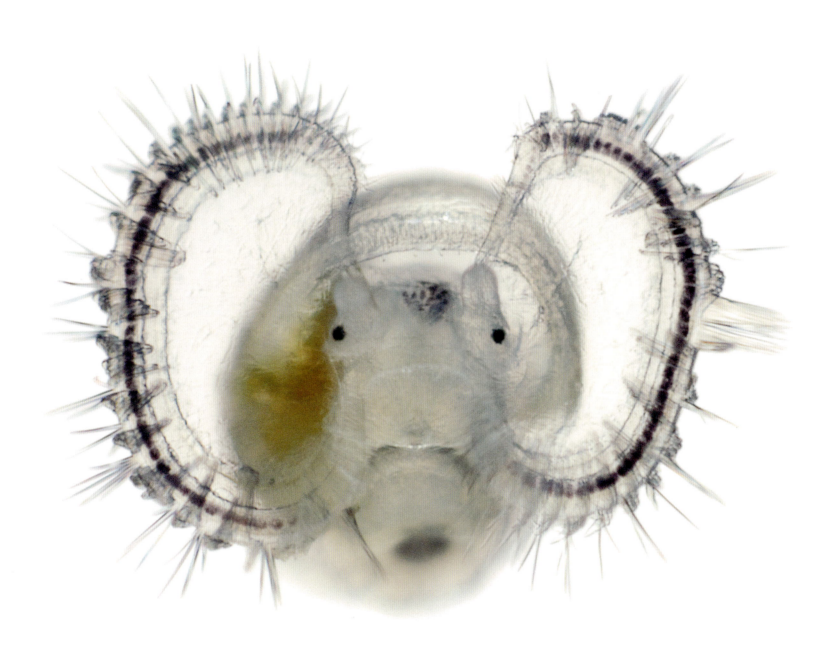

Snail larva

class Gastropoda

0.04" (1 mm)

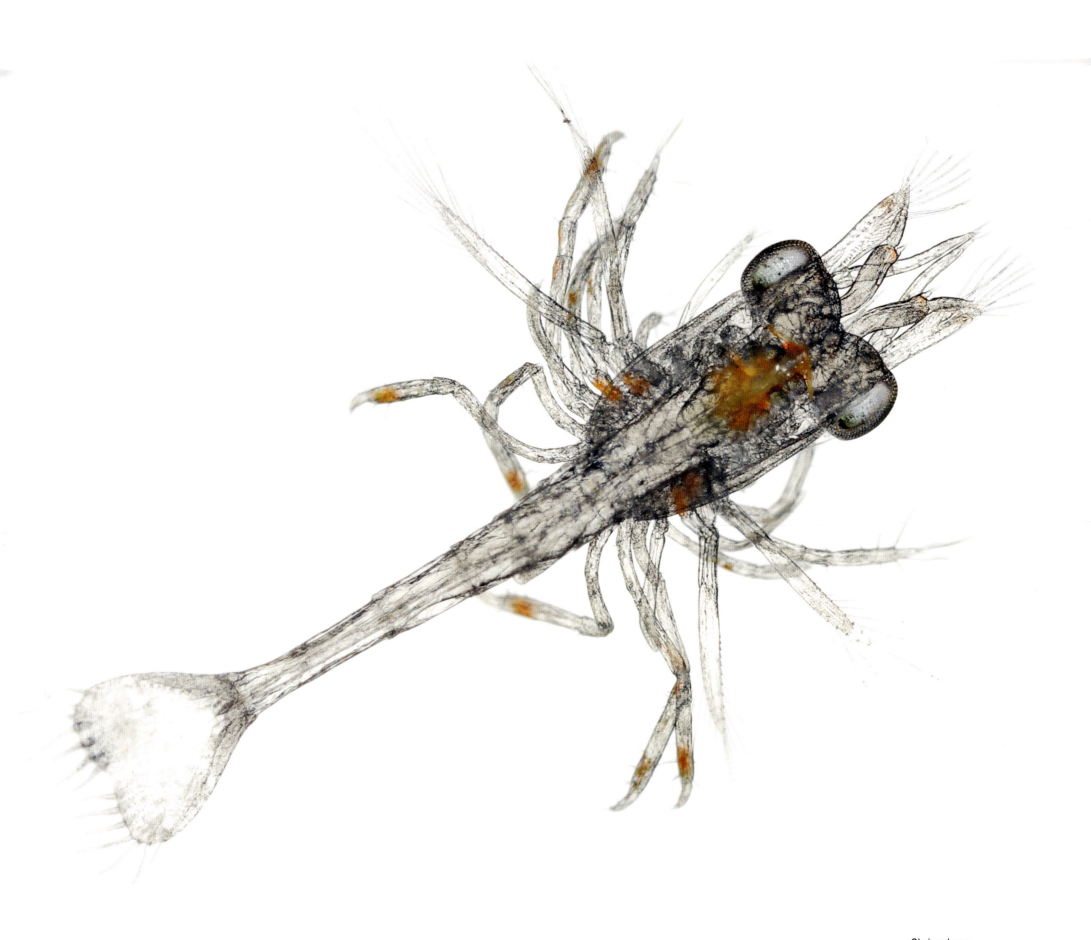

Shrimp larva

infraorder Caridea

0.26" (6.7 mm)

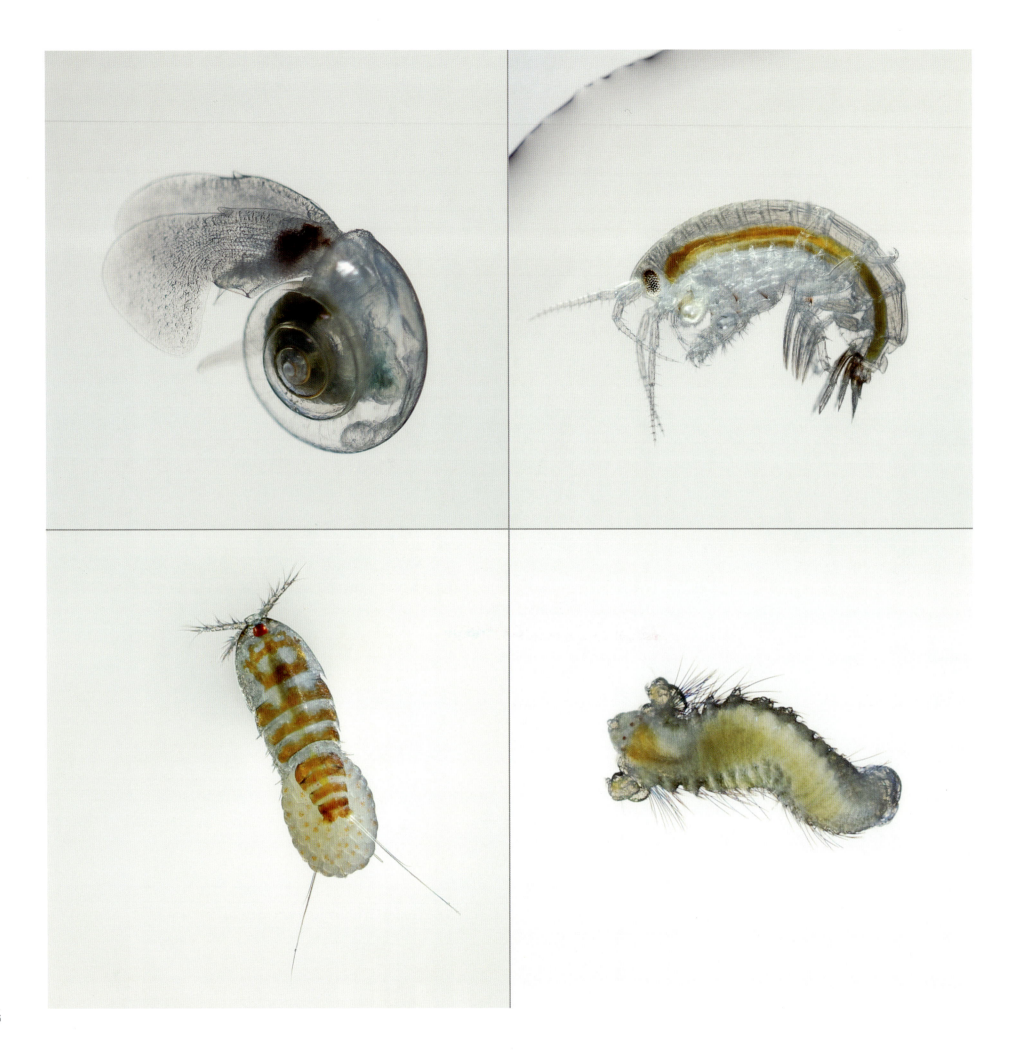

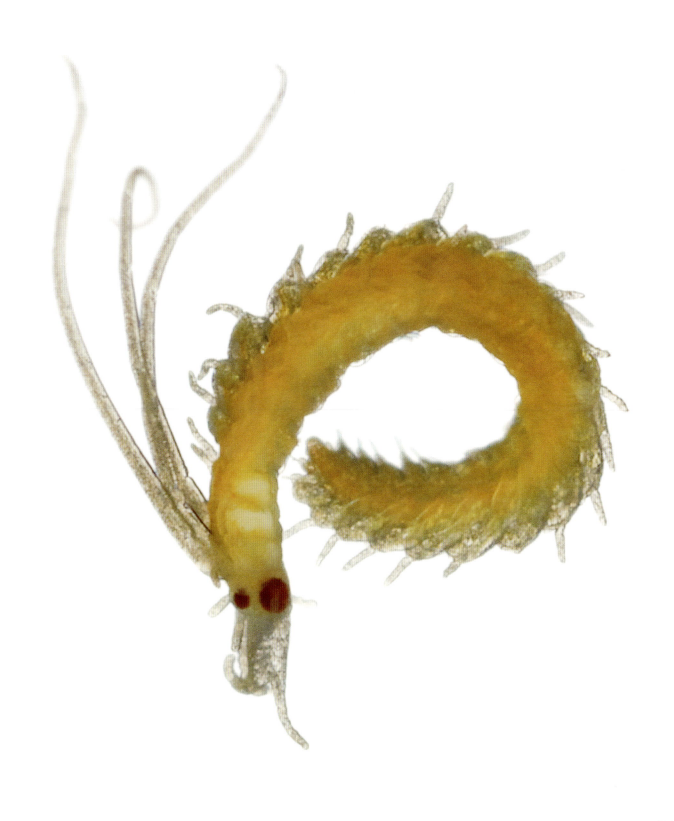

Sea butterfly *(top left)*

Limacina helicina

0.07″ (1.9 mm)

Amphipod *(top right)*

Atylus tridens

0.14″ (3.5 mm)

Copepod with eggs *(bottom left)*

Harpacticus sp.

0.06″ (1.5 mm)

Polychaete worm larva *(bottom right)*

family Spionidae

0.06″ (1.5 mm)

Polychaete worm

family Syllidae

0.11″ (2.8 mm)

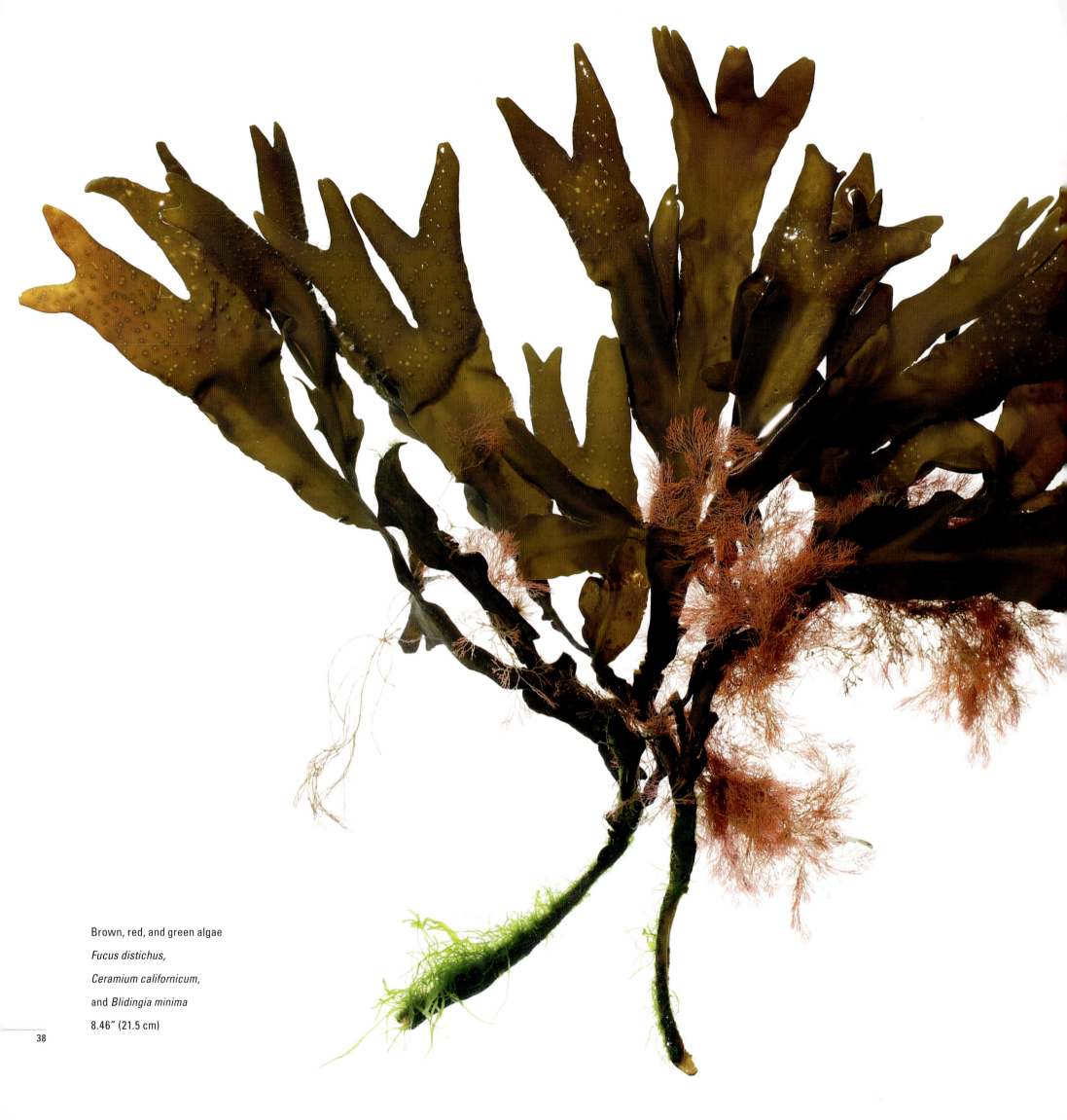

Brown, red, and green algae

Fucus distichus,

Ceramium californicum,

and *Blidingia minima*

8.46" (21.5 cm)

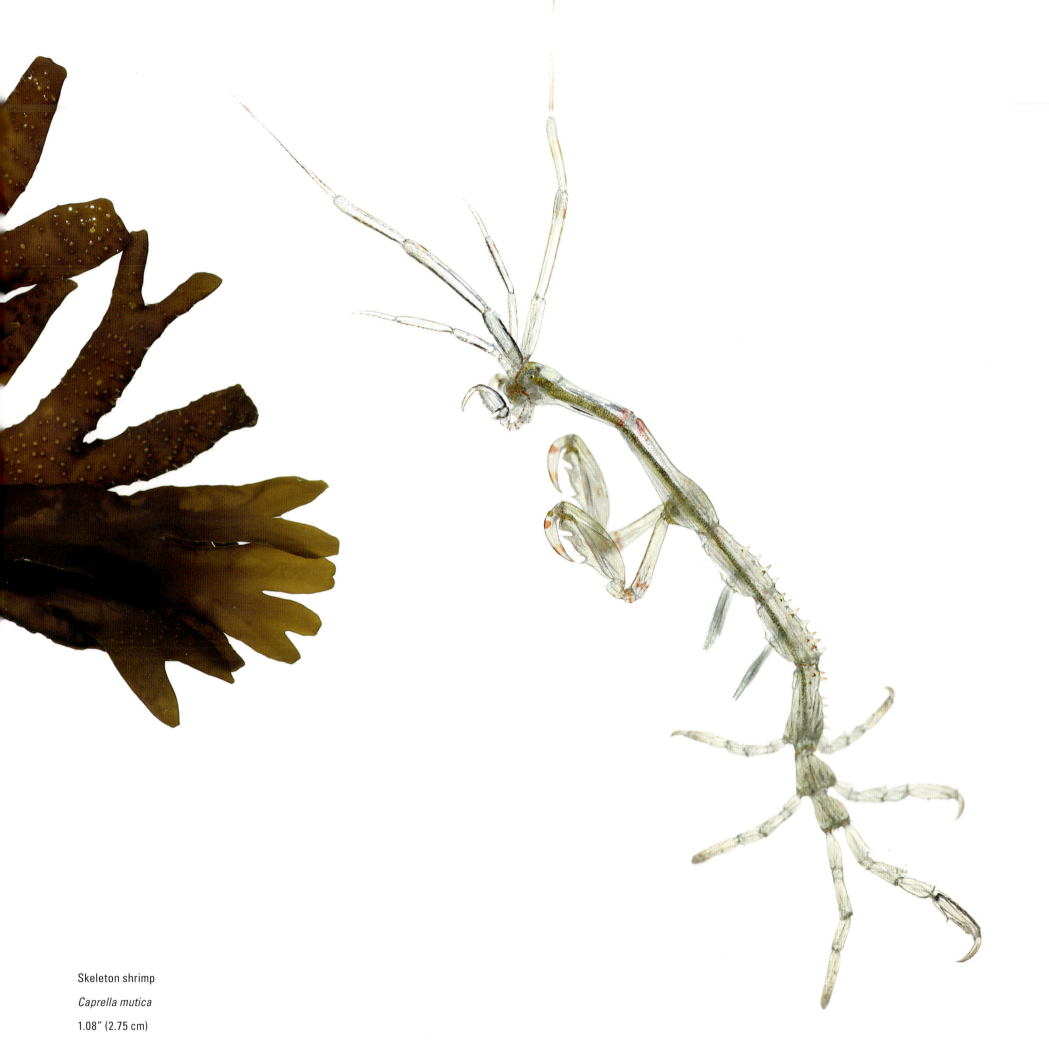

Skeleton shrimp

Caprella mutica

1.08" (2.75 cm)

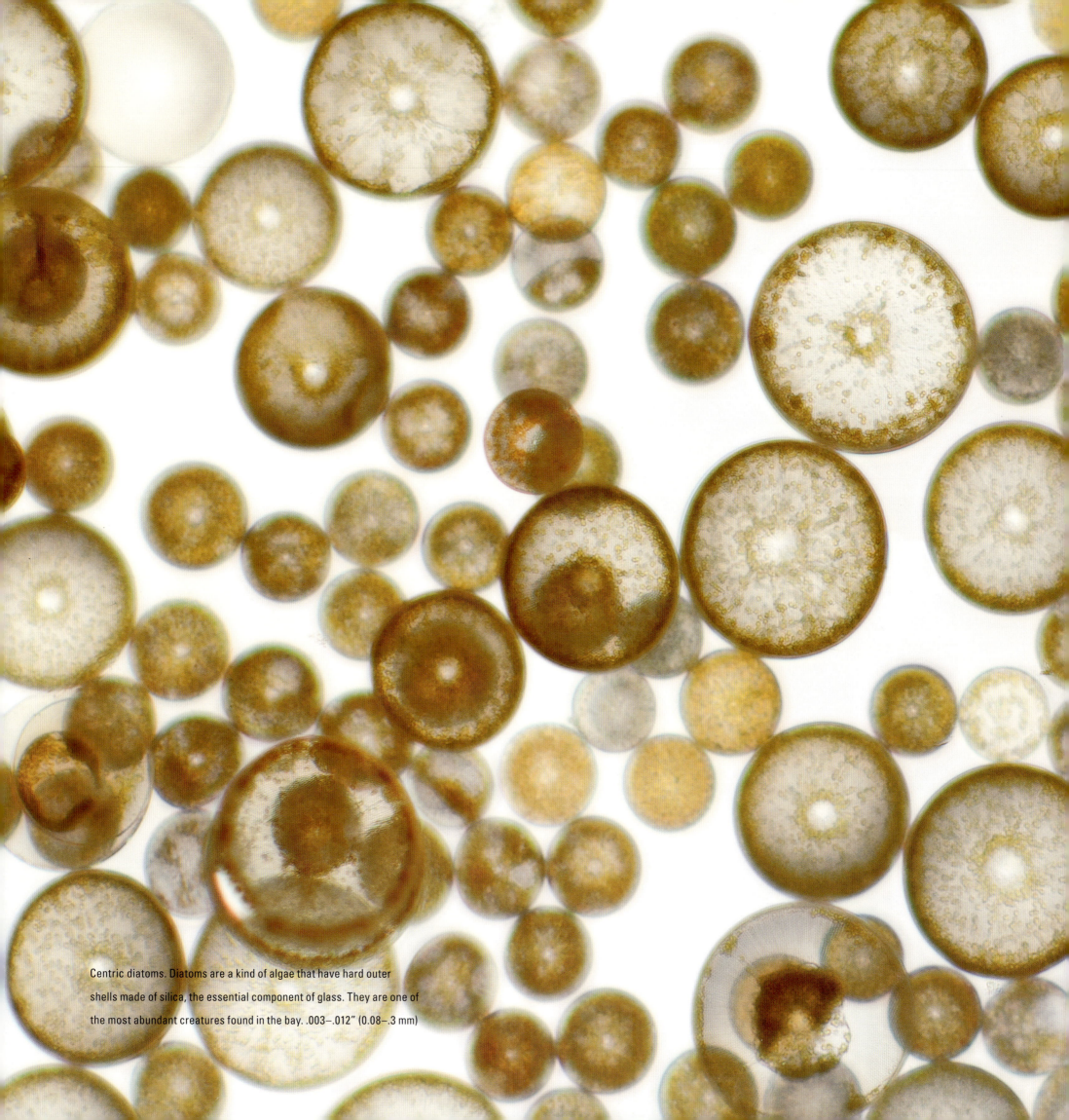

Centric diatoms. Diatoms are a kind of algae that have hard outer shells made of silica, the essential component of glass. They are one of the most abundant creatures found in the bay. .003–.012" (0.08–.3 mm)

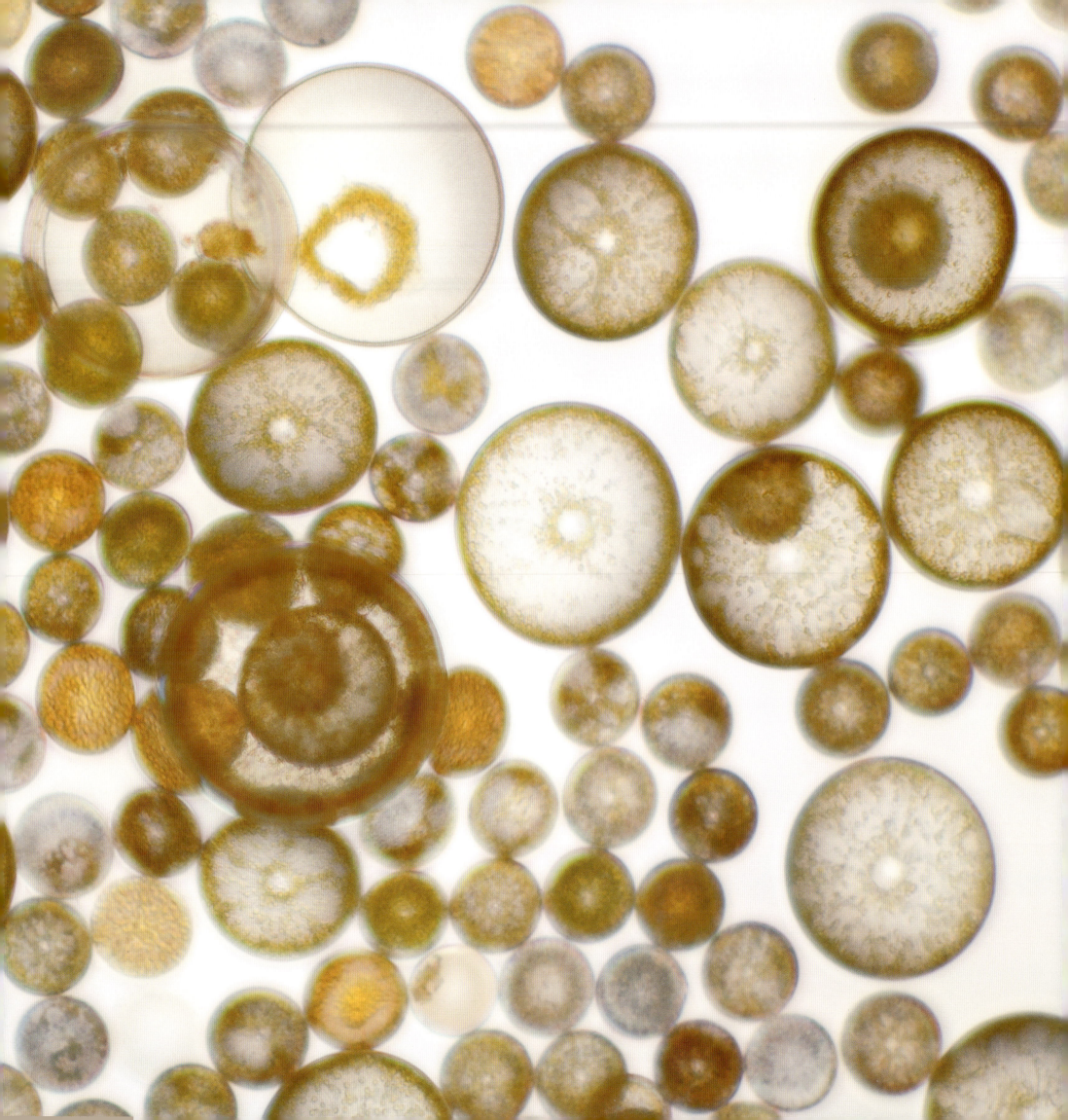

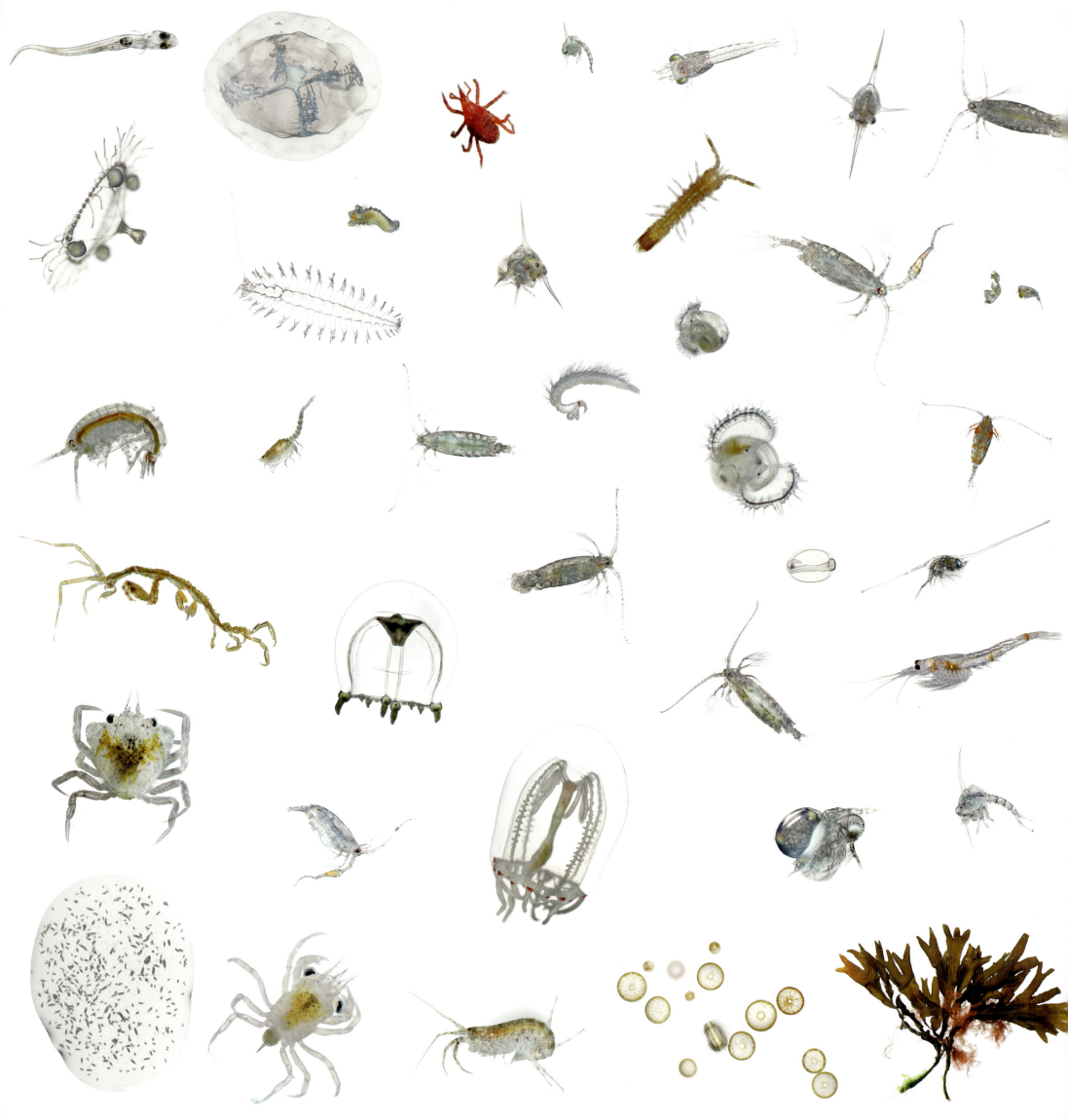

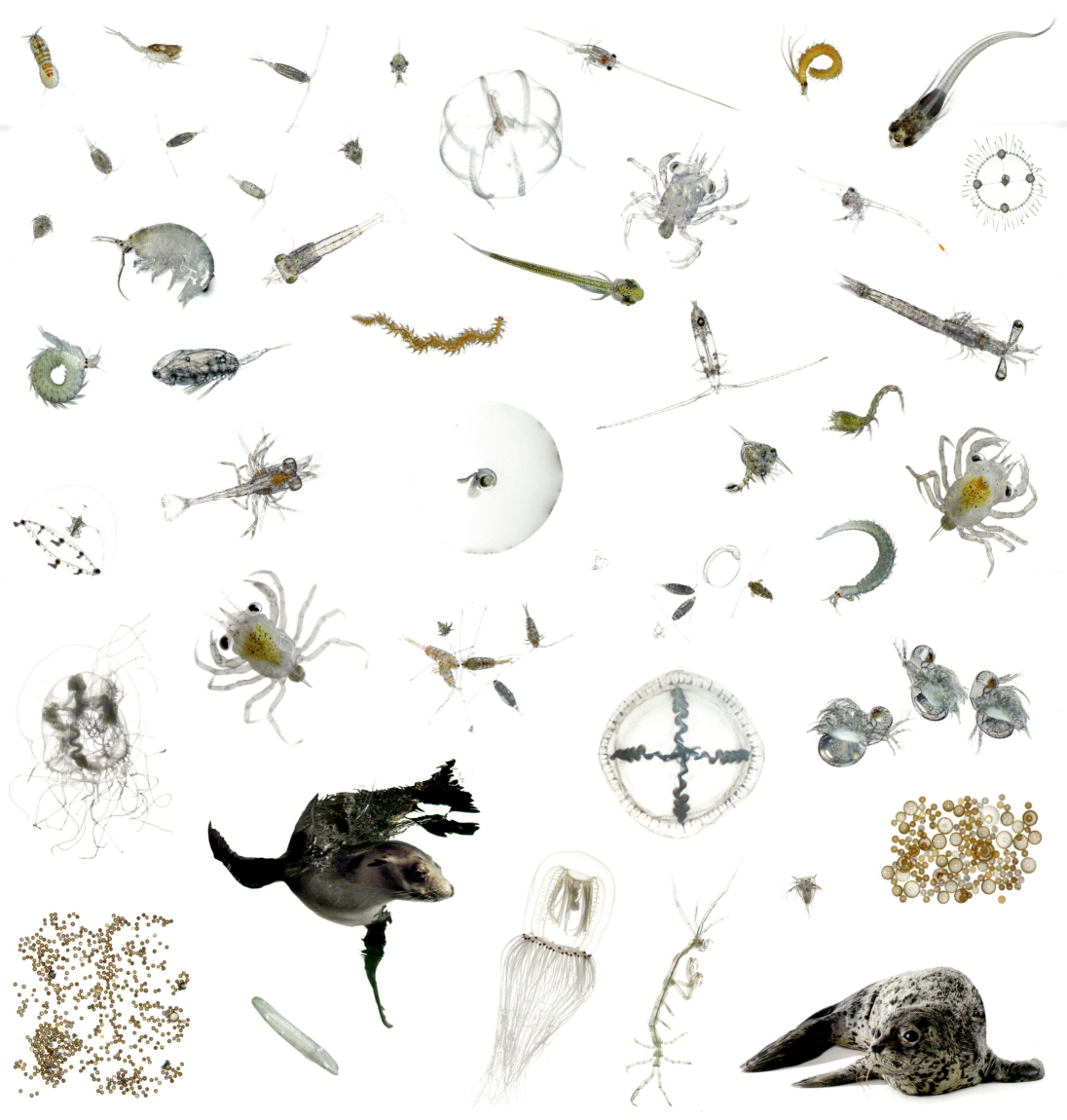

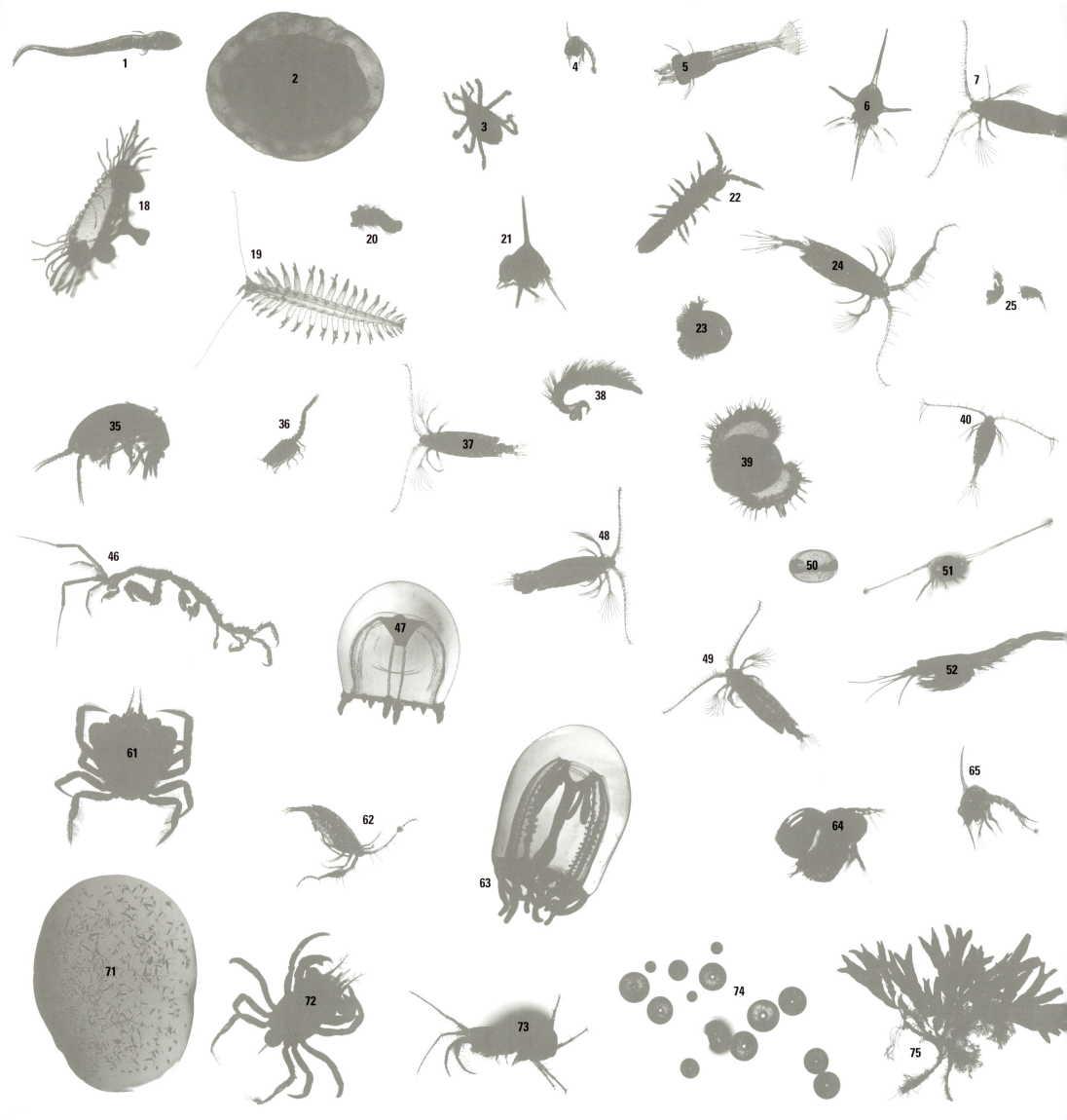

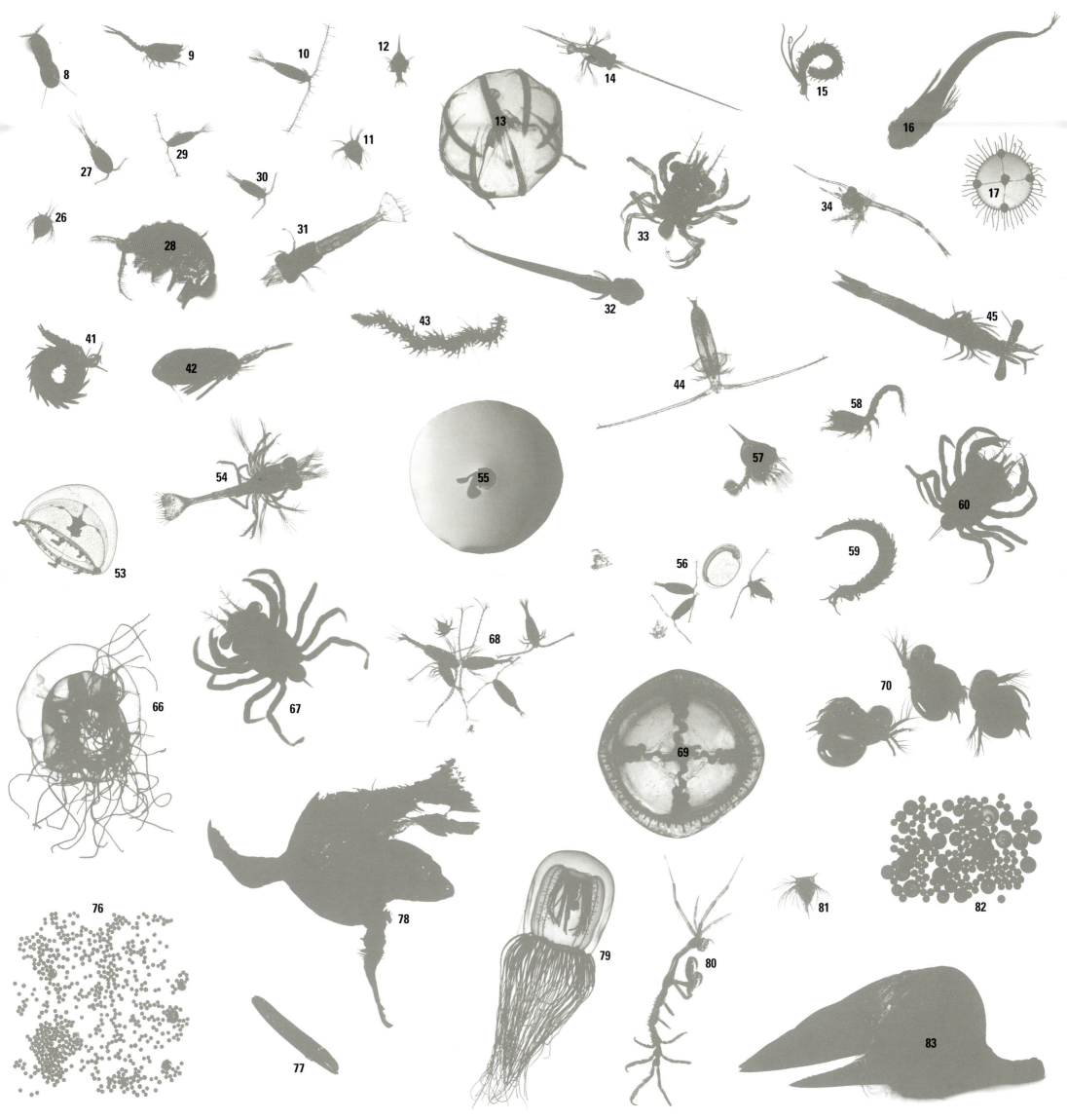

SPECIES KEY

1. Fish larva
2. Hydrozoan jellyfish, *Polyorchis penicillatus*
3. Saltwater mite, family Halacaridae
4. Crab larva, *Hemigrapsus oregonensis*
5. Shrimp, infraorder Caridea
6. Crab larva, family Pinnotheridae
7. Copepod, *Epilabidocera longipedata*
8. Copepod with eggs, *Harpacticus* sp.
9. Helmet shrimp, *Cumella vulgaris*
10. Copepod, *Sinacalanus doerri*
11. Crustacean larva, order Cirripedia
12. Crab larva, *Hemigrapsus oregonensis*
13. Ctenophore, *Pleurobrachia bachei*
14. Porcelain crab larva, family Porcellanidae
15. Polychaete worm, family Syllidae
16. Fish larva
17. Hydrozoan jellyfish, *Obelia* sp.
18. Hydrozoan jellyfish, *Obelia* sp.
19. Polychaete worm, *Tomopteris* sp.
20. Polychaete worm larva, family Spionidae
21. Crab larva, family Pinnotheridae
22. Isopod, *Idotea* sp.
23. Snail larva, class Gastropoda
24. Copepod, *Epilabidocera longipedata*
25. Copepods, *Corycaeus anglicus*
26. Barnacle larva, order Cirripedia
27. Copepod, *Acanthocyclops robustus*
28. Amphipod, *Ampelisca abdita*
29. Copepod, *Acartia* sp.
30. Copepod, *Eurytemora affinis*
31. Shrimp larva, infraorder Caridea
32. Fish larva
33. Slender rock crab larva, *Metacarcinus gracilis*
34. Shrimp larva, infraorder Caridea
35. Amphipod, *Atylus tridens*
36. Cumacean, *Cumella vulgaris*
37. Copepod, *Epilabidocera longipedata*
38. Polychaete worm, subfamily Autolytinae
39. Snail larva, class Gastropoda
40. Copepod, *Tortanus* sp.
41. Polychaete worm, subfamily Autolytinae
42. Copepod, *Acartia* sp.
43. Polychaete worm, subfamily Autolytinae
44. Copepod, *Eucalanus* sp.
45. Mysid shrimp, *Alienacanthomysis macropsis*
46. Skeleton shrimp, *Caprella mutica*
47. Hydrozoan jellyfish, class Hydrozoa
48. Copepod, *Epilabidocera longipedata*
49. Copepod, *Epilabidocera longipedata*
50. Fish egg, class Actinopterygii
51. Porcelain crab larva, *Petrolisthes* sp.
52. Mysid shrimp, family Mysidae
53. Hydrozoan jellyfish, class Hydrozoa
54. Shrimp larva, infraorder Caridea
55. Sea butterfly, *Limacina helicina*
56. Copepods, fish egg, and barnacle larvae
57. Crab larva, family Pinnotheridae
58. Cumacean, *Nippoleucon hinumensis*
59. Polychaete worm, subfamily Autolytinae
60. Dungeness crab larva, *Metacarcinus magister*
61. Dungeness crab, *Metacarcinus magister*
62. Copepod, *Epilabidocera longipedata*
63. Hydrozoan jellyfish, *Polyorchis penicillatus*
64. Water flea, order Cladocera
65. Crab larva, *Hemigrapsus oregonensis*
66. Hydrozoan jellyfish, class Hydrozoa
67. Dungeness crab larva, *Metacarcinus magister*
68. Collection of zooplankton
69. Hydrozoan jellyfish, *Aglauropsis aeora*
70. Water fleas, order Cladocera
71. Drop of water containing zooplankton
72. Dungeness crab larva, *Metacarcinus magister*
73. Amphipod, *Erithonius brasiliensis*
74. Centric diatoms, division Bacillariophyta
75. Brown, red, and green algae, *Fucus distichus, Ceramium californicum, Blidingia minima*
76. Centric diatoms, division Bacillariophyta
77. Eel grass seed, family Zosteraceae
78. California sea lion pup, *Zalophus californianus*
79. Hydrozoan jellyfish, *Polyorchis penicillatus*
80. Skeleton shrimp, *Caprella mutica*
81. Barnacle larva, order Cirripedia
82. Centric diatoms, division Bacillariophyta
83. Pacific harbor seal pup, *Phoca vitulina*

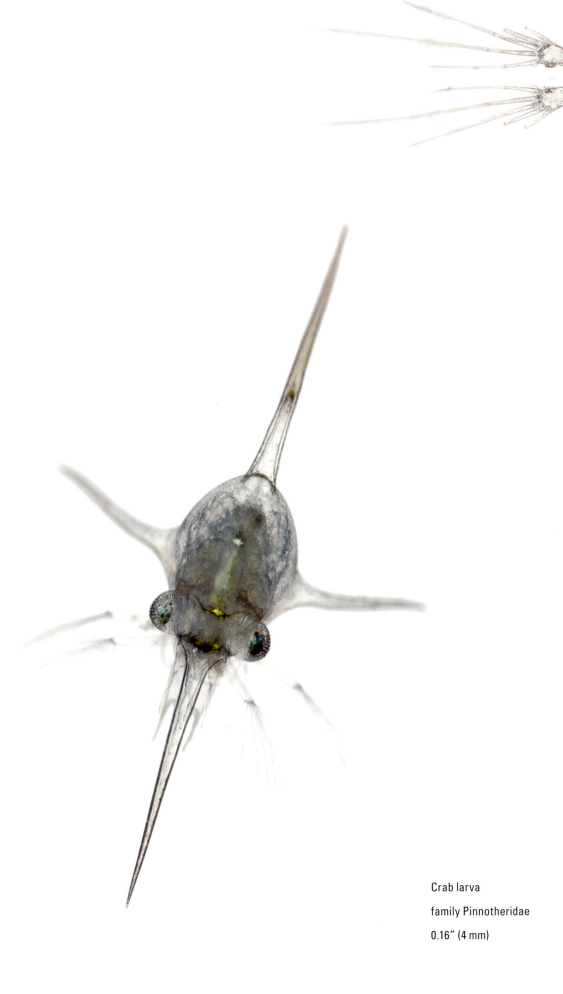

Crab larva

family Pinnotheridae

0.16" (4 mm)

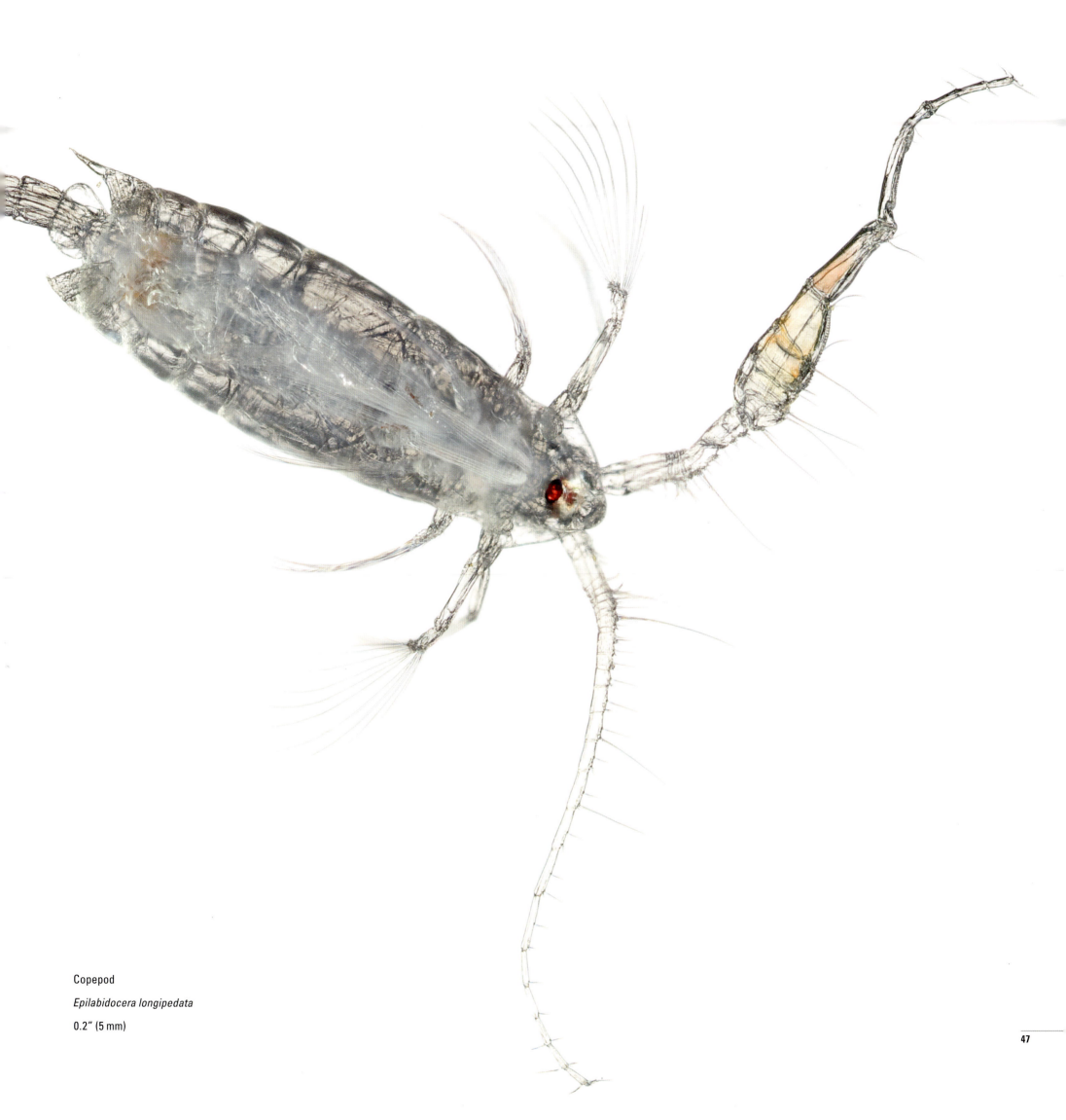

Copepod

Epilabidocera longipedata

0.2" (5 mm)

Tiger moth

Symphlebia suanoides

1.2" (3 cm)

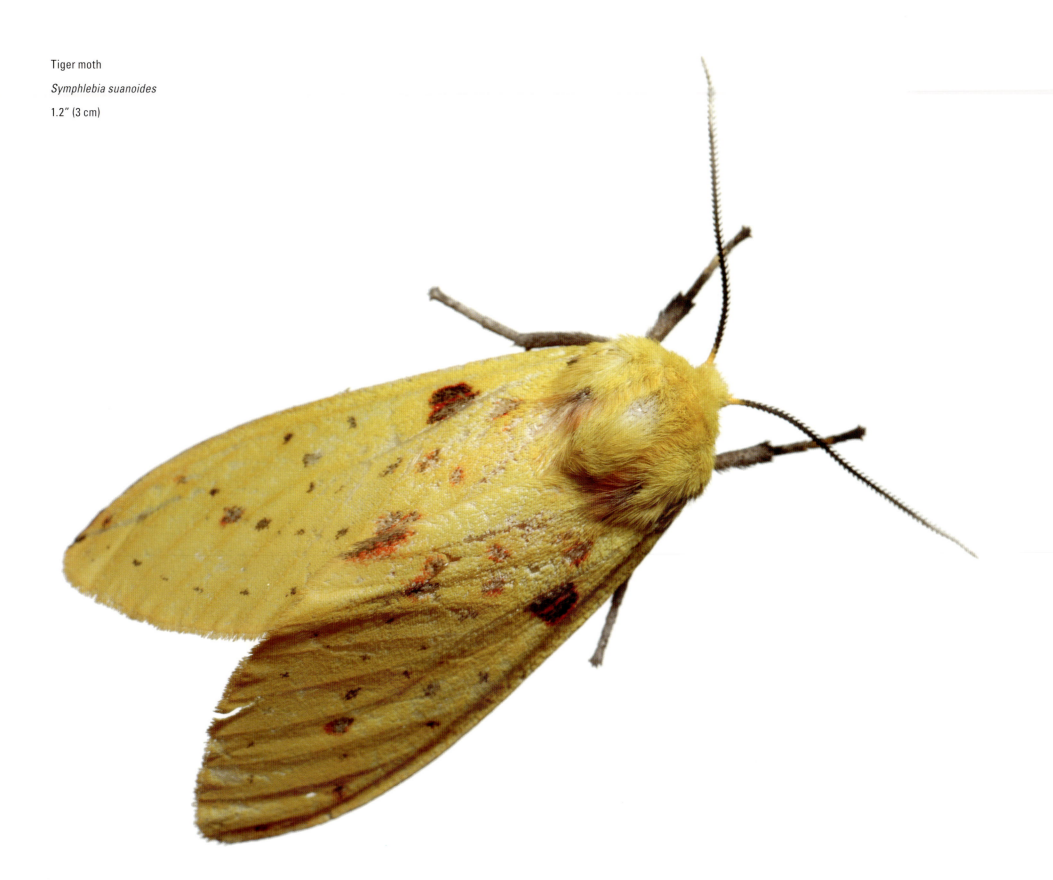

TROPICAL CLOUD FOREST

MONTEVERDE CLOUD FOREST RESERVE, COSTA RICA

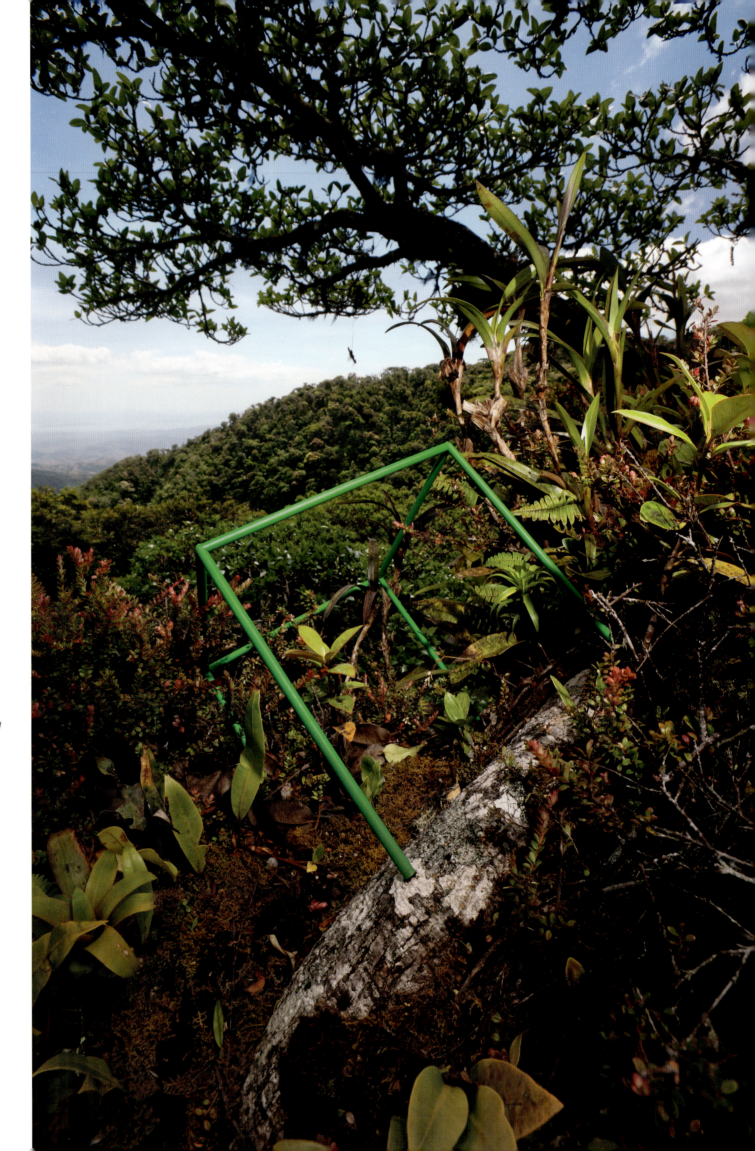

Along the stout limb of a strangler fig a hundred feet up in the canopy of the Monteverde cloud forest, a luxuriant garden grows. Orchids, ferns, and bromeliads form living layers on the mossy bough, sprouting one atop another and creating canopy soil. They gather moisture from the rain and mist and vie for space in the sun. Most of the animals that thrive in this treetop ecosystem are fingertip-small beetles, ants, moths, and spiders—and prey for larger tree dwellers like rodents and monkeys. Insects and birds, including hummingbirds, do much of the pollinating, while the nimble-footed mammals serve as vital dispersers of seeds. To survey this tropical richness, Liittschwager climbed ropes, scooted along creaking branches, and sampled day and night. None of the canopy's mammalian denizens was spied investigating the chosen spot. But 5 birds flitted by, and the team recorded 24 plant species and more than 500 insects representing 100 species within the cube's green borders.

MONTEVERDE CLOUD FOREST RESERVE, COSTA RICA

"THE LAST BIOTIC FRONTIER." That is how scientists describe the high tree canopy of the tropics, an area that had never really been explored before the 1980s. Yet in the few decades since we first entered that new realm, we've found species, behaviors, and interactions we'd never, or at least rarely, encountered on the forest floor. The orchids, bromeliads, canopy ants, beetles, and microbes of the high canopy were the missing pieces of the phenomenal jigsaw puzzle that is the tropical rain forest.

Of course, some of the arboreal plant and animal groups of the canopy had been described earlier by botanists and zoologists who had collected samples from fallen trees. But these collected items revealed almost nothing about how rain forests actually function. The intricate interconnections among organisms and how they behave individually and in concert were virtually unknown to us. A single cubic foot of arboreal space within the bigger forest system can encompass its own ecosystem-in-miniature—animals, plants, fungi, microbes, and even soils held aloft by branches so high above the forest floor that they were, until recently, beyond human grasp.

Hanging by a rope no thicker than the width of my pinky finger, I ascend a colossal strangler fig in the Monteverde Cloud Forest Reserve in northwest Costa Rica. Earlier this morning, I'd aimed a powerful slingshot up into the canopy and propelled a slender nylon line over a high branch of the strangler fig. I'd used the nylon line to haul up a climbing rope. With that and the help of a mountain-climbing harness and clamps, I begin ascending the hundred feet (the equivalent height of a ten-story building) to the canopy. This method, developed 30 years ago, allows me and other canopy researchers to move from forest floor to canopy without harming ourselves, the tree, or the diverse and fragile world of living things aloft.

In 15 minutes of steady climbing, I shift from the darkness and humidity of the forest floor to a place of light, wind, space. I reach my target branch, tie myself to the limb above me with stout purple webbing, and rest on a broad, nearly horizontal bough. And my universe is suddenly transformed from two to three dimensions. With the full 360º vantage I now have, grand views emerge, as a thousand thousand leaves bend and dance in the wind, and the myriad tree crowns in my arboreal neighborhood—each species a different form and color—create complex patterns I couldn't see from the forest floor below. I feel the deep excitement that comes from entering a world that has only seldom been explored.

Monteverde's forest is typical of tropical cloud forests worldwide. These mountainous biomes are bathed regularly in the mist and clouds that arise in the warm, moist lowlands below and are driven upward by the trade winds of low latitude regions. The high winds and persistent mists create forests that are smaller in stature to their lowland counterparts but are far richer and more abundant in canopy-dwelling plants.

In the Costa Rican cloud forest, strangler figs function as keystone resources for arboreal and terrestrial animals, providing flower nectar and fruits that feed roving monkeys, rodents, and birds. The particular strangler fig I'm perched in is a massive tree, with a trunk over 20 feet in diameter, a height that would top a 20-story building, and a spreading crown that would cover more that two city blocks. But its size belies its modest beginnings: It started its life cycle as a tiny seed scattered by a monkey or bird on the branch of a host tree. As the seed germinated, it put out a strong, flexible root that snaked along the host trunk to the forest floor. Once attached to the ground, the fig began growing quickly, using water and nutrients in the soil. Over the next decades, its roots ultimately surrounded the host trunk and its own flourishing leaves and stems took over the crown space, eventually replacing the original host that supported it. After some time, the dead host decomposed, leaving nothing but fig branches and trunks for other plants, animals, and microbes to colonize.

And colonize they do. A cubic foot placed on the branch of this tree for 24 hours hosts a riot of life—birds, mammals, mosses, microbes, bromeliads, and the most apparent and diverse denizens of the cloud forest—epiphytes.

Epiphytes (*epi* meaning upon, *phyte* meaning plant) derive structural support from the strangler fig but not nutrients or water, which can be in short supply in the desert-like canopy, with its heat, desiccating winds, and long periods between rains. The epiphytic cacti that perch on the outer branches of rain forest trees are as succulent and resistant to water loss as any plant you would encounter in the Mojave Desert. Both have evolved a particular type of photosynthesis called CAM (or Crassulacean Acid Metabolism), which allows them to carry out energy transformations during the cooler nighttime, rather than the daytime. That nighttime work means they lose less water through their leaf surfaces.

Great resources for the birdlife of the canopy, the epiphytes, many of which are orchids, supply nectar, fruit, insects, and nesting materials.

Bromeliads too are supportive players in the cloud forest, thanks in part to their architecture. Relatives of the pineapple, these plants have a rosette of stiff, upward-thrusting leaves that catch water and form mini-ponds in the canopy. If we placed our cubic foot over a bromeliad during the long dry season, we'd see that this mini-oasis supports arboreal animals ranging in size from microscopic bacteria to large frogs to arboreal vine snakes hunting tadpoles in the bromeliad ponds.

Covering nearly every available piece of canopy real estate are arboreal mosses that form contiguous carpets over the length and width of branches and trunks. As these mosses die and decompose, they create a canopy soil, and within that rich organic matter dwell beetles, ants, bacteria, fungi, even earthworms. Each carry out the functions of ground-dwelling invertebrates—decomposing, transferring nutrients, and creating a food source for birds and arboreal reptiles and mammals.

Microbial life, the bacteria and fungi that are abundant in our one cubic foot, are

one of the most poorly understood elements of the canopy. The few studies that have compared canopy and forest floor microorganisms have shown that, although some common microbes can be found in both canopy and the forest floor, the vast bulk of canopy populations are never encountered below. How they become established, grow, and disperse to other canopy sites remains wholly unknown and represents a rich area for more study.

Initially, canopy researchers believed that this wealth of life in the treetops was resilient, capable of regenerating after small-scale disturbances, like the kick of a primate foot that dislodges a population of bromeliads or the long-term drought of El Niño years. But recent experiments that removed epiphytes along one yard and the entire circumference of experimental branches proved how fragile the canopy environment is. It sometimes took longer than three decades for epiphytes to return to each sampled branch. More alarming, the species that did grow back were not the same as those in the original communities. Arboreal birds and mammals, we've found, are similarly fragile.

These days, all of the life in the high canopy faces challenges, as the forests themselves become increasingly threatened throughout the tropics. From the Cameroons to Costa Rica, logging, development, climate change, and changes in agricultural land use have led to the disappearance and fragmentation of rain forests at an alarming pace. Now as we canopy researchers hang from our arboreal perches, we can see clear cuts and fragmentation just beyond the parks and reserves in which we climb and study. In recent years, even as I make my measurements of the abundance of canopy life in the protected forests of Monteverde, I can hear chainsaws just outside the reserve's borders.

After this particularly full day of observing and documenting the canopy, I reluctantly descend through the dense, moist darkness of the forest. Once on the ground, I again see trees from the typical human perspective—nothing more than silent cylinders of wood and bark. But I know that high above, their crowns create three-dimensional networks, radiating with forms, colors, and life stories we are just beginning to understand.

— Nalini Nadkarni

Bromeliad

Werauhia sp.

13.2″ (33.5 cm)

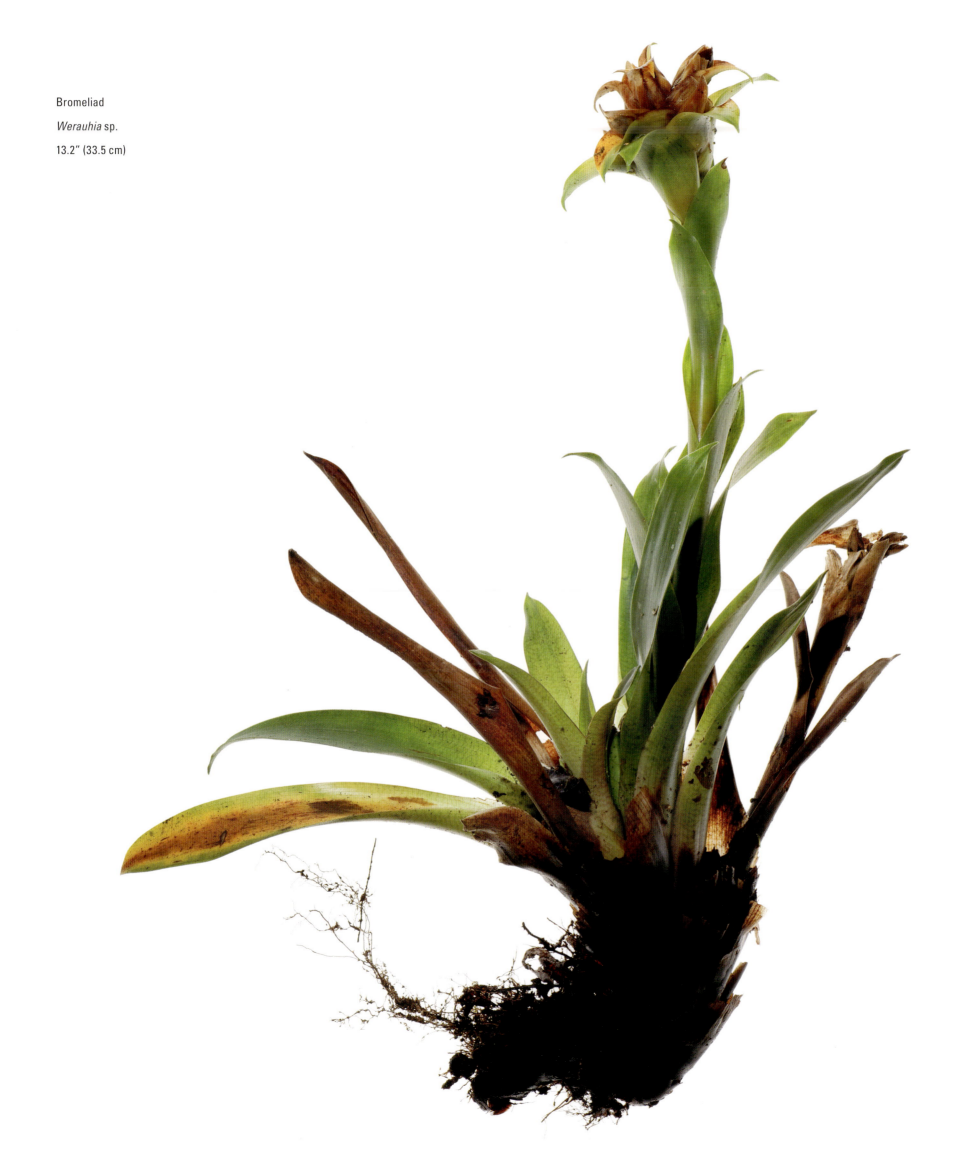

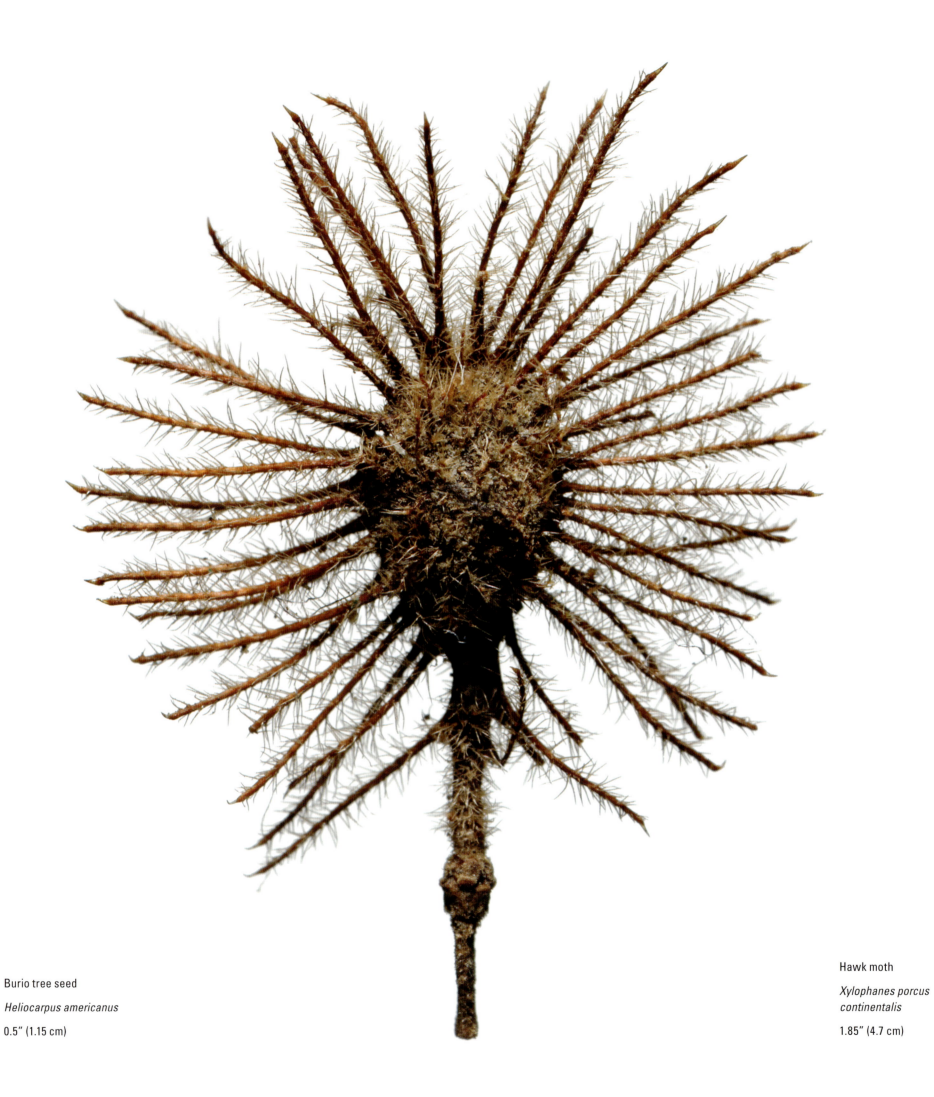

Burio tree seed

Heliocarpus americanus

0.5″ (1.15 cm)

Hawk moth

*Xylophanes porcus
continentalis*

1.85″ (4.7 cm)

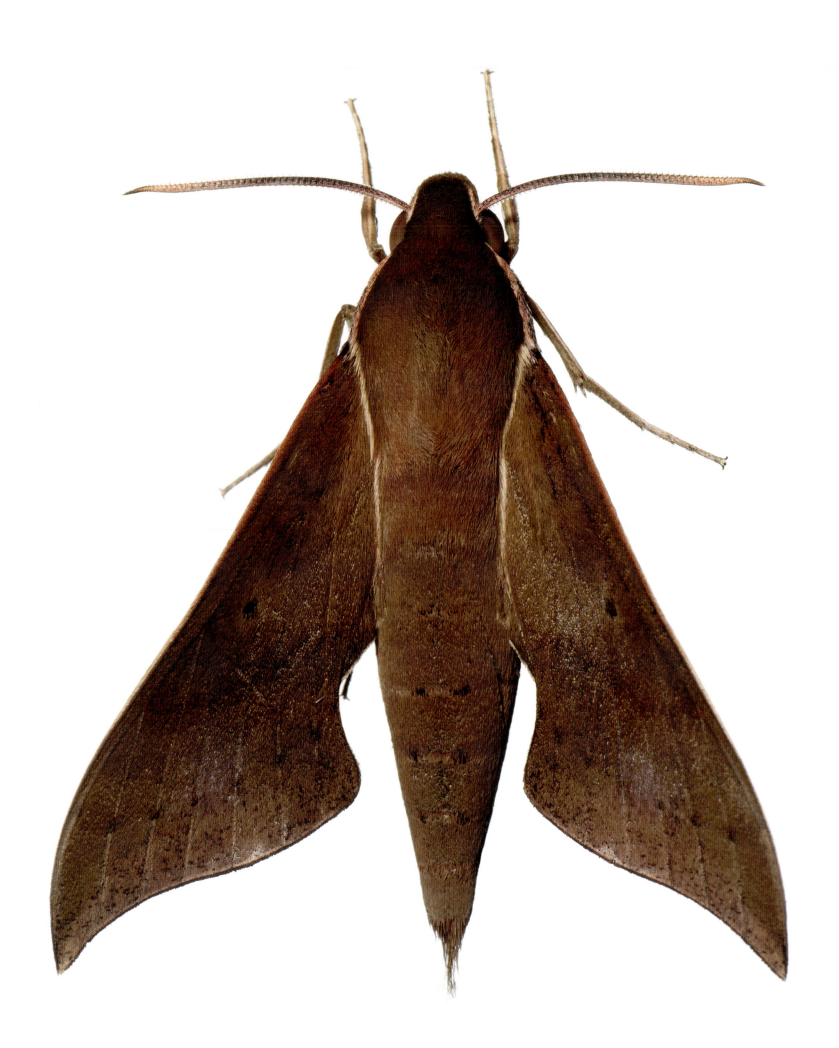

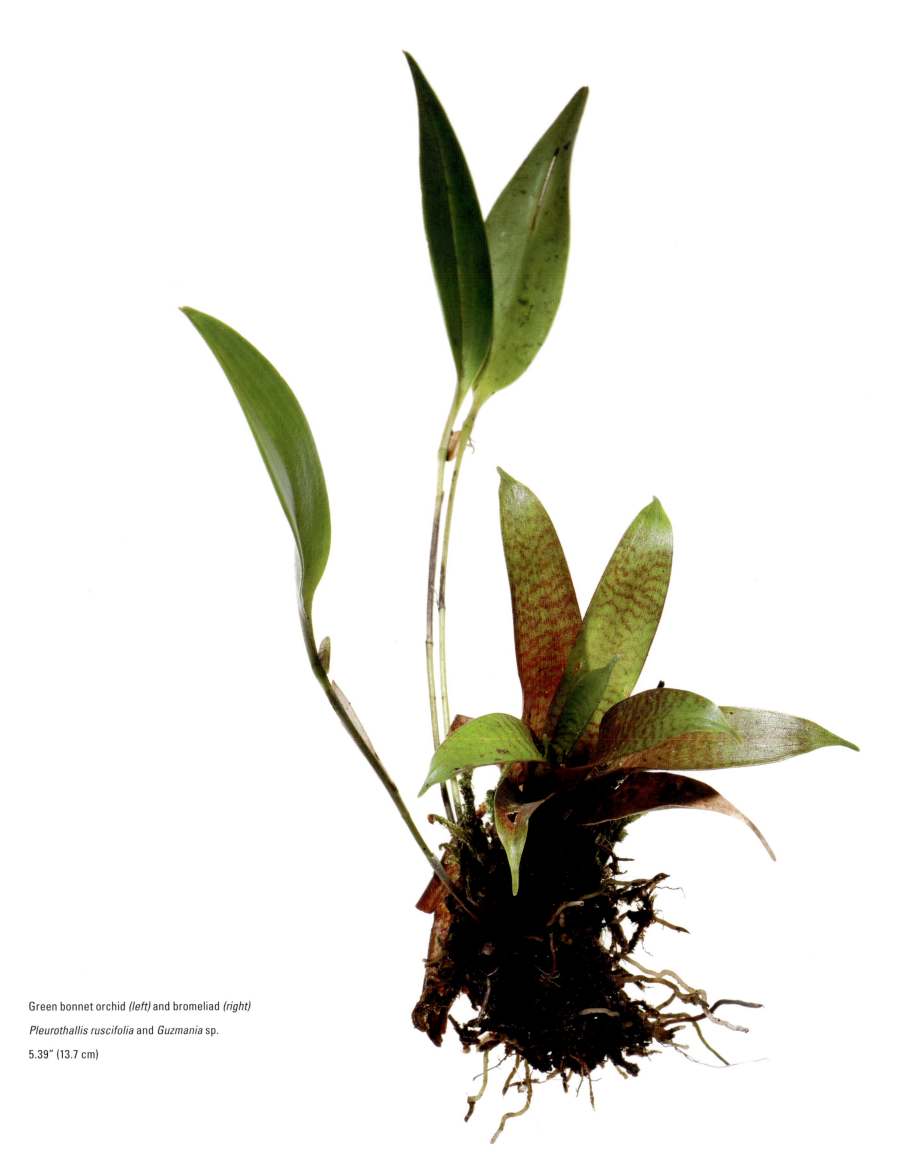

Green bonnet orchid *(left)* and bromeliad *(right)*

Pleurothallis ruscifolia and *Guzmania* sp.

5.39″ (13.7 cm)

Flea beetle *(top)*
subfamily Alticini
0.47″ (1.2 cm)

Long-legged fly *(bottom)*
Condylostylus sp.
0.3″ (0.75 cm)

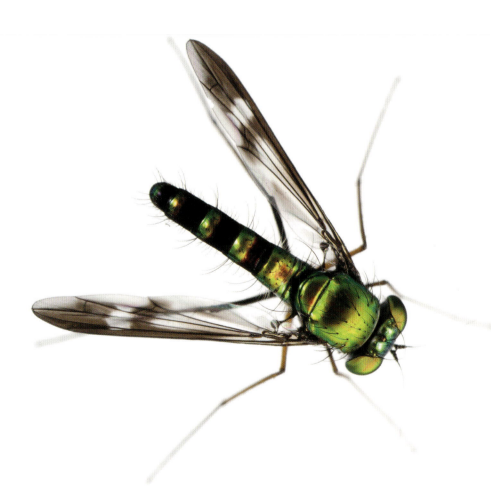

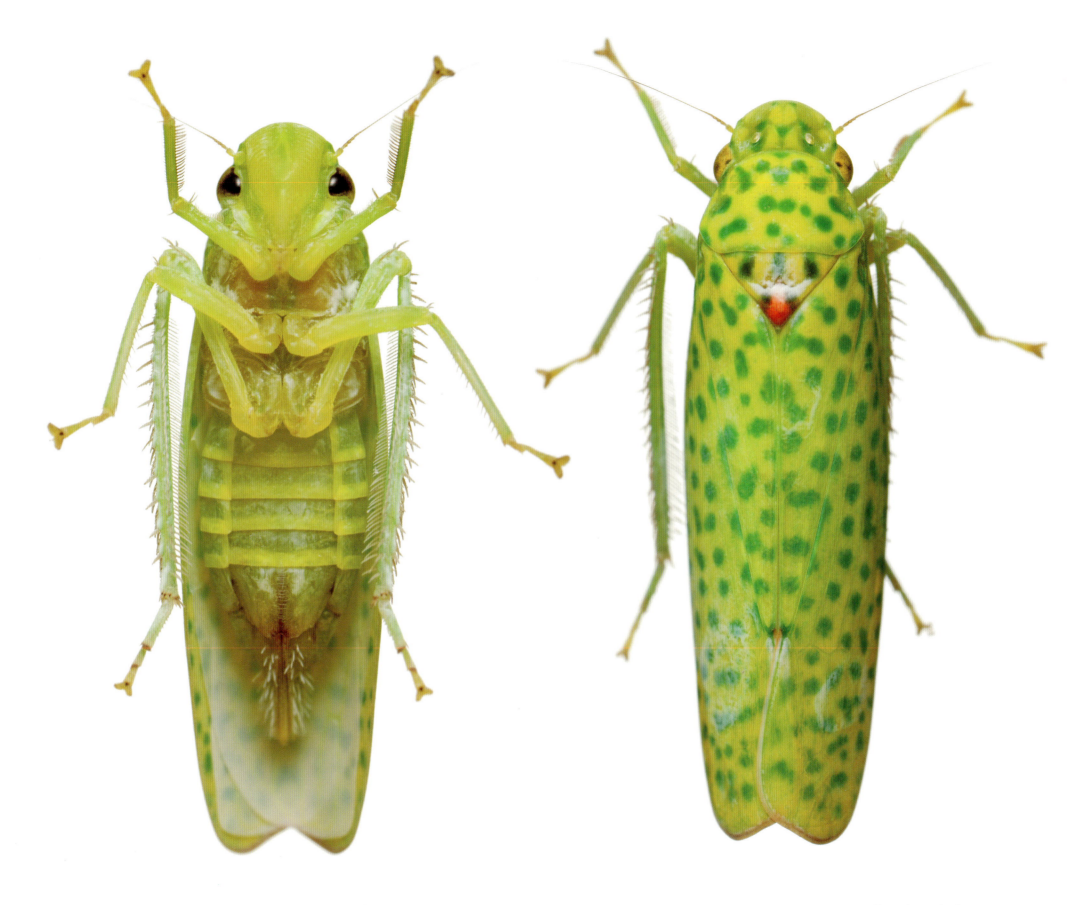

Sharpshooter leafhopper

Paromenia isabellina

0.51" (1.3 cm)

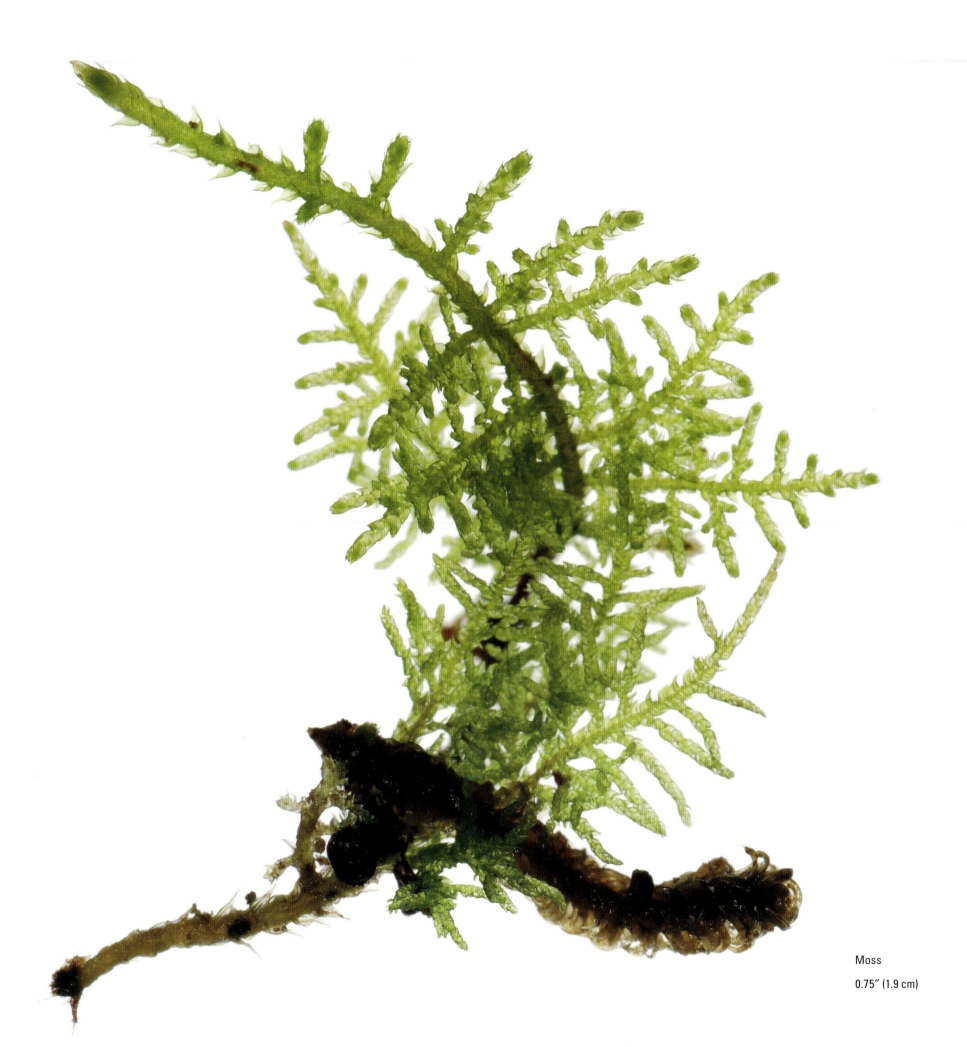

Moss
0.75" (1.9 cm)

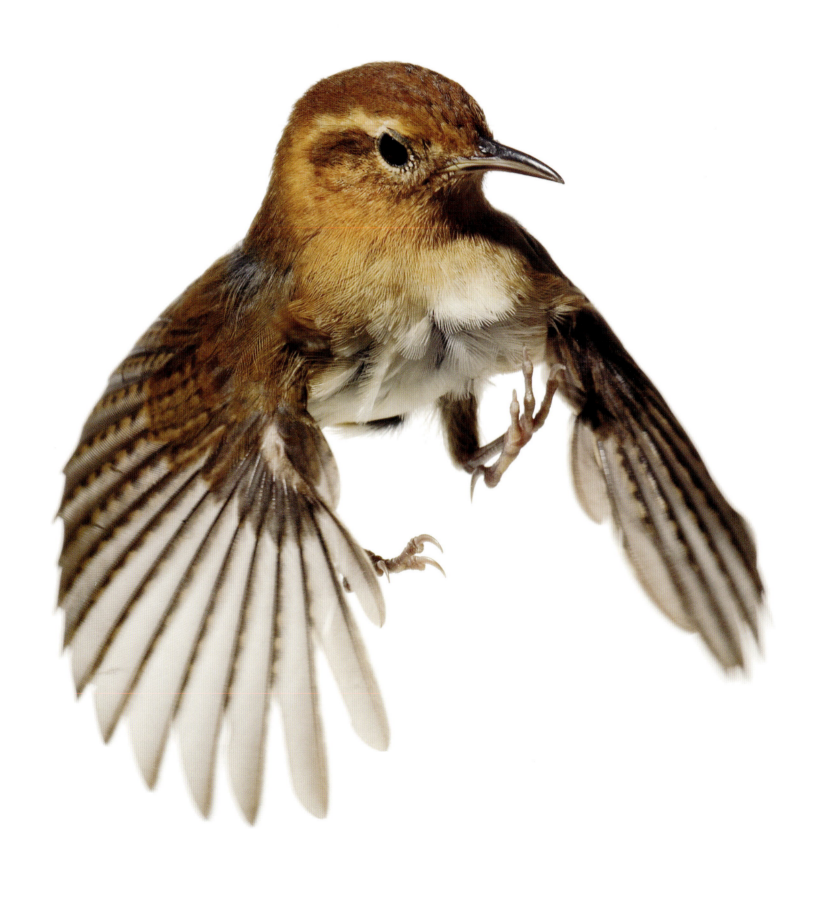

Ochraceous wren

Troglodytes ochraceus

3.15″ (8.0 cm) long

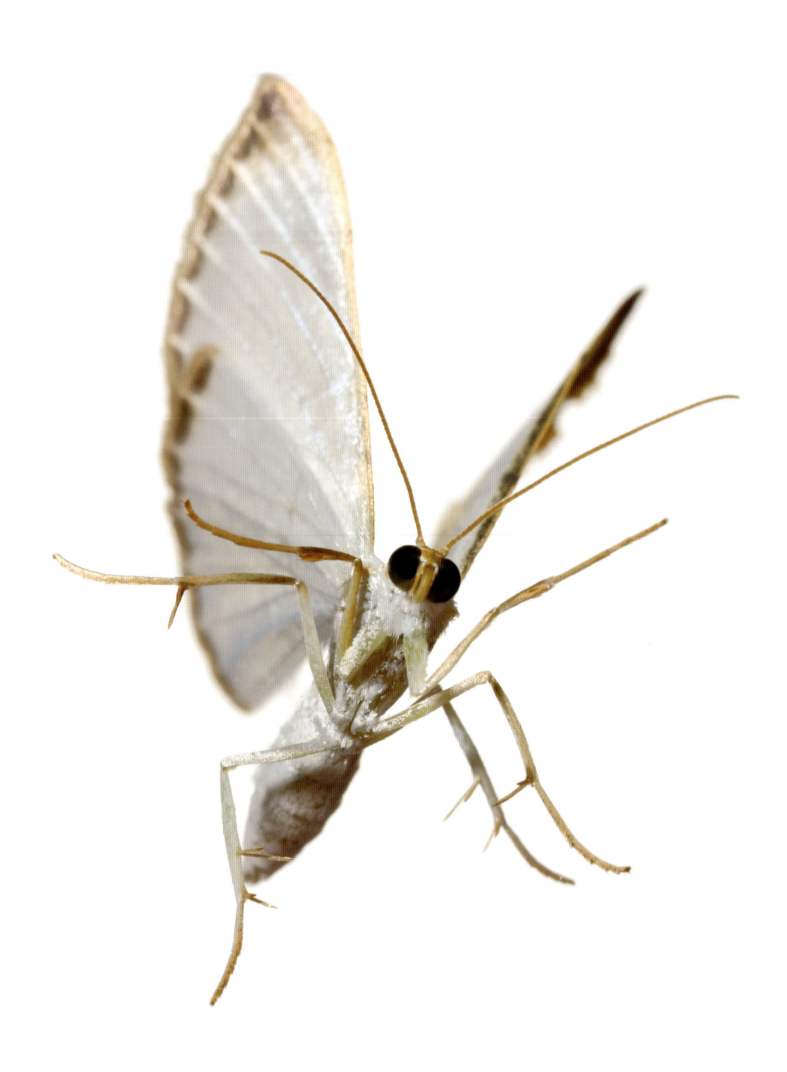

Geometer moth

Leuciris fimbriaria

0.35″ (0.9 cm) long

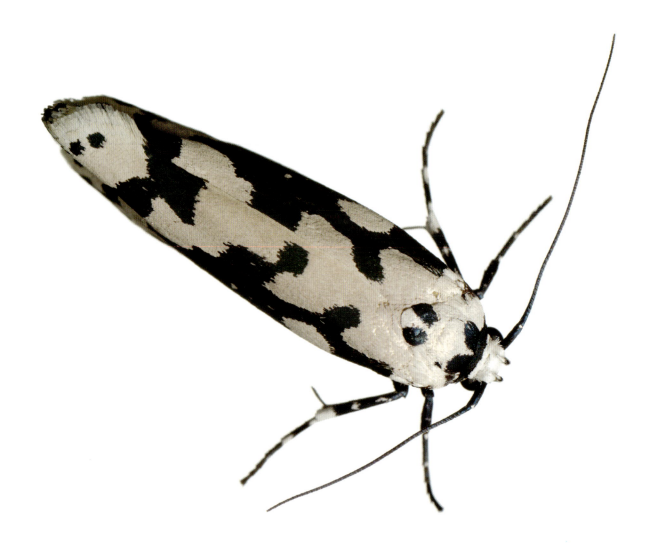

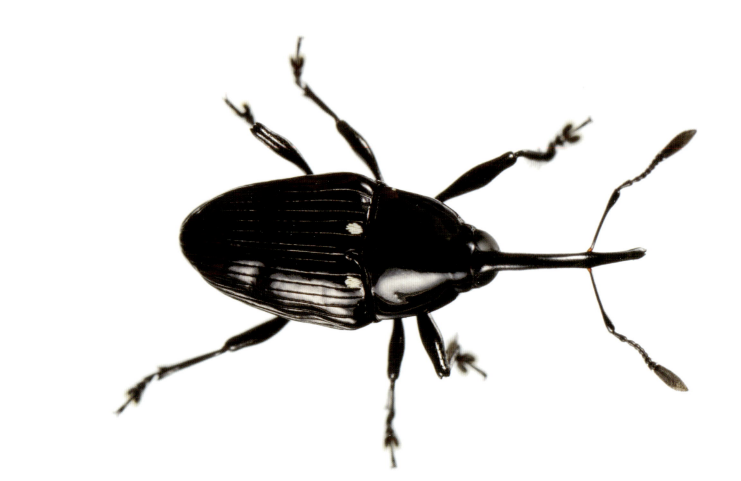

Owlet moth *(top)*

family Noctuidae

0.67" (1.7 cm) long

Weevil *(bottom)*

family Curculionidae

0.31" (0.8 cm) long

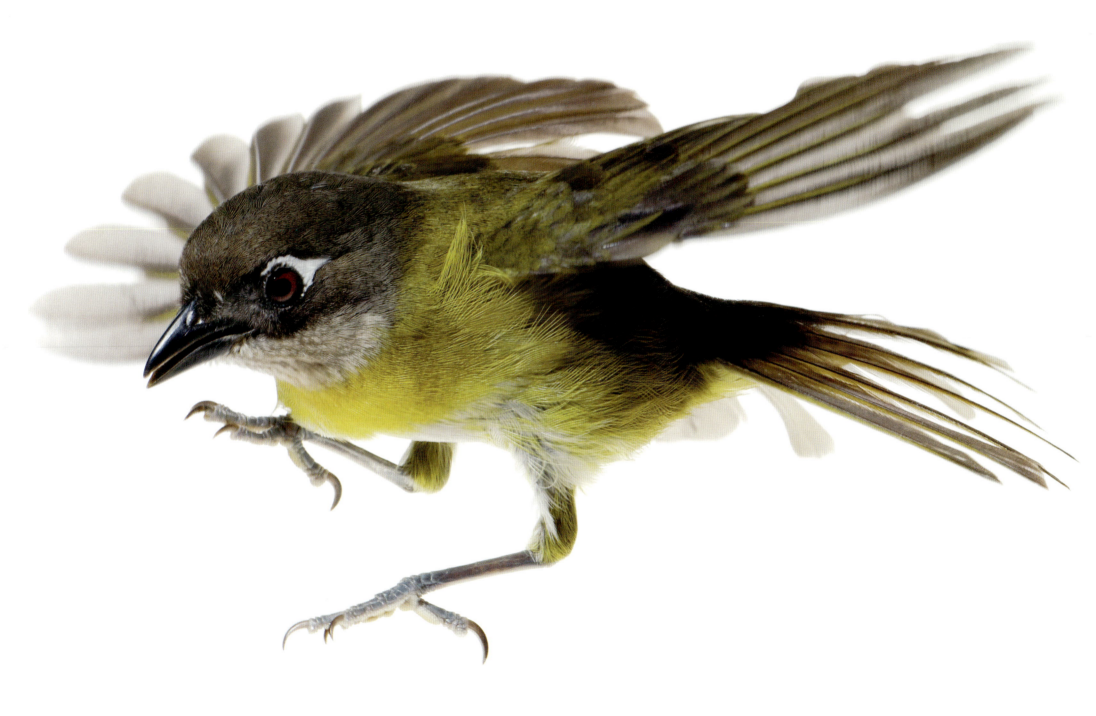

Common bush tanager

Chlorospingus ophthalmicus

4.33″ (11 cm) long

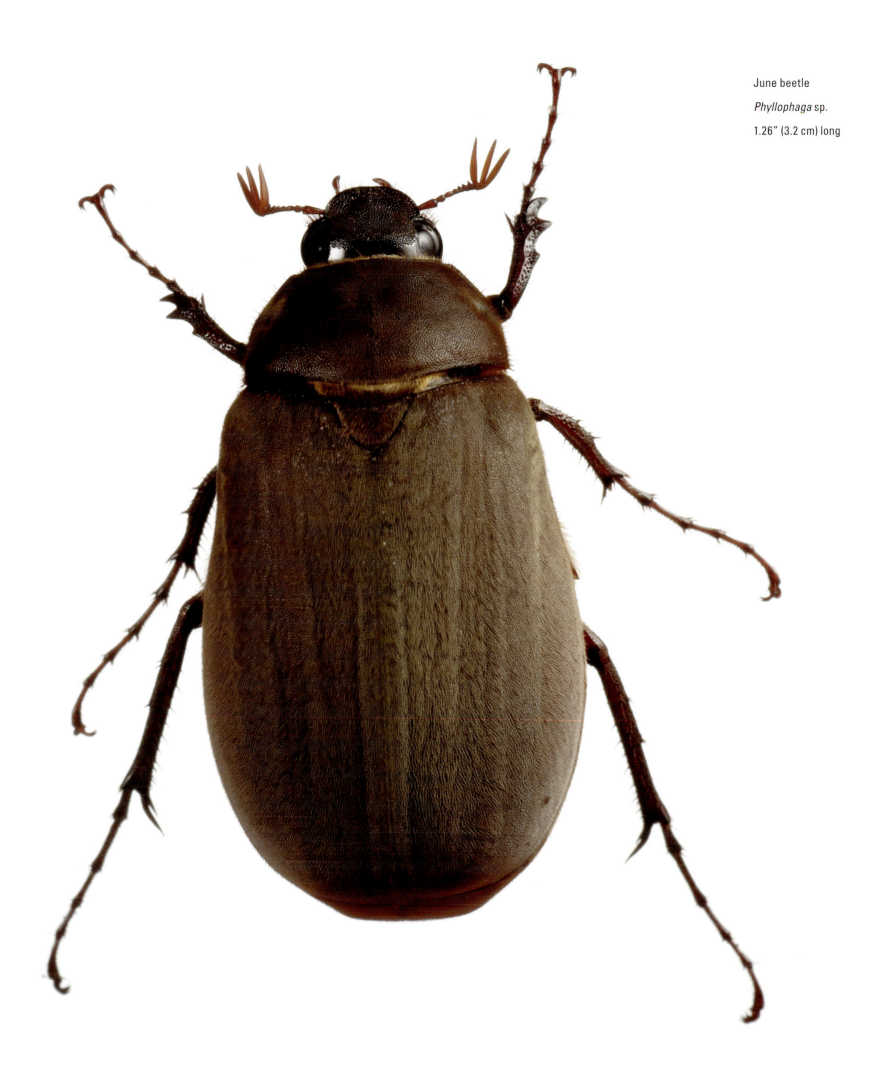

June beetle
Phyllophaga sp.
1.26″ (3.2 cm) long

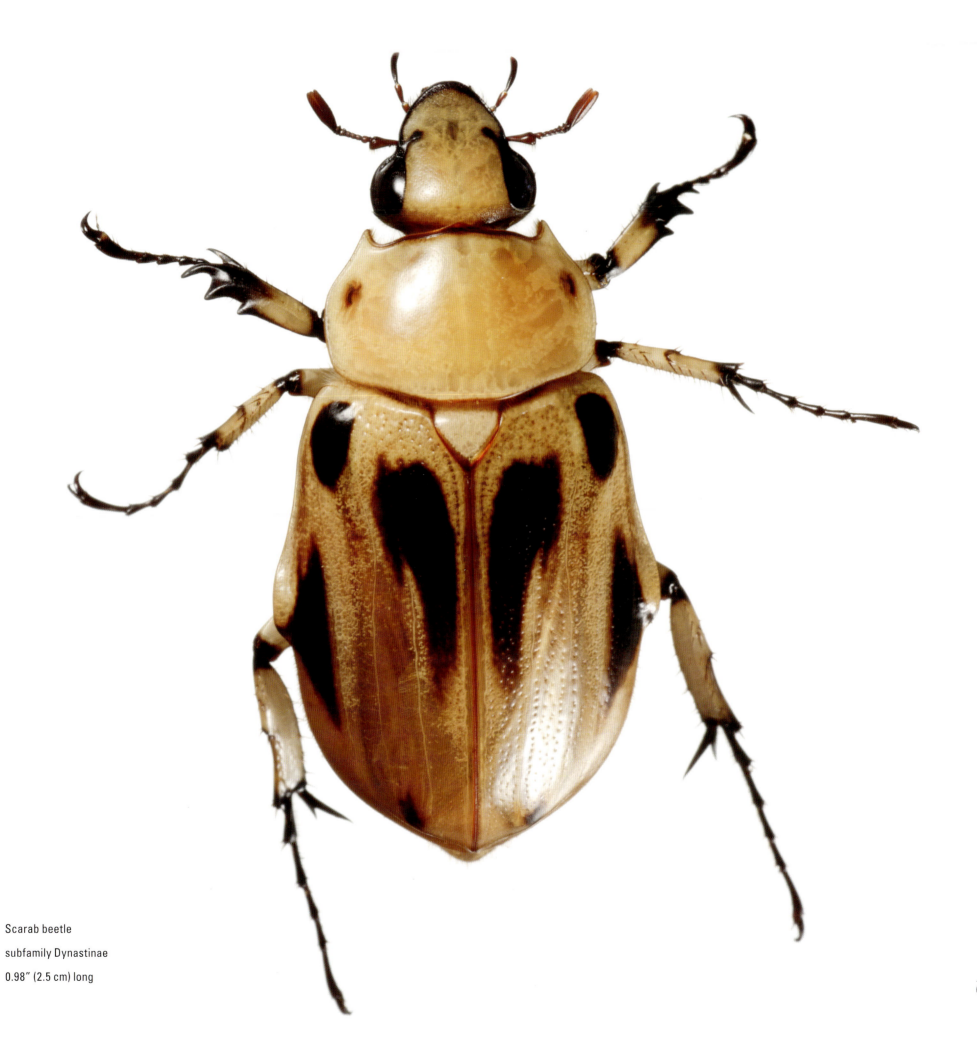

Scarab beetle

subfamily Dynastinae

0.98″ (2.5 cm) long

Common bush tanager

Chlorospingus ophthalmicus

2.36" (6 cm) tall

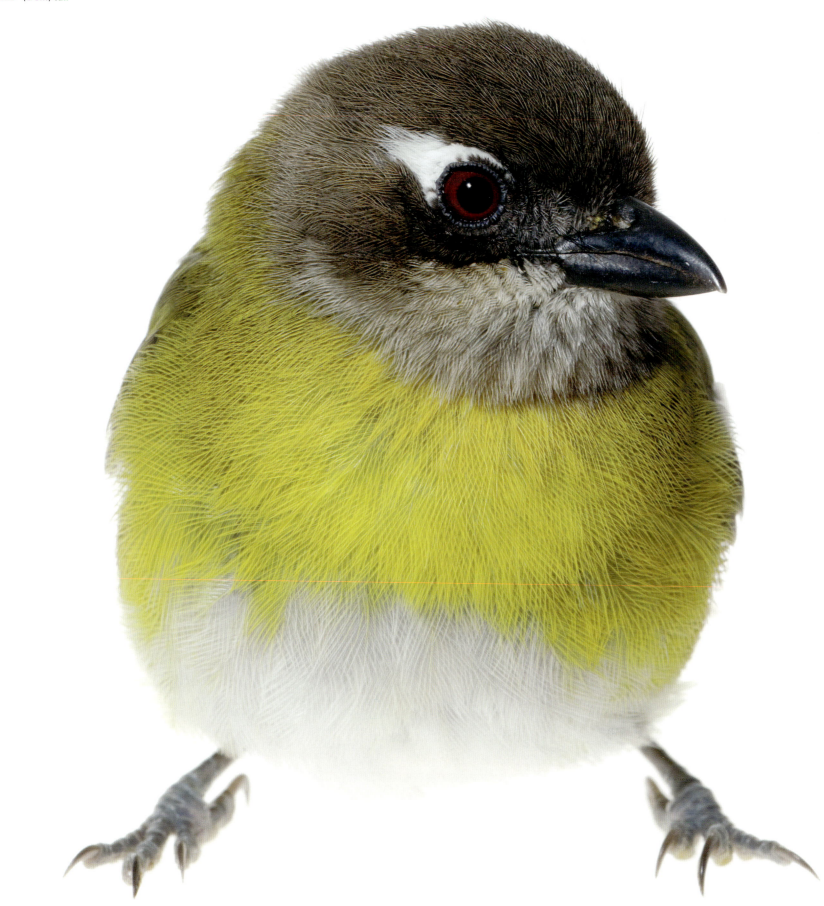

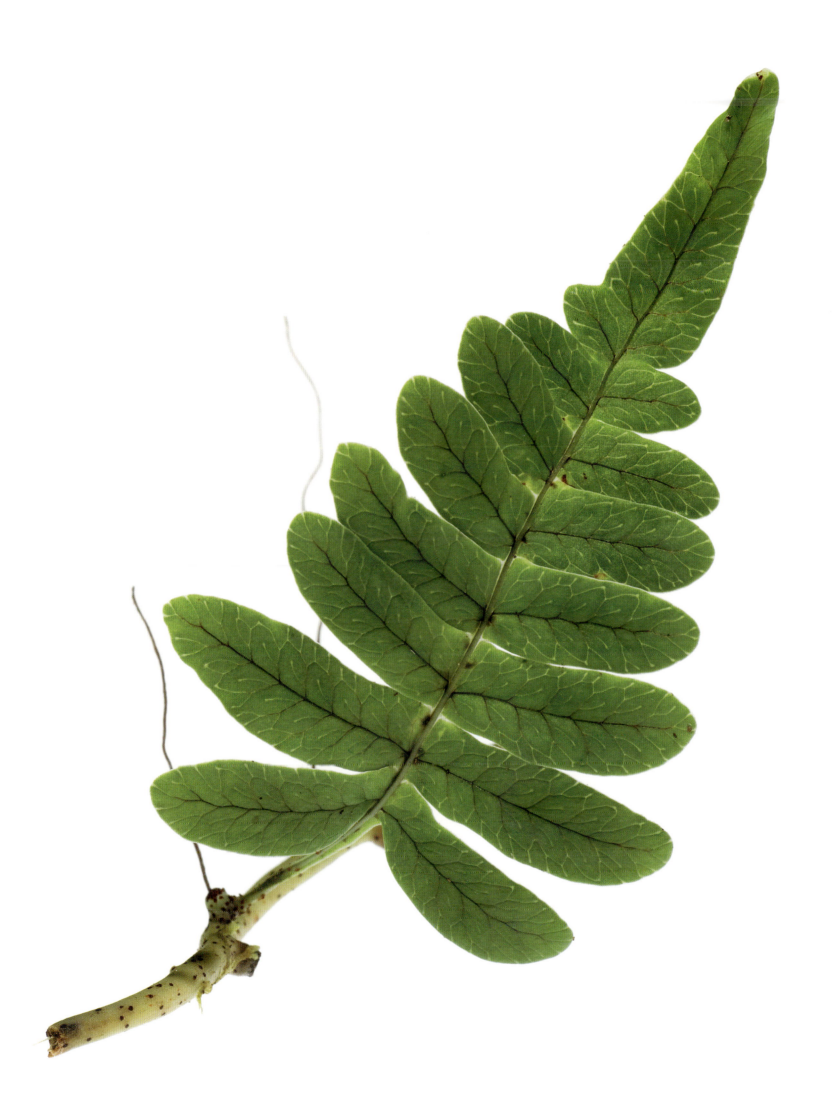

Rockcap fern

Polypodium sp.

3.43″ (8.7 cm) long

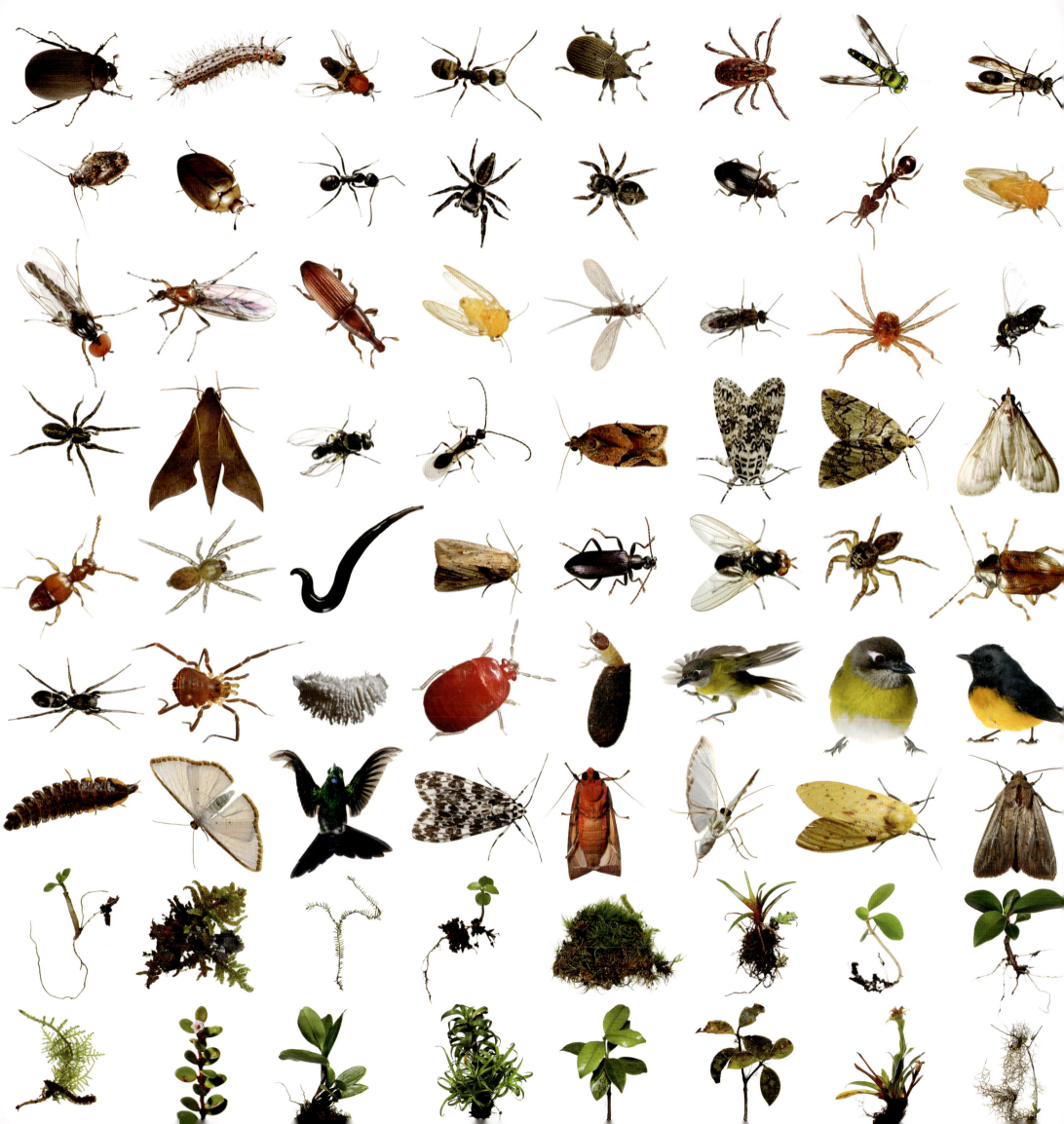

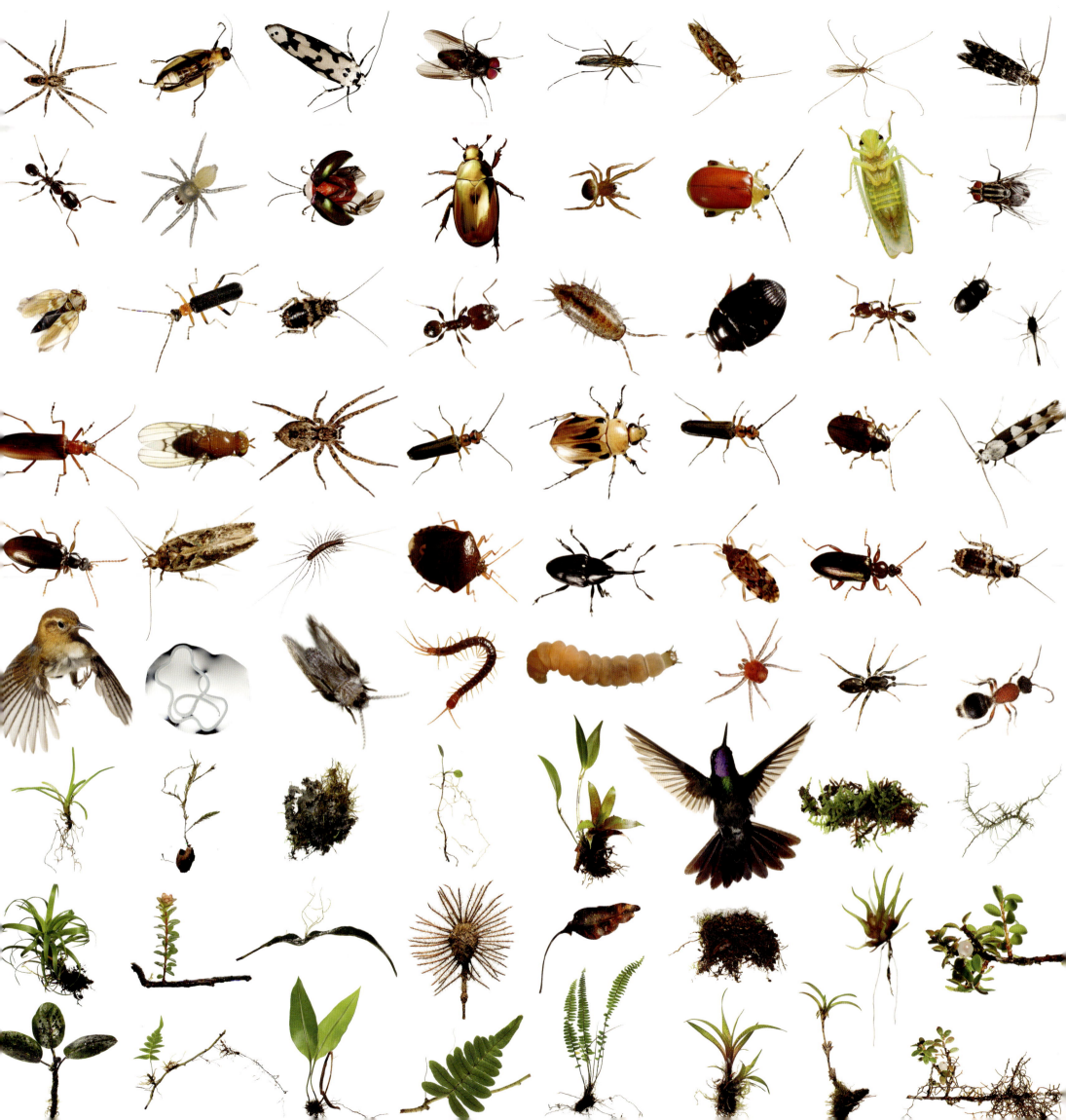

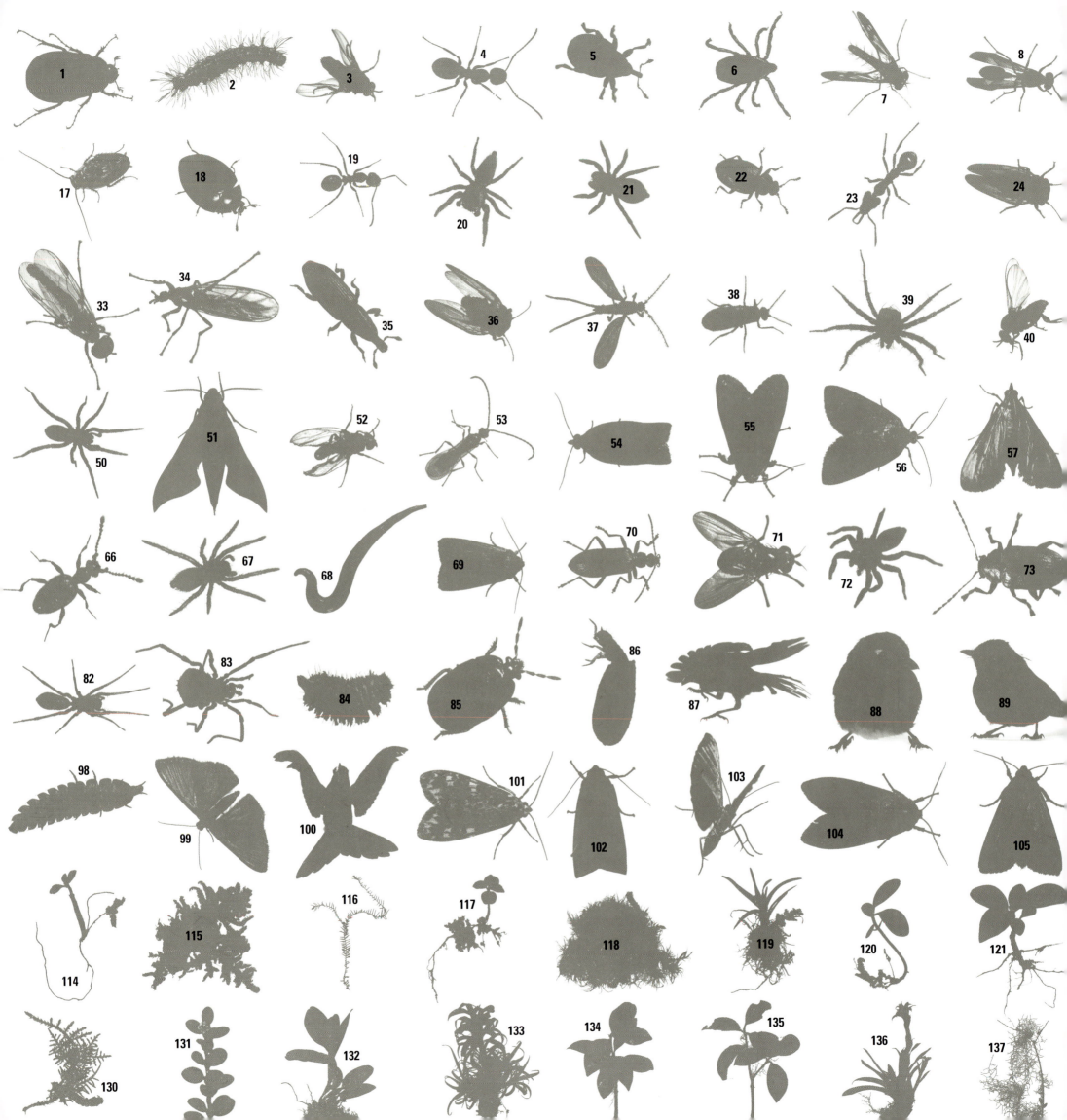

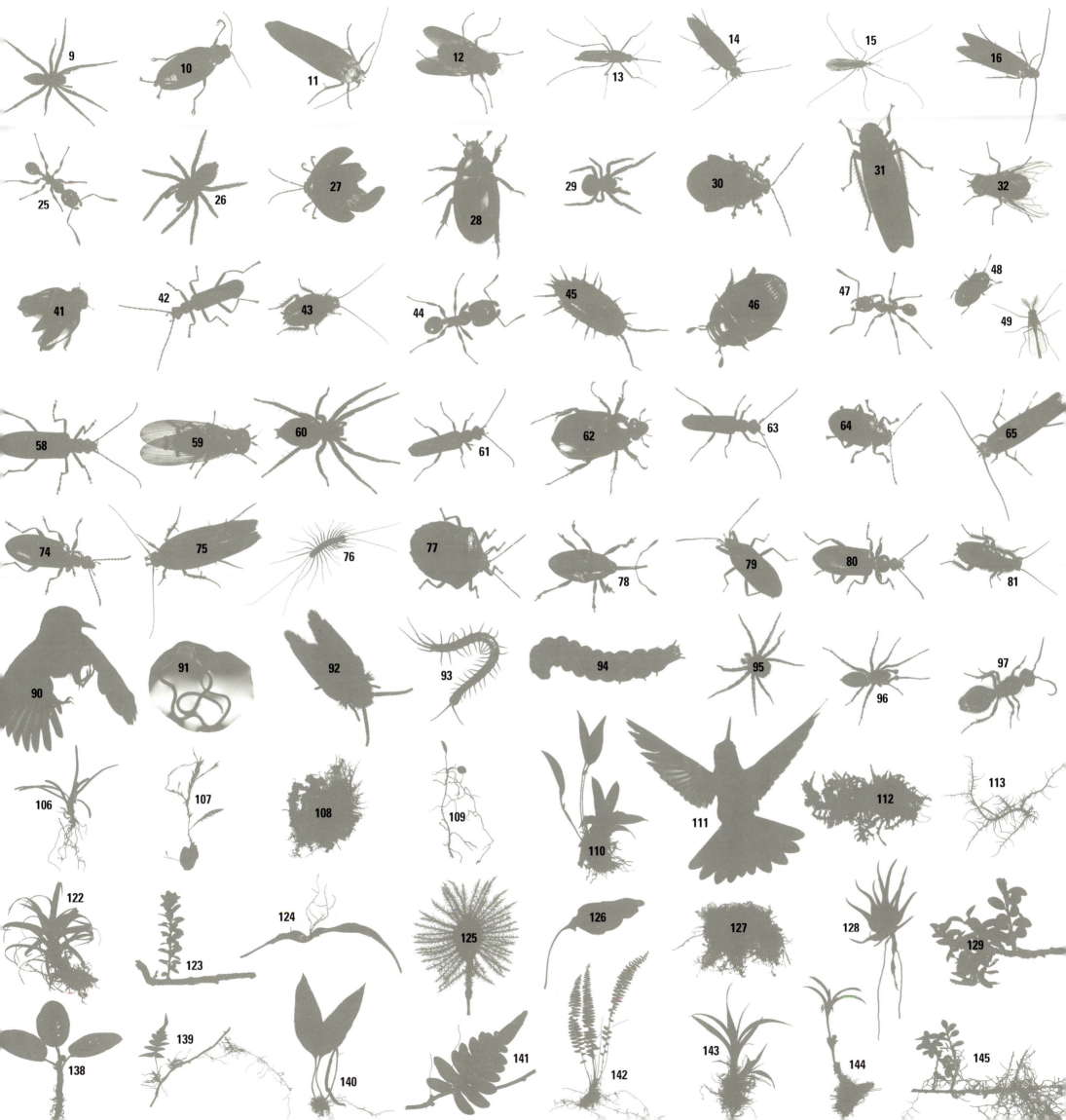

SPECIES KEY

1. June beetle, *Phyllophaga* sp.
2. Caterpillar, family Arctiidae
3. Black fly, *Simulium callidum*
4. Carpenter ant, *Componotus* sp.
5. Weevil, family Curculionidae
6. Tick, family Ixodidae
7. Long-legged fly, *Amblypsilopus* sp.
8. Wasp, *Polybia* sp.
9. Ghost spider, family Anyphaenidae
10. Firefly, family Lampyridae
11. Owlet moth, family Noctuidae
12. Latrine fly, *Fannia* sp.
13. Mosquito, *Aedes quadrivittatus*
14. Concealer moth, family Oecophoridae
15. Crane fly, *Limonia* sp.
16. Moth, order Lepidoptera
17. Cockroach, order Blatodea
18. Pleasing fungus beetle, subfamily Erotylinae
19. Carpenter ant, *Camponotus* sp.
20. Jumping spider, family Salticidae
21. Jumping spider, family Salticidae
22. Feather-winged beetle, family Ptiliidae
23. Ant, *Strumigenys* sp.
24. Jumping plant louse, family Psyllidae
25. Ant, *Pheidole* sp.
26. Spider, order Araneae
27. Flea beetle, subfamily Alticini
28. Jewel scarab, *Chrysina resplendens*
29. Orb weaver spider, family Araneidae
30. Flea beetle, subfamily Alticini
31. Sharpshooter leafhopper, *Paromenia isabellina*
32. Flesh fly, family Sarcophagidae
33. Fever fly, *Dilophus* sp.
34. Fever fly, *Dilophus* sp.
35. Weevil, family Curculionidae
36. Jumping plant louse, family Psyllidae
37. Scale insect, family Coccoidae
38. Fly, order Diptera
39. Mite, order Acari
40. Black fly, *Simulium metallicum*
41. Planthopper, family Delphacidae
42. Soldier beetle, family Cantharidae
43. Cockroach, order Blatodea
44. Ant, *Pheidole* sp.
45. Woodlouse, order Isopoda
46. Water scavenger beetle, family Hydrophilidae
47. Ant, *Pheidole* sp.
48. Feather-winged beetle, family Ptiliidae
49. Midge, family Chironomidae
50. Sac spider, family Corinnidae
51. Hawk moth, *Xylophanes porcus continentalis*
52. Fly, order Diptera
53. Wasp, family Diapriidae
54. Tortrix moth, family Tortricidae
55. Owlet moth, *Lichnoptera illudens*
56. Geometer moth, family Geometridae
57. Snout moth, family Pyralidae
58. False blister beetle, family Oedemeridae
59. Fly, family Lauxaniidae
60. Ghost spider, family Anyphaenidae
61. Soldier beetle, family Cantharidae
62. Scarab beetle, family Scarabaeidae
63. Soldier beetle, family Cantharidae
64. Leaf beetle, subfamily Eumolpinae
65. Moth, order Lepidoptera
66. Short-winged mold beetle, subfamily Pselaphinae
67. Spider, order Araneae
68. Leech, subclass Hirudinea
69. Owlet moth, family Noctuidae
70. Darkling beetle, family Tenebrionidae
71. Fly, family Lauxaniidae
72. Jumping spider, family Salticidae
73. Leaf beetle, subfamily Eumolpinae
74. Long-jointed beetle, subfamily Lagriinae
75. Moth, order Lepidoptera
76. House centipede, family Scutigeridae
77. Shield bug, family Pentatomidae
78. Weevil, family Curculionidae
79. Seed bug, *Balboa variabilis*
80. Long-jointed beetle, subfamily Lagriinae
81. Cockroach, order Blatodea
82. Sac spider, family Corinnidae
83. Harvestman, *Pachylicus* sp.
84. Mealybug, family Pseudococcidae
85. Mite, order Acari
86. Case-bearing leaf beetle larva, family Chrysomelidae
87. Common bush tanager, *Chlorospingus ophthalmicus*
88. Common bush tanager, *Chlorospingus ophthalmicus*
89. Slate-throated redstart, *Myioborus miniatus*
90. Ochraceous wren, *Troglodytes ochraceus*
91. Worm
92. Moth fly, family Psychodidae
93. Centipede, class Chilopoda
94. Beetle larva, order Coleoptera
95. Mite, order Acari
96. Sac spider, family Corinnidae
97. Wasp, order Hymenoptera
98. Beetle, superfamily Elateroidea
99. Geometer moth, *Leuciris fimbriaria*
100. Green-crowned brilliant, *Heliodoxa jacula*
101. Tiger moth, *Eucereon leria*
102. Tiger moth, *Melese* sp.
103. Geometer moth, *Leuciris fimbriaria*
104. Tiger moth, *Symphlebia suanoides*
105. Owlet moth, *Leucania latiuscula*
106. Bromeliad, family Bromeliaceae
107. Moss, division Bryophyta
108. Lichen and moss
109. Seedling
110. Green bonnet orchid and bromeliad, *Pleurothallis ruscifolia* and *Guzmania* sp.
111. Purple-throated mountain gem, *Lampornis calolaemus*
112. Moss, division Bryophyta
113. Lichen
114. Seedling
115. Moss and lichen
116. Moss, division Bryophyta
117. Seedling
118. Moss, division Bryophyta
119. Bromeliad and lichen
120. Radiator plant, *Peperomia* sp.
121. Radiator plant, *Peperomia* sp.
122. Bromeliad, *Tillandsia insignis*
123. Tropical blueberry, *Disterigma humboldtii*
124. Fern with moss attached, *Elaphoglossum* sp.
125. Burio tree seed, *Heliocarpus americanus*
126. Deer's tongue fern with moss attached, *Elaphoglossum* sp.
127. Soil sample with lichen
128. Bromeliad, family Bromeliaceae
129. Tropical blueberry, *Disterigma humboldtii*
130. Moss, division Bryophyta
131. Tropical blueberry, *Disterigma humboldtii*
132. Orchid, *Encyclia* sp.
133. Bromeliad, *Tillandsia insignis*
134. Epiphytic shrub, *Gaiadendron punctatum*
135. Epiphytic shrub, *Gaiadendron punctatum*
136. Bromeliad, *Werauhia* sp.
137. Moss and lichen
138. Strangler fig, *Ficus tuerckheimii*
139. Rockcap fern, *Polypodium ptilorhizon*
140. Deer's tongue fern, *Elaphoglossum* sp.
141. Rockcap fern, *Polypodium* sp.
142. Spleenwort fern, *Asplenium* sp.
143. Bromeliad, family Bromeliaceae
144. Orchid, *Maxillaria fulgens*
145. Tropical blueberry and moss, *Disterigma humboldtii*

Leech *(left)*
0.98" (2.5 cm) long

Centipede
class Chilopoda
1.5" (3.8 cm) long

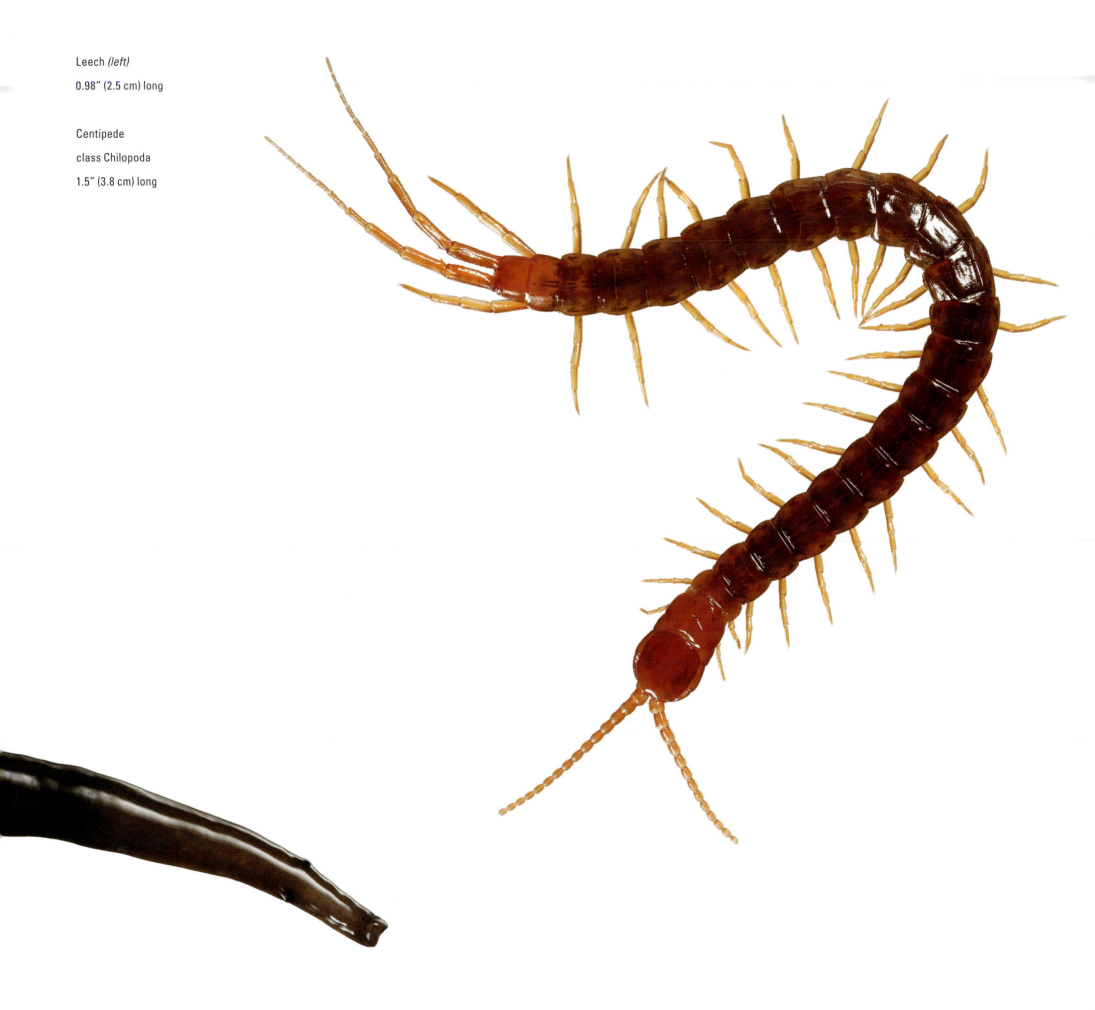

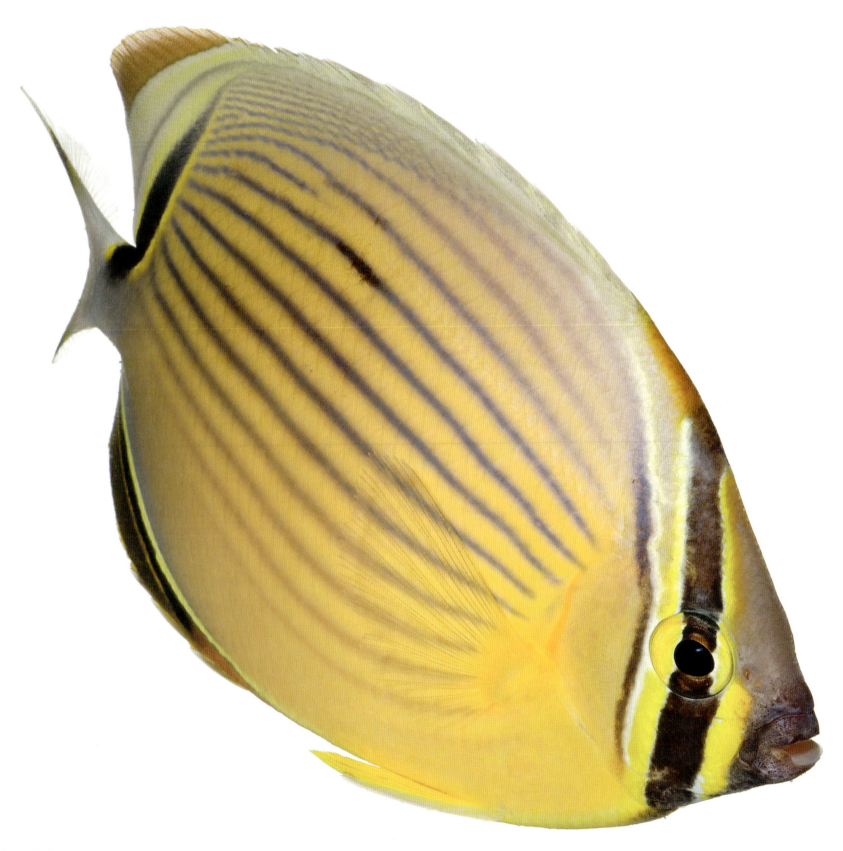

Oval butterflyfish

Chaetodon lunulatus

2.95″ (7.5 cm) tall

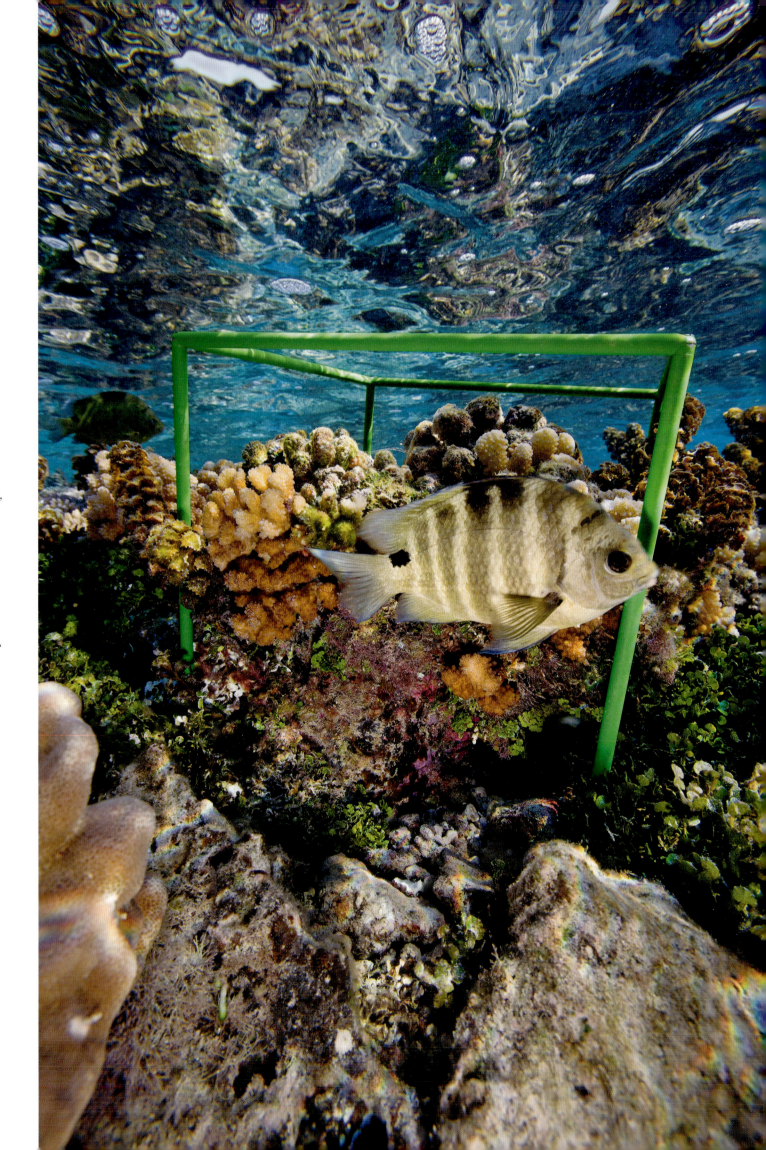

A coral reef and its residents grow best in clean, sun-drenched water with no sediment. At Temae Reef off the Pacific island of Moorea, Liittschwager worked with scientists from the Moorea Biocode Project—a venture to inventory every species on Moorea large enough to be gripped in the finest tweezers. He photographed more than 600 individuals, not counting the plankton swarm that sent tens of thousands of shrimplike hatchlings drifting through the cube one moonless night. Biocode researchers are conducting DNA sequencing on Liittschwager's collection, part of a larger effort to assign a unique identifier to each species. "Such detail will give us a new way to look at the ecosystem," says Smithsonian research zoologist Chris Meyer. This small survey only hints at the reef's full diversity: Many animals flee during sampling and, Meyer says, "if you moved the cube over just a few feet, a third of your finds might be different."

TEMAE REEF, MOOREA, FRENCH POLYNESIA

CORAL REEFS are sometimes compared to cities and sometimes to rain forests. Both comparisons are apt, which gives you an idea of how extraordinary they are—and how hard to categorize. Reefs are part animal, part vegetable, and part mineral; they are at once mostly dead and, at the same time, teeming with life.

At the surface of a reef is a thin layer of living tissue made up of lentil-size animals known, unflatteringly, as polyps. They belong to the phylum Cnidaria, along with sea anemones and jellyfish, and they are shaped a bit like a flower, with six (or a multiple of six) tentacles surrounding a central mouth. The polyps of a reef are all connected to one other and, in many cases, genetically identical. In their tentacles are stinging cells, known as nematocysts, which they use like tiny harpoons, to spear even tinier prey. Meanwhile, residing inside the polyps are microscopic algae known as zooxanthellae. Zooxanthellae are photosynthesizers, producing sugars that they then share with their coral hosts. This symbiotic relationship is crucial; it's what gives the polyps the extra energy needed to excrete the vast exoskeleton of calcium carbonate that forms the reef's structure.

Coral reefs grow in a great swath that stretches like a belt around the belly of the earth, from 30º north latitude to 30º south latitude. As a rule, the oceans in this region are nutrient poor—so much so that they are sometimes referred to as liquid deserts. The lack of nutrients limits the growth of phytoplankton, which can cloud the seas, so the waters in this belt are often a crystalline blue. Paradoxically, though, reefs are some of the most densely populated habitats in the world, with an estimated one million and perhaps as many as nine million species living in or around them.

How is it that so many creatures can thrive in this liquid desert? The answer seems to be a highly efficient recycling system through which nutrients are, in effect, passed from one reef-dwelling organism to another. In this tightly interconnected system every creature has a role to play—from the worms that bore into the reef and the sea squirts that attach themselves to the surface to the jellyfish that float like specters above.

(A study of Australia's Great Barrier Reef found that a single volleyball-size boulder from the reef contained more than a thousand worms representing a hundred different species.) Something like a quarter of all fish in the seas spend at least part of their lives on reefs; these include grazers, who feed off plant life attached to the reef; detritivores, who scavenge their food from dead material; and piscivores, who eat the grazers and detritivores and any other fish they have the good fortune to swallow.

The one cubic foot of reef whose residents are pictured here sits off Moorea, an island in French Polynesia about nine miles northwest of Tahiti. A volcanic island, Moorea is almost entirely surrounded by reef. Charles Darwin, who visited the area in 1835, looked out over Moorea from one of Tahiti's highest points and compared the island to a picture and the encircling reef to a piece of matting paper that had been cut out to fit it exactly. (The view helped inspire his theory—largely correct—of how coral reefs grow and form.) "Glad that we have visited these islands," he wrote in his diary, for coral reefs "rank high amongst the wonderful objects in the world."

Darwin's scientific perspicacity helped clear up some, though far from all, of the mysteries that had surrounded coral reefs since Europeans first encountered them on the initial voyage of Captain James Cook. In 1770, Cook quite literally ran into the Great Barrier Reef, off the east coast of Australia; as a result, his ship, the *Endeavour*, had to be beached for several weeks for repairs. Later, in Polynesia, Cook encountered whole cliffs made of coral and was flummoxed. By the late 18th century, it was vaguely understood that reefs were formed by "insects," by which the naturalists of the day simply meant invertebrates. "If these Coral rocks were first formed in the Sea by animals, how came they to be thrown up to such a height?" Cook asked.

Our cubic foot sample was taken in Polynesia—from a spot on Temae Reef, off the northeast tip of Moorea, along what's known as the reef crest. As the term suggests, the reef crest is the highest part of the reef—or, if you prefer, the place where the water is the shallowest—and it acts like a wall, protecting the corals behind it from wave action. In this one cubic foot we found more than 600 individual animals and plants more than a millimeter in size—some living permanently in the space, others swimming or floating through. And this is not counting the many thousands of creatures less than a millimeter that floated by the cube each hour. Some of the more spectacular creatures included a nearly transparent baby octopus; a juvenile pillow cushion star, colored in the shades of a Christmas ornament; and a sacoglossan sea slug covered in what looked like a frill of ribbons. There were wrasses and boxfish and brittle stars and shrimp and polychaete worms and nearly 200 crabs, some as small as the letters on this page.

In recent decades, the reefs around Moorea, like reefs in most of the rest of the world, have been subject to increasing pressure from global warming. In so-called bleaching events, which occur when water temperatures rise too high, corals expel their symbiotic algae as a stress response and slowly starve. (The algae are what give corals their varied hues, which is why bleached reefs turn a ghostly white.) Meanwhile, reefs are also under threat from changing water chemistry, another consequence of rising carbon dioxide levels. If nothing is done to reduce emissions, many scientists fear that by mid-century reefs worldwide will no longer be able to sustain themselves and will slowly disappear. With them will go the wealth of life they support. As the creatures from just this one cubic foot attest, the losses up and down the food chain would be staggering.

— *Elizabeth Kolbert*

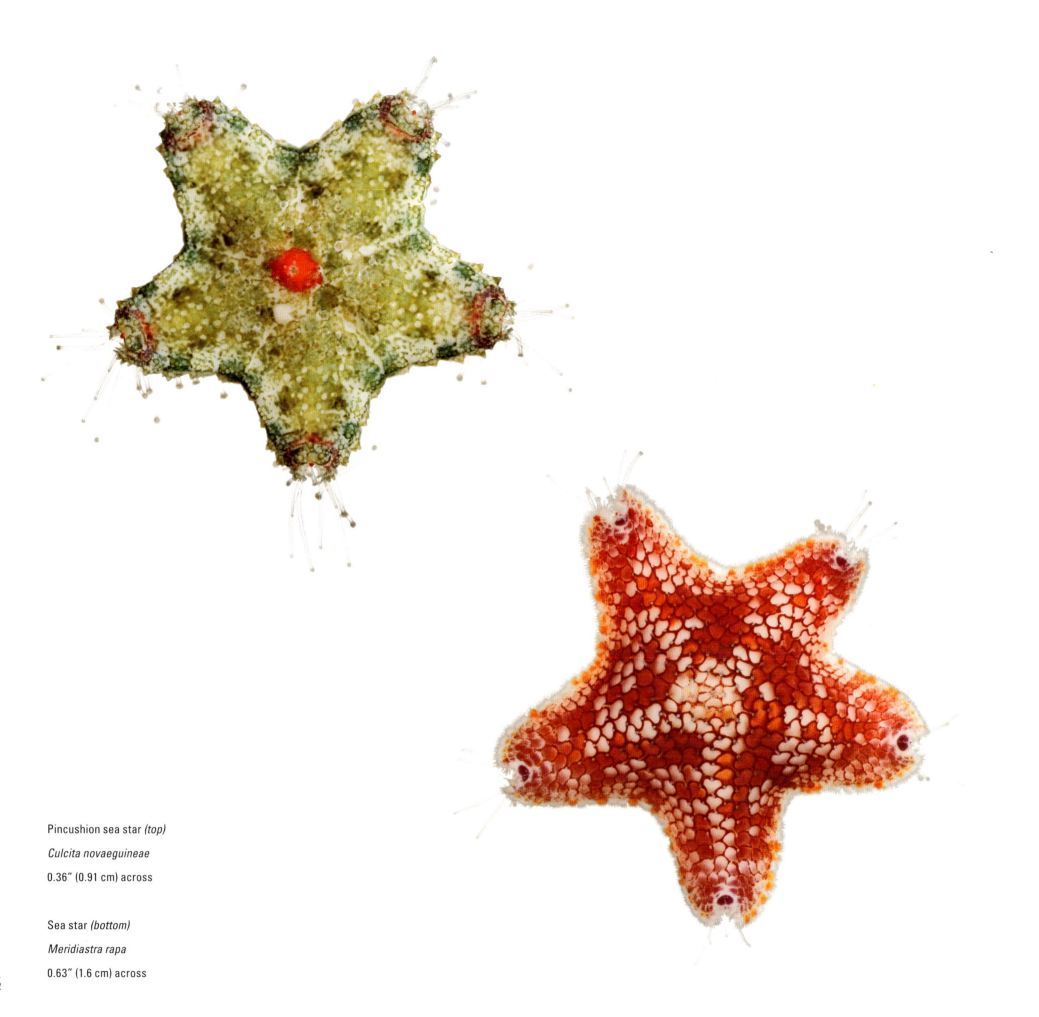

Pincushion sea star *(top)*

Culcita novaeguineae

0.36" (0.91 cm) across

Sea star *(bottom)*

Meridiastra rapa

0.63" (1.6 cm) across

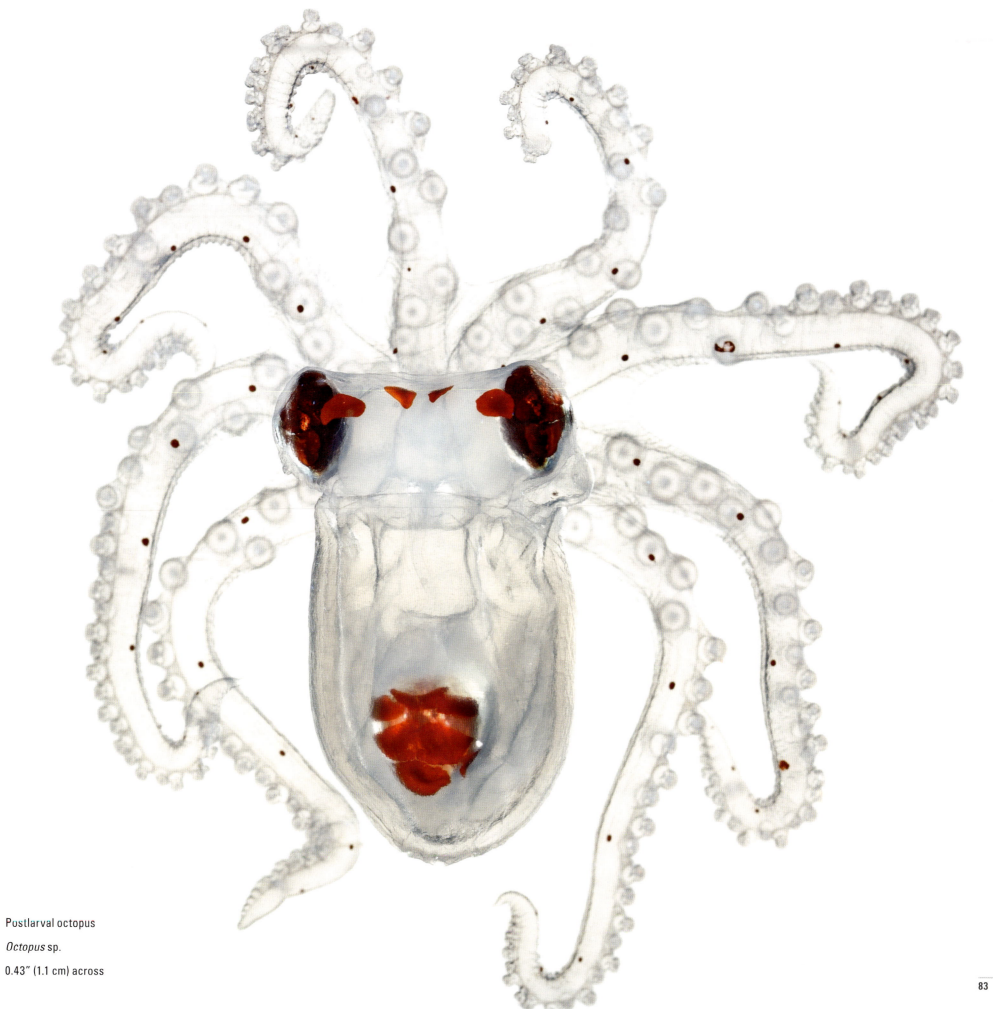

Postlarval octopus

Octopus sp.

0.43" (1.1 cm) across

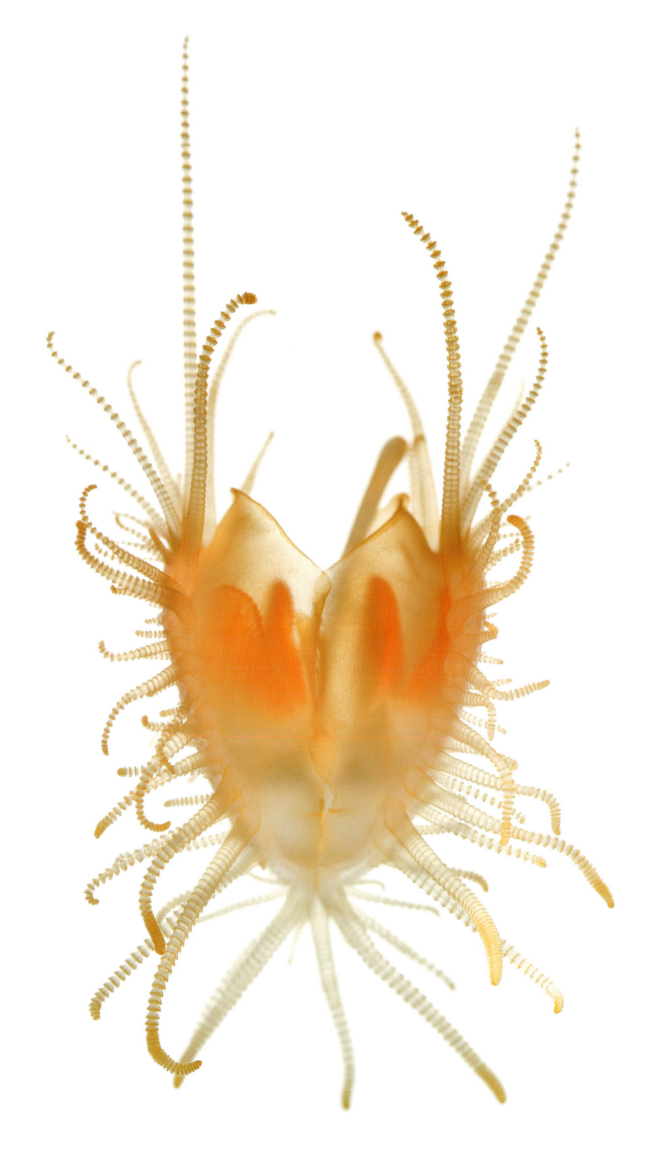

File clam *(both)*

Limaria sp.

0.79″ (2 cm) tall

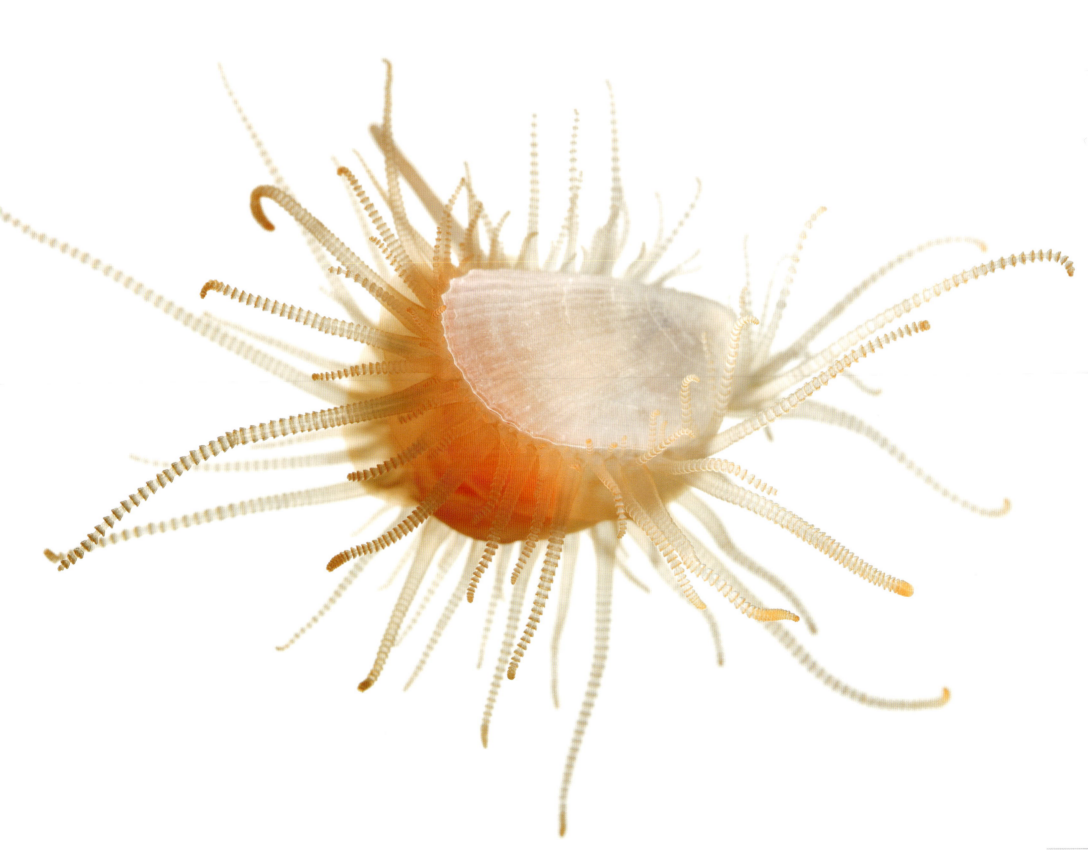

Lemonpeel angelfish

Centropyge flavissimus

1.3" (3.3 cm) tall

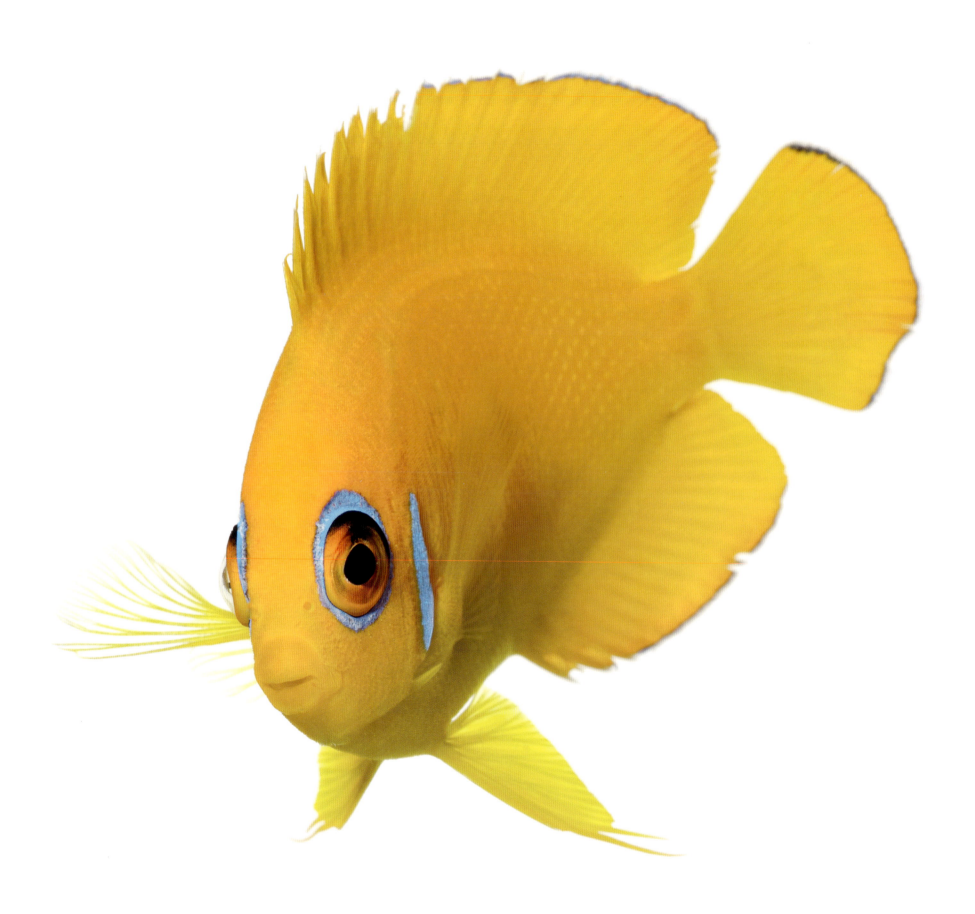

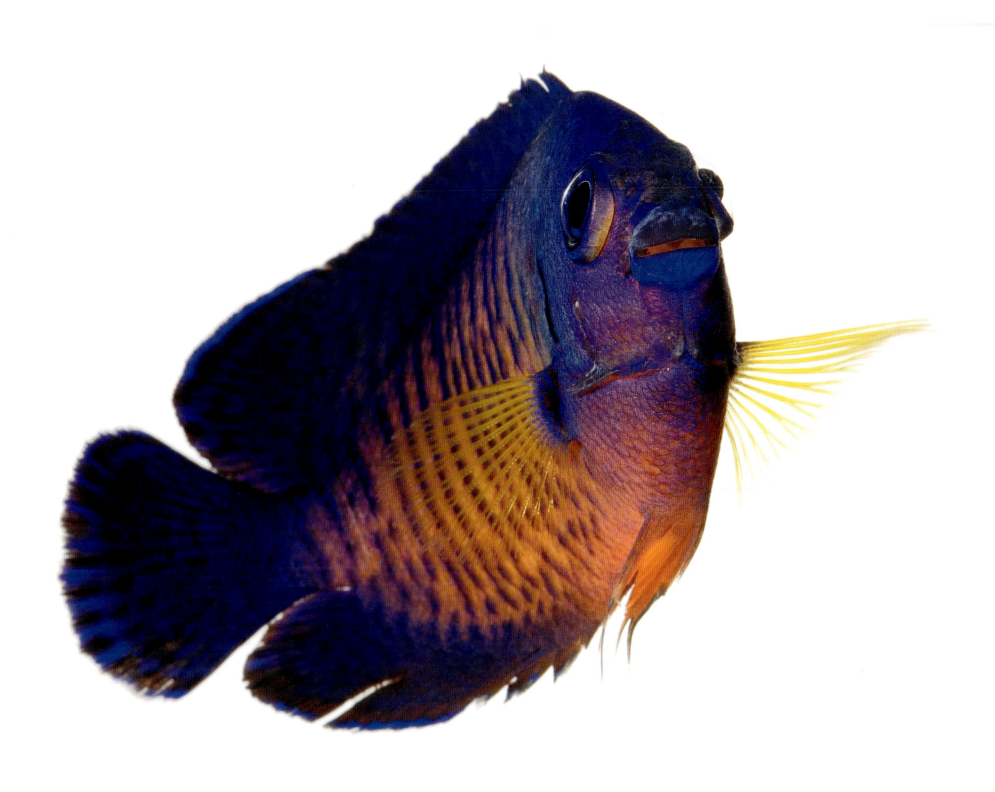

Twospined angelfish

Centropyge bispinosa

0.87" (2.2 cm) tall

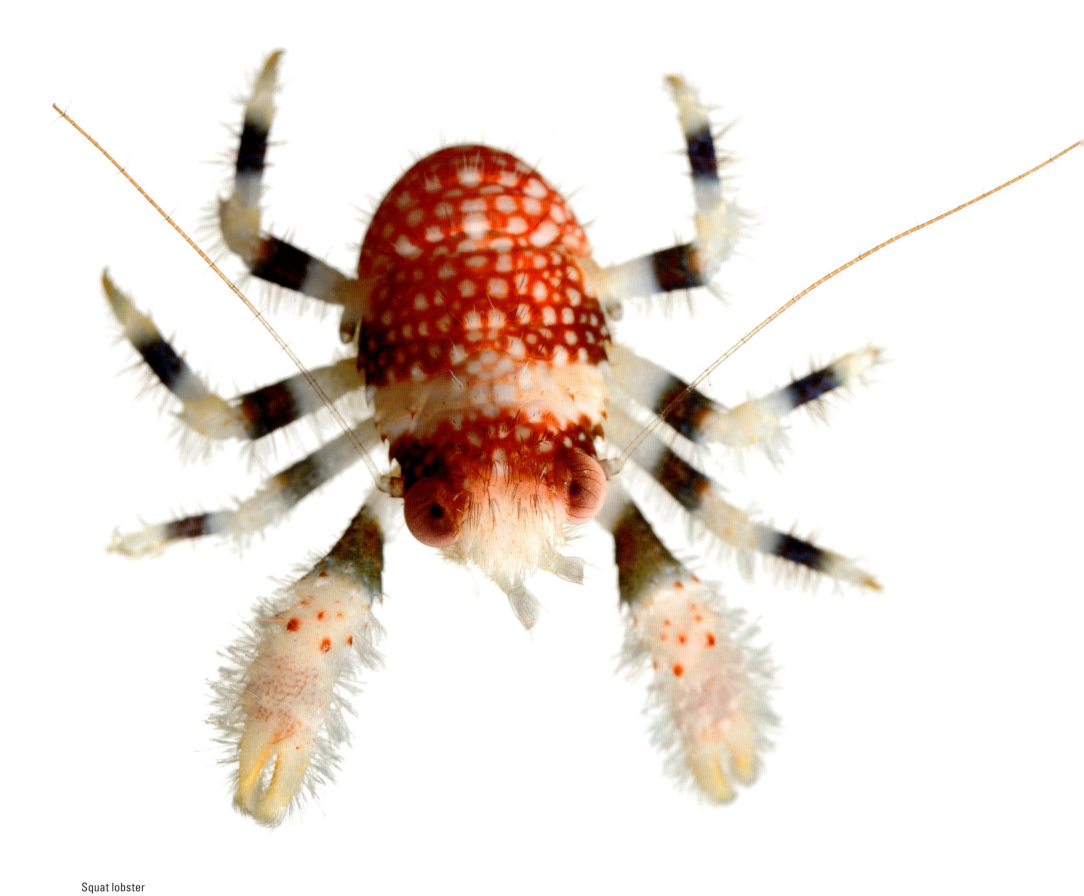

Squat lobster

Galathea pilosa

0.49" (1.25 cm) across

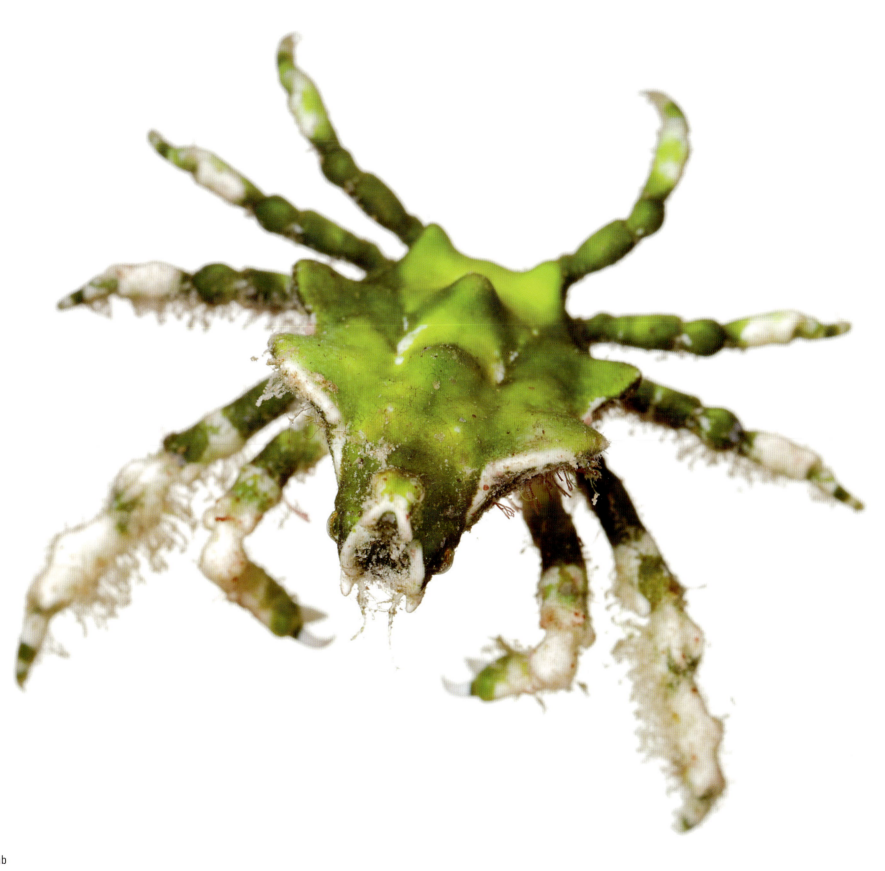

Halimeda crab

Huenia heraldica

0.9″ (2.2 cm) across

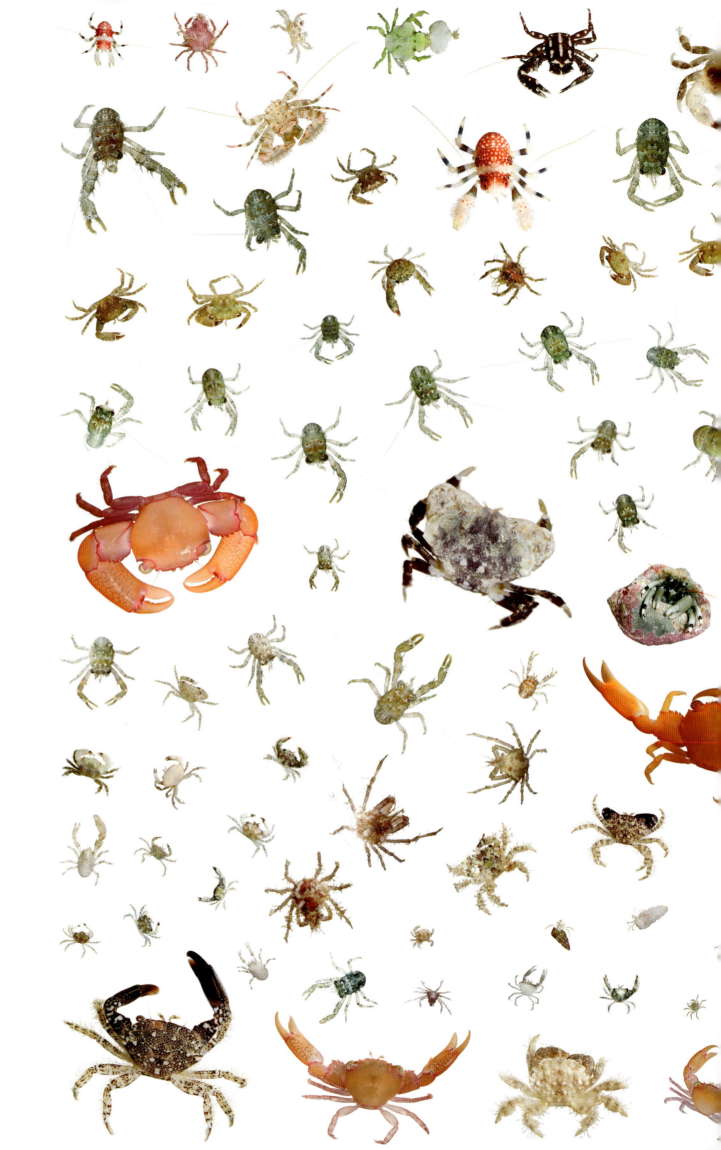

A mosaic of 190 crabs representing 7 taxonomic families, more then 22 genera, and at least 32 species. The largest family— the showy pebble crabs—are deadly poisonous to would-be predators. Other pieces of the mosaic include five more crab families— hermit, guard, spider, porcelain, and gall—and squat lobsters, whose claws can be several times the length of their body.

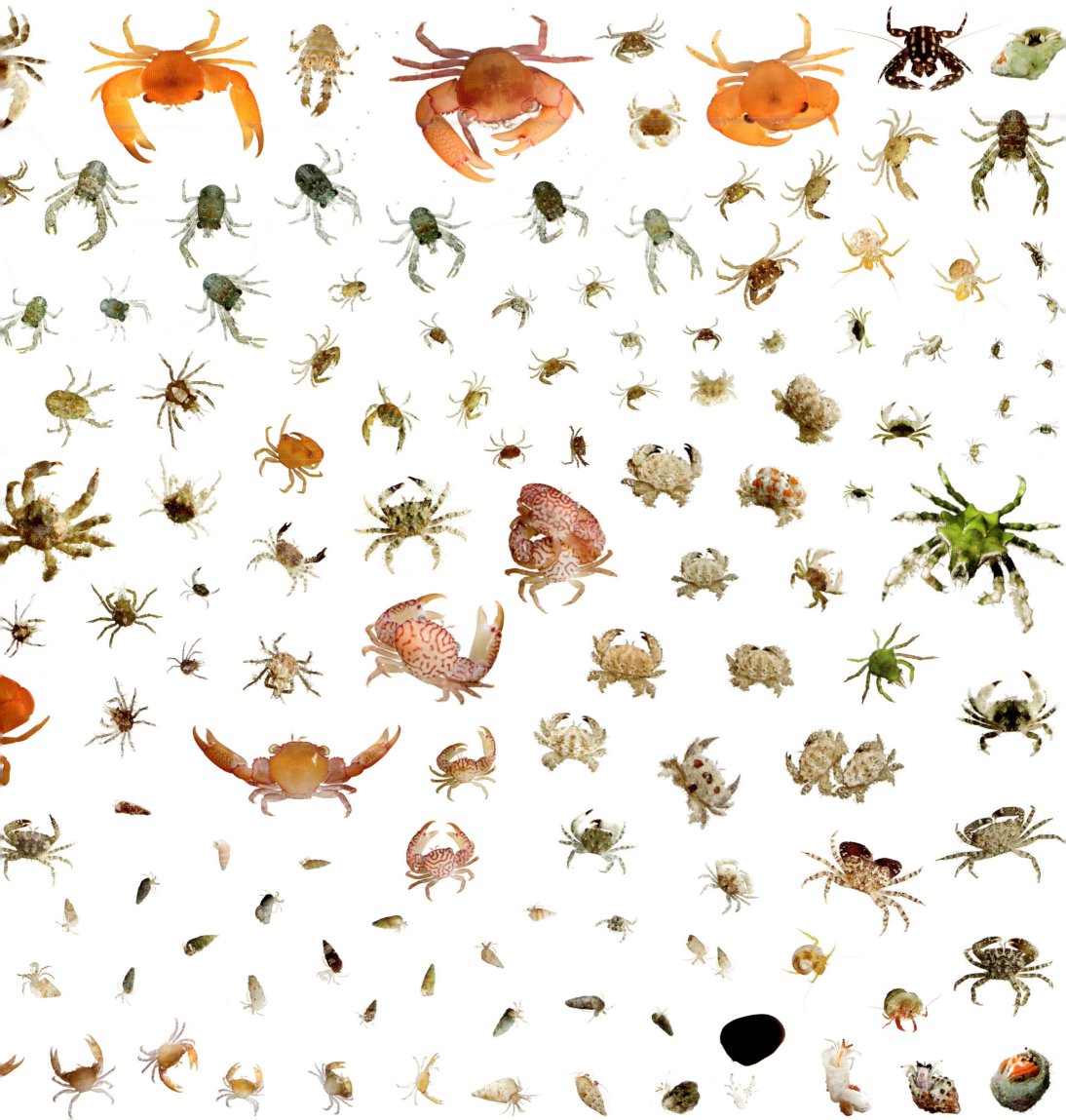

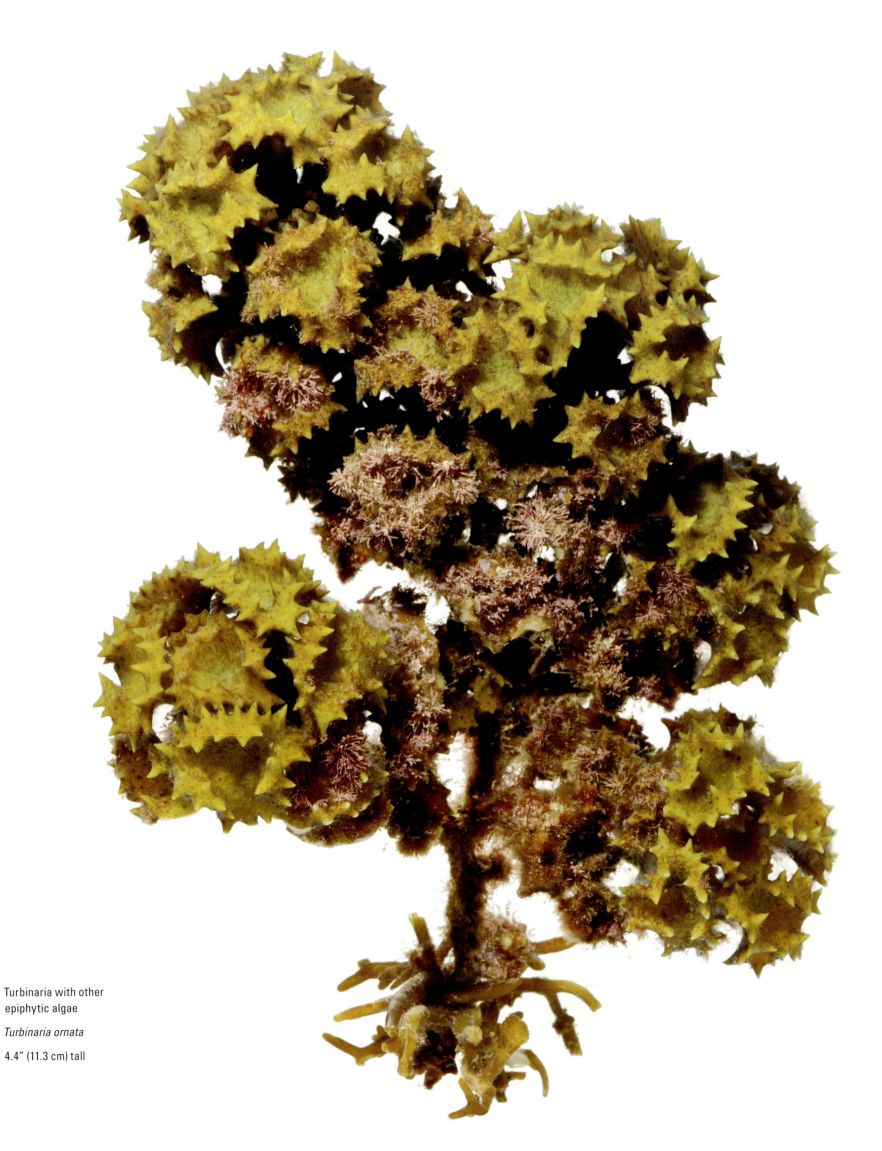

Turbinaria with other
epiphytic algae

Turbinaria ornata

4.4″ (11.3 cm) tall

Green bubble algae with crab

Ventricaria ventricosa (algae)

1.0″ (2.5 cm) across

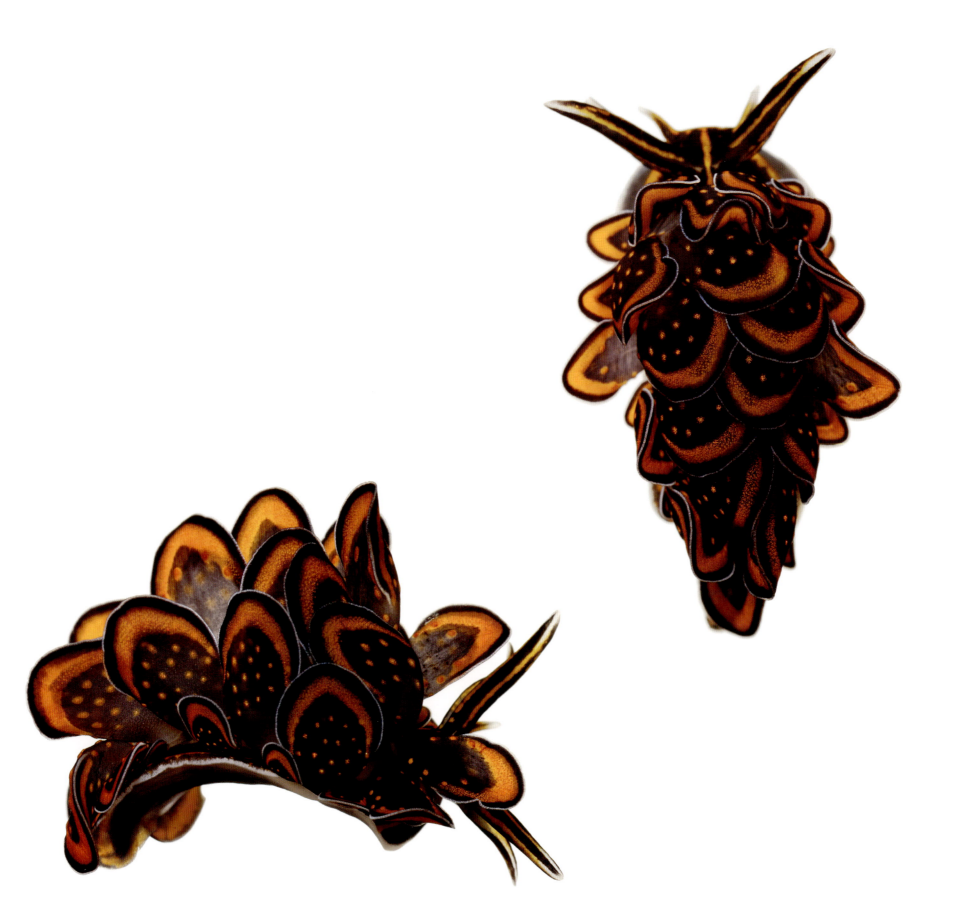

Sacoglossan sea slug

Cyerce nigricans

0.7" (1.67 cm) long

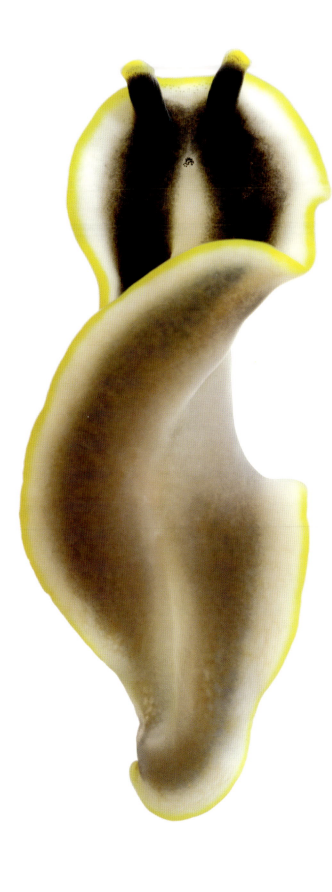

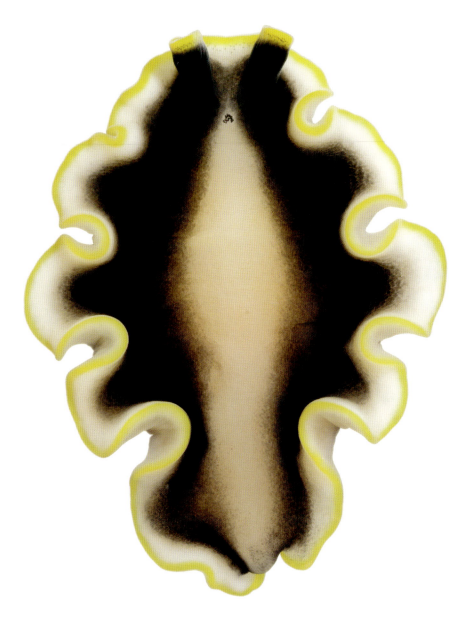

Flatworm

Pseudoceros paralaticlavus

0.4″ (1.1 cm) long

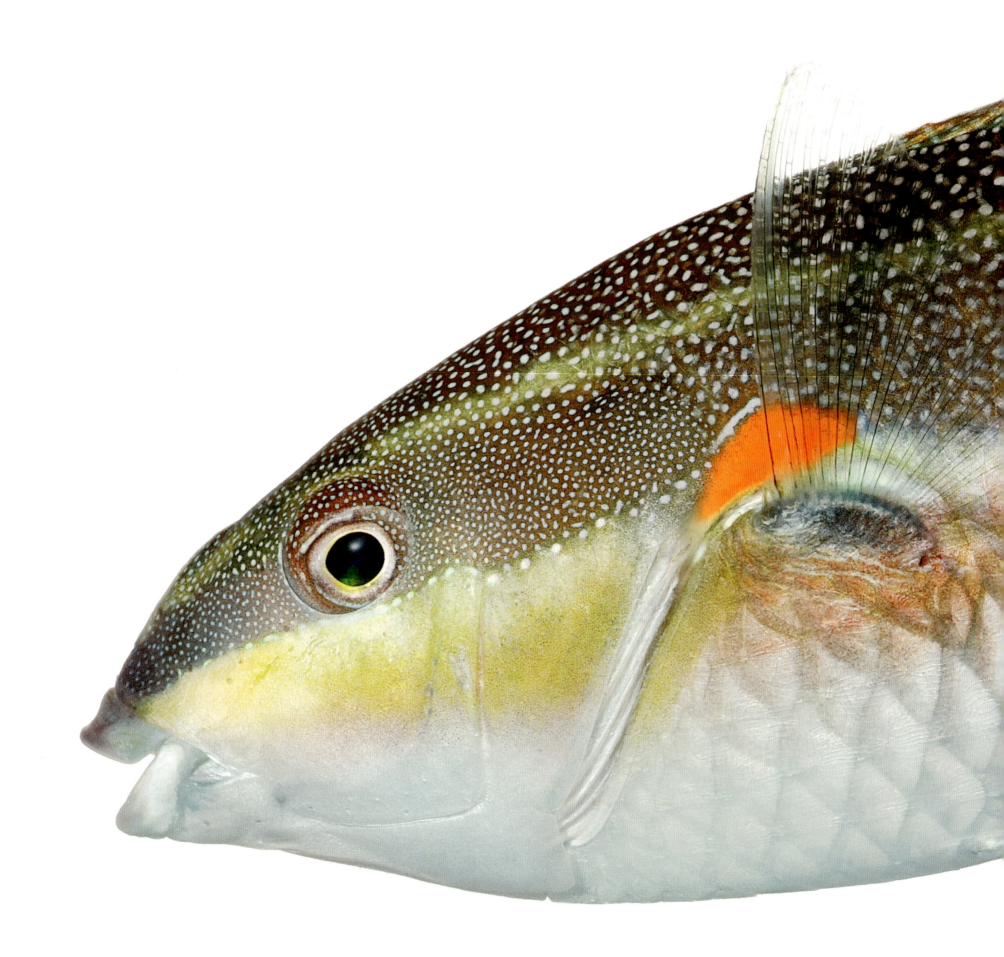

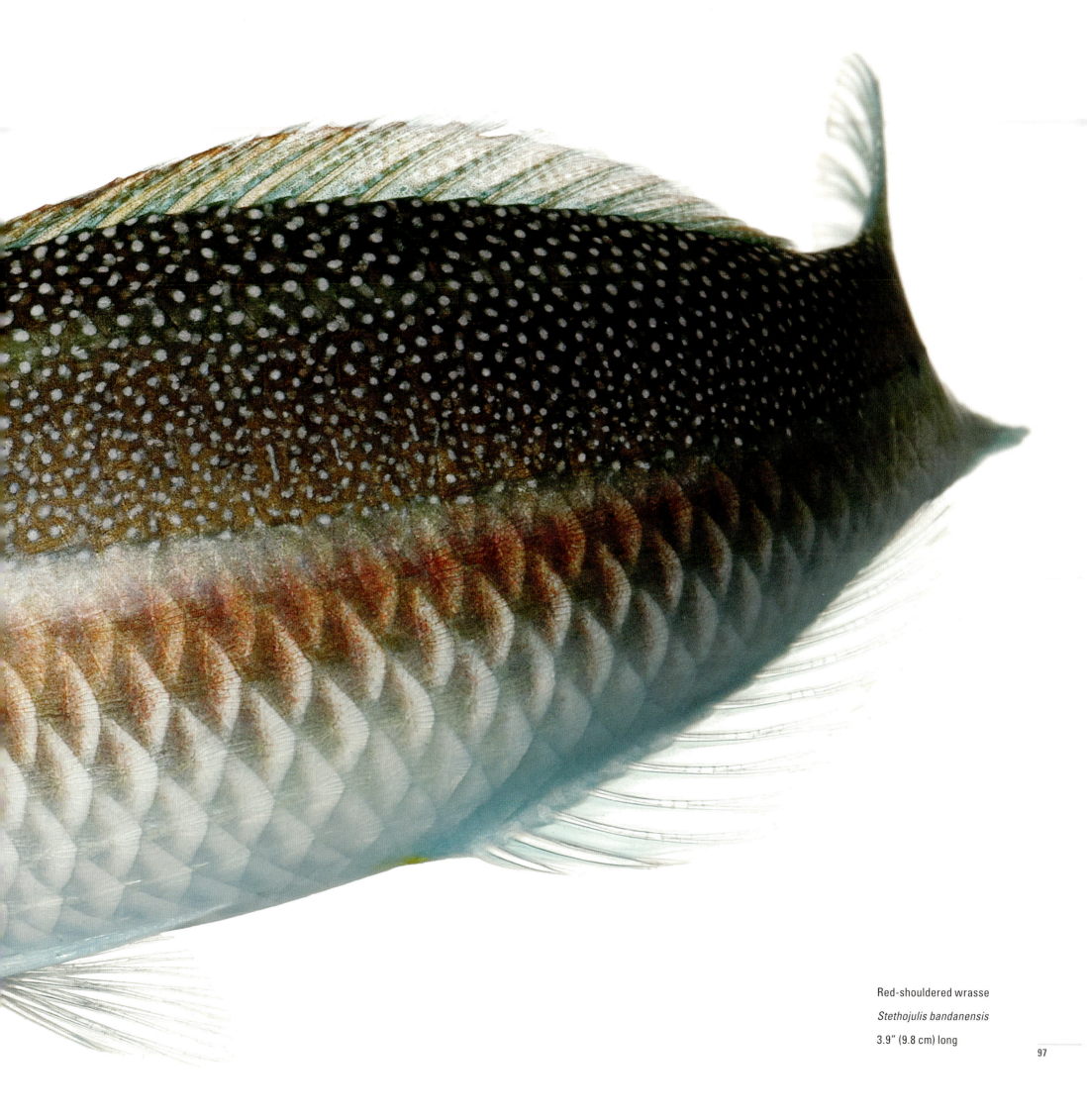

Red-shouldered wrasse

Stethojulis bandanensis

3.9" (9.8 cm) long

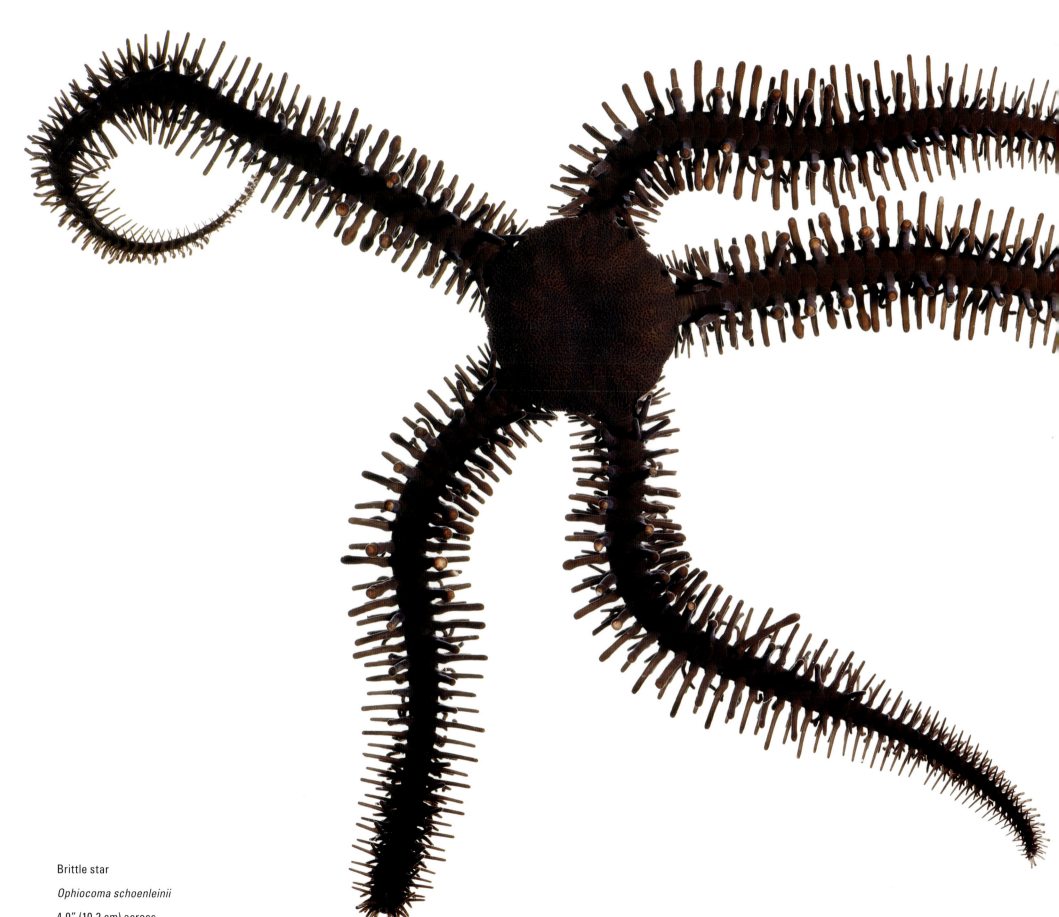

Brittle star

Ophiocoma schoenleinii

4.0" (10.2 cm) across

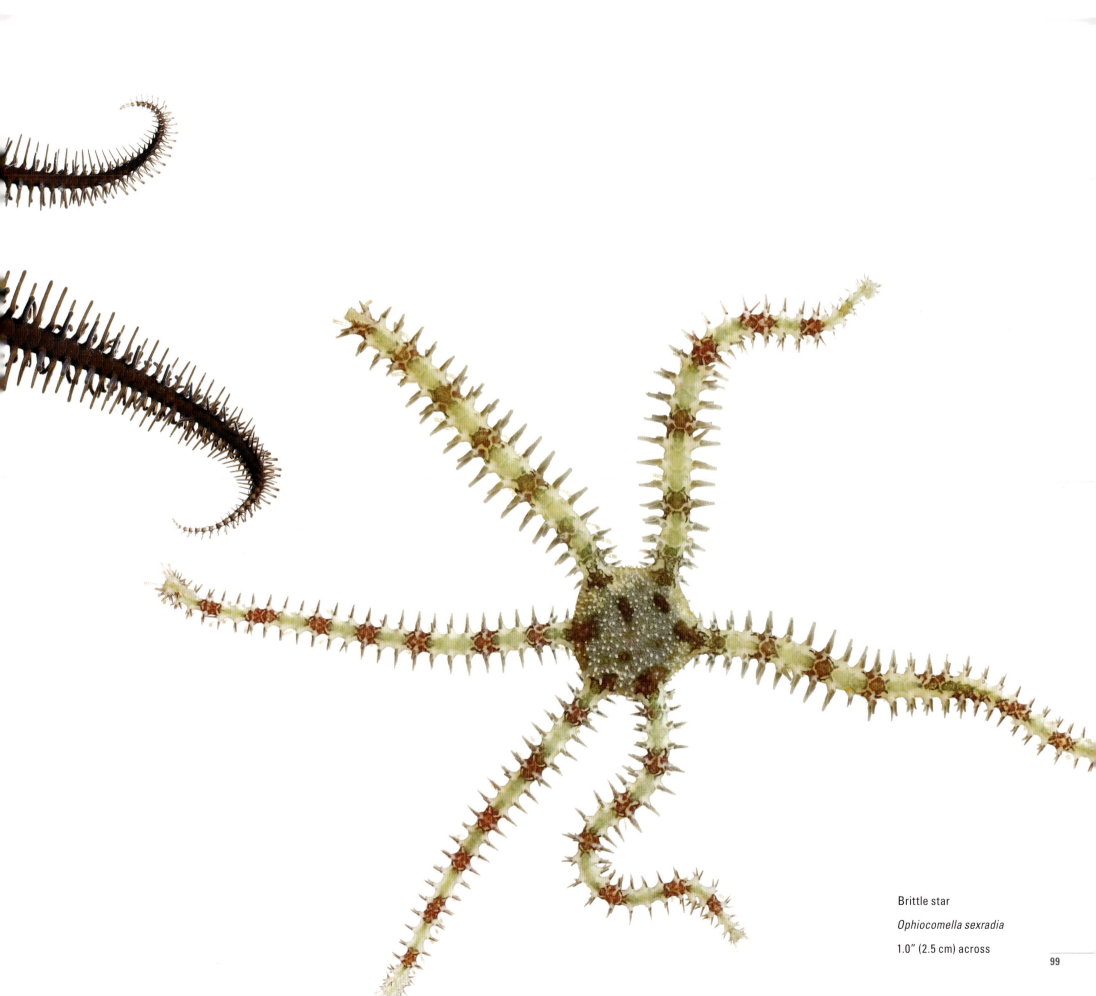

Brittle star

Ophiocomella sexradia

1.0" (2.5 cm) across

Blue-black urchin *(left)*

Echinothrix diadema

4.7″ (12 cm) tall

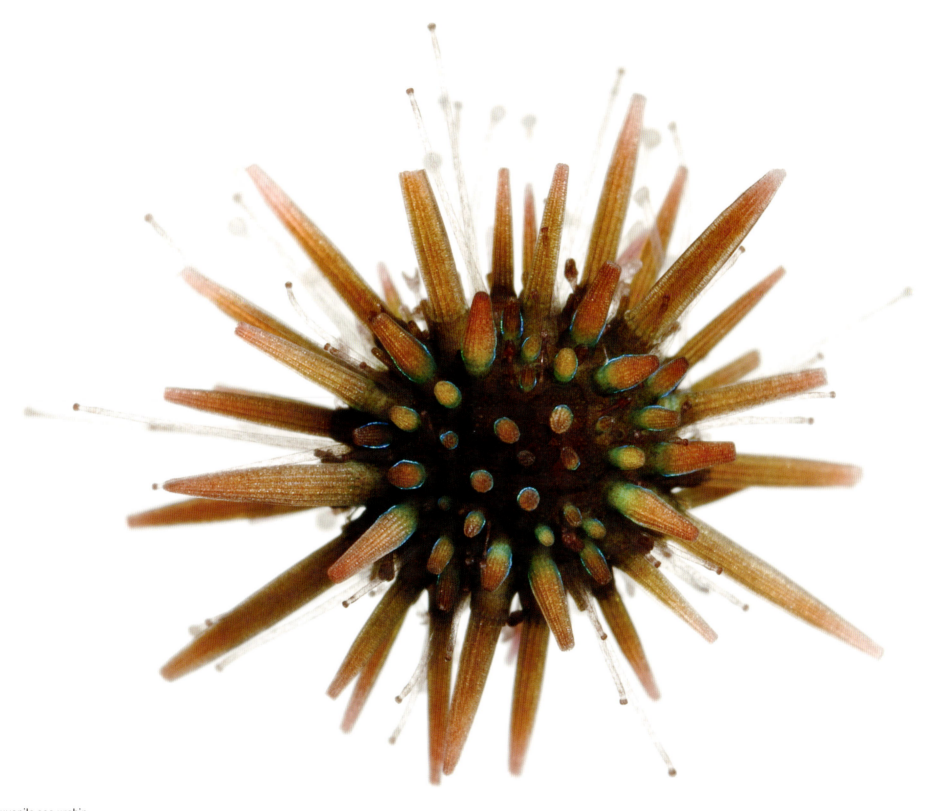

Juvenile sea urchin

Echinometra sp.

0.24″ (6 mm) across

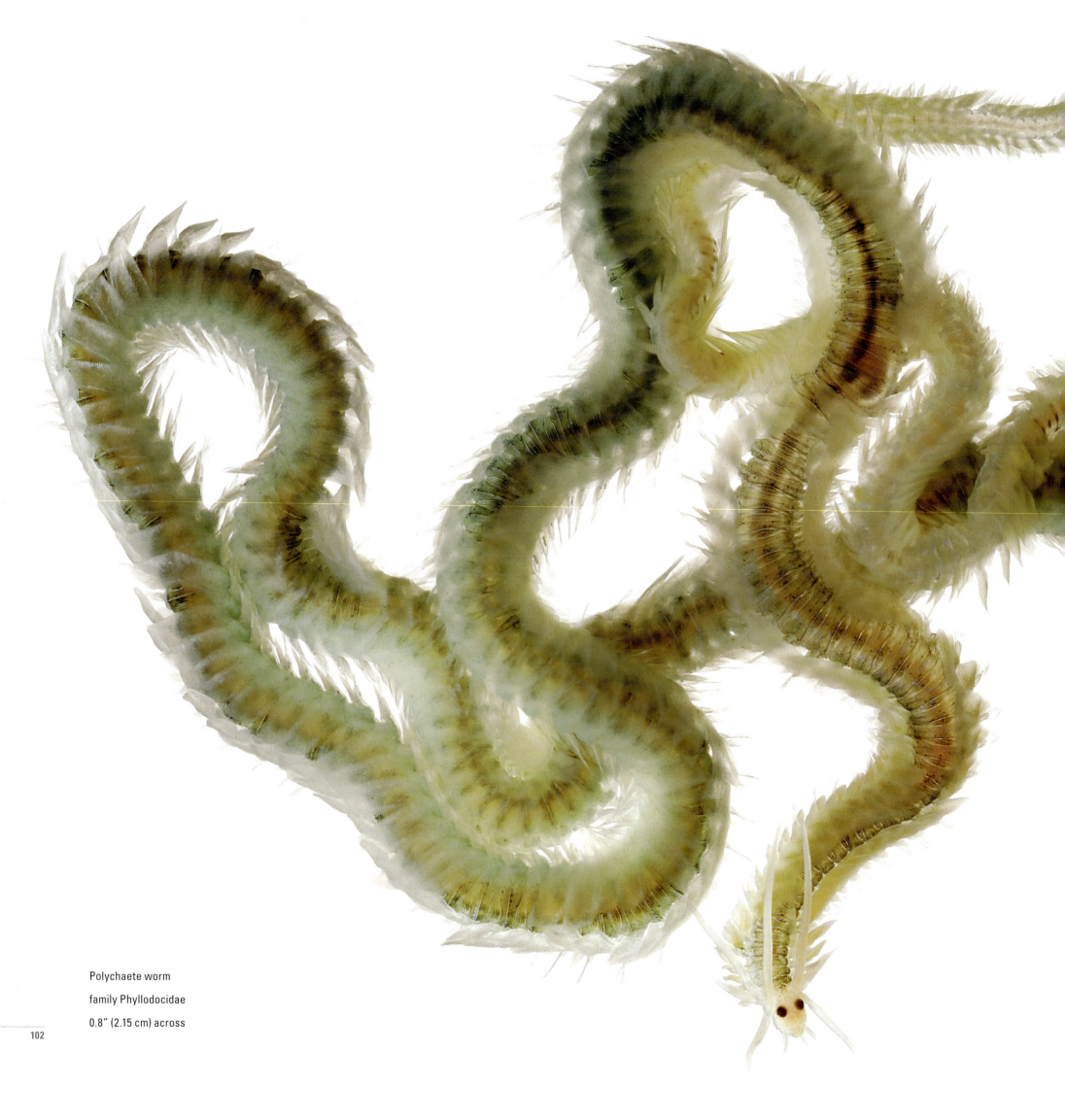

Polychaete worm

family Phyllodocidae

0.8″ (2.15 cm) across

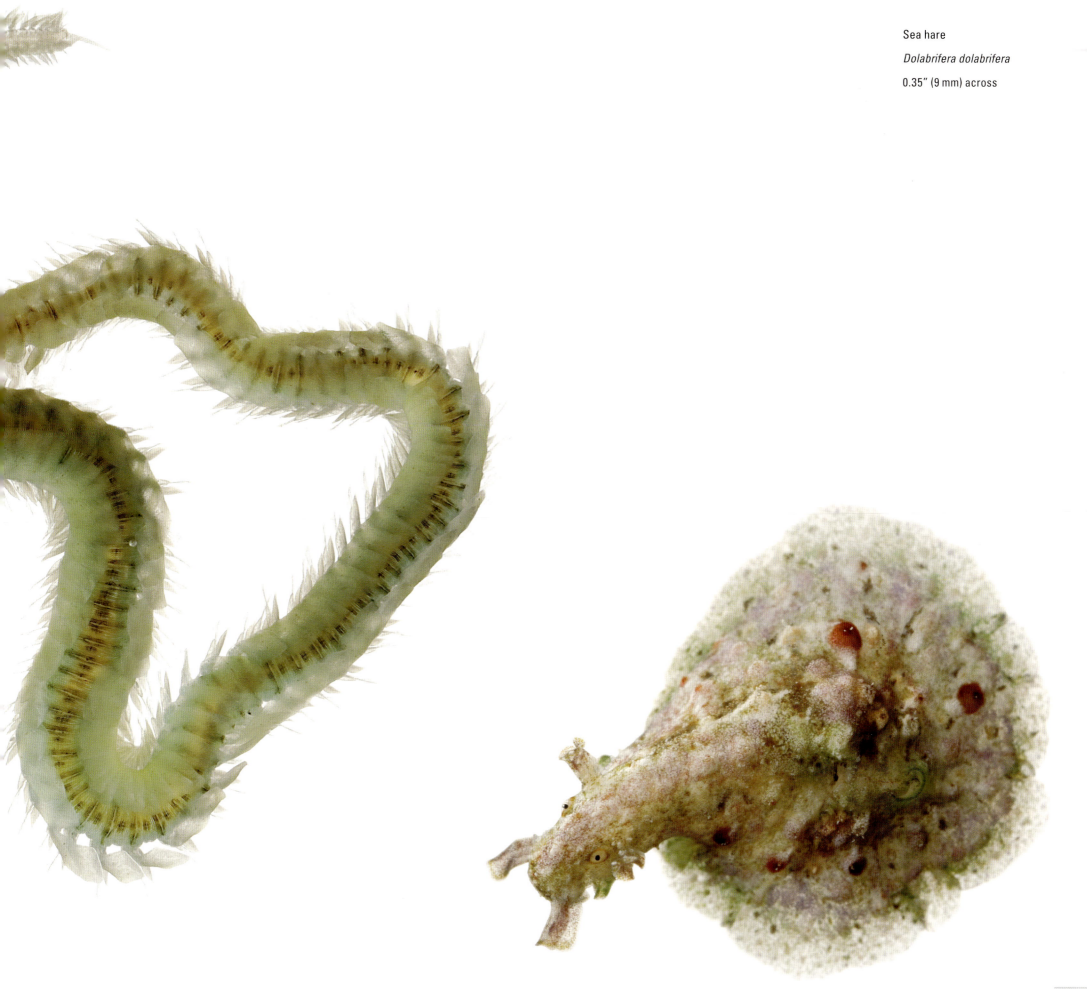

Sea hare
Dolabrifera dolabrifera
0.35" (9 mm) across

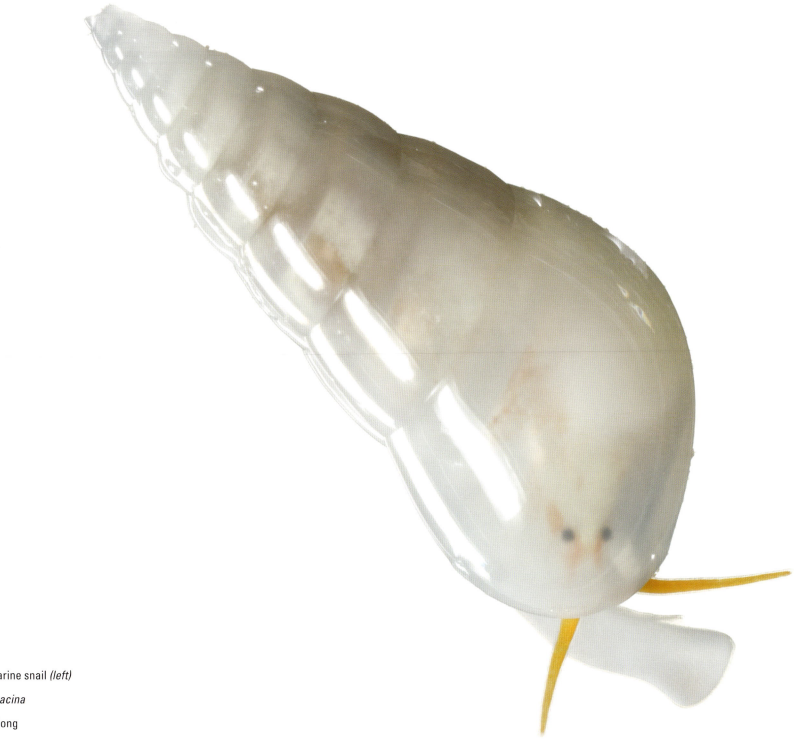

Shell-less marine snail *(left)*

Titiscania limacina

0.39″ (1 cm) long

Parasitic snail

Melanella sp.

0.28″ (7 mm)

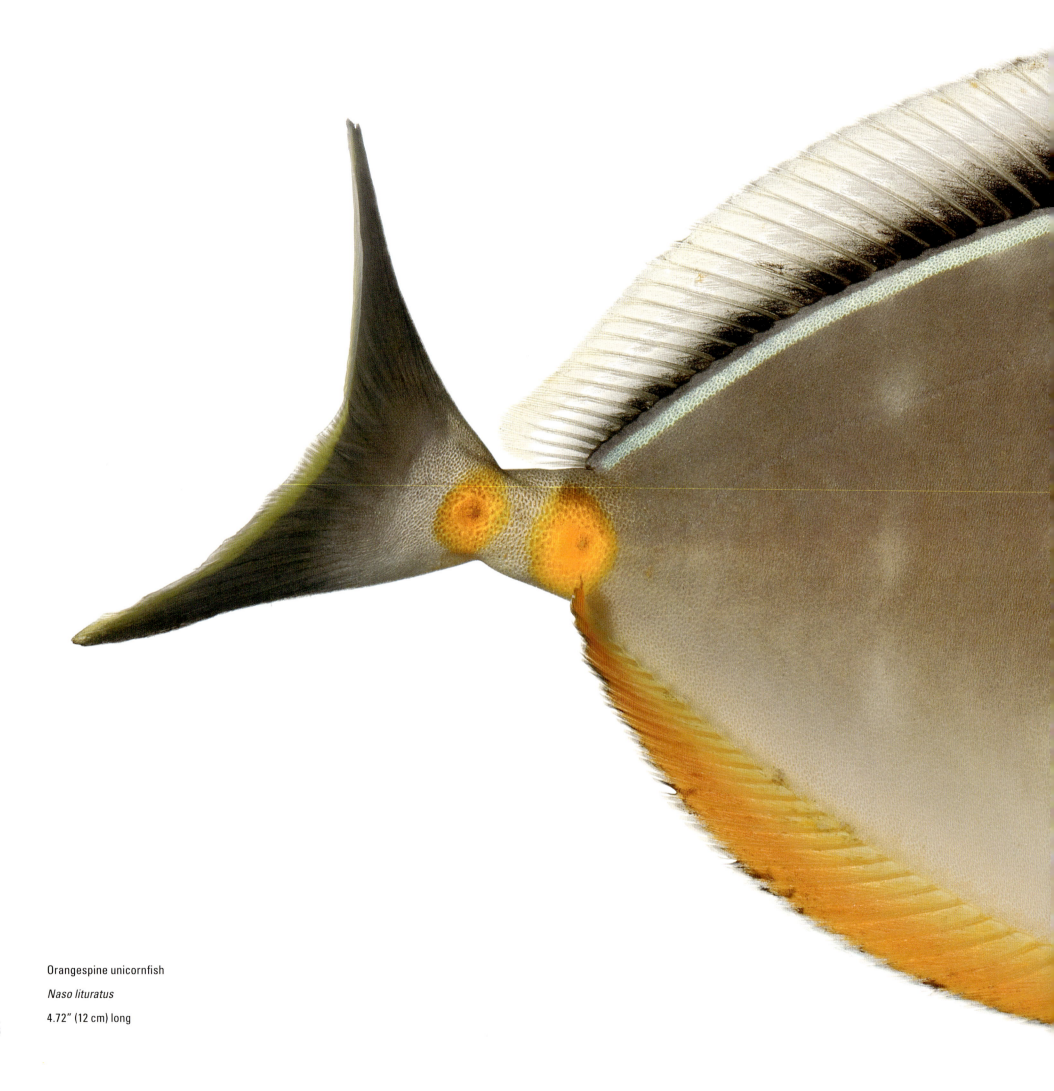

Orangespine unicornfish

Naso lituratus

4.72" (12 cm) long

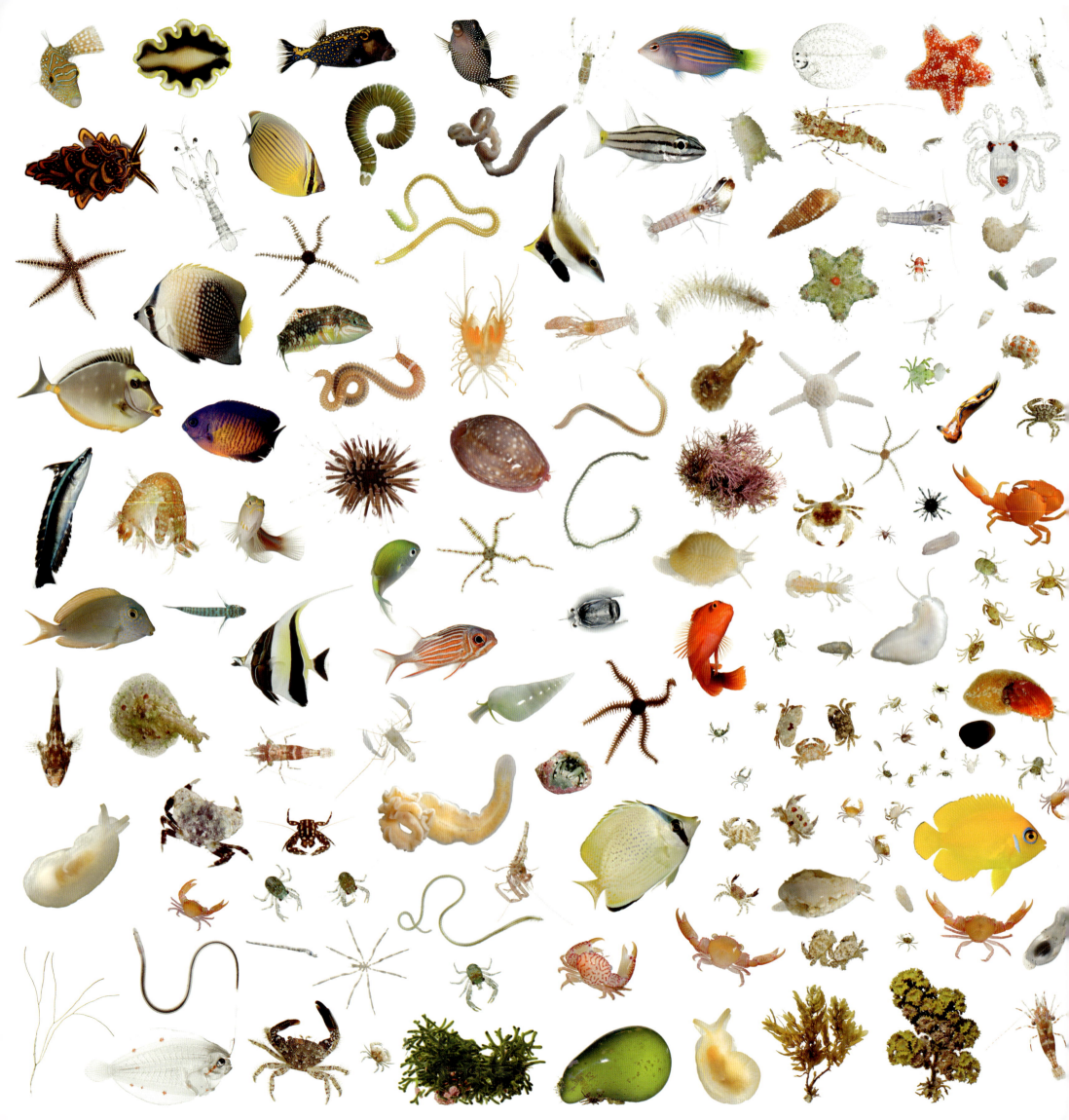

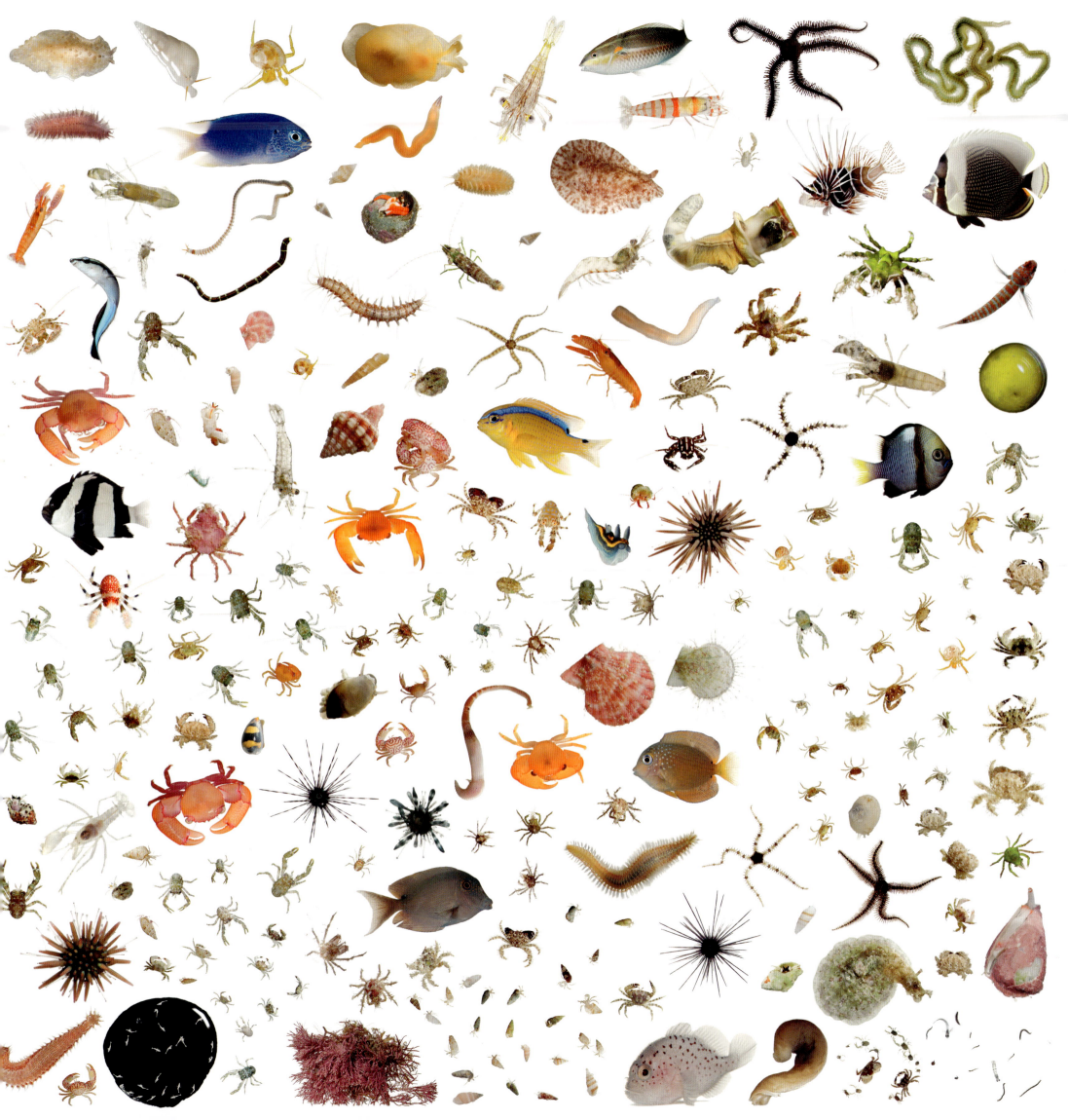

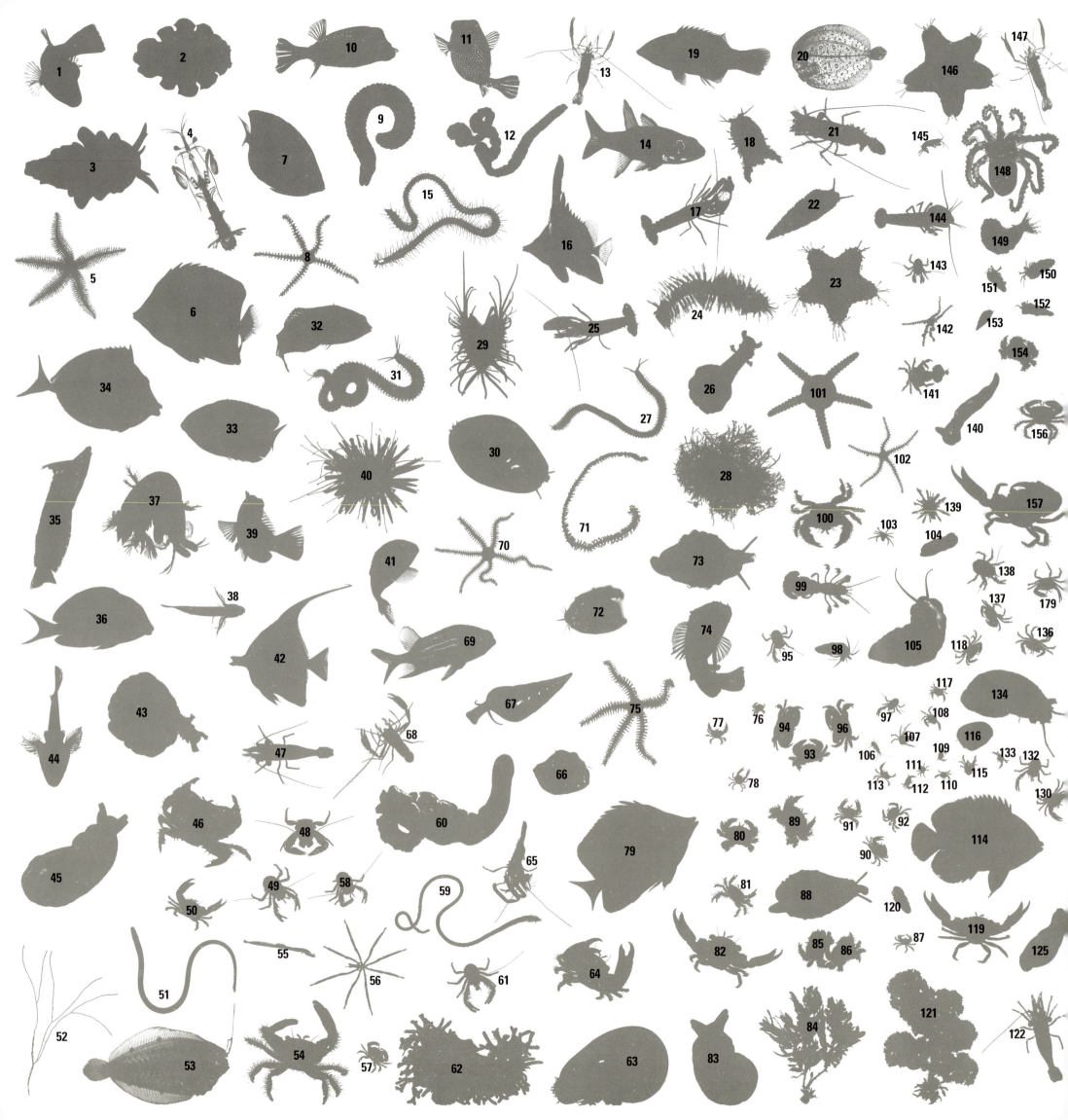

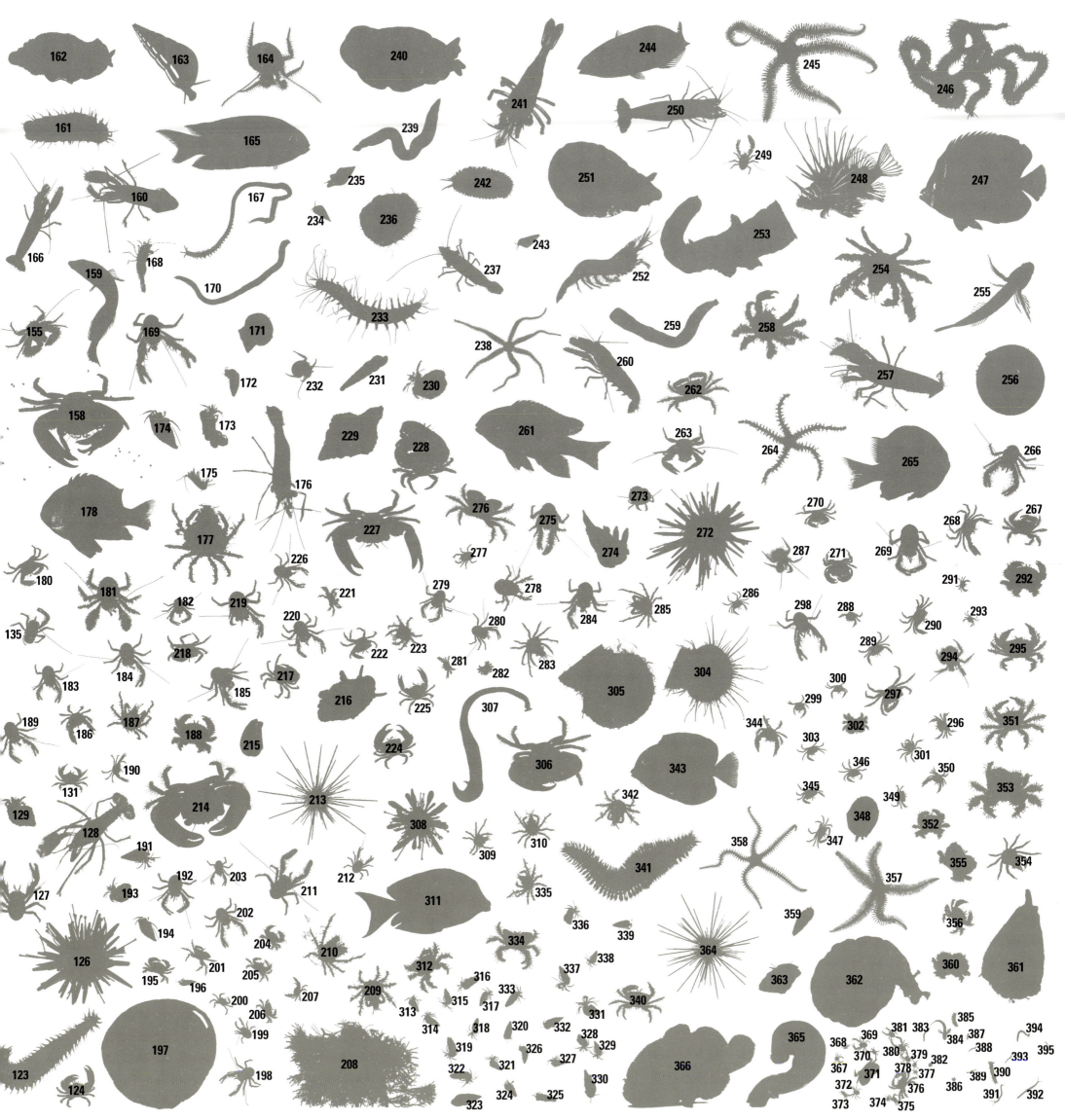

SPECIES KEY

1. Spotted toby, *Canthigaster solandri*
2. Flatworm, *Pseudoceros paralaticlavus*
3. Sacoglossan sea slug, *Cyerce nigricans*
4. Mantis shrimp, order Stomatopoda
5. Banded brittle star, *Ophiocoma pica*
6. Tahitian butterflyfish, *Chaetodon trichrous*
7. Oval butterflyfish, *Chaetodon lunulatus*
9. Ribbon worm, *Notospermus geniculatus*
10. Moorish idol, *Zanclus cornutus*
11. Spotted boxfish, *Ostracion meleagris*
12. Ribbon worm, *Baseodiscus delineatus*
13. Palaemonoid shrimp, *Palaemonella* sp.
14. Fiveline cardinalfish, *Cheilodipterus quinquelineatus*
15. Polychaete worm, class Polychaeta
16. Pennant bannerfish, *Heniochus chrysostomus*
17. Pistol shrimp, *Alpheus collumianus* complex
18. Marine isopod, *Sphaeromatidae* sp.
19. Sixline pygmy wrasse, *Pseudocheilinus hexataenia*
20. Flounder larva, order Pleuronectiformes
21. Marble shrimp, *Saron* sp.
22. Cerith snail, *Bittium glareosum*
23. Pincushion star, *Culcita novaeguineae*
24. Polychaete worm, class Polychaeta
25. Pistol shrimp, *Alpheus bucephalus*
26. Sea hare, *Dolabrifera dolabrifera*
27. Polychaete worm, class Polychaeta
28. Red algae
29. File clam, *Limaria* sp.
30. Porous cowry, *Cypraea poraria*
31. Bristle worm, family Eunicidae
32. Pearl-spotted wrasse, *Halichoeres margaritaceus*
33. Twospined angelfish, *Centropyge bispinosa*
34. Orangespine unicornfish, *Naso lituratus*
35. False cleanerfish, *Aspidontus taeniatus*
36. Brown surgeonfish, *Acanthurus nigrofuscus*
37. Mantis shrimp, family Gonodactylidae
38. Brokenbar pygmygoby, *Eviota disrupta*
39. Arceye hawkfish, *Paracirrhites arcatus*
40. Sea urchin, *Echinometra* sp.
41. Blue-green chromis, *Chromis viridis*
42. Moorish idol, *Zanclus cornutus*
43. Sea hare, *Dolabrifera dolabrifera*
44. Darkspotted scorpionfish, *Sebastapistes tinkhami*
45. Side-gilled snail, *Berthella stellata*
46. Pebble crab, family Xanthidae
47. Marble shrimp, *Saron* sp.
48. Porcelain crab, *Petrolisthes carinipes*
49. Squat lobster, *Galathea* sp.
50. Guard crab, *Trapezia serenei*

51. Black-striped snake eel, *Callechelys catostoma*
52. Green algae, *Chlorodesmis fastigiata*
53. Longlure flounder, *Asterorhombus filifer*
54. Pebble crab, *Chlorodiella* sp.
55. Pipefish larva, family Syngnathinae
56. Sea spider, class Pycnogonida
57. Pebble crab, family Xanthidae
58. Squat lobster, *Galathea* sp.
59. Polychaete worm, family Phyllodocidae
60. Flatworm, *Prosthiostomium* sp.
61. Squat lobster, *Galathea* sp.
62. Green algae, *Codium geppiorum*
63. Green bubble algae, *Ventricaria ventricosa*
64. Guard crab, *Trapezia speciosa*
65. Shrimp, *Periclimenes* sp.
66. Guam hermit crab, *Calcinus guamensis*
67. Parasitic sea snail, *Melanella* sp.
68. Shrimp, *Microprosthema* sp.
69. Crown squirrelfish, *Sargocentron diadema*
70. Brittle star, *Ophiocomella sexradia*
71. Polychaete worm, family Phyllodocidae
72. Mantis shrimp, order Stomatopoda
73. Snail, family Triviidae
74. Flame hawkfish, *Neocirrhites armatus*
75. Brittle star, *Ophiocoma erinaceus*
76. Pebble crab, family Xanthidae
77. Pebble crab, *Liocarpiloides integerrimus*
78. Coral crab, *Tetralia* sp.
79. Speckled butterflyfish, *Chaetodon citrinellus*
80. Pebble crab, *Psaumis cavipes*
81. Pebble crab, *Chlorodiella laevissima* complex
82. Guard crab, *Trapezia serenei*
83. Side-gilled snail, *Berthellina delicata*
84. Sargassum, *Sargassum mangarevense*
85. Pebble crab, *Psaumis cavipes*
86. Pebble crab, *Psaumis cavipes*
87. Pebble crab, *Chlorodiella* sp.
88. Snail, *Erato* sp.
89. Pebble crab, family Xanthidae
90. Guard crab, *Trapezia serenei*
91. Guard crab, *Trapezia serenei*
92. Pebble crab, family Xanthidae
93. Pebble crab, *Gaillardiellus superciliaris*
94. Pebble crab, *Lophozozymus dodone*
95. Squat lobster, *Galathea* sp.
96. Pebble crab, *Cyclodius ungulatus*
97. Squat lobster, *Galathea* sp.
98. Hermit crab, *Pagurixus* sp.
99. Mud shrimp, *Upogebia* sp.
100. Pebble crab, *Xanthias lamarcki*
101. Brittle star, *Ophiarthrum elegans*
102. Brittle star, class Ophiuroidea
103. Spider crab, *Menaethius* sp.
104. Marine flatworm, order Polycladida
105. Shell-less marine snail, *Titiscania limacina*
106. Amphipod, suborder Gammaridea
107. Spider crab, *Menaethius* sp.
108. Pebble crab, *Chlorodiella barbata*
109. Pebble crab, *Liocarpilodes integerrimus*
110. Pebble crab, *Liocarpilodes integerrimus*

111. Gall crab, *Hapalocarcinus* sp.
112. Pebble crab, *Liocarpilodes integerrimus*
113. Pebble crab, *Chlorodiella* sp.
114. Lemonpeel angelfish, *Centropyge flavissimus*
115. Squat lobster, *Galathea* sp.
116. Sponge, phylum Porifera
117. Pebble crab, family Xanthidae
118. Pebble crab, *Chlorodiella barbata*
119. Guard crab, *Trapezia serenei*
120. Hermit crab, *Pagurixus* sp.
121. Turbinaria, *Turbinaria ornata*
122. Marble shrimp, *Saron* sp.
123. Lined fireworm, *Pherecardia striata*
124. Guard crab, *Trapezia speciosa*
125. Bubble snail, *Atys semistriata*
126. Juvenile sea urchin, *Echinometra* sp.
127. Squat lobster, *Galathea* sp.
128. Dotted snapping shrimp, *Alpheus obesomanus* complex
129. Guam hermit crab, *Calcinus guamensis*
130. Guard crab, *Trapezia serenei*
131. Pebble crab, *Xanthias lamarcki*
132. Squat lobster, *Galathea* sp.
133. Pebble crab, *Liocarpilodes integerrimus*
134. Abalone, *Stomatella sanguinea*
135. Squat lobster, *Galathea* sp.
136. Pebble crab, *Chlorodiella barbata*
137. Pebble crab, *Chlorodiella* sp.
138. Squat lobster, *Phylladiorhynchus* sp.
139. Urchin, *Echinothrix* sp.
140. Sacoglossan sea slug, *Thuridilla multimarginata*
141. Halimeda crab, *Huenia heraldica*
142. Brittle star, class Ophiuroidea
143. Squat lobster, *Galathea pilosa*
144. Pistol shrimp, *Synalpheus* sp.
145. Amphipod, suborder Gammaridea
146. Sea star, *Meridiastra rapa*
147. Shrimp, *Palaemonella* sp.
148. Octopus larva, *Octopus* sp.
149. Sponge, family Syconidae
150. Hermit crab, family Paguridae
151. Hermit crab, *Pagurixus* sp.
152. Hermit crab, family Paguridae
153. Snail, *Bittium* sp.
154. Rubble crab, *Paractaea rufopunctata* complex
155. Porcelain crab, *Petrolisthes* sp.
156. Pebble crab, *Chlorodiella* sp.
157. Guard crab, *Trapezia bidentata*
158. Guard crab, *Trapezia serenei*
159. False cleanerfish, *Aspidontus taeniatus*
160. Pistol shrimp, *Alpheus collumianus* complex
161. Scale worm, *Polynoidea* sp.
162. Flatworm, *Thysanozoon* sp.
163. Parasitic sea snail, *Melanella* sp.
164. Hermit crab, *Trichopagurus trichophthalmus*
165. Peacock damselfish, *Pomacentrus pavo*
166. Pistol shrimp, *Alpheus lottini*
167. Polychaete worm, family Eunicidae
168. Shrimp, *Thor* sp.
169. Squat lobster, *Galathea* sp.
170. Ribbon worm, *Micrura callima*
171. Scallop, *Pascahinnites coruscans*
172. Hermit crab, family Paguridae
173. Hermit crab, *Calcinus* sp.
174. Hermit crab, *Pagurixus* sp.
175. Amphipod, suborder Gammaridea
176. Shrimp, *Periclimenes* sp.
177. Halimeda crab, *Huenia heraldica*
178. Humbug dascyllus, *Dascyllus aruanus*

179. Pebble crab, *Chlorodiella barbata*
180. Pebble crab, *Chlorodiella barbata*
181. Squat lobster, *Galathea pilosa*
182. Squat lobster, *Galathea* sp.
183. Squat lobster, *Galathea* sp.
184. Squat lobster, *Galathea* sp.
185. Squat lobster, *Galathea* sp.
186. Pebble crab, *Liocarpilodes integerrimus*
187. Spider crab, *Menaethius* sp.
188. Pebble crab, *Psaumis cavipes*
189. Squat lobster, *Galathea* sp.
190. Guard crab, *Trapezia serenei*
191. Hermit crab, *Pagurixus* sp.
192. Squat lobster, *Galathea* sp.
193. Hermit crab, *Calcinus* sp.
194. Hermit crab, *Pagurixus* sp.
195. Pebble crab, *Xanthias lamarcki*
196. Hermit crab, *Pagurixus* sp.
197. Pistol shrimp larvae, *Alpheus collumianus* complex
198. Squat lobster, *Galathea* sp.
199. Squat lobster, family Galatheaidae
200. Pebble crab, *Chlorodiella* sp.
201. Pebble crab, *Chlorodiella* sp.
202. Squat lobster, *Galathea* sp.
203. Squat lobster, *Galathea* sp.
204. Pebble crab, *Liocarpiloides integerrimus*
205. Pebble crab, *Chlorodiella* sp.
206. Pebble crab, *Chlorodiella* sp.
207. Pebble crab, *Liocarpiloides integerrimus*
208. Red algae
209. Spider crab, *Menaethius* sp.
210. Crab, superfamily Majoidea
211. Squat lobster, *Galathea* sp.
212. Squat lobster, *Galathea* sp.
213. Long-spined sea urchin, *Diadema savignyi*
214. Guard crab, *Trapezia serenei*
215. Margin shell, family Marginellidae
216. Cowry, family Cypraeidae
217. Guard crab, *Trapezia bidentata*
218. Pebble crab, *Chlorodiella barbata*
219. Squat lobster, *Galathea* sp.
220. Squat lobster, *Galathea* sp.
221. Pom pom crab, *Lybia* sp.
222. Pebble crab, *Chlorodiella barbata*
223. Spider crab, *Majoidea* sp.
224. Guard crab, *Trapezia speciosa*
225. Guard crab, *Trapezia serenei*
226. Squat lobster, *Galathea* sp.
227. Rusty guard crab, *Trapezia bidentata*
228. Guard crab, *Trapezia speciosa*
229. Fine-net peristernia, *Peristernia nassatula*
230. Hermit crab, *Calcinus* sp.
231. Snail, class Gastropoda
232. Hermit crab, *Trichopagurus trichophthalmus*
233. Polychaete worm, class Polychaeta
234. Snail, family Eulimidae
235. Snail, family Costellariidae
236. Hermit crab, *Calcinus nitidus*
237. Marble shrimp, *Saron* sp.
238. Savigny's spiny brittle star, *Ophiactis savignyi*
239. Ribbon worm, *Reptantia* sp.
240. Side-gilled snail, *Berthellina delicata*
241. Shrimp, *Harpiliopsis* sp.
242. Scale worm, family Polynoidae
243. Snail, family Eulimidae
244. Red-shouldered wrasse, *Stethojulis bandanensis*
245. Brittle star, *Ophiocoma schoenleinii*
246. Polychaete worm, class Polychaeta

247. Reticulated butterflyfish, *Chaetodon reticulatus*
248. Clearfin lionfish, *Pterois radiata*
249. Squat lobster, family Galathaeidae
250. Euryone shrimp, *Parabetaeus euryone*
251. Nudibranch, *Peltodoris rubra*
252. Shrimp, *Periclimenes* sp.
253. Worm-shelled snail, *Dendropoma maxima*
254. Halimeda crab, *Huenia heraldica*
255. Brokenbar pygmygoby, *Eviota disrupta*
256. Bubble algae, *Ventricaria ventricosa*
257. Pistol shrimp, *Alpheus diadema*
258. Spider crab, *Perinia tumida*
259. Proboscis from ribbon worm, *Reptantia* sp.
260. Shrimp, *Alpheus lottini*
261. Surge demoiselle, *Chrysiptera leucopoma*
262. Pebble crab, *Chlorodiella* sp.
263. Porcelain crab, *Petrolisthes carinipes*
264. Brittle star, *Ophiarthrum elegans*
265. Yellowtail dascyllus, *Dascyllus flavicaudus*
266. Squat lobster, *Galathea* sp.
267. Pebble crab, *Xanthias lamarcki*
268. Pebble crab, *Chlorodiella barbata*
269. Squat lobster, *Galathea* sp.
270. Pebble crab, *Chlorodiella barbata*
271. Pebble crab, family Xanthidae
272. Sea urchin, *Echinometra* sp.
273. Hermit crab, *Pagurixus ruber*
274. Nudibranch, *Roboastra gracilis*
275. Squat lobster, *Galathea* sp.
276. Squat lobster, *Galathea* sp.
277. Squat lobster, *Phylladiorhynchus* sp.
278. Squat lobster, *Phylladiorhynchus* sp.
279. Squat lobster, *Galathea* sp.
280. Squat lobster, *Galathea* sp.
281. Pebble crab, *Liocarpiloides integerrimus*
282. Pebble crab, *Psaumis cavipes*
283. One-horned spider crab, *Menaethius monoceros*
284. Squat lobster, *Galathea* sp.
285. Spider crab, *Menaethius* sp.
286. Pebble crab, *Chlorodiella* sp.
287. Hermit crab, *Trichopagurus trichophthalmus*
288. Pebble crab, family Xanthidae
289. Pebble crab, *Chlorodiella barbata*
290. Pebble crab, *Chlorodiella barbata*
291. Pebble crab, *Liocarpilodes integerrimus*
292. Pebble crab, *Psaumis cavipes*
293. Pebble crab, *Chlorodiella* sp.
294. Hermit crab, *Trichopagurus trichophthalmus*
295. Pebble crab, *Xanthias lamarcki*
296. Pebble crab, family Xanthidae
297. Pebble crab, *Chlorodiella barbata*
298. Squat lobster, *Galathea* sp.
299. Pebble crab, *Liocarpilodes integerrimus*
300. Pebble crab, *Chlorodiella* sp.
301. Gall crab, *Hapalocarcinus* sp.
302. Pebble crab, *Psaumis cavipes*
303. Pebble crab, *Chlorodiella* sp.
304. Scallop, *Pascahinnites coruscans*
305. Scallop, *Pascahinnites coruscans*
306. Rusty guard crab, *Trapezia bidentata*
307. Peanut worm, *Phascolosoma* sp.
308. Juvenile sea urchin, *Echinothrix* sp.
309. Spider crab, *Menaethius* sp.
310. Spider crab, *Menaethius* sp.

311. Twospot bristletooth, *Ctenochaetus binotatus*
312. Pebble crab, *Cyclodius ungulatus*
313. Hermit crab, *Pagurixus* sp.
314. Hermit crab, *Pagurixus* sp.
315. Hermit crab, *Pagurixus* sp.
316. Hermit crab, family Paguridae
317. Hermit crab, *Pagurixus* sp.
318. Hermit crab, *Pagurixus* sp.
319. Hermit crab, *Pagurixus* sp.
320. Hermit crab, *Pagurixus* sp.
321. Hermit crab, *Pagurixus* sp.
322. Hermit crab, *Pagurixus* sp.
323. Snail, *Bittium* sp.
324. Hermit crab, *Pagurixus* sp.
325. Hermit crab, family Paguridae
326. Snail, family Rissoidae
327. Hermit crab, *Pagurixus* sp.
328. Hermit crab, *Pagurixus* sp.
329. Hermit crab, *Pagurixus* sp.
330. Snail, *Bittium* sp.
331. Hermit crab, *Pagurixus* sp.
332. Hermit crab, *Pagurixus* sp.
333. Hermit crab, *Pagurixus* sp.
334. Pebble crab, *Chlorodiella* sp.
335. Spider crab, *Menaethius* sp.
336. Hermit crab, *Pagurixus* sp.
337. Hermit crab, *Pagurixus* sp.
338. Hermit crab, *Pagurixus* sp.
339. Hermit crab, *Pagurixus* sp.
341. Orange fireworm, *Eurythoe complanata*
342. Spider crab, *Menaethius* sp.
343. Twospot bristletooth, *Ctenochaetus binotatus*
344. Pebble crab, *Liocarpilodes integerrimus*
345. Pebble crab, *Chlorodiella barbata*
346. Pebble crab, *Chlorodiella* sp.
347. Pebble crab, *Chlorodiella barbata*
348. Clam, family Tellinidae
349. Pebble crab, family Xanthidae
350. Pebble crab, *Liocarpilodes integerrimus*
351. Pebble crab, *Cyclodius ungulatus*
352. Pebble crab, *Psaumis cavipes*
353. Areolated xanthid crab, *Pilodius areolatus*
354. Spider crab, *Menaethius* sp.
355. Pebble crab, *Psaumis cavipes*
356. Pebble crab, family Xanthidae
357. Banded brittle star, *Ophiocoma pica*
358. Brittle star, *Ophiocoma* sp.
359. Snail, *Bittium* sp.
360. Pebble crab, *Psaumis cavipes*
361. Cone snail, *Conus sponsalis*
362. Sea hare, *Dolabrifera dolabrifera*
363. Hermit crab, *Calcinus morgani*
364. Black long-spined urchin, *Diadema savignyi*
365. Headshield slug, order Cephalaspidea
366. Coral croucher, *Caracanthus maculatus*

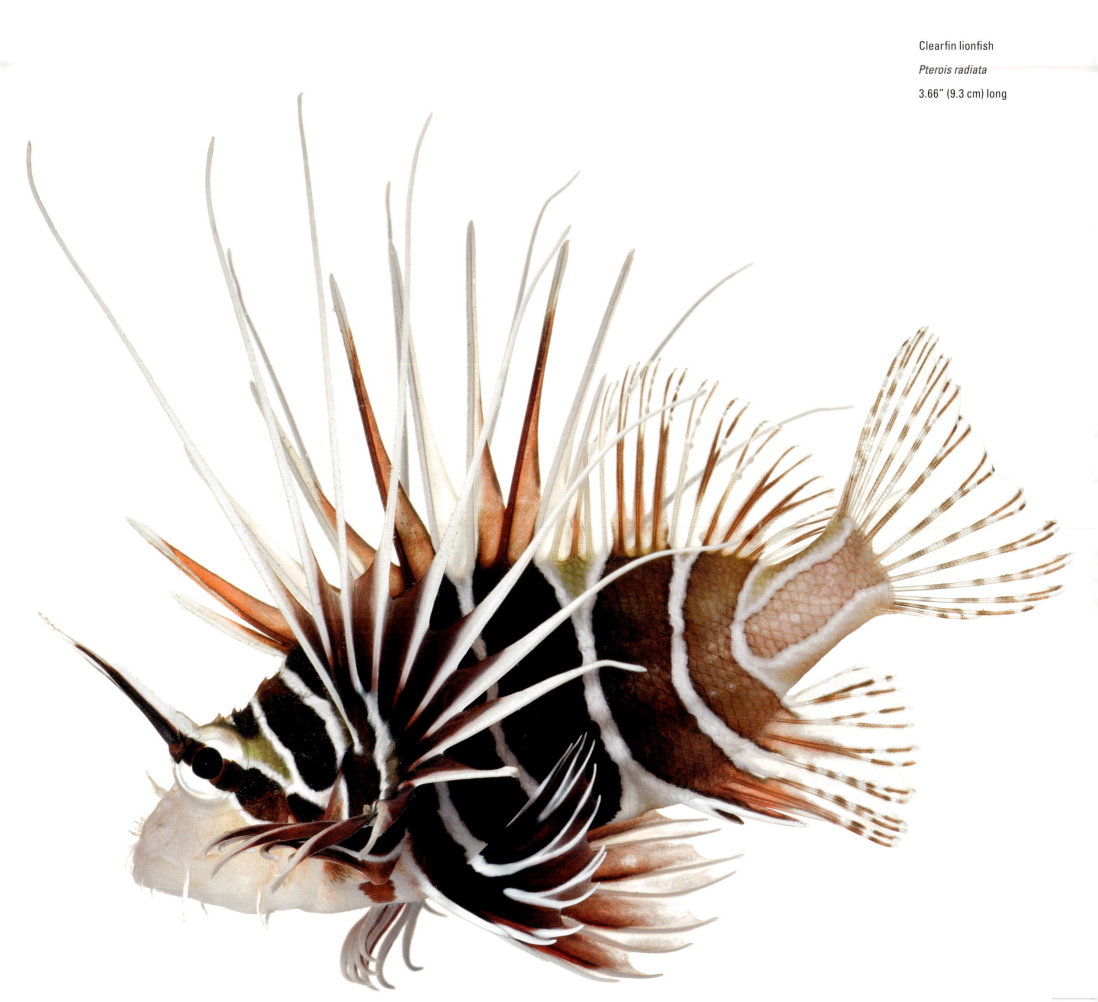

Glossy buckthorn

Rhamnus frangula

2.36" (6 cm) long

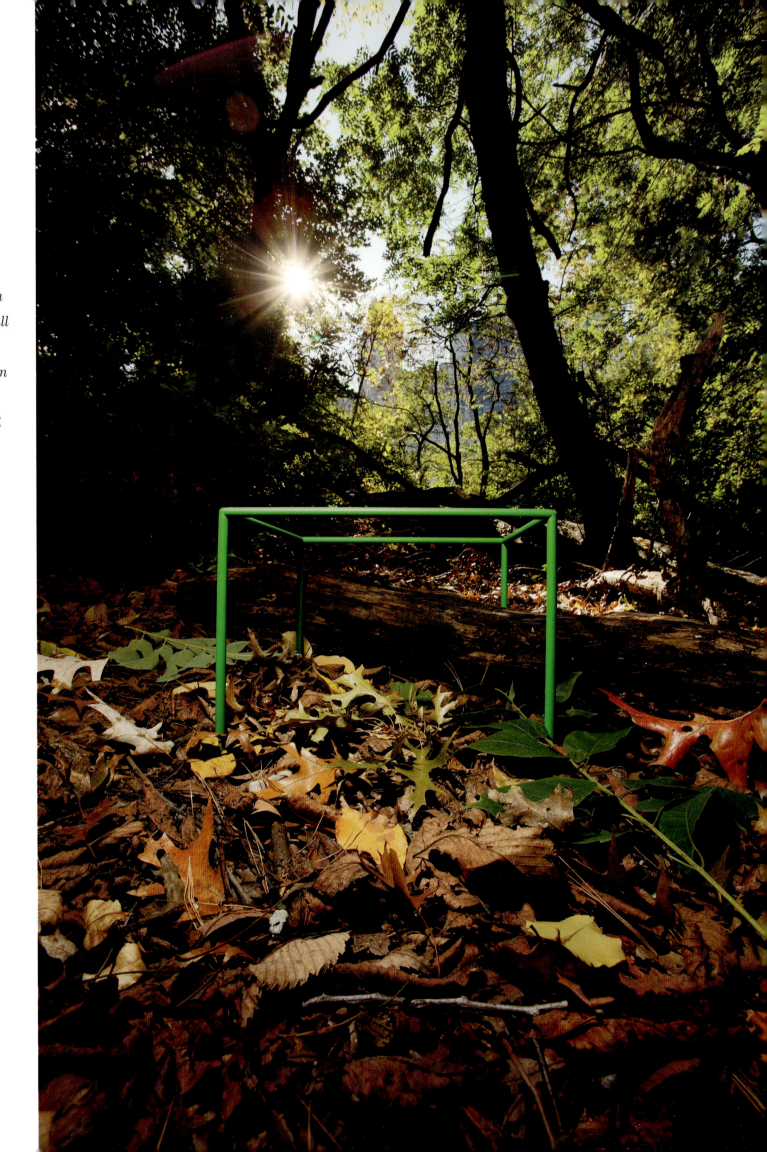

David Liittschwager straddled his green cubic-foot frame over a decaying deadfall log in the Hallett Nature Sanctuary, a three-acre fenced-off area at the southern edge of New York's Central Park.
The cube housed millipedes (some coiled so tightly in defensive postures that they're impossible to pick up), beetles, seeds, spiders, weevils, midges, leaves, and springtails (insects .04 to 0.2 inch long that catapult themselves over enormous distances). Season and time of day determined what Liittschwager found. It's "a week's worth of what's there," he says. Because his team worked at the end of a dry October, they found no earthworms. Absences told a story, too. When one day they found their cube askew, they knew only a raccoon was large enough to do that, and at night they found virtually no flying insects because the city lights that attract them also kill them.

HALLETT NATURE SANCTUARY, CENTRAL PARK, NEW YORK CITY

CARY GRANT doesn't see it, but we do. It's visible in the rear window of the cab he's taking—as Roger Thornhill in *North by Northwest*—to a midday martini in the Oak Room of the Plaza, unaware that he'll soon be on the run from nasties who mistake him for a secret agent, then be running in a cornfield from an evil crop-duster and, via Eva Marie Saint, scrambling around presidential nostrils on Mount Rushmore. He ends up closer to "nature" than he would ever choose to be, though he has already been close, at least to one of nature's iterations, because just north of the Oak Room lie the Pond, the Lake, the Great Lawn, the Ramble, and all the other cultivated interventions of Central Park, where city folk hit fungoes across a greensward, paddle around a lake, bike under pruned trees, or sit on a bench to eat hot dogs and potato chips then walk off lunch along smartly plotted routes free of cars and buses.

I think it's instinctive when we construct cities to also craft an escape from city-ness. A city colonizes— it *settles down*—what is first of all some sort of country wildness. Urban willfulness metabolizes amorphous country into structures and patterned thoroughfares. It doesn't so much tame the natural order as it ingests and converts it into a system of cultural products. Then, as a city rises, it feels the lack of open spaces it has filled, so it invents fresh green spaces as models or exemplars of "country." A green space like Central Park generates its own relationship with the urban ambiance surrounding it. The trees scrub the atmosphere; the waters offer a consoling calm and clarity we don't get from looking at the Hudson or the sluggish East River; the landscaping gives the intellectual satisfaction and reassurance that in *this* nature we're free from having to think about change and organic corruption. The Park is an imaging of something unruly laid to rest, so that humans can rest.

But where there is now cultivated open space, there once was human culture. In the early 19th century, roosters were scratching dirt patches in the northern reaches of where the Park would be. The stretch of land between Fifth and Eighth Avenues and 59th and 106th Streets wasn't of much use for private development because it was mostly an irregular terrain of swamps and bluffs broken up by rocky outcrops. Creating the park meant tearing down hundreds of shanties occupied by roughly 1,600 of the city's poor, including Irish pig farmers, German gardeners, and the residents of Seneca Village, one of the city's most stable African-American settlements.

Roger Thornhill certainly wasn't thinking about Central Park while drinking with his pals, and he didn't know that out his cab's rear window (where we moviegoers *can* see it) lay a swatch of marginal wilderness most New Yorkers don't know exists, a four-acre breakdown zone where the natural order—mostly untended and untrod—is allowed to have its way. That zone, the Hallett Nature Sanctuary, was closed off to visitors in 1934 to protect it as a stopover for the many bird species that migrate along the Atlantic flyway. The green, growing, decomposing world was allowed to do what it does without human interventions. More or less. The wild is subject to invasive species. Ailanthus and wisteria have had to be eliminated or thinned, even while native plants are still being introduced. And in 2002 a couple of maple trees infested by the Asian longhorned beetle had to be cut down and removed, so the experiment in letting nature really take its course ended.

The Hallett is a space where city and country crunch each other. It greets, across 59th Street, the Plaza, the Pierre, and the Sherry-Netherland hotels, the Apple Store, FAO Schwarz, and the zippity mania of pedestrians, businesses, and Fifth Avenue's show-window dioramas of humanity's self-satisfied and self-satisfying luxuries—everything that makes that chunk of New York an icon of a perfected civilization, or at least a civilization in process of perfecting an imagination of itself. At first the Hallett looks like a pocket of disorder, but it's only an apparent (and stewarded) disorder, for it teems with

the orders of freshness and decay. A few years ago the photographer David Liittschwager created a compact archive of those orders. He straddled a frame measuring one cubic foot over a log and photographed whatever abided or passed through the cube. Season and time of day determined what he found. Because he photographed at the very dry end of October, there were no earthworms. The singularity of the creatures and their stark individuation in Liittschwager's images remind us that species are in a sense countable but not comprehensible—there's no way to get it all in at the same time. Coded into each species is a biblical "multitude," which itself is only one of many other multitudes. One wonders how much time it would take to create an album of every species in a cubic foot in all seasons and ambient conditions. We can maybe, at best, glimpse a moment in time that in its amplifications is visionary in reach and numbers. The density of any sliver of biodiversity, even if it's unglamorous leaf litter in a deciduous forest in the middle of a city, virtually exhausts the imagination.

I'm a card-carrying city boy raised in Philadelphia, where in summer we lived on the streets. During the dog days, if you were obtuse enough to step barefoot on the toasted asphalt you deserved what your stupidity invited, and you certainly didn't think about what the asphalt covered over (or killed). Now, when I'm on New York's streets in soggy August, if I think about what's underfoot my images go down a sidewalk grate or staircase to a platform and tunnels, and the tunnels under tunnels, and abandoned spaces in those hundreds of miles of track, fiber-optic cables, and sewer pipes, along with the rats, beetles, roaches, occasional reptiles, and the other subterranean creatures sustained down there. If I'm in the park, underfoot is grass, and that's as far as I go. But, guided by Liittschwager's images, if I look down in the Hallett, as I did one August day, I can think my way through the layers of leaves, branches, soil, and the lowdown busyness of creatures we pay no mind, all of them diversely articulated marvels of natural selection: millipedes (some coiled so tightly in defensive postures that they're impossible to pick up), beetles, spiders, weevils, midges, and springtails (insects .04 to 0.2

inch long that catapult themselves over enormous distances), leopard slugs, ash and oak and maple leaves, seeds, iridescent wasp and fly wings, and glow worms. It's a diversity and comprehensiveness of forms that the poet Gerard Manley Hopkins celebrates in his devotional poem, "Pied Beauty":

> *All things counter, original, spare, strange;*
> *Whatever is fickle, freckled (who knows how?)*
> *With swift, slow; sweet, sour; adazzle, dim.*

Then again, some wonders aren't always wonders. When I visited the Hallett, the resident biologist took me to the source of the glistening, splintery waterfall that feeds the Pond. You take beauty where you can get it—the source, atop the Promontory, is a garden hose. And the truly wild sometimes comes to visit the stewarded wild. In 2006 park personnel noticed that a lot of feral cats and ducks were disappearing, thanks to a coyote that jumped the Hallett's fence, used the space as his own personal sanctuary, and, once found out, was immediately dubbed Hal. A few years later, in February, another coyote was video-recorded walking on the frozen Pond. The wild lives in the imagination, too. While I was waiting for someone to unlock the gate and show me in, a few schoolboys stopped and wanted to know what was behind the fence. "A nature sanctuary," I said. "They just let things grow wild." So one of them asked: "There *wolves* in there?"

—*W. S. Di Piero*

Raccoon

Procyon lotor

13.78" (35 cm)
height at shoulders

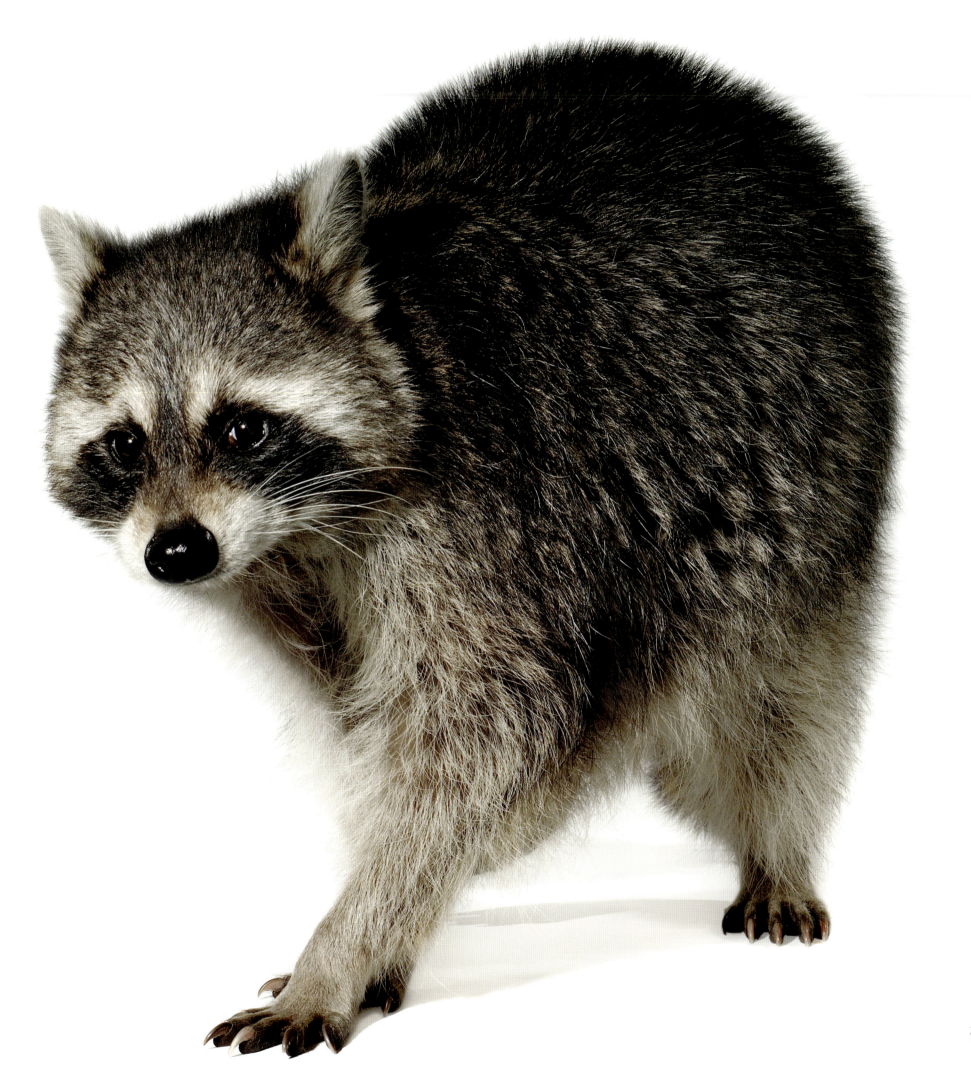

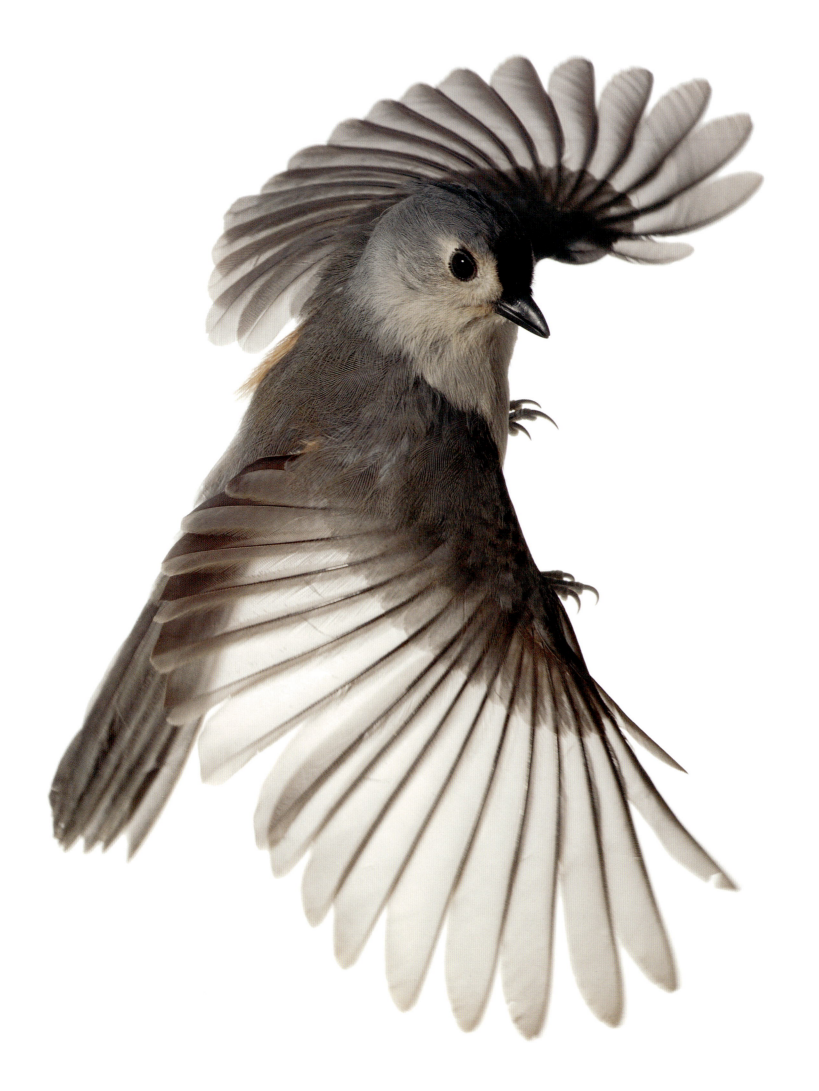

Tufted titmouse

Baeolophus bicolor

9.06" (23 cm)
across wing span

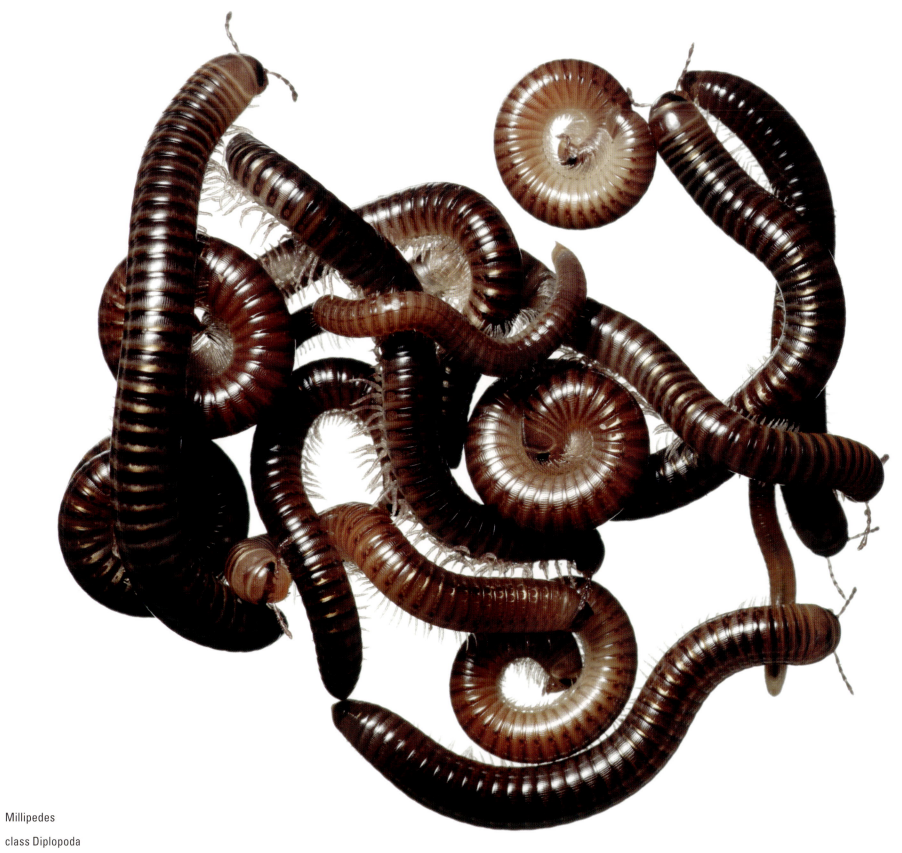

Millipedes

class Diplopoda

0.91" (2.3 cm) long—
longest specimen

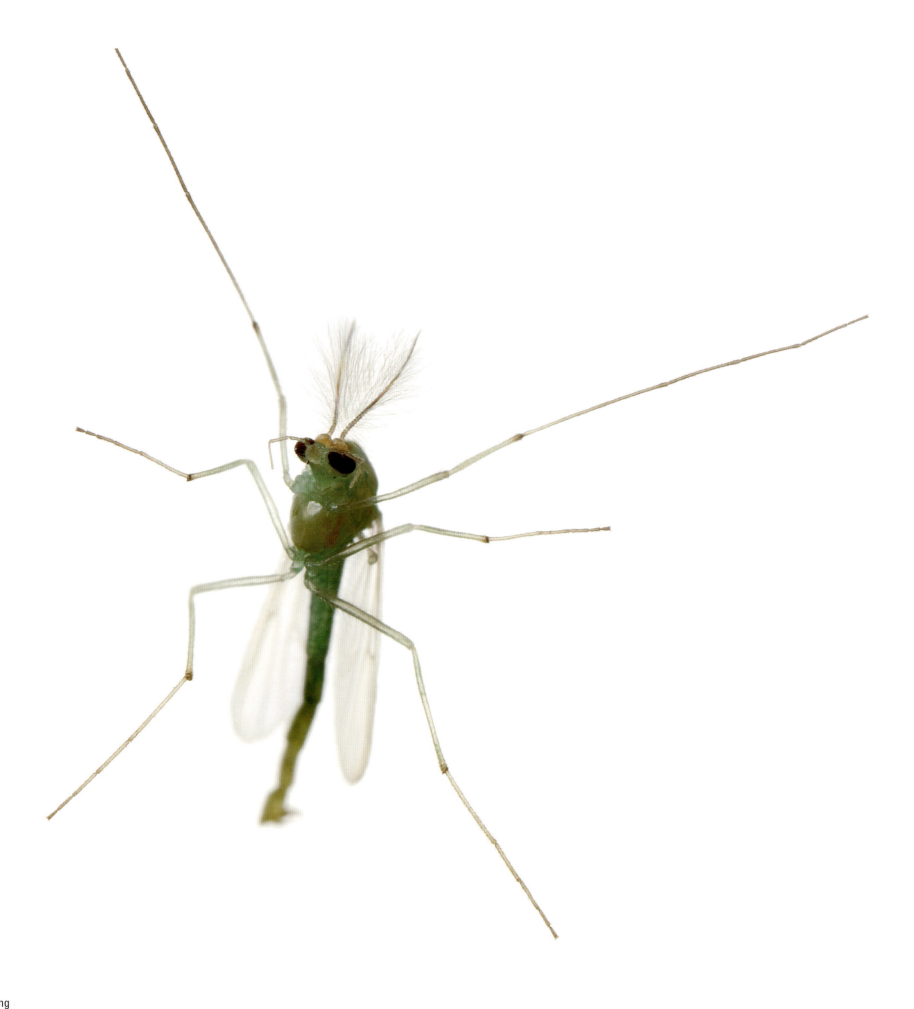

Midge

Smittia sp.

0.16" (0.4 cm) long

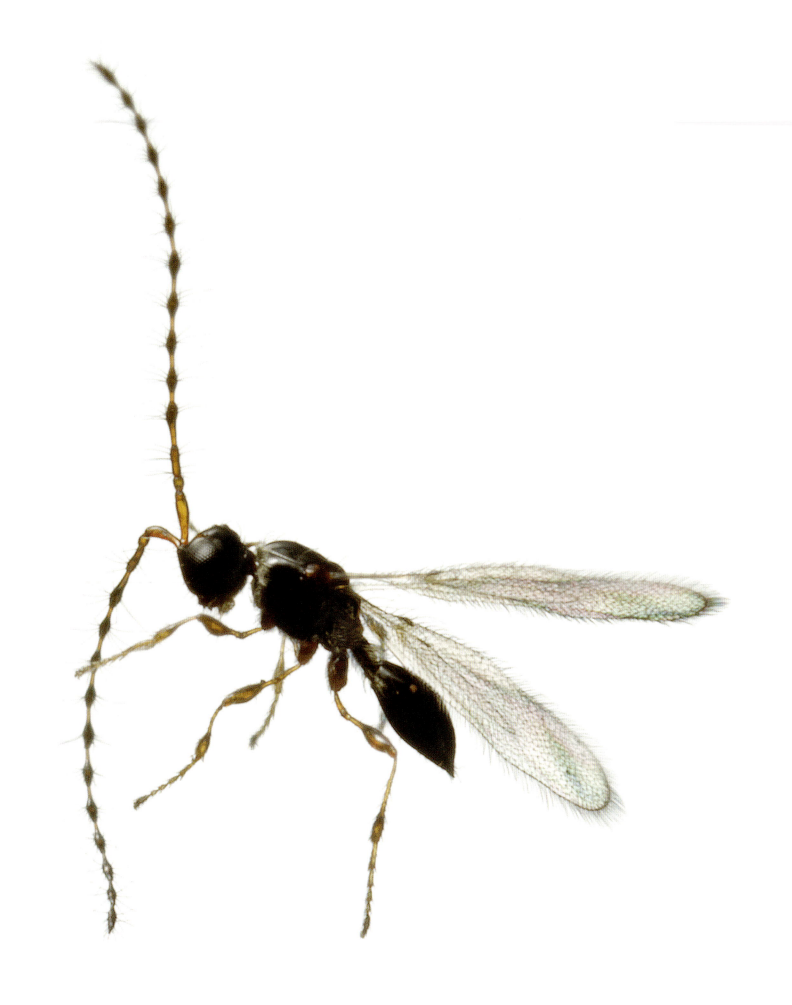

Chalcidoid wasp

superfamily Chalcicoidea

0.06″ (0.15 cm)
body length

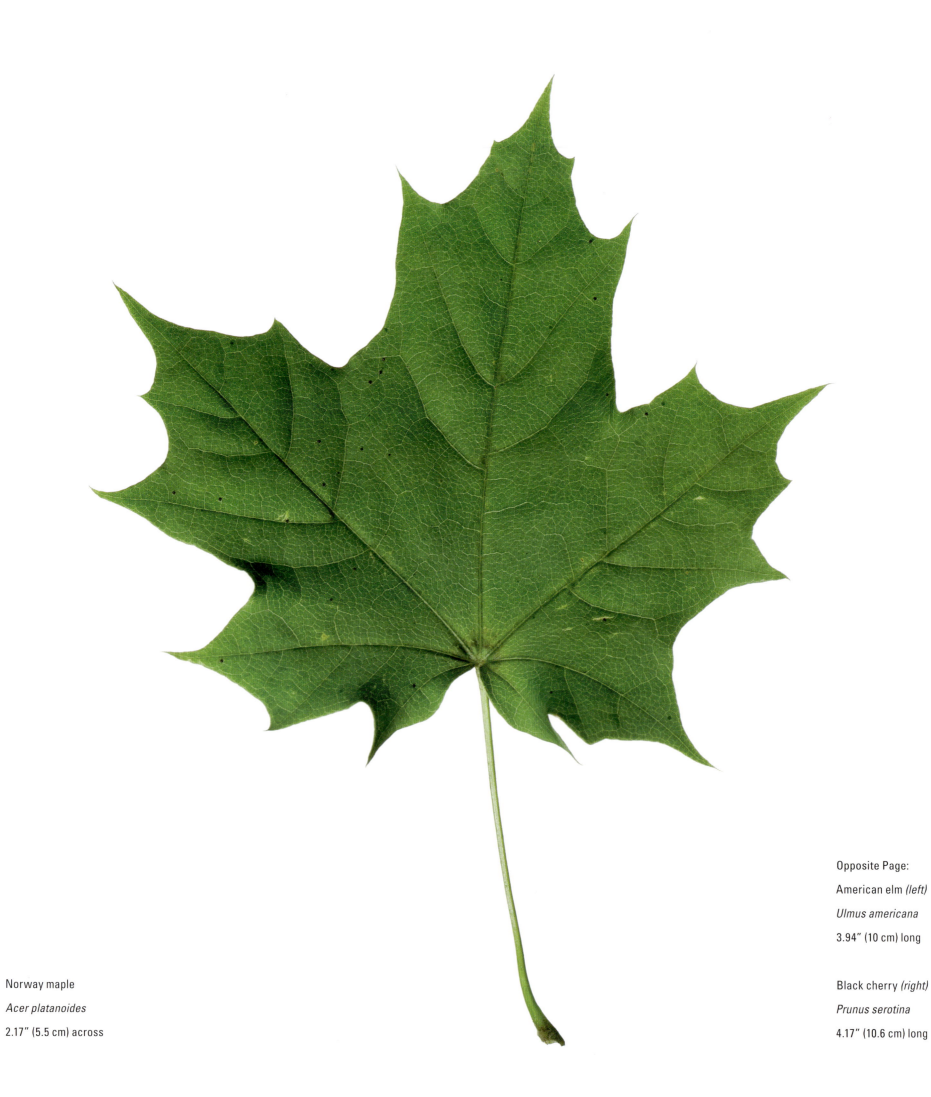

Norway maple
Acer platanoides
2.17" (5.5 cm) across

Opposite Page:
American elm *(left)*
Ulmus americana
3.94" (10 cm) long

Black cherry *(right)*
Prunus serotina
4.17" (10.6 cm) long

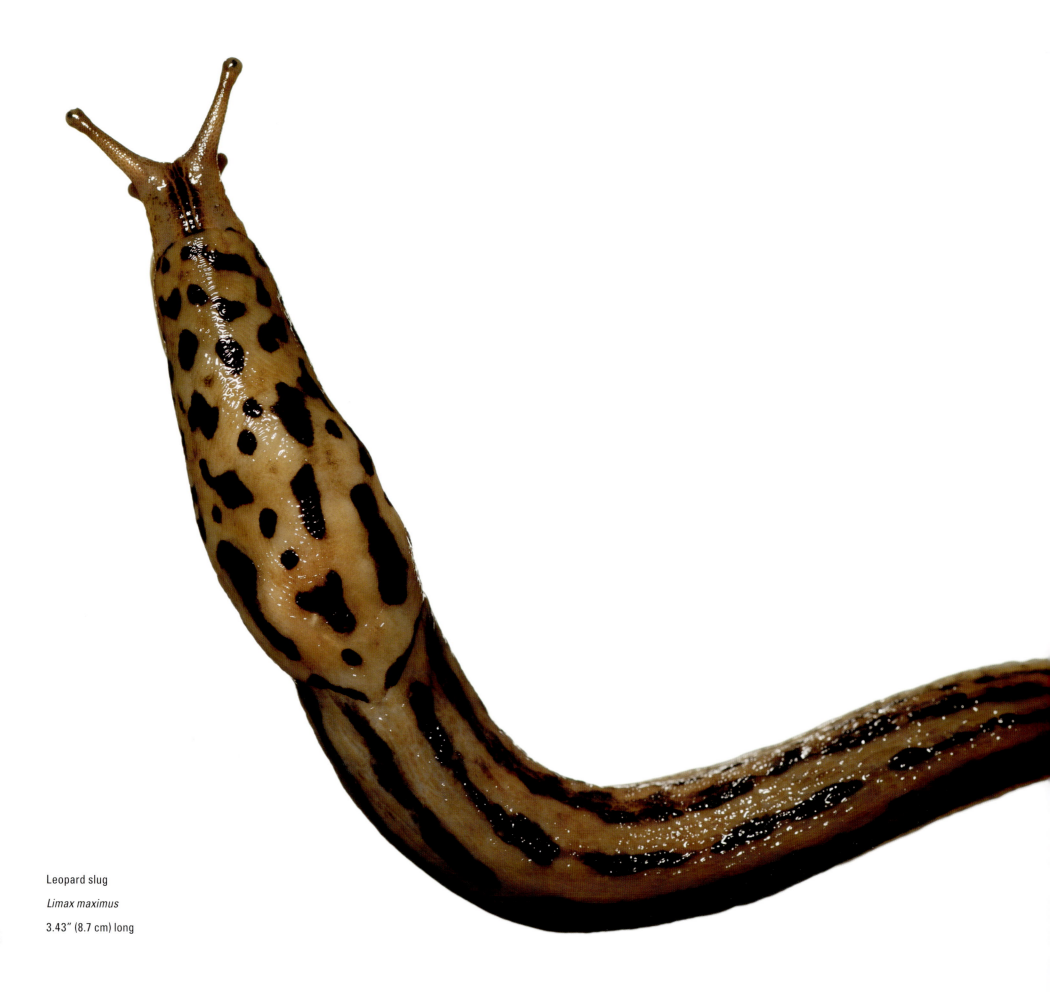

Leopard slug

Limax maximus

3.43" (8.7 cm) long

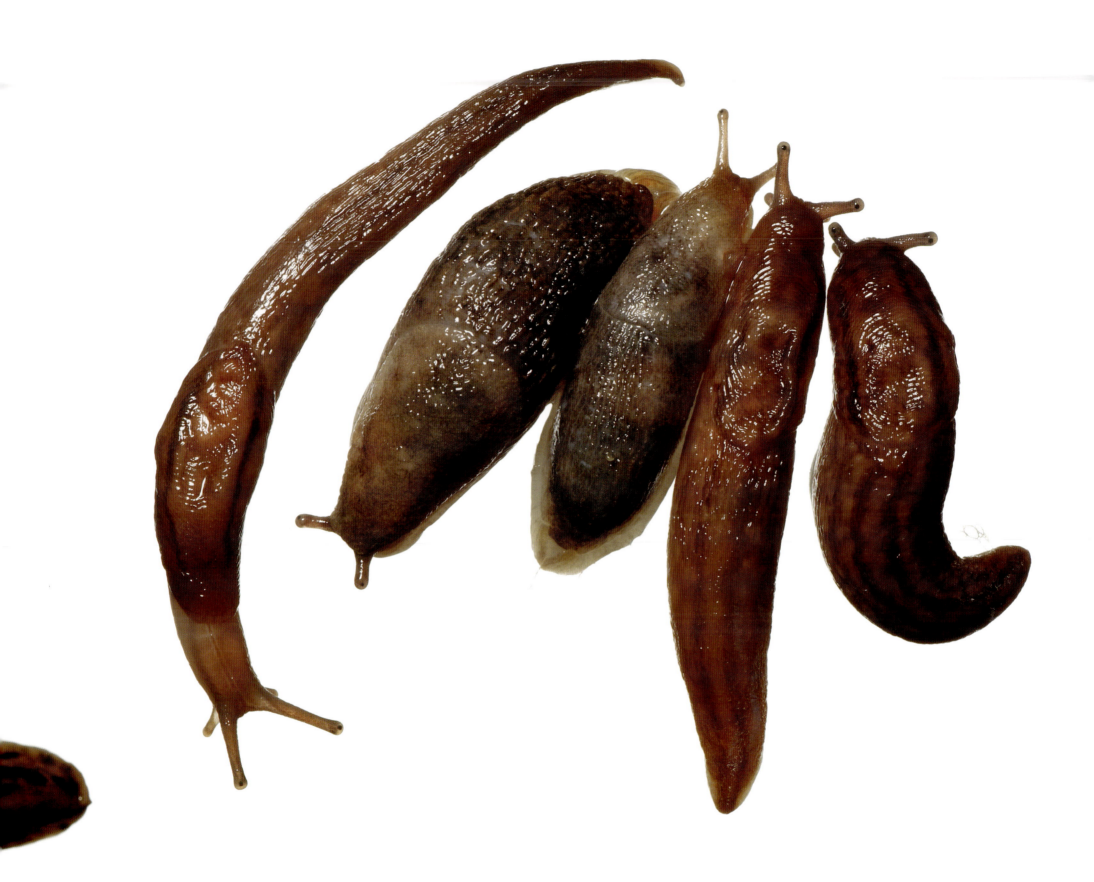

Various slugs

class Gastropoda

2.01″ (5.1 cm) long—
longest specimen

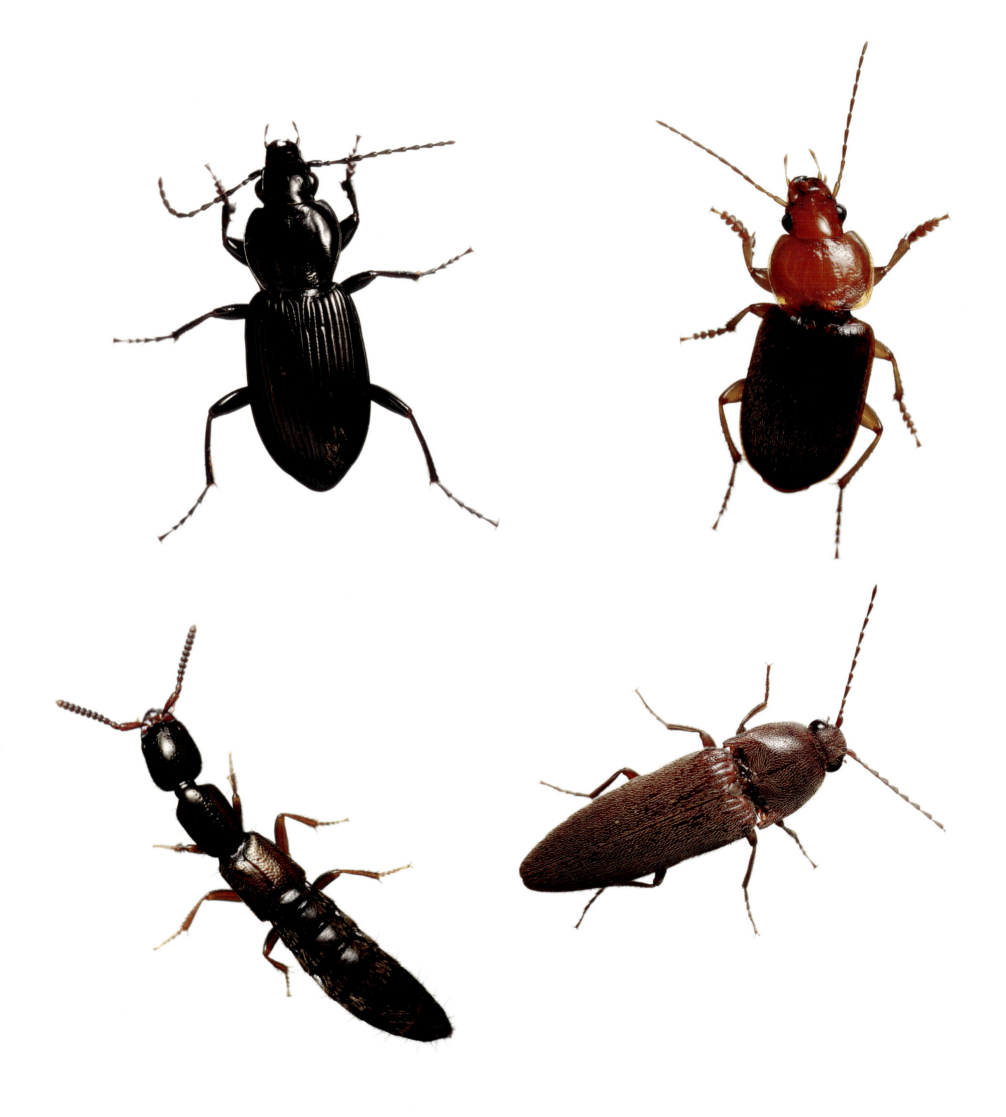

Eastern subterranean termite
Reticulitermes flavipes
0.2" (0.5 cm) long each

Woodland ground beetle *(top left)*
Pterostichus sp.
0.43" (1.1 cm) long

Ground beetle *(top right)*
Amphasia interstitialis
0.39" (1 cm) long

Rove beetle *(bottom left)*
Xantholinus linearis
0.2" (0.5 cm) long

Click beetle *(bottom right)*
Melanotus sp.
0.47" (1.2 cm) long

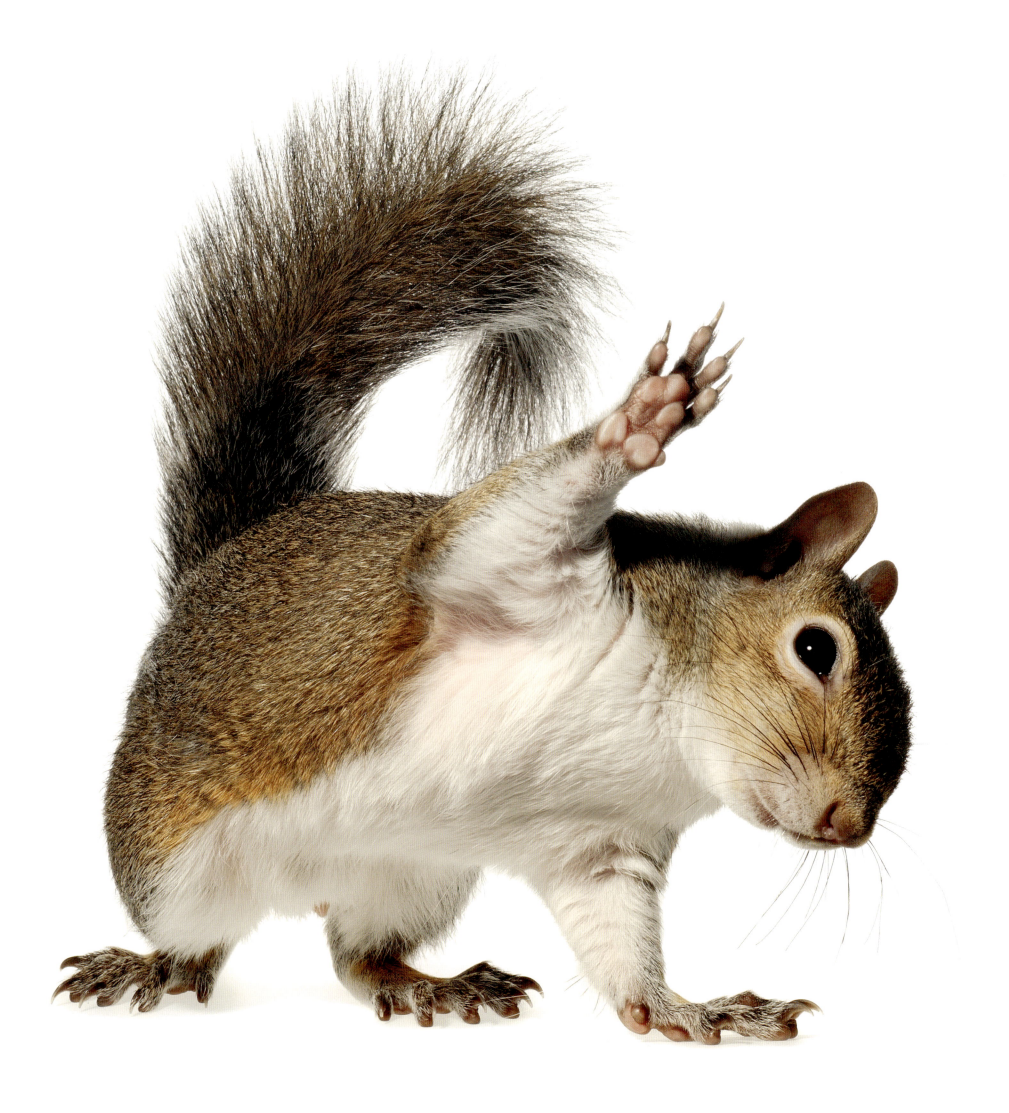

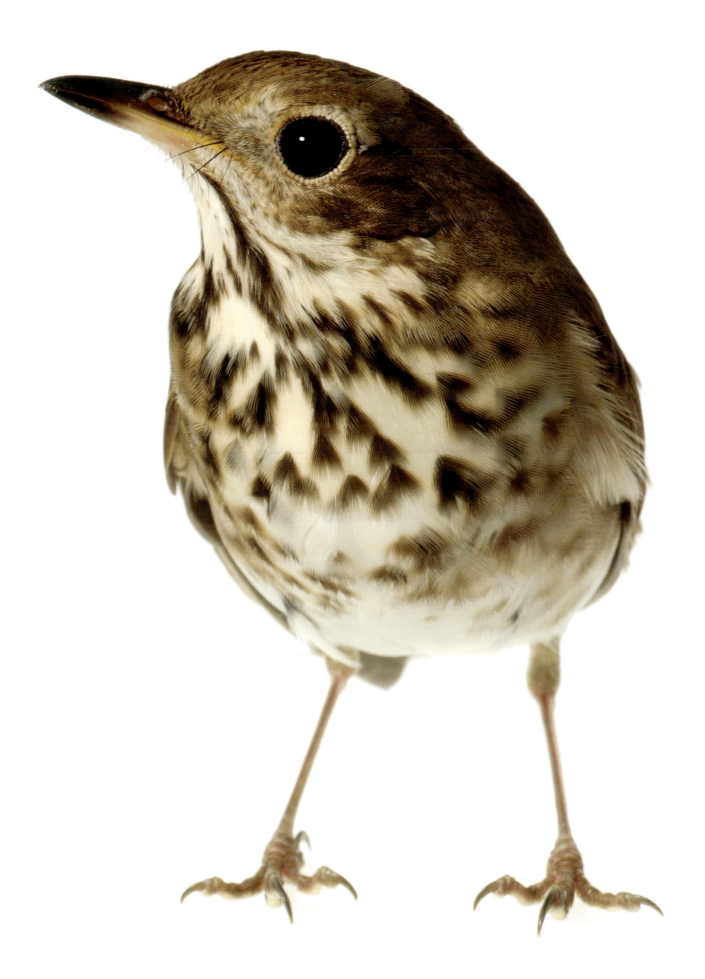

Eastern gray squirrel *(left)*

Sciurus carolinensis

7.09" (18 cm) body length

Hermit thrush

Catharus guttatus

6.3" (16 cm) long

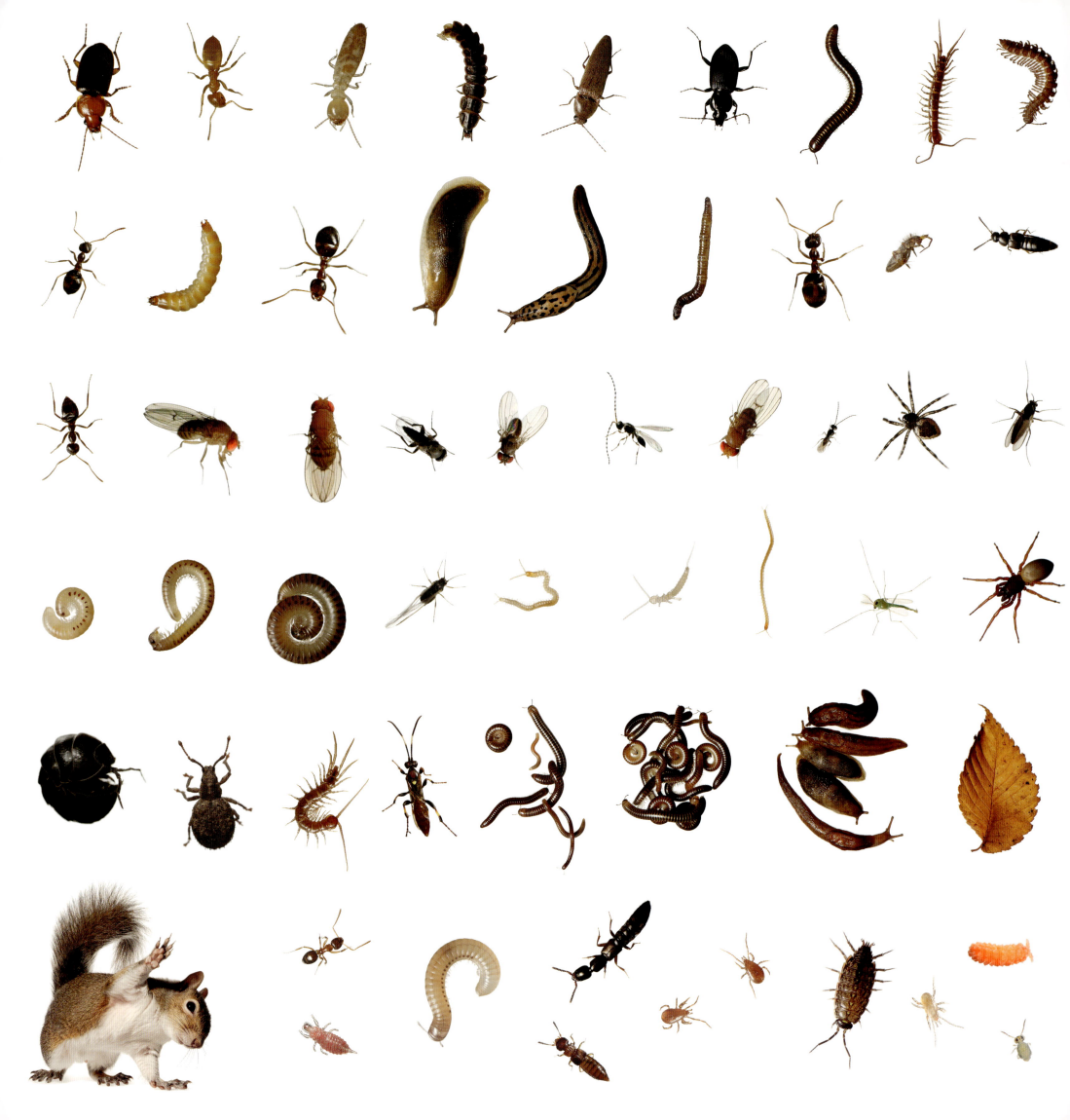

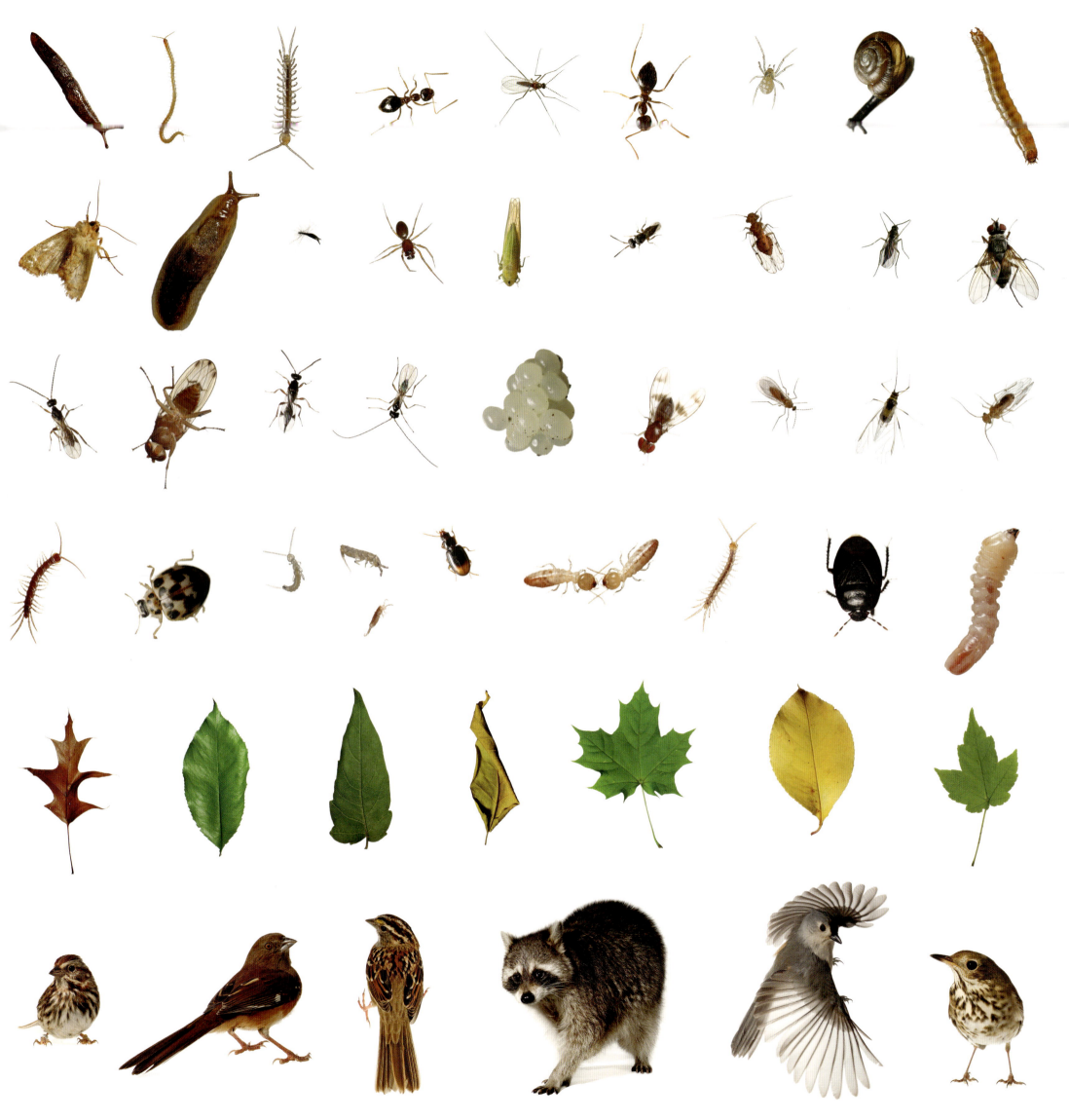

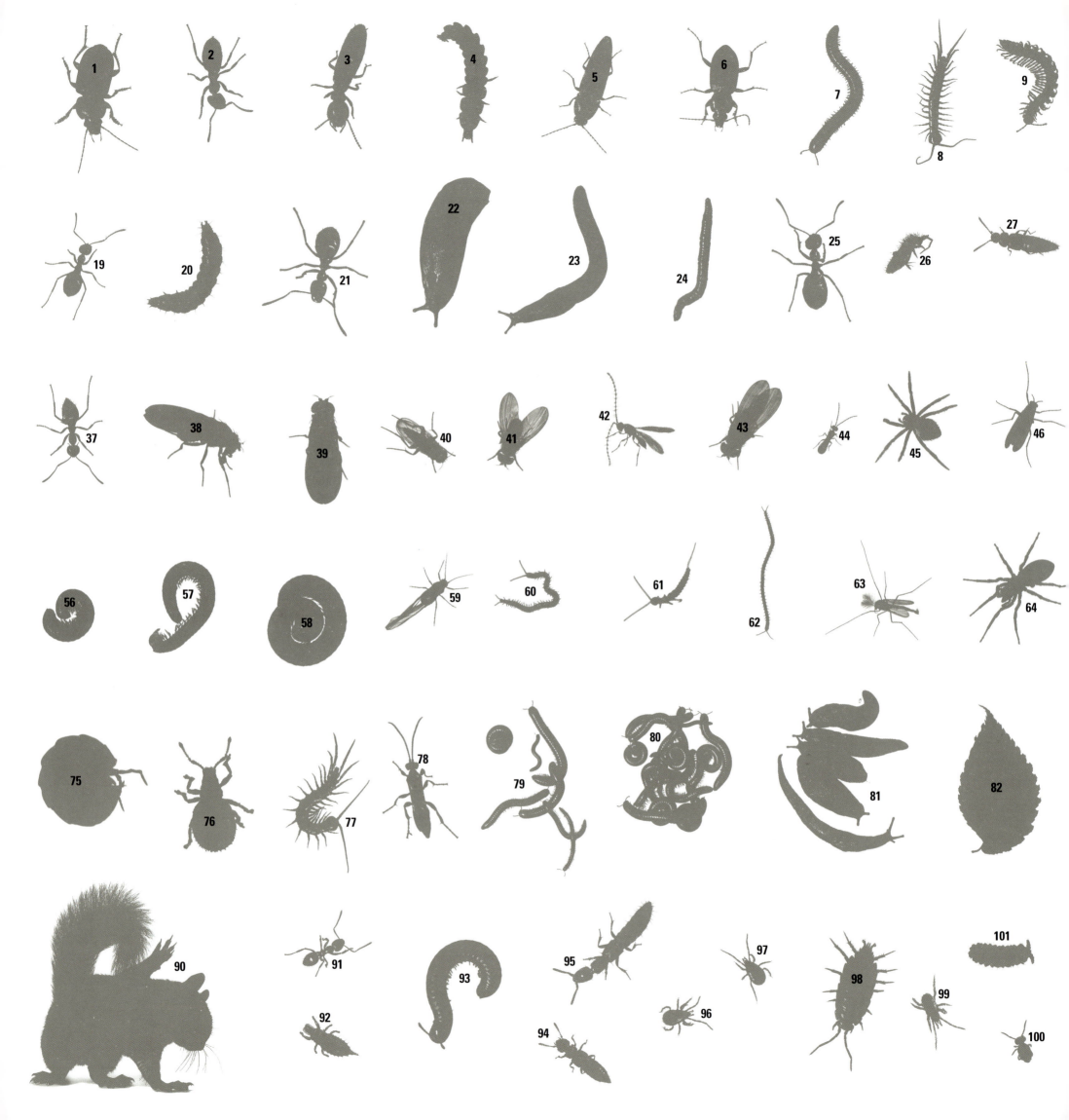

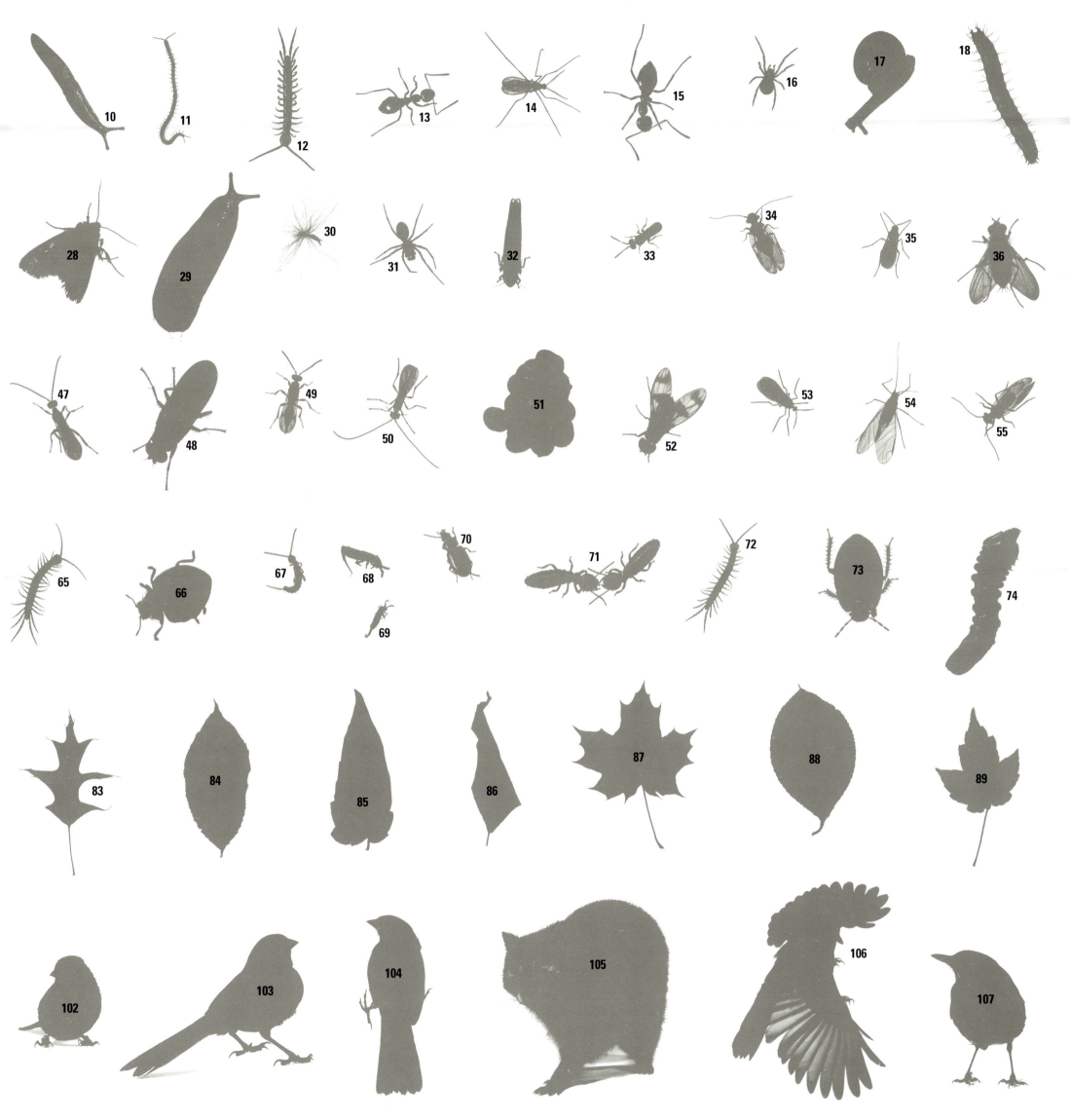

SPECIES KEY

1. Ground beetle, *Amphasia interstitialis*
2. False honey ant, *Prenolepis imparis*
3. Eastern subterranean termite, *Reticulitermes flavipes*
4. Glow worm beetle
5. Click beetle, *Melanotus* sp.
6. Woodland ground beetle, *Pterostichus* sp.
7. Millipede
8. Stone centipede, *Lithobius* sp.
9. Flat-backed millipede
10. Slug, *Deroceras* sp.
11. Soil centipede
12. Stone centipede, *Lithobius* sp.
13. False honey ant, *Prenolepis imparis*
14. Midge
15. False honey ant, *Prenolepis imparis*
16. Spider
17. Snail
18. Beetle larva
19. False honey ant, *Prenolepis imparis*
20. Beetle larva
21. False honey ant, *Prenolepis imparis*
22. Garden slug, *Arion* sp.
23. Leopard slug, *Limax maximus*
24. Larva
25. False honey ant, *Prenolepis imparis*
26. Springtail, *Entomobrya* sp.
27. Rove beetle
28. Owlet moth
29. Garden slug, *Arion* sp.
30. Cattail seed, *Typha* sp.
31. Spider
32. Leafhopper
33. Wasp
34. Booklouse
35. Midge
36. House fly
37. False honey ant, *Prenolepis imparis*
38. Fruit fly, *Drosophila* sp.
39. Fruit fly, *Drosophila* sp.
40. Scuttle fly
41. Fly
42. Chalcidoid wasp
43. Fruit fly, *Drosophila* sp.
44. Wasp
45. Spider
46. Midge
47. Wasp
48. Fruit fly, *Drosophila* sp.
49. Wasp
50. Wasp
51. Eggs
52. Fruit fly, *Drosophila* sp.
53. Midge
54. Aphid
55. Booklouse
56. Millipede
57. Millipede
58. Millipede
59. Aphid
60. Soil centipede
61. Dipluran
62. Soil centipede
63. Midge, *Smittia* sp.
64. Woodlouse hunter, *Dysdera crocata*
65. Stone centipede, *Lithobius* sp.
66. Twenty-spotted lady beetle, *Psyllobora vigintimaculata*
67. Dipluran
68. Springtail
69. Springtail
70. Ground beetle
71. Eastern subterranean termite, *Reticulitermes flavipes*
72. Stone centipede, *Lithobius* sp.
73. Burrowing bug, *Pangaeus* sp.
74. Longhorn beetle grub
75. Pillbug, *Armadillidium vulgare*
76. Broad-nosed weevil, *Myosides seriehispidus*
77. Stone centipede, *Lithobius* sp.
78. Parasitic wasp, *Cratichneumon* sp.
79. Millipedes
80. Millipedes
81. Various slugs
82. American elm, *Ulmus americana*
83. Pin oak, *Quercus palustris*
84. Black cherry, *Prunus serotina*
85. White ash, *Fraxinus americana*
86. Unidentified leaf
87. Norway maple, *Acer platanoides*
88. Glossy buckthorn, *Rhamnus frangula*
89. Red maple, *Acer rubrum*
90. Eastern gray squirrel, *Sciurus carolinensis*
91. False honey ant, *Prenolepis imparis*
92. Thrip larva
93. Millipede
94. Rove beetle, *Anotylus* sp.
95. Rove beetle, *Xantholinus linearis*
96. Predatory mite
97. Predatory mite
98. Woodlouse, *Philoscia muscorum*
99. Mite
100. Springtail
101. Insect
102. Song sparrow, *Melospiza melodia*
103. Eastern towhee, *Pipilo erythrophthalmus*
104. White-throated sparrow, *Zonotrichia albicollis*
105. Raccoon, *Procyon lotor*
106. Tufted titmouse, *Baeolophus bicolor*
107. Hermit thrush, *Catharus guttatus*

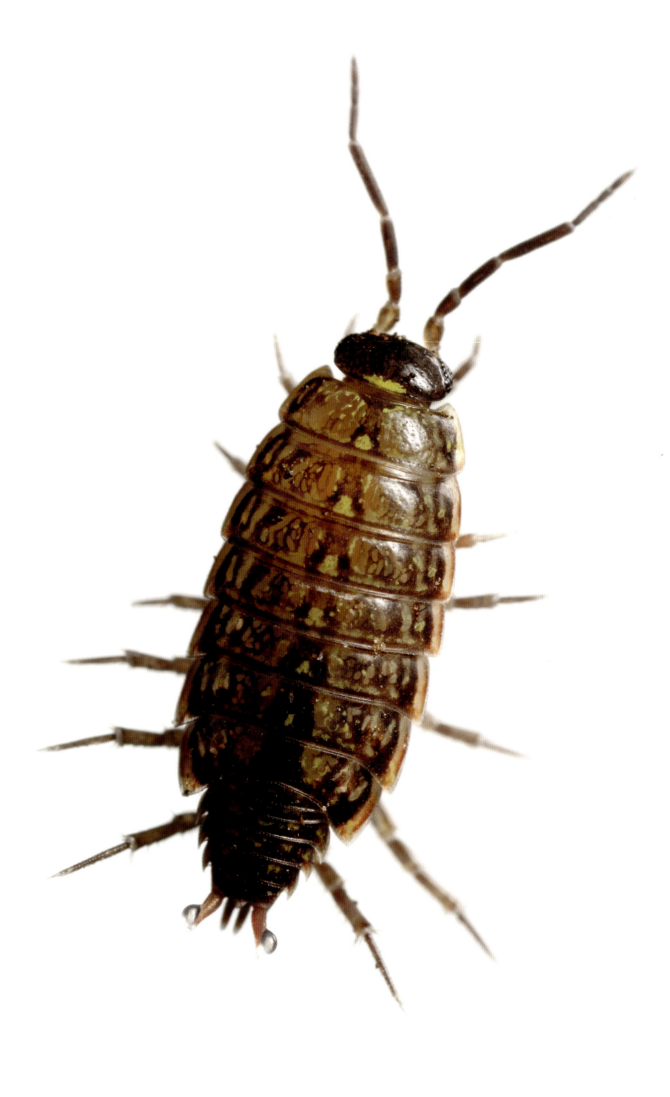

Common striped woodlouse *(left)*

Philoscia muscorum

0.25″ (0.6 cm) long

Pillbug

Armadillidium vulgare

0.28″ (0.7 cm) across

Golden darter

Etheostoma denoncourti

1.06" (2.7 cm) long

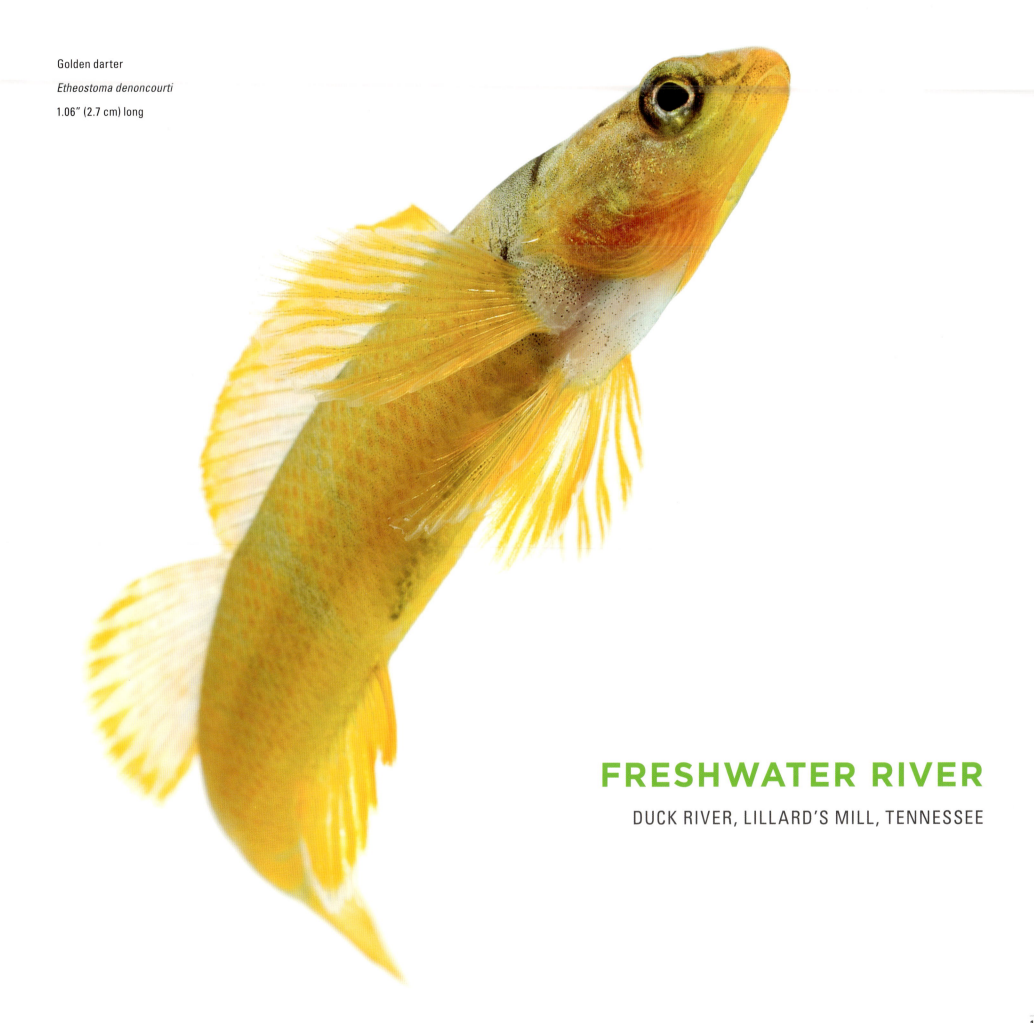

FRESHWATER RIVER

DUCK RIVER, LILLARD'S MILL, TENNESSEE

It's one of the most biodiverse waterways in the U.S., and it harbors several endemic species—animals found nowhere else on Earth. Why such wealth in central Tennessee's Duck River? Time, says Don Hubbs of the Tennessee Wildlife Resources Agency. Part of an ancient, sprawling watershed, the 290-mile Duck River has streamed over its limestone base for millions of years. The mineral-rich geology favors creatures that are, in turn, vital to the river—including the 54 mussel species that filter the Duck's waters. The survey spot was at Lillard Mill, about 15 miles east of Columbia, Tennessee. After days of working in swirling waters turbid from rich crops of algae, the team lifted a sample into a tank for clearer access. The surveyors noted a bigclaw crayfish and several turtles, including one sporting a flamboyant algae coat. Evidence of 32 fish species, more than a hundred non-native Asian clams, and 7 species of mussels, 3 of them endangered, further hints at the prosperity of this river.

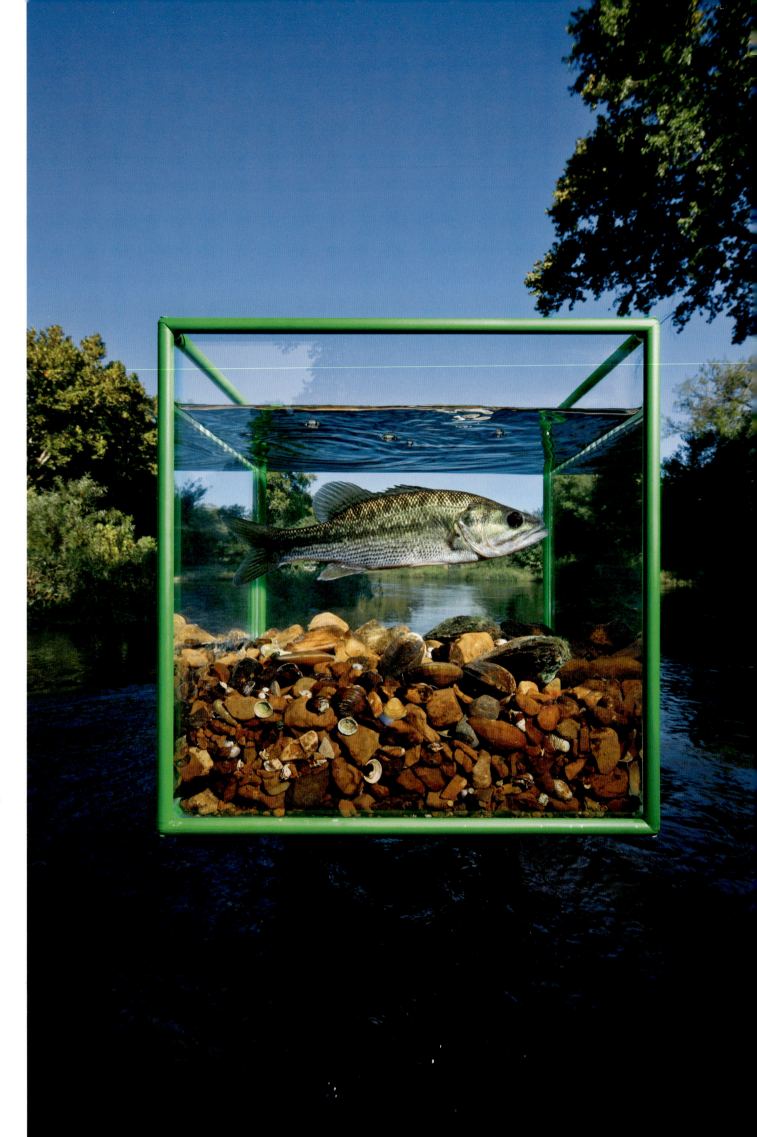

DUCK RIVER, LILLARD'S MILL, TENNESSEE

BEYOND THE LOOSE ENDS of an old mill village in central Tennessee, a gravel lane passes through a portal in the trees and dead-ends at the edge of a small green river. Lillard's Mill landing, on the Duck River, is a fairly nondescript place, with a small boat launch, a scattering of empty beer cans, a few snagged fishing lures, and, just upstream, a minor, abandoned dam.

What's not evident to the untrained eye is that Lillard's Mill is also a point of entry to one of the most biologically diverse freshwater ecosystems on the planet. The Duck River, which flows from the Cumberland Plateau to the broad floodplain of the Tennessee, is the most ecologically diverse river in North America—an unexpected, hidden matrix of aquatic life harboring 151 species of insects and animals, more than all the rivers of Europe combined.

Dig a few handfuls of sediment from the bottom and the river's significance begins to reveal itself: Half of what you hold in your hands is sand and gravel, and the rest is live creatures—mussels, snails, juvenile crayfish, the squirming larvae of stoneflies and dragonflies. The very foundation of the river is alive. The fact that so much meaning can be concealed beneath a placid, unassuming surface is telling. It seems possible that the driving force of planetary life is actually very small, and that its intricacies are lost on most of us.

On a given summer weekend canoeists, swimmers, sunbathers, and fly fishers congregate at the Lillard's Mill landing, generally unaware that they're immersing themselves in one of Earth's biological wonders. One frequent habitué, a guide for a local canoe rental outfit, says the Duck is known primarily for good fishing and pleasant day-floats, and that children are more likely than adults to hone in on its rich aquatic menagerie. "One kid had a fish in a cup, a turtle, ten mussels, and three crawfish," he recalls, pausing to chew on a plug of tobacco. "There's a lot of stuff in this river. It's the most diverse river in Tennessee—maybe more than that."

His last observation is a rare local nod to the Duck's broader significance. To most area residents, the Duck is just a playground with critters. As evidence of this, the guide says he and his friends can no longer use their favorite rope swing because a few locals took to trespassing on private land to go mudding in their four-wheel drives, including in the river's sensitive shallows, where they uncaringly churned up entire miniature, submerged universes with their spinning, studded tires.

Another local man, who enjoys whiling away summer afternoons watching the goings-on at the landing, observes in a strong Tennessee drawl, "They's some hillbilly sons o' bitches up in here. It can get pretty red."

Aside from its diversity, the Duck's most salient feature is its profound greenness. The river channels every imaginable verdant hue, from the tint of its sun-dappled shoals to the deep green of its shady pools, from the long, vivid tresses of algae waving in its currents to the pixelated palette of overhanging oak, willow, and maple leaves. Viewed from the landing at Lillard's Mill, the scene appears almost colorized.

The motif continues down to the smallest details. In the shallows, a tiny green-striped turtle swims about, its shadow moving across a bottom loosely paved with stones and mussel shells upholstered in velvet moss, while a phalanx of dragonflies, many with iridescent emerald highlights, patrols the air space above. Even when viewed individually, out of context, the species that inhabit the Duck are clearly products of the green.

In ecological terms, green signifies richness, up to a point. Notably, green is also the color of sewage, and of suffocating algae blooms, so it's crucial that there be a balance, that the nutrient wealth be accessible to all, yet not to the point of being corruptive. The Duck is in balance. Though not pristine, it is unperturbed. Its life systems are intact. Each species has what it needs, in abundance.

The Duck's diversity and balance are the result of a long history—it's an ancient, highly nuanced river that's been influenced by the wanderings of oceans and watercourses across exceptionally varied terrains. Its human history indicates that the river has remained stable and has included humans in its ecological mix for centuries. One of Tennessee's more stunning archaeological caches was found near Lillard's Mill, including amazing sword-like stone knives, stone fish hooks, and decorative shell, evidence of Native American life dating to the 15th century. During the Civil War both

Union and Confederate troops frequently used the local ford, and the now-defunct Lillard's Mill capitalized on the river's consistent, even flows. Considering all that, it's easy to imagine the roving bands of dragonflies careening past a Cherokee camp at the river's edge, darting between the splashing legs of horses bearing war-weary Civil War soldiers, and parting around a tattooed woman of this century, sitting in a lawn chair and soaking her feet in the cool water on a summer day. The Duck's ecological features in the vicinity of Lillard's Mill would be similar from any epoch—a rarity in these days when most rivers have been seriously degraded by human activity.

The river's ecological stability is rooted in its relative lack of development and in its geography—channels cut through limestone and shale, bordered by small, hilly farms and patches of deciduous and evergreen forests, oak barrens, prairie wetlands, and cedar glades. The upper river has been impounded to create Normandy Lake, and Lillard's Mill is the site of an abandoned hydroelectric dam, but the scope of these changes has been limited. Overall, the region has an air of quiet rural stability.

Today, the Duck's typically shallow, braided channels can be transformed into violent torrents after heavy rains, as evidenced by the driftwood and the carcass of an apparently drowned opossum high in the limbs of overhanging trees. Even under normal circumstances its currents constantly shift, eroding and depositing soils, creating and destroying temporary habitats, sweeping grassy shoals clean one day and burying them beneath sediments the next. Wind uproots trees, opening new passageways while closing others. The river is in a constant state of flux. The currents tug this way, then that.

In the aftermath of a recent high water event, a school of mosquito fish swims through a series of warm, shrinking pools, nervously scattering at the sound of a human voice. A few mussels, out for a sightless, slow-motion stroll, explore shallow water bottoms that will soon be exposed. All of the species that inhabit the Duck must adjust to constantly changing influences. Nothing is static. But so long as the changes are temporary or incremental, the river and its associated species adapt.

The river's intricate ecological balance could easily be disturbed by manmade alterations of its flow or the expansion of invasive species like Asian mussels or pollutants from sources like dairy farms, which dump large volumes of animal waste into runoff. Given the loss of aquatic habitat elsewhere, the value of the Duck's ecosystem

has been heightened, which is why it's been studied extensively and is now a protected watershed. These days a freshwater environment is considered valuable if it supports sport fish such as bass and blue gill, but for biological sustainability, the habitat has to be stable for the entire, diverse array of species. How life is distributed throughout the habitat has profound consequences, and diversity, particularly when it encompasses endangered species, strengthens the whole.

Generally speaking, a place that supports 50 species has a higher ecological value than one that sustains 10. But if those 10 species are restricted to one location, the value of the habitat increases dramatically. The greatest value comes from a habitat that has a high number of species, including many that exist nowhere else, within a concentrated area. That's the Duck. In some areas of the planet, there may be 50 species of plant and animal life scattered over a thousand square miles, but in the Duck as many can be found within sight of Lillard's Mill.

For biologists, the array of mussels that thrive in the natural sections of the river below Lillard's Mill is nothing short of astonishing. Because they're filter-feeders with limited movements, mussels are sensitive to even minute changes, and they're directly dependent on a stream's overall health. As such, they are clear indicators of its ecological balance. Many rivers have no mussels at all anymore. Others have scattered populations of a single species. The Duck hosts 55 species, in abundance— 7 in that single cubic foot of habitat below Lillard's Mill, 3 of them endangered because there are so few places left in the world where they can survive and thrive.

Mussels have no eyes, yet many in the Duck have devised visual mechanisms for reproduction that involve females secreting artificial lures to attract fish that inadvertently disperse their eggs. One species of mussel uses a lure that precisely mimics a minnow—something the mussel itself has never seen. It is tempting to imagine a kind of consciousness behind the development of such delicate, complex lifelines.

The Duck itself is a kind of delicate, complex lifeline. While its supply of water bugs, mussels, fish, snails, crayfish, and plants may fluctuate, it never runs out. The balance sustains itself. It offers clues to a world that is both larger and smaller than we might have imagined, nearly hidden beyond the fringes of an old mill town.

—*Alan Huffman*

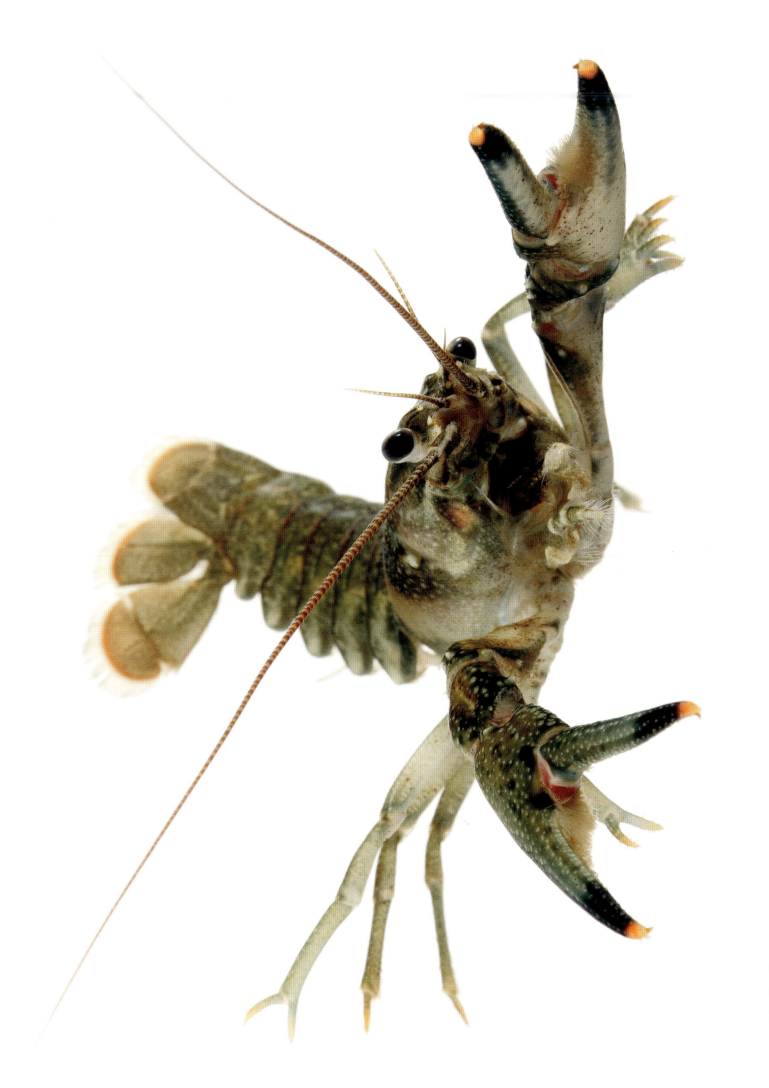

Crayfish

Orconectes placidus

2.95" (7.5 cm) long

River cooter

Pseudemys concinna

4.0" (10.16 cm) across

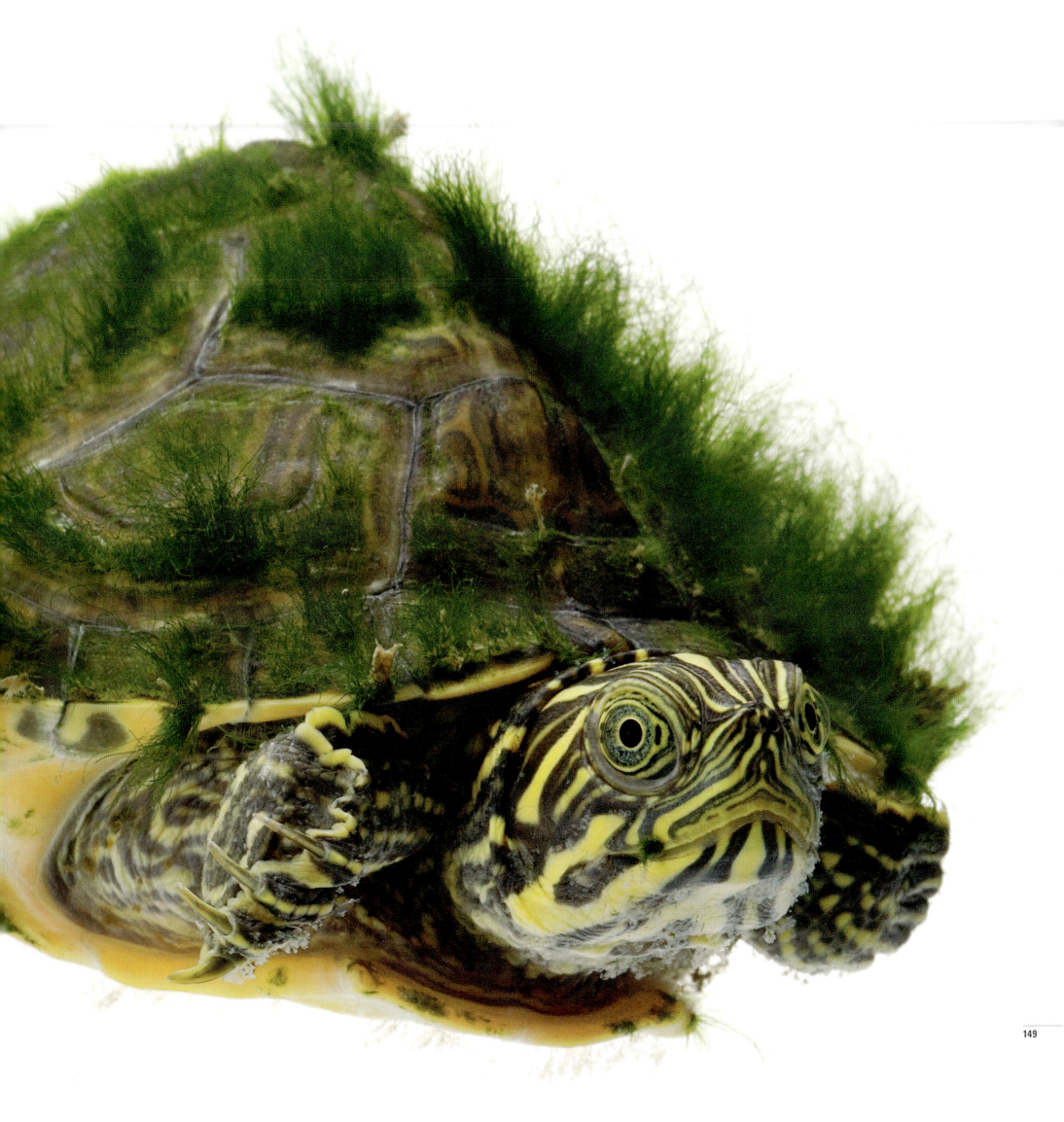

Bigeye chub *(top)*

Hybopsis amblops

2.64" (6.7 cm) long

Banded darter *(bottom)*

Etheostoma zonale

2.76" (7 cm) long

Largescale stoneroller *(top)*

Campostoma oligolepis

3.15" (8 cm) long

Ashy darter *(bottom)*

Etheostoma cinereum

3.31" (8.4 cm) long

Spinyleg dragonfly

Dromogomphus sp.

0.93" (2.36 cm) long

Springtime darner

Basiaeschna janata

0.97″ (2.46 cm) across

Red-eared slider

Trachemys scripta elegans

length of carapace 1.97" (5 cm)

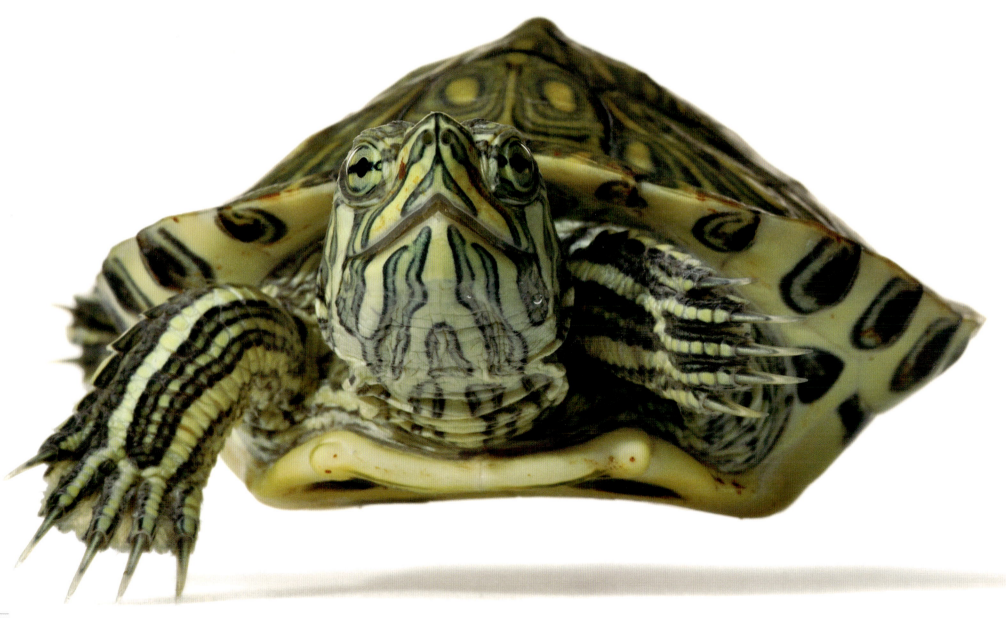

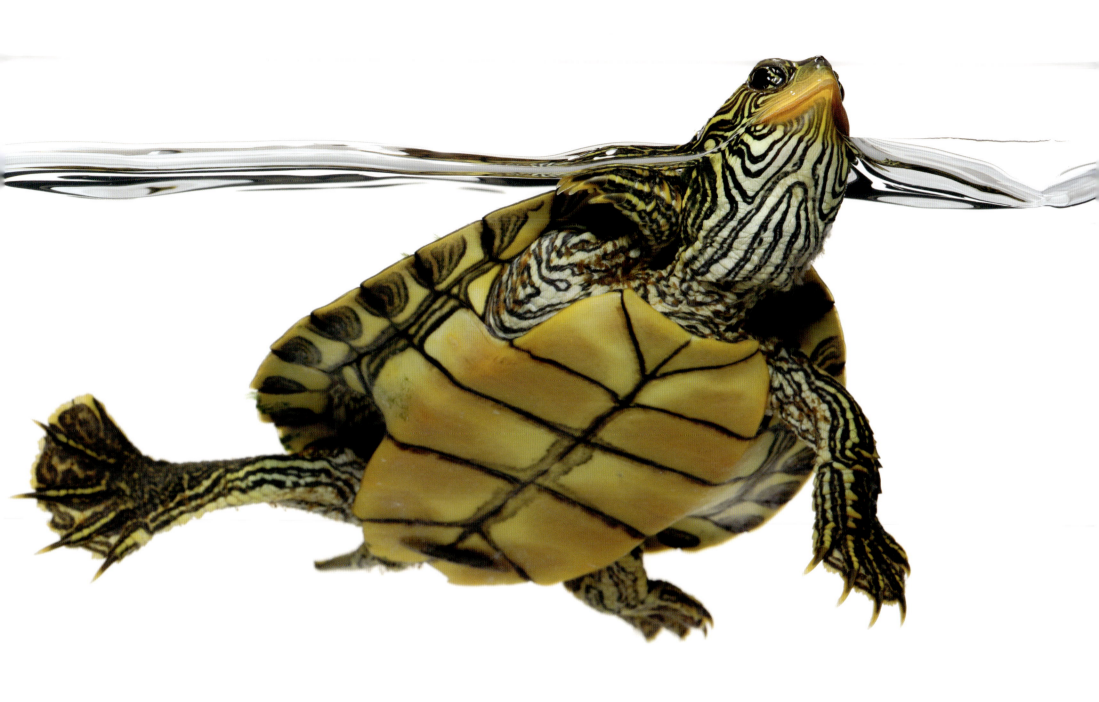

Common map turtle

Graptemys geographica

length of carapace 2.6″ (6.6 cm)

Stonefly nymph

Agnetina capitata

0.59" (1.5 cm) long

Long-horned casemaker caddisfly

Triaenodes injustus

length of case 0.63" (1.6 cm)

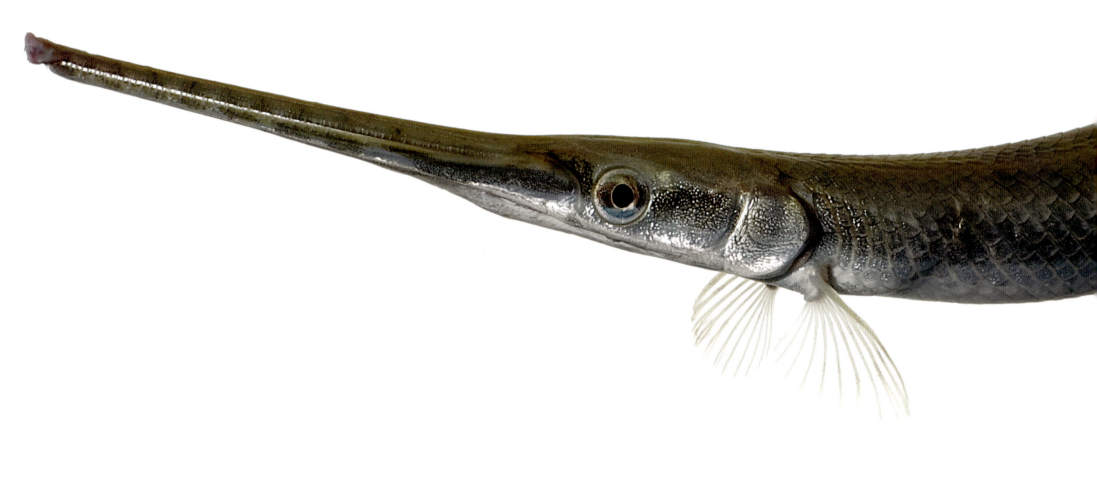

Longnose gar

Lepisosteus osseus

12.0″ (30.48 cm) long

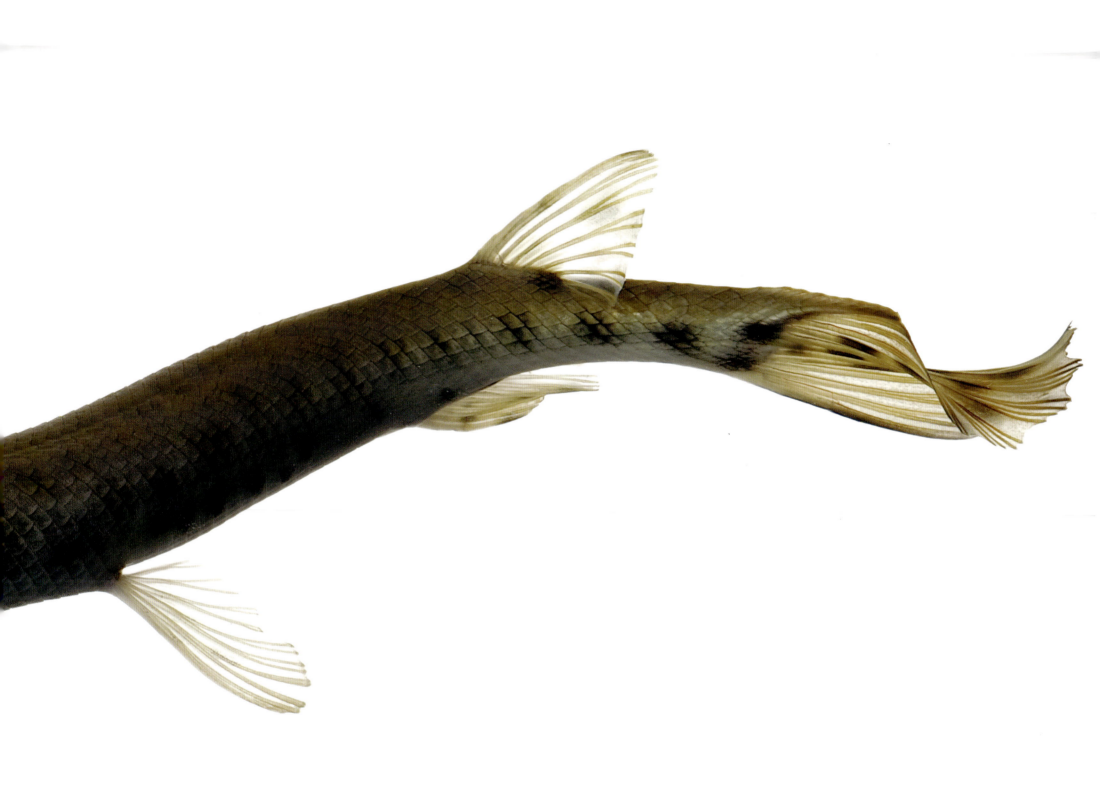

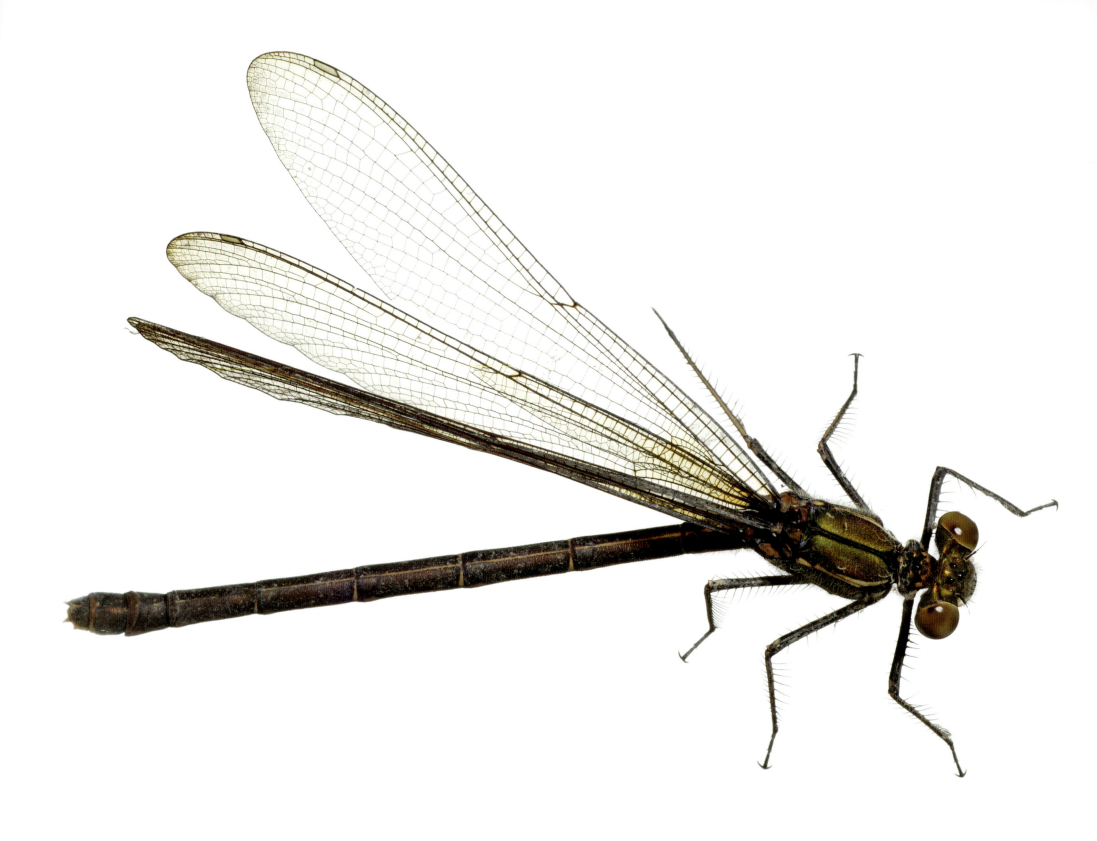

American rubyspot

Hetaerina americana

1.57″ (4 cm) long

Blue-ringed dancer

Argia sedula

1.22″ (3.1 cm) long

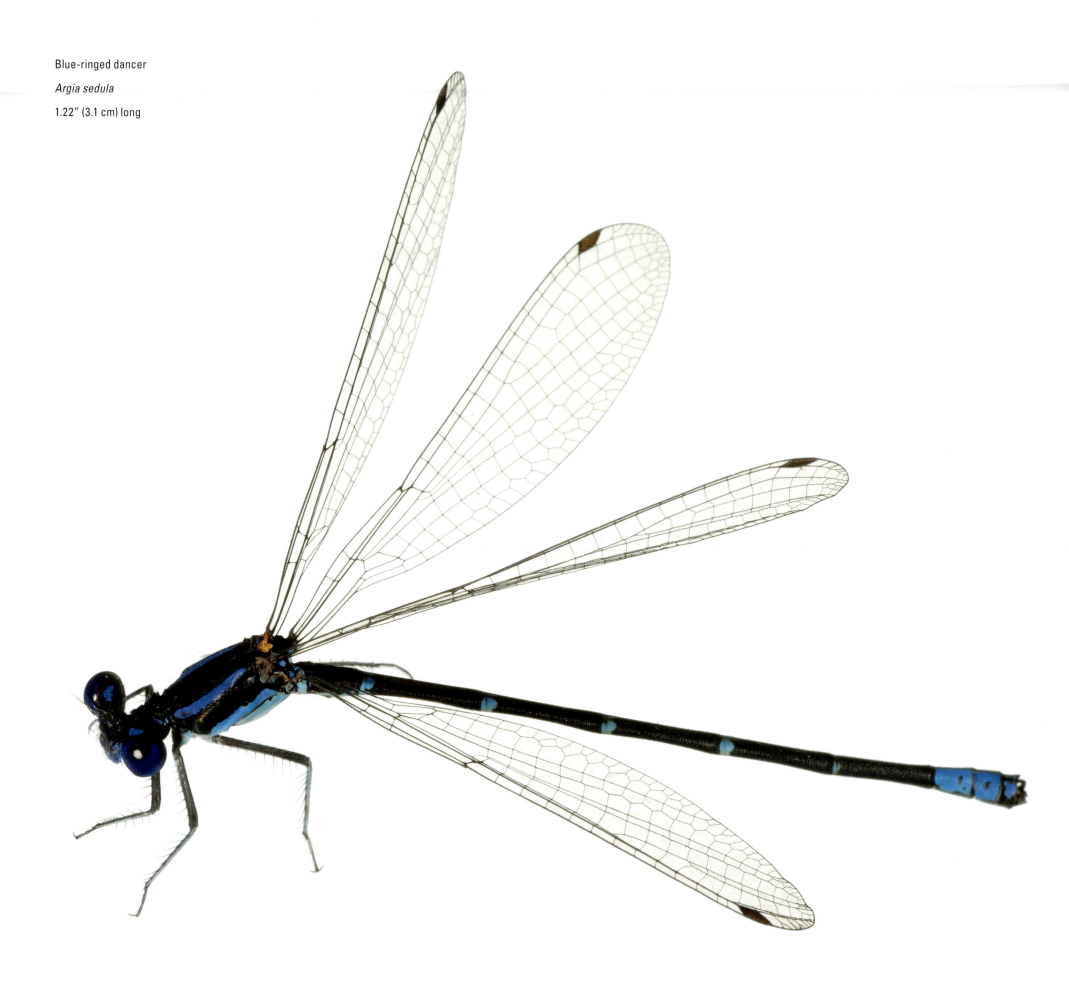

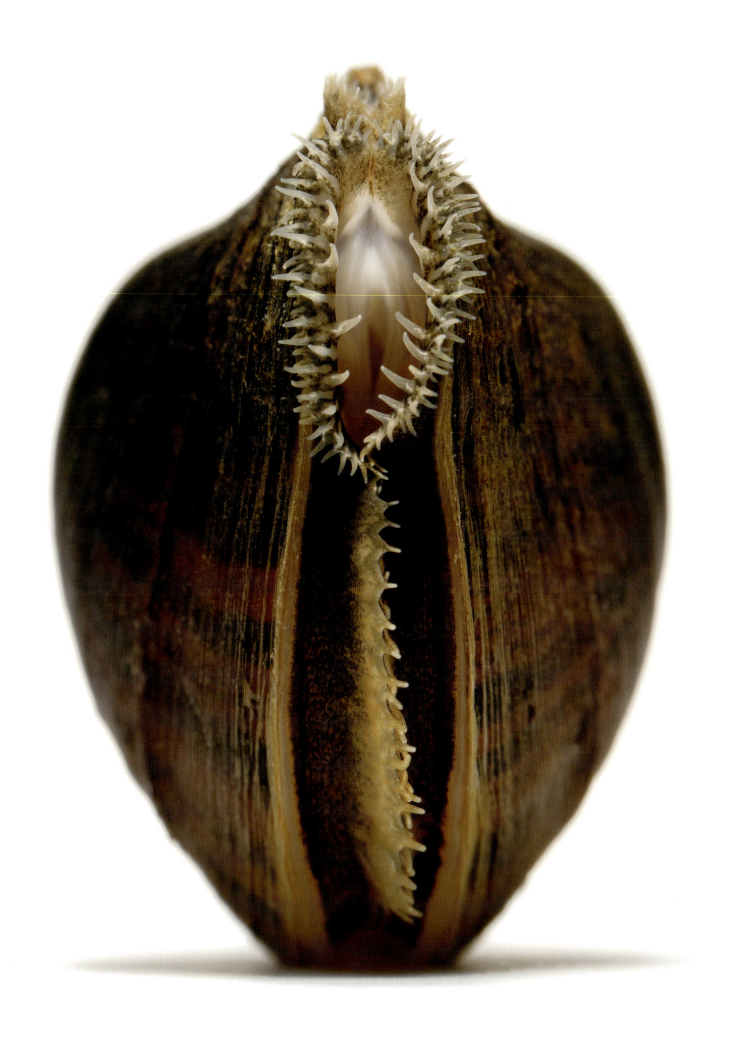

Mountain creekshell *(left)*

Villosa vanuxeminsis

0.91" (2.3 cm) top to bottom

Pistolgrip

Quadrula verrucosa

2.44" (6.2 cm) across

Longear sunfish

Lepomis megalotis

5.75" (14.6 cm) long

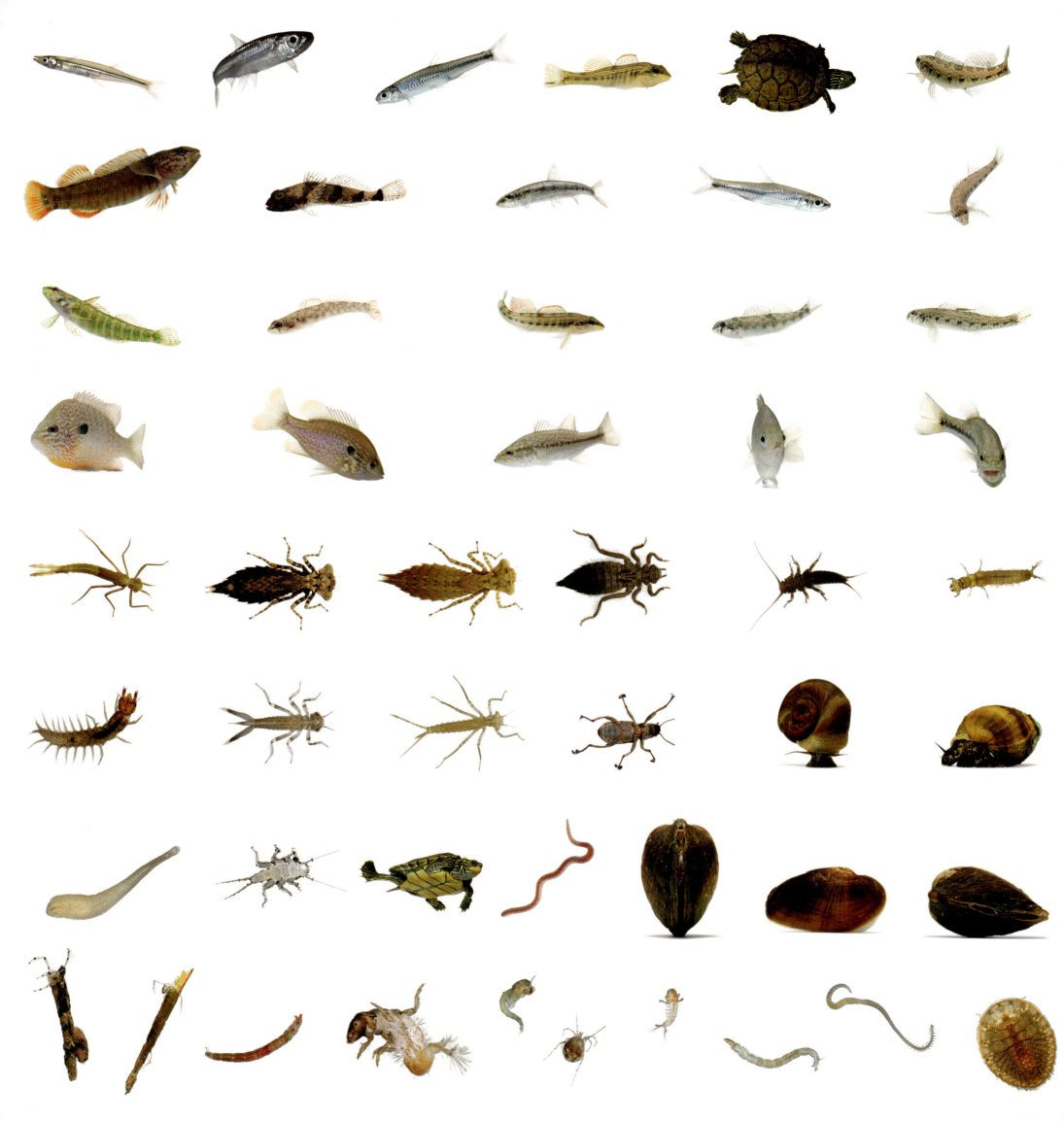

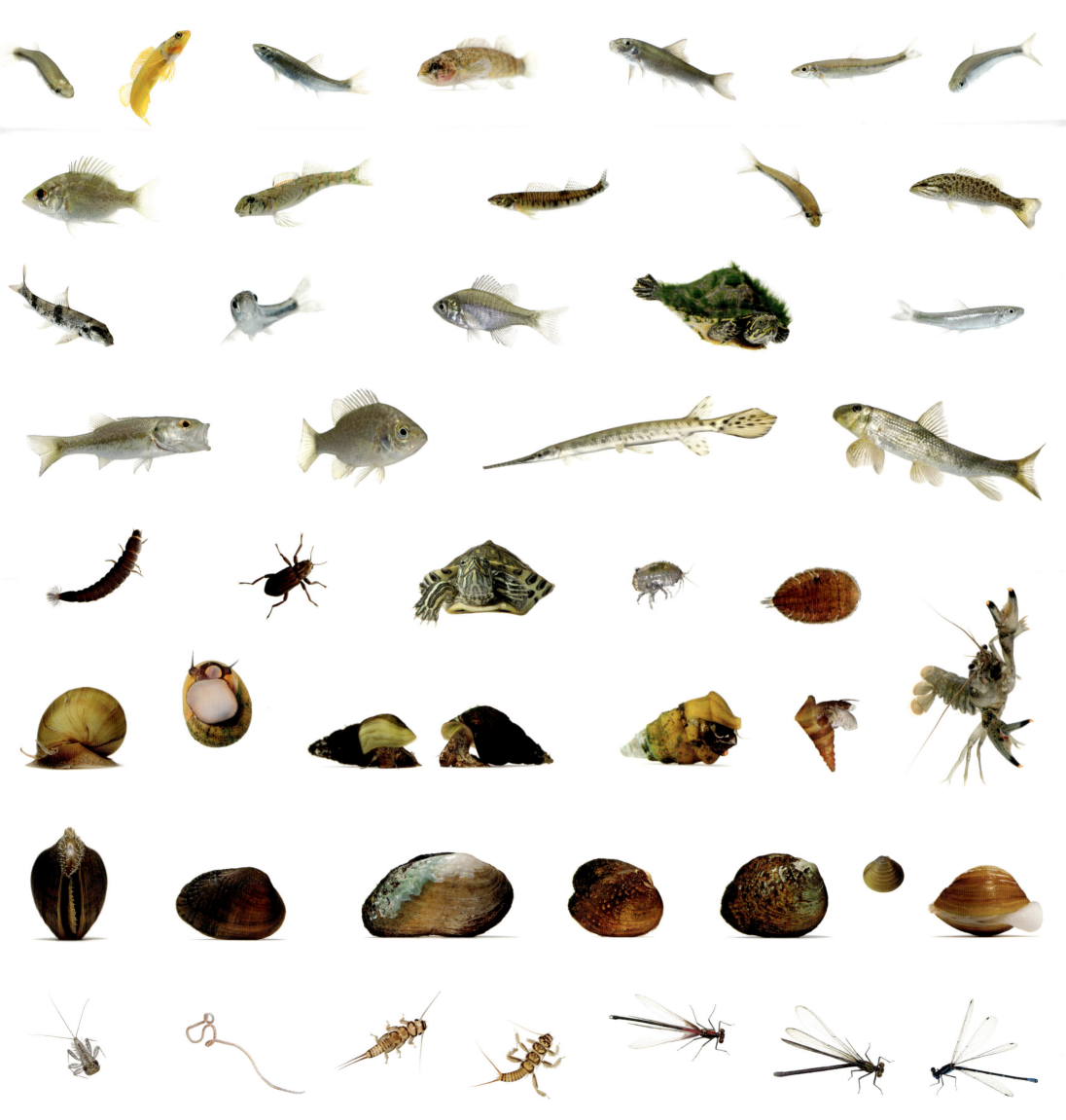

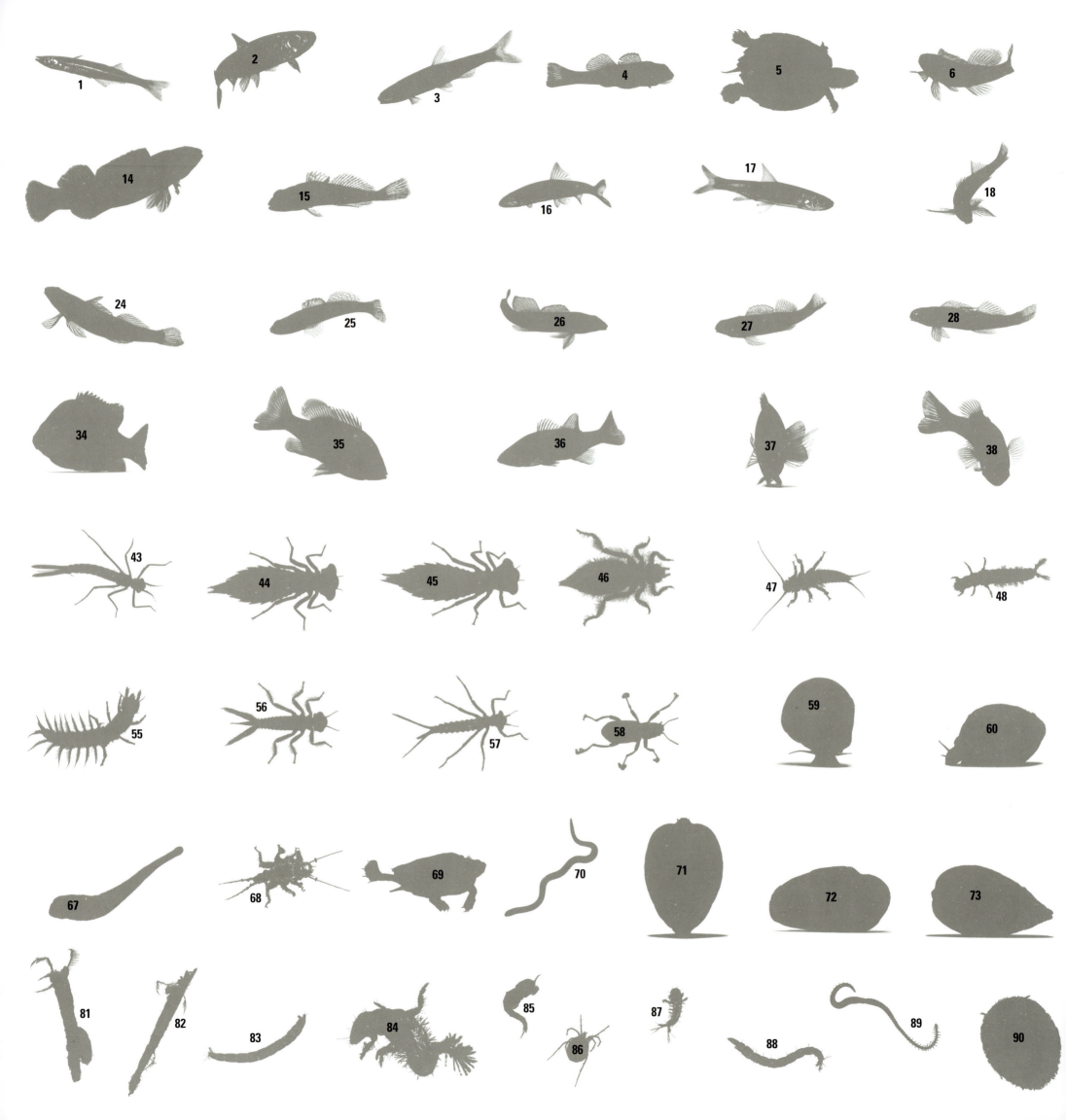

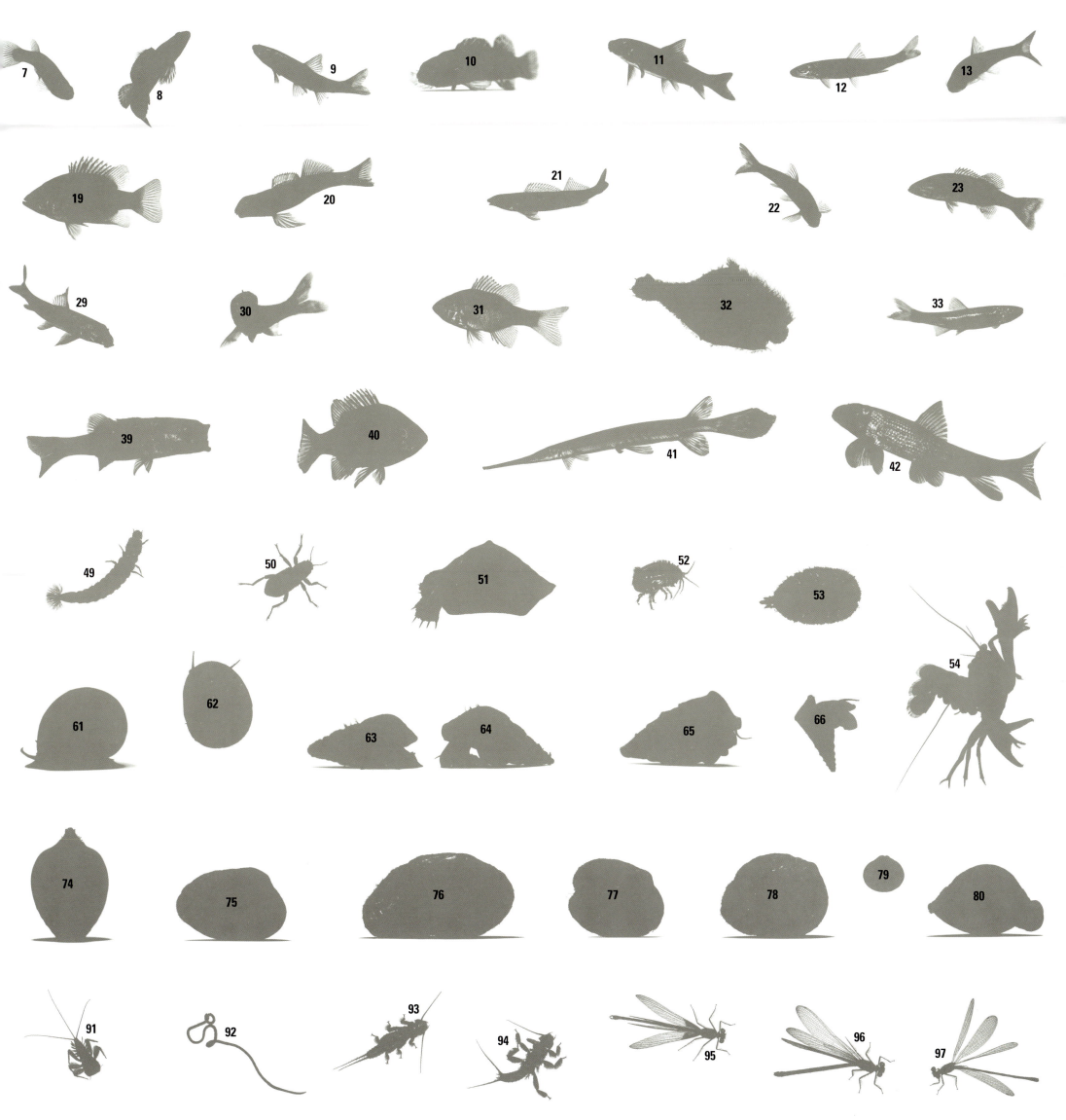

SPECIES KEY

1. Brook silverside, *Labidesthes sicculus*
2. Telescope shiner, *Notropis telescopus*
3. Sawfin shiner, *Notropis* sp. (undescribed)
4. Ashy darter, *Etheostoma cinereum*
5. Common map turtle, *Graptemys geographica*
6. Snubnose darter, *Etheostoma simoterum*
7. Blackspotted topminnow, *Fundulus olivaceus*
8. Golden darter, *Etheostoma denoncourti* (male)
9. Largescale stoneroller, *Campostoma oligolepis*
10. Golden darter, *Etheostoma denoncourti* (female)
11. Smallmouth redhorse, *Moxostoma breviceps*
12. Streamline chub, *Erimystax dissimilis*
13. Spotfin shiner, *Cyprinella spiloptera*
14. Coppercheek darter, *Etheostoma aquali*
15. Banded sculpin, *Cottus carolinae*
16. Blotched chub, *Erimystax insignis*
17. Bigeye shiner, *Notropis boops*
18. Speckled darter, *Etheostoma stigmaeum*

19. Rock bass, *Amblopites rupestris*
20. Greenside darter, *Etheostoma blennioides*
21. Logperch, *Percina caprodes*
22. Bigeye chub, *Hybopsis amblops*
23. Smallmouth bass, *Micropterus dolimieu*
24. Banded darter, *Etheostoma zonale*
25. Striated darter, *Etheostoma striatulum*
26. Ashy darter, *Etheostoma cinereum*
27. Saffron darter, *Etheostoma flavum*
28. Snubnose darter, *Etheostoma simoterum*
29. Northern hog sucker, *Hypentelium nigricans*
30. Telescope shiner, *Notropis telescopus*
31. Bluegill, *Lepomis macrochirus*
32. River cooter, *Pseudemys concinna*
33. Whitetail shiner, *Cyprinella galactura*
34. Longear sunfish, *Lepomis megalotis* (male)

35. Longear sunfish, *Lepomis megalotis* (juvenile male)
36. Largemouth bass, *Micropterus salmoides*
37. Bluegill, *Lepomis macrochirus*
38. Spotted bass, *Micropterus punctulatus*
39. Spotted bass, *Micropterus punctulatus*
40. Redear sunfish, *Lepomis microlophus*
41. Longnose gar, *Lepisosteus osseus*
42. Northern hog sucker, *Hypentelium nigricans*
43. Ruby spot nymph, *Hetaerina americana*
44. Springtime darner, *Basiaeschna janata*
45. Springtime darner, *Basiaeschna janata*
46. Spinyleg dragonfly, *Dromogomphus* sp.
47. Stonefly nymph, *Pteronarcys* sp.
48. Common net-spinner, *Hydropsyche patera*

49. Riffle beetle larva, *Stenelmis* sp.
50. Riffle beetle, *Stenelmis sexlineata*
51. Red-eared slider, *Trachemys scripta*
52. Sideswimmer, Scud, *Hyalella azteaca*
53. Water penny, *Ectopria* sp.
54. Crayfish, *Orconectes placidus*
55. Hellgrammite, *Corydalus cornutus*
56. Dancer damsel nymph, *Argia* sp.
57. Pond damsel, *Argia* sp.
58. Riffle beetle, *Stenelmis lateralis*
59. Ram's horn snail, *Planorbella trivolvis*
60. Ornate rocksnail, *Lithasia geniculata*
61. Pointed campeloma, *Campeloma decisum*
62. Onyx rocksnail, *Leptoxis praerosa*
63. Panel elimia, *Elimia laqueata*

64. Panel elimia, *Elimia laqueata*
65. Silty hornsnail, *Pleurocera canaliculatum*
66. Immature pleurocerid snail
67. Leech, *Helobdella trisserialis*
68. Stonefly nymph, order Plecoptera
69. Common map turtle, *Graptemys geographica*
70. Aquatic worm, *Pteronarcys* sp.
71. Oyster mussel, *Epioblasma capsaeformis*
72. Spike, *Elliptio dilatata*
73. Spike, *Elliptio dilatata*
74. Mountain creekshell, *Villosa vanuxeminsis*
75. Birdwing pearlymussel, *Lemiox rimosus*
76. Pistolgrip, *Quadrula verrucosa*
77. Cumberland monkeyface, *Quadrula intermedia*
78. Cumberland monkeyface, *Quadrula intermedia*
79. Asian clam, *Corbicula fluminea*

80. Asian clam, *Corbicula fluminea*
81. Longhorned case maker, *Nectopsyche exquista*
82. Longhorned case maker, *Triaenodes injustus*
83. Non-biting midge larva, *Cryptochironomus* sp.
84. Common net-spinner, *Cheumatopsyche* sp.
85. Midge pupa, order Diptera
86. Aquatic mite, *Stenelmis sexlineata*
87. Common net-spinner, *Cheumatopsyche* sp.
88. Non-biting midge larva, *Conchapelopia* sp.
89. Aquatic earthworm, *Branchirua sowerbyi*
90. Water penny, *Psephenus herricki*
91. Flatheaded mayfly nymph, *Leucrocuta* sp.
92. Aquatic worm, *Limnodrilus hoffmeisteri*
93. Stonefly nymph, *Neoperla* sp.
94. Stonefly nymph, *Agnetina capitata*
95. American rubyspot, *Hetaerina americana* (male)
96. American rubyspot, *Hetaerina americana* (female)
97. Blue-ringed dancer, *Argia sedula*

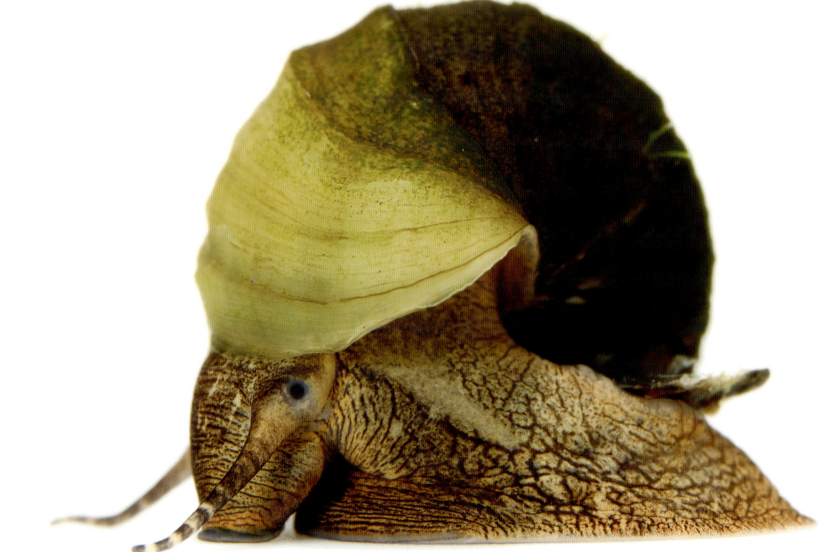

Panel elimia *(both)*

Elimia laqueata

0.79″ (2 cm) across

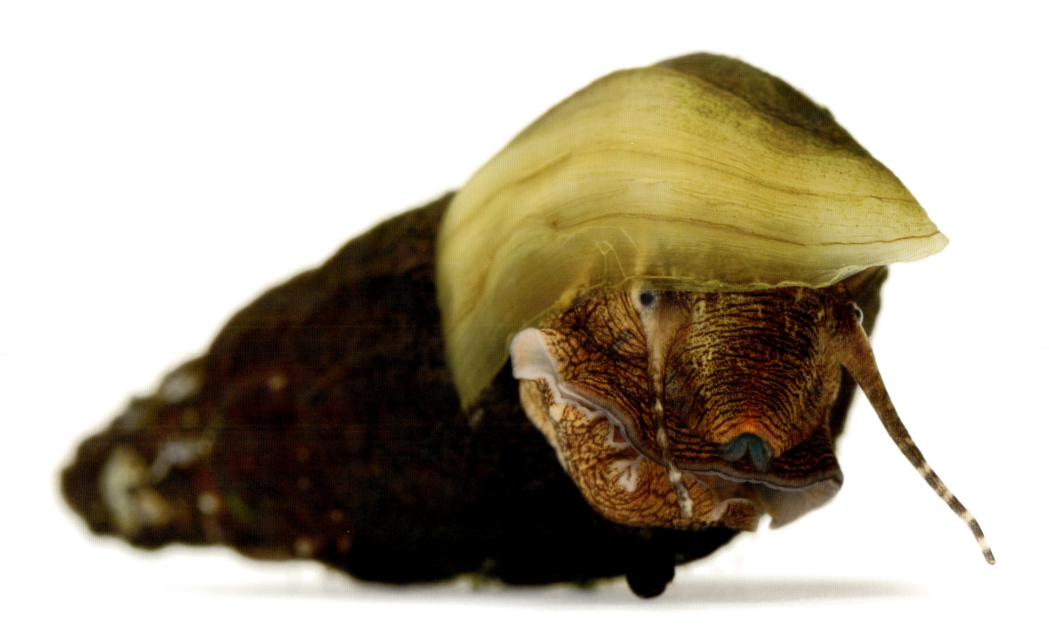

Daisy

Ursinia paleacea

1.3" (3.3 cm) across

MOUNTAIN FYNBOS

TABLE MOUNTAIN NATIONAL PARK, SOUTH AFRICA

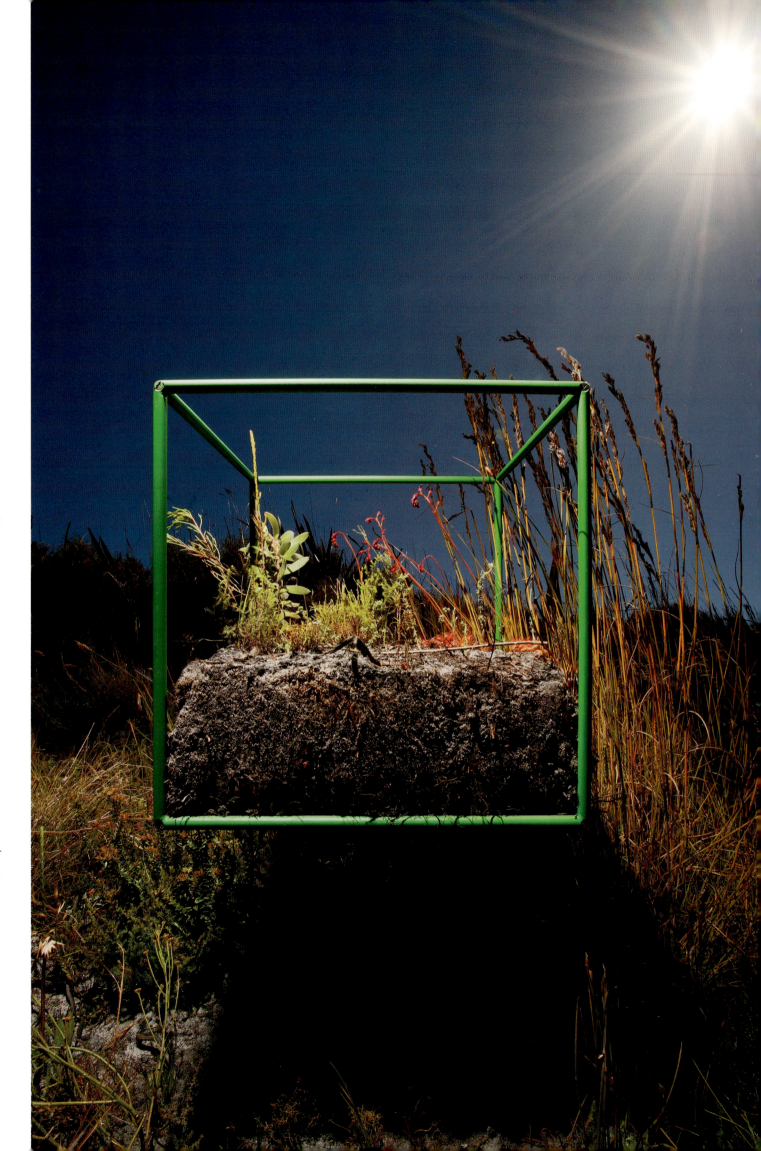

Fynbos, derived from Dutch, refers to the "fine-leaved" vegetation that grows in the mountainous areas of the Cape Floristic Region (CFR, as botanists call the unique area of floral diversity at the southern tip of Africa). The soils here are rocky and nutrient poor, the scrub prone to going up in flames. Yet adversity has fostered one of the richest concentrations of plant diversity in the world: Some 9,000 native species live in the CFR—many of them evolved here and live nowhere else. Liittschwager's shovelful of fynbos came out of Table Mountain National Park, the monumental mesa that towers over Cape Town. Sifting through samples, the photographer counted 90 separate species, including 25 types of plants just on the soil surface, along with some 200 seeds representing at least 5 of those species. Root masses held a host of crawlies, and the sticky leaves of a carnivorous sundew plant—looking too pretty to be predatory—offered another fistful of insects to the tally.

TABLE MOUNTAIN NATIONAL PARK, SOUTH AFRICA

The biological wonders of the Cape Floristic Region at Africa's southern tip offer a bottomless box of mysteries. The magnificent floral diversity and the multitude of minute and intricate survival strategies of the plants and animals in this confined area never cease to amaze.

The region stretches in a narrow 60 to 120 mile wide by 700 mile long coastal belt. Yet despite its small size (only .06 percent of Earth's land area, equivalent to Portugal or Austria), it contains a staggering 3 percent of all floral diversity—50 times what would be expected for an area so small. Perhaps more impressive is that more than two-thirds of its 9,000 or so vascular plant species are restricted to the region, probably because it is so removed from any similar environments. The particular Mediterranean-type climate here—cold, wet winters, hot, dry summers, and the consequent propensity to burn—is only found in such far-off locations as Western Australia (the most similar to Africa's southern tip), Chile, California, and the Mediterranean Basin.

Two biomes predominate in the Cape Floristic Region—the arid Succulent Karoo and Fynbos, where we placed our cubic foot. While the term *fynbos* is derived from the Dutch for "fine bush," there are a few theories as to why it is described as fine. It could mean fine looking, which, when fynbos is viewed in full bloom in spring or early summer, is difficult to deny; or fine scale, an allusion to its minute detail; or even fine leaved because of the preponderance of small shrub species here, most from the daisy, pea, and heather families. Other characteristic groups that give the Fynbos its ambience and occasionally paint whole landscapes with color are the stunning array of irises of every hue; the wide variety of proteas, ranging from small trees to prostrate creepers; and the broad assortment of Cape reeds of various sizes, colors, and textures.

In the course of 24 hours, the one cubic foot of Mountain Fynbos we sampled revealed almost 30 plant species and roughly 70 invertebrates. But being stationary, the cube couldn't capture what is arguably the most amazing component of Fynbos diversity—how much it changes from location to location. If we picked the cube up and walked ten feet, we could get as much as a 50 percent difference in the plant species

we encountered. If we moved it uphill, with a slight change in moisture, we might find none of the same species. This rapid change in composition is driven by differences in fire history and changes in the availability of water, nutrients, and light over tens to hundreds of feet, with each species preferring a particular combination of conditions.

At a grander scale, if we moved the cube to a different mountainside altogether, we'd get an even more radically different species composition, because many Fynbos species are restricted to their own mountain. Spread like an archipelago across the Cape Floristic Region, these mountains, separated by deep river valleys, have become evolutionary islands. Dispersal of species among them is typically so rare that when some individuals do manage to make the leap to a new mountain environment, they are usually isolated from others of their kind. Over time they take a different evolutionary trajectory from the original population, often diverging to form new species. The result is that one commonly finds similar-looking, closely related species in similar habitats on different mountains.

As with all evolution, species in the Fynbos were shaped, and continue to be shaped, by their greatest challenges. For plants these challenges include accessing the resources needed to complete their lifecycle, transferring pollen among individuals to allow seed set, and evolving ways to protect and transport those seeds to suitable sites so that new individuals will thrive. In the Fynbos these challenges can be particularly daunting, and many specialized adaptations and interspecies interactions have evolved to help overcome them.

In Mediterranean-type climates summers are particularly stressful, because they are not only the hottest time of year but also the driest. While scientists are still resolving the details, there is much evidence suggesting that the narrow, rolled leaves characteristic of Fynbos flora have evolved to help plants offload heat while minimizing water loss. The rolled leaf protects the evaporative surface area, conserving moisture, while being narrow reduces the thickness of the layer of still air around the leaf, allowing heat to be lost from the leaf surface more quickly.

In addition to the stresses of summer drought, the low-nutrient status of the soils in the region means that species require specialized root adaptations or mycorrhizal associations (mutualisms with fungi) to scrape together a meager living. Mycorrhiza

reside in or on the root surface, acquiring sugars from the plant, and in turn provide the plant with nutrients these fungi expertly extract from the soil. Some plant species have taken a more extreme approach to nutrient acquisition and hunt for their food. The Alice sundew (*Drosera aliciae*) found in our cubic foot captures small insects and other creatures on its sticky leaves and releases enzymes to digest and absorb the nutrients from its prey. A related group of species, the genus *Roridula*, has gone one step further, outsourcing some of the process. These species also capture prey on their sticky leaves but are unable to digest them. Instead, they have developed a mutualism with two hemipteran species, or true bugs, *Pameridea marlothii* and *P. roridulae*. Able to walk on the leaves without getting stuck, the bugs consume the stranded prey and deposit droppings on the leaves; it's the high-nutrient droppings that are then absorbed by the plant. But wait, that's not all. In addition to the bugs, a spider (*Synaema marlothii*) similarly digests prey and deposits droppings on the plant. The complication is that, given the chance, the spider will also eat the *Pameridea* bugs. At first glance, this may seem bad news for the plant, but it turns out that the regulation of the bug population by the spider is critical in maintaining the benefits of this three-way relationship. When times are lean and prey items are scarce, the true bugs take to feeding on the plant to supplement their nutrition. Too many bugs would kill the plants, and the network of interactions would fall apart.

Perhaps one of the most impressive sights in the Fynbos is its fires. Now mostly caused by humans, in the past these fires were started by lightning and sparks from rockfalls. While fire is a major constraint on the demography of plant populations, it is also essential for the renewal of the system and the long-term survival of a number of species. Without fire, many species would age and begin to die off, while others would be out-shaded and perish. To persist through fires, many plants have evolved the ability to resprout from starch-filled rootstocks. Others have developed strategies to defend their seeds so that they can survive and take advantage of the open, post-fire environment.

One of the more obvious strategies for doing this is serotiny, or the "closed-cone" strategy, whereby seeds are held in the canopy of the plant in fire-proof cones that do not burn and only open to release the seeds after the plant is burned. Other species employ animal dispersers such as ants or rodents to secrete their seeds below the soil surface,

protecting them from the heat of fires. Nut-like seeds, such as those of *Hypodiscus aristatus*, have small fatty bodies called elaiosomes attached to them. Released onto the soil surface, these seeds are soon found by ants, who carry them down into their underground nests. The ants consume the elaiosomes, but the hard nut-shelled seeds remain safely buried in the nest, protected by the anti-fungal and anti-bacterial hormones secreted by the ants.

Recently, scientists have discovered that other large Fynbos nut seeds are dispersed by mice, which scatter or larder-hoard the seeds much as squirrels do with acorns. The mice bury the seeds in the soil when they are plentiful, storing them for times when food is less abundant. The seeds survive if the stash is either forgotten or the mice are driven away by fire. Soil-stored seeds remain dormant until their germination is triggered by a pulse of heat as fire passes above.

The Fynbos is also replete with diverse and often complex pollination systems, including flowers that lure male bees with the perfumed oils they need to tempt female bees; or cheesy-smelling pollen that attracts rodents; or pollen parcels that are transported on the frayed edges of sunbird tongues. Other specialized mutualisms with pollinators like butterflies, moths, sunbirds, beetles, and long-tongued flies have driven the evolution of the myriad floral forms found in fynbos, and now dominate in gardens all over the world.

Many Fynbos species also contain aromatics and secondary compounds that serve an array of functions, such as protecting against herbivores or parasites, reducing water loss, or increasing flammability so that neighbors (competing plants) too are killed in the event of fire. Humans benefit from these plant compounds as well, as they can be extracted for use in perfumes and pharmaceuticals, and they create the exotic flavors found in rooibos, honeybush, and buchu teas.

While the images captured here portray an impressive array of floral and faunal diversity, they are far from a comprehensive inventory of the life that resides in a cubic foot of the Fynbos. There are a multitude of creatures many orders of magnitude smaller than the smallest mite we found. Indeed it would take more than a lifetime simply to document the diversity of life in one cubic foot here. Even one cubic inch of the Fynbos is a world worth contemplating.

—Jasper and Peter Slingsby

Jumping spider

Aelurillus cristatopalpus

0.1″ (0.35 cm) long

Alice sundew

Drosera aliciae

0.6" (1.52 cm) across

Alice sundew

Drosera aliciae

1.7" (4.3 cm) across

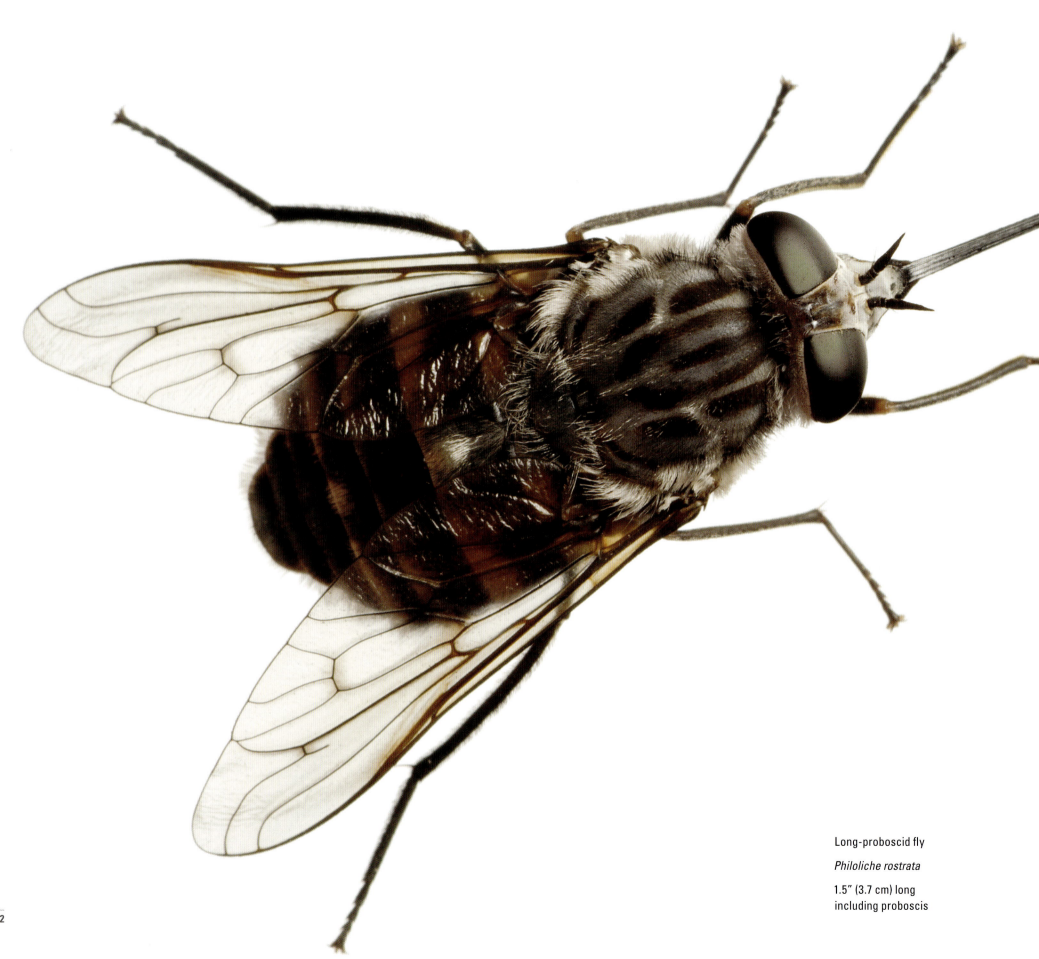

Long-proboscid fly

Philoliche rostrata

1.5" (3.7 cm) long
including proboscis

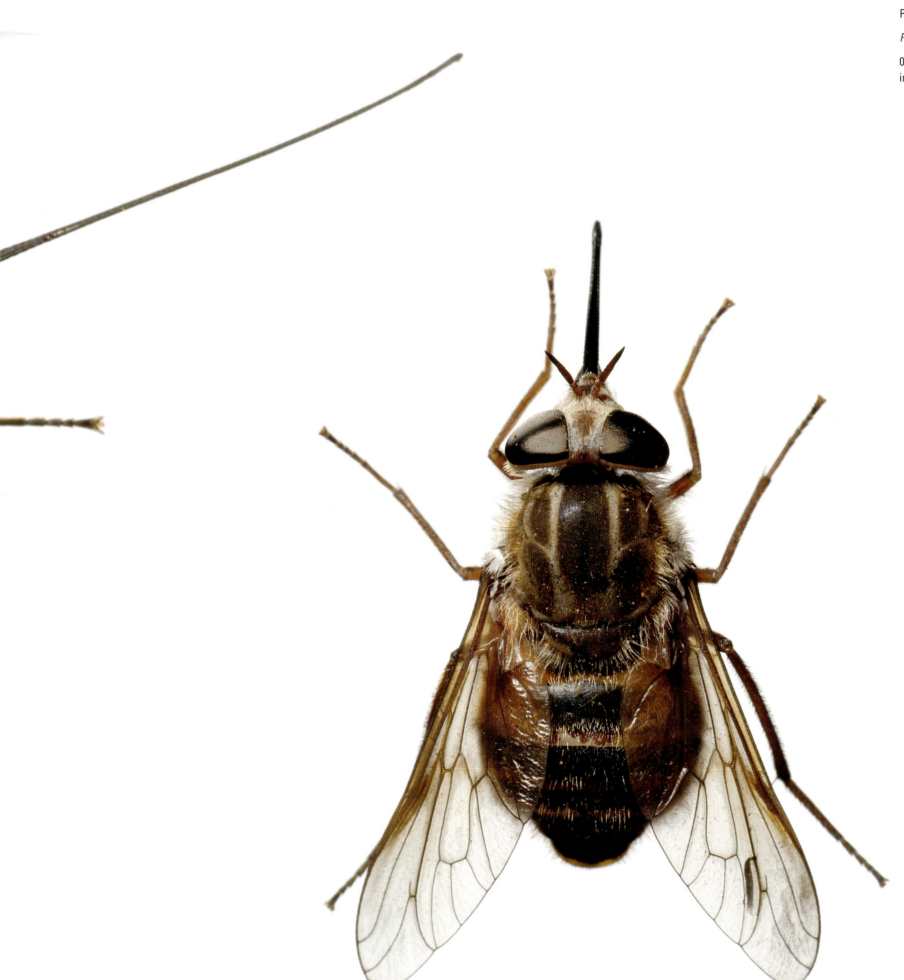

Proboscid fly

Philoliche lateralis

0.7" (1.7 cm) long
including proboscis

Pill millipede

Sphaerotherium sp.

0.3" (0.7 cm) across

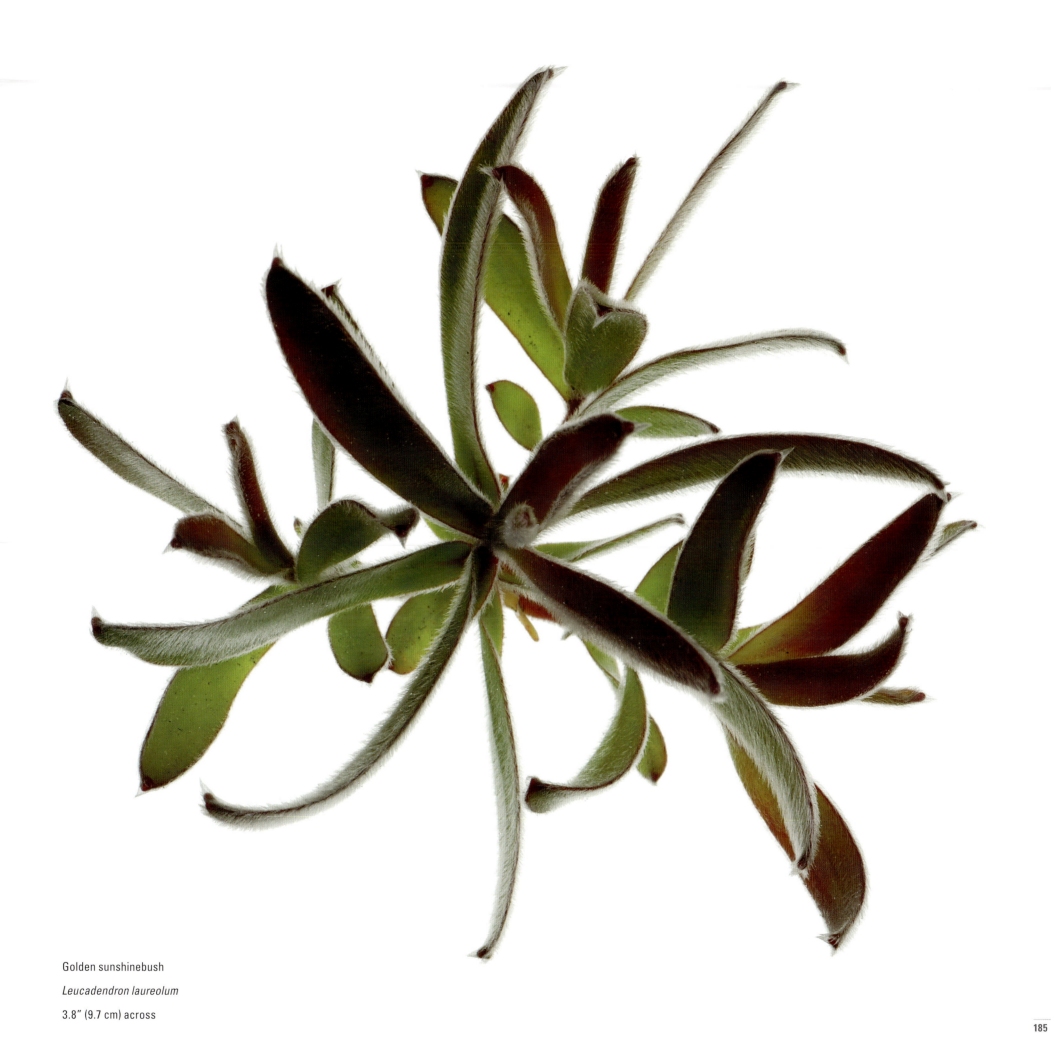

Golden sunshinebush

Leucadendron laureolum

3.8″ (9.7 cm) across

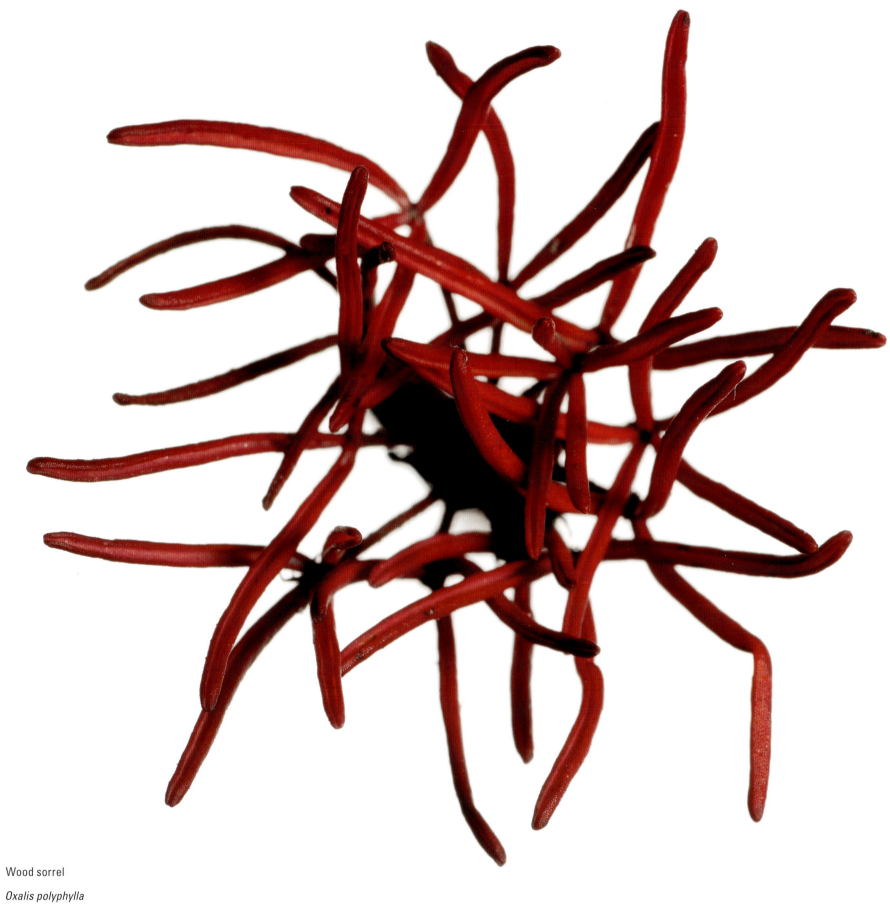

Wood sorrel

Oxalis polyphylla

1.4″ (3.6 cm) across

Wood sorrel bulb

Oxalis polyphylla

1.0" (2.6 cm) long (bulb only)

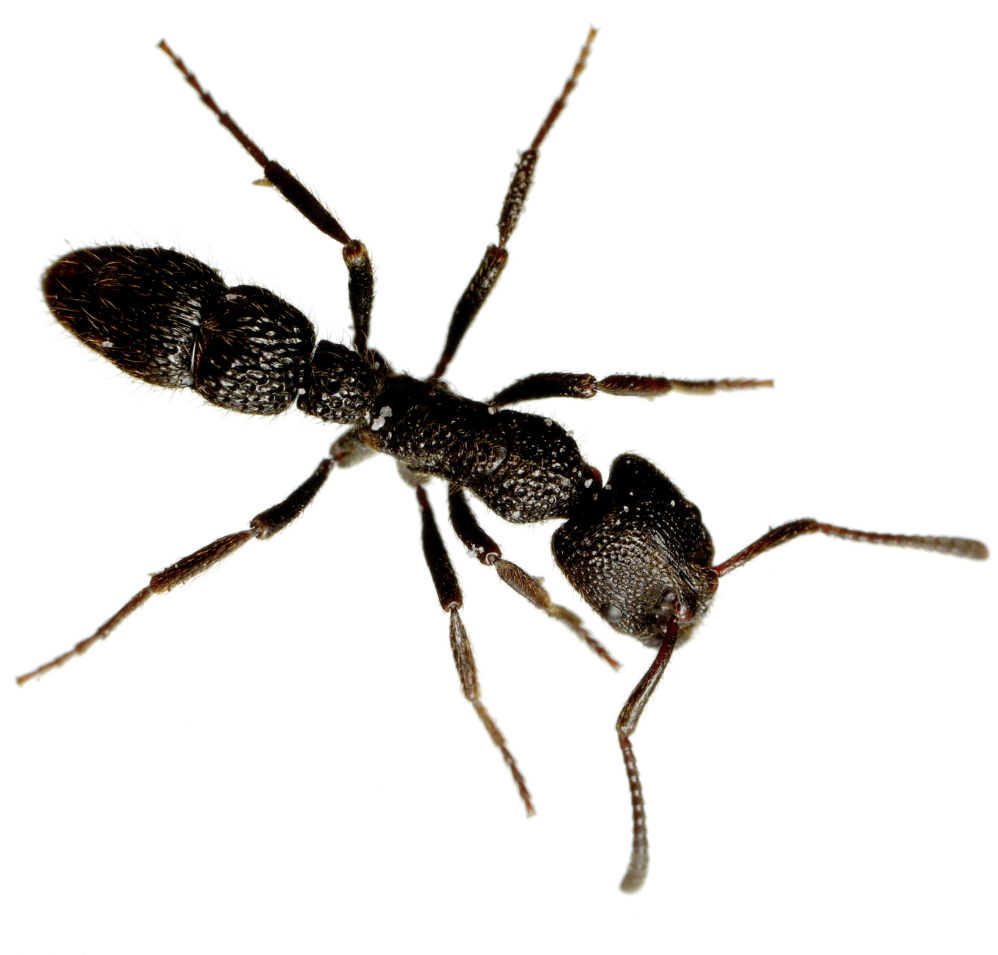

Rugged ponerine ant

Pachycondyla pumicosa

0.6″ (1.4 cm) long

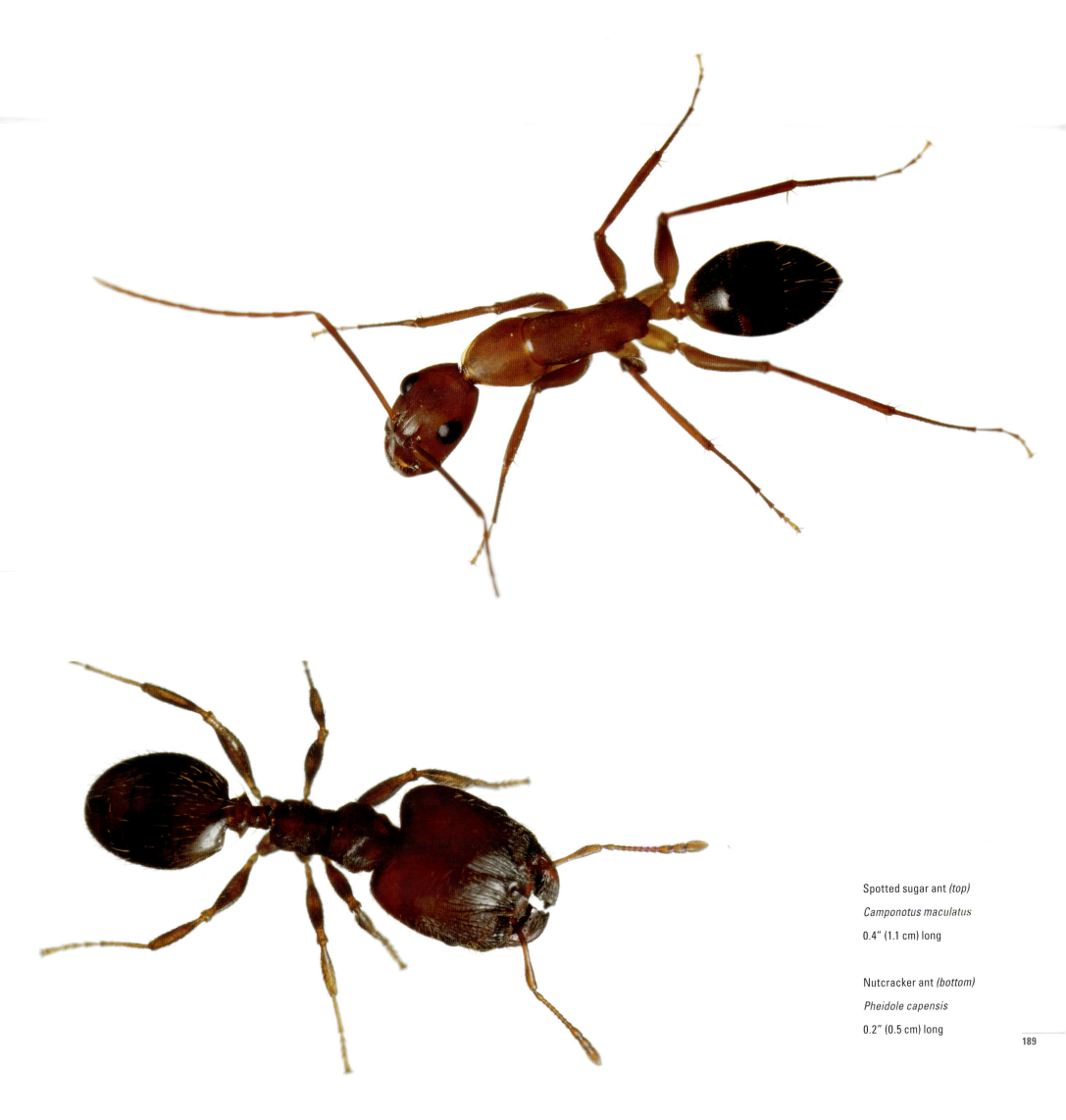

Spotted sugar ant *(top)*
Camponotus maculatus
0.4" (1.1 cm) long

Nutcracker ant *(bottom)*
Pheidole capensis
0.2" (0.5 cm) long

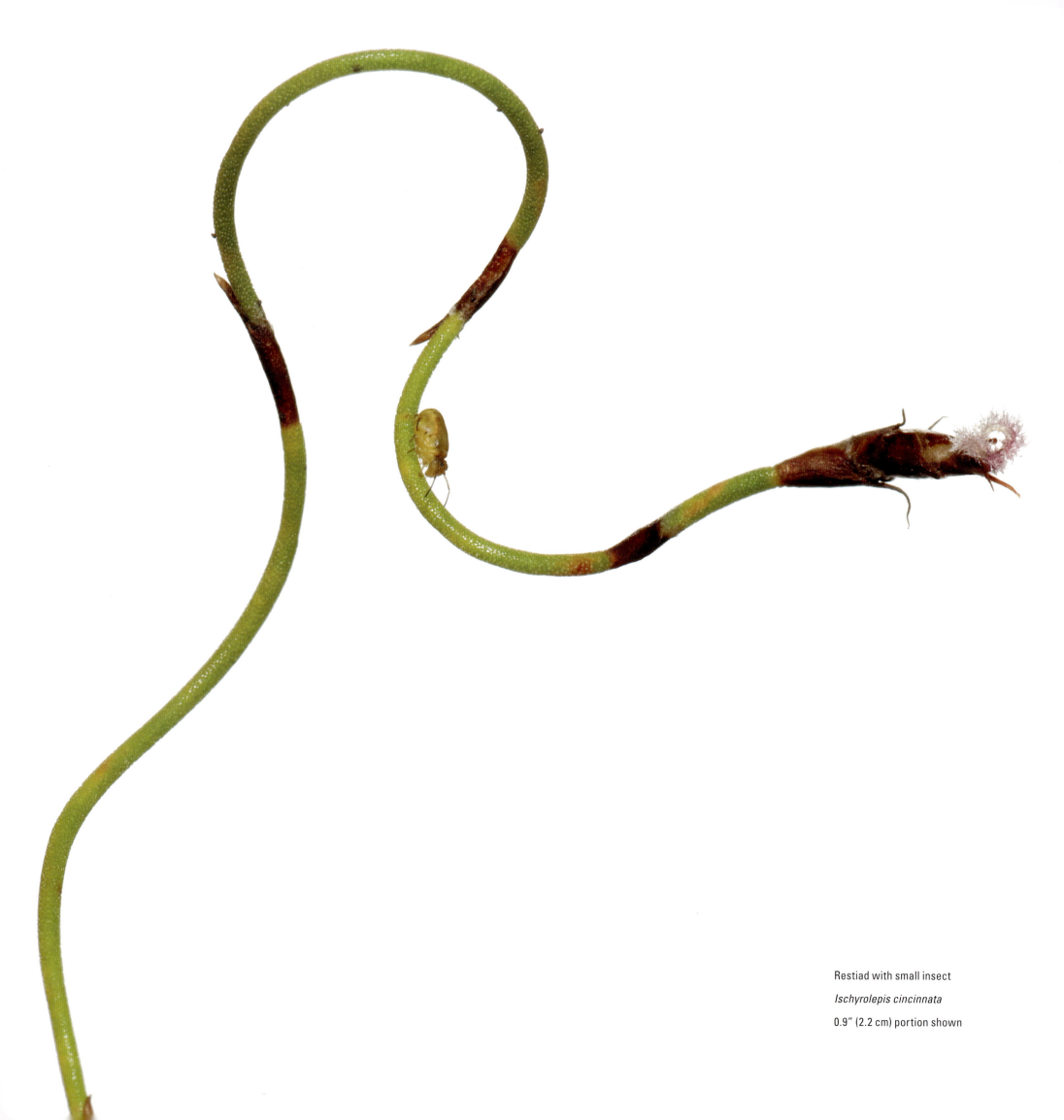

Restiad with small insect

Ischyrolepis cincinnata

0.9" (2.2 cm) portion shown

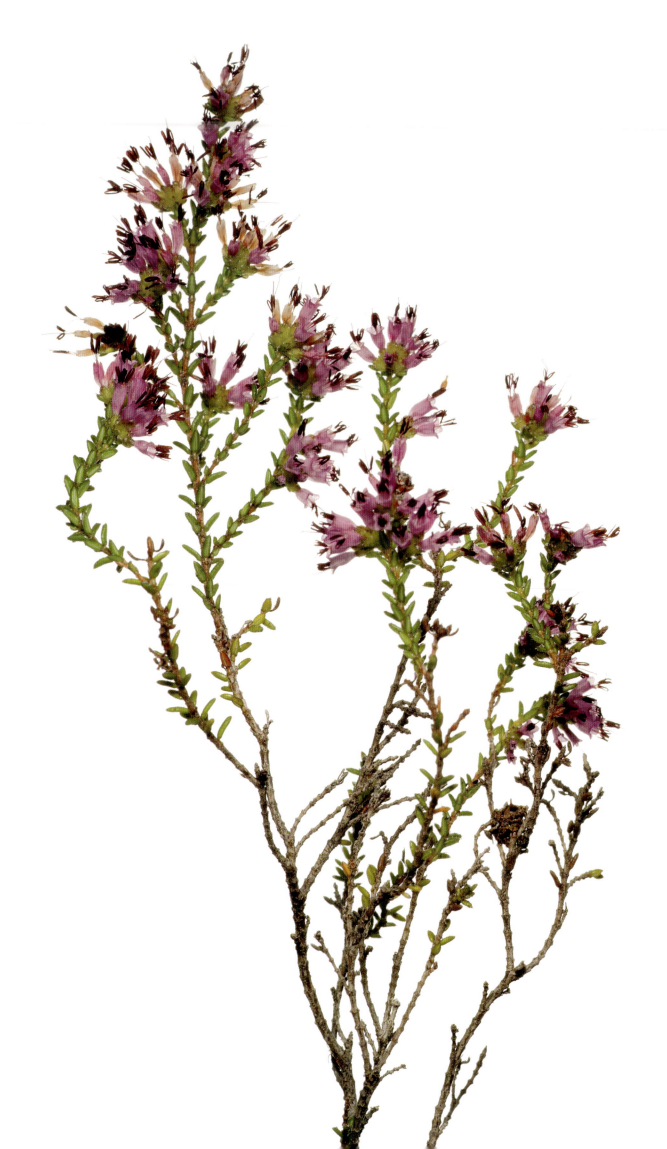

Heath

Erica labialis

3.3″ (8.4 cm) tall in frame

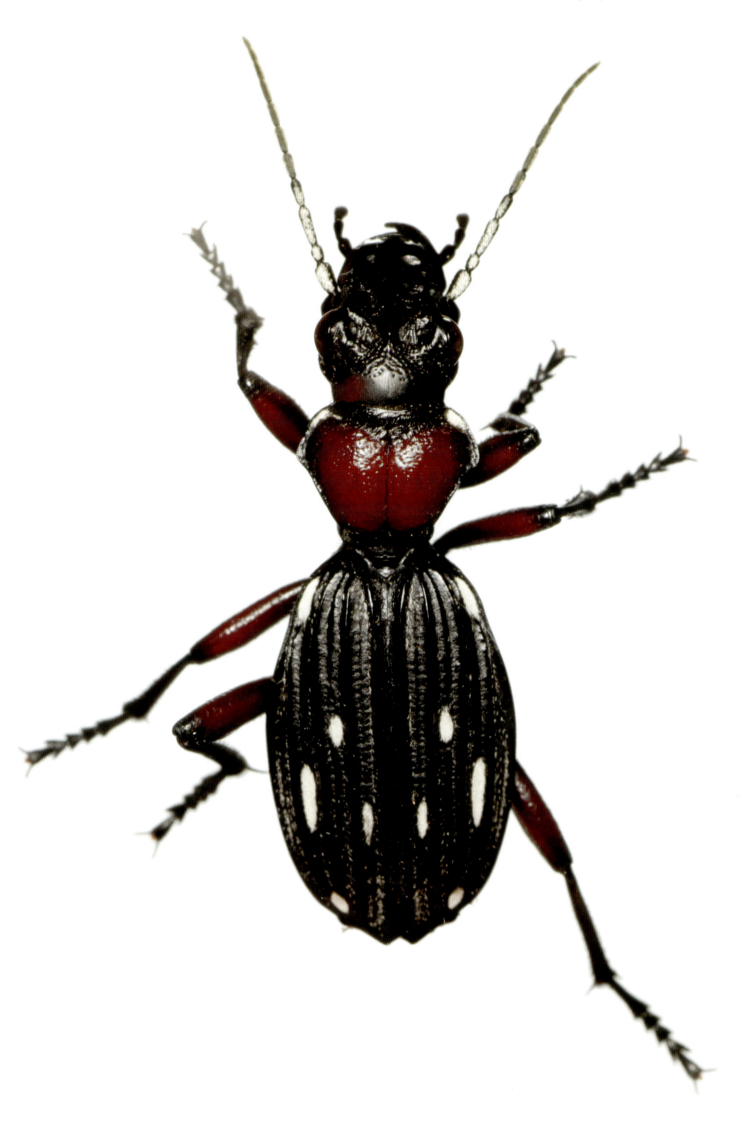

Ten-spotted ground beetle

Thermophilum decemguttatum

1.2" (3.1 cm) long

Earthworm

phylum Annelida

3.2″ (8.1 cm) long
uncoiled

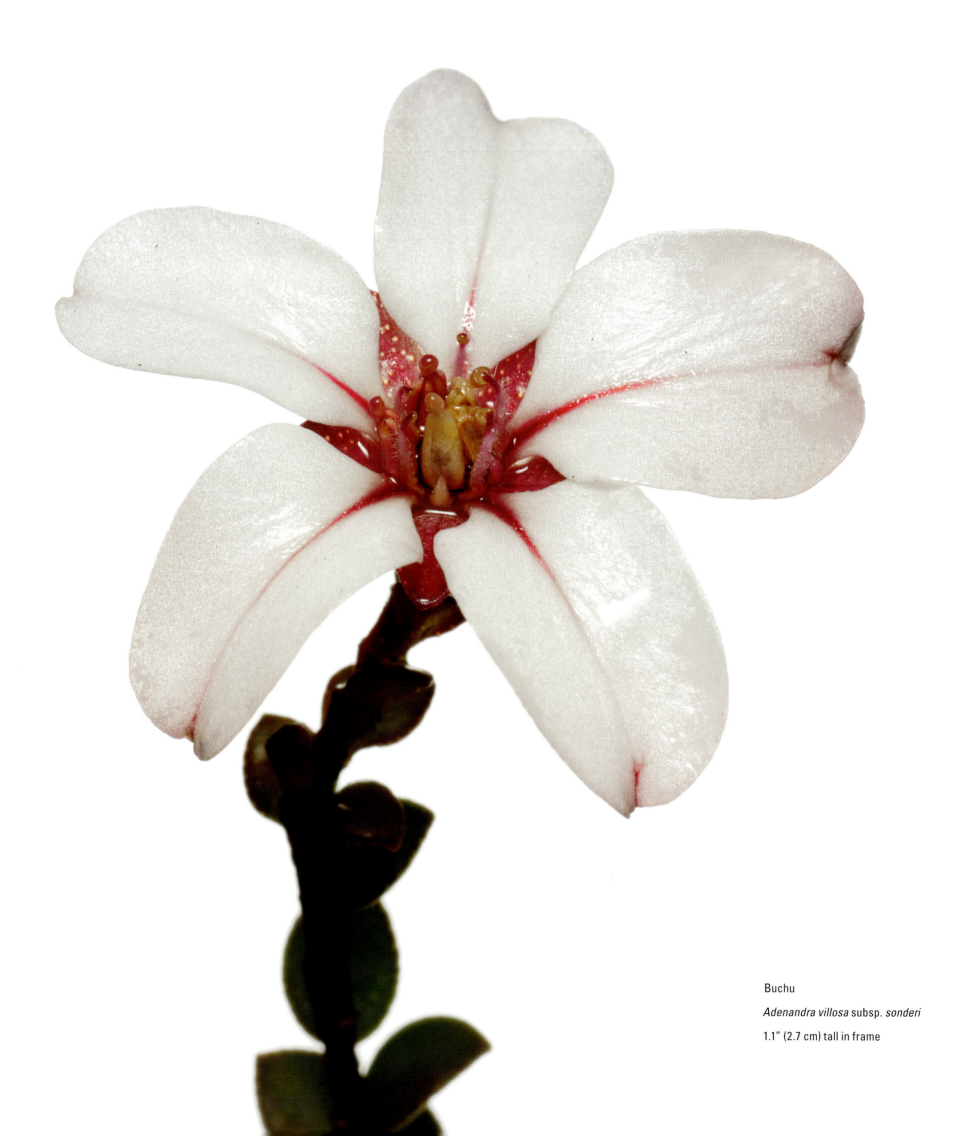

Buchu

Adenandra villosa subsp. *sonderi*

1.1" (2.7 cm) tall in frame

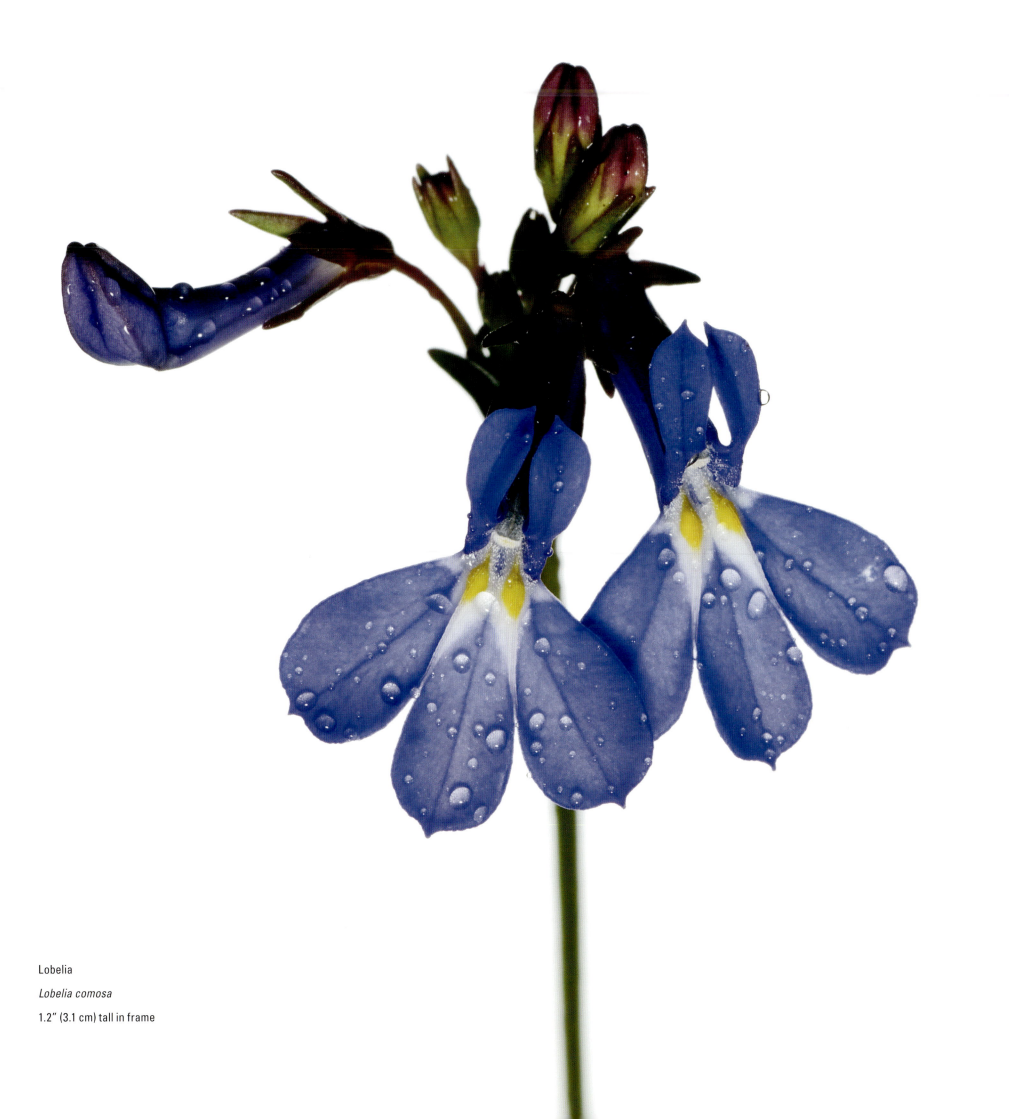

Lobelia

Lobelia comosa

1.2″ (3.1 cm) tall in frame

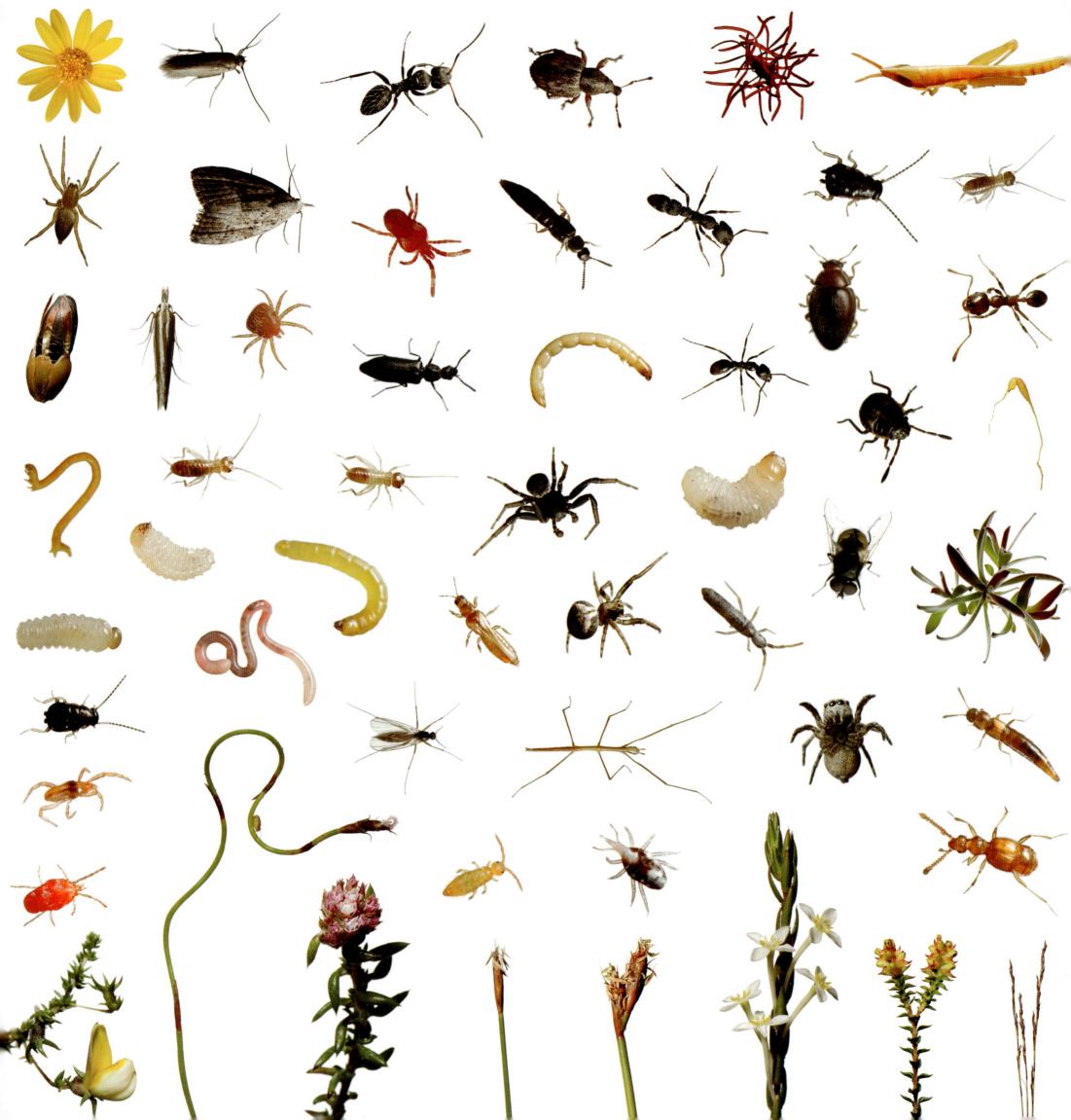

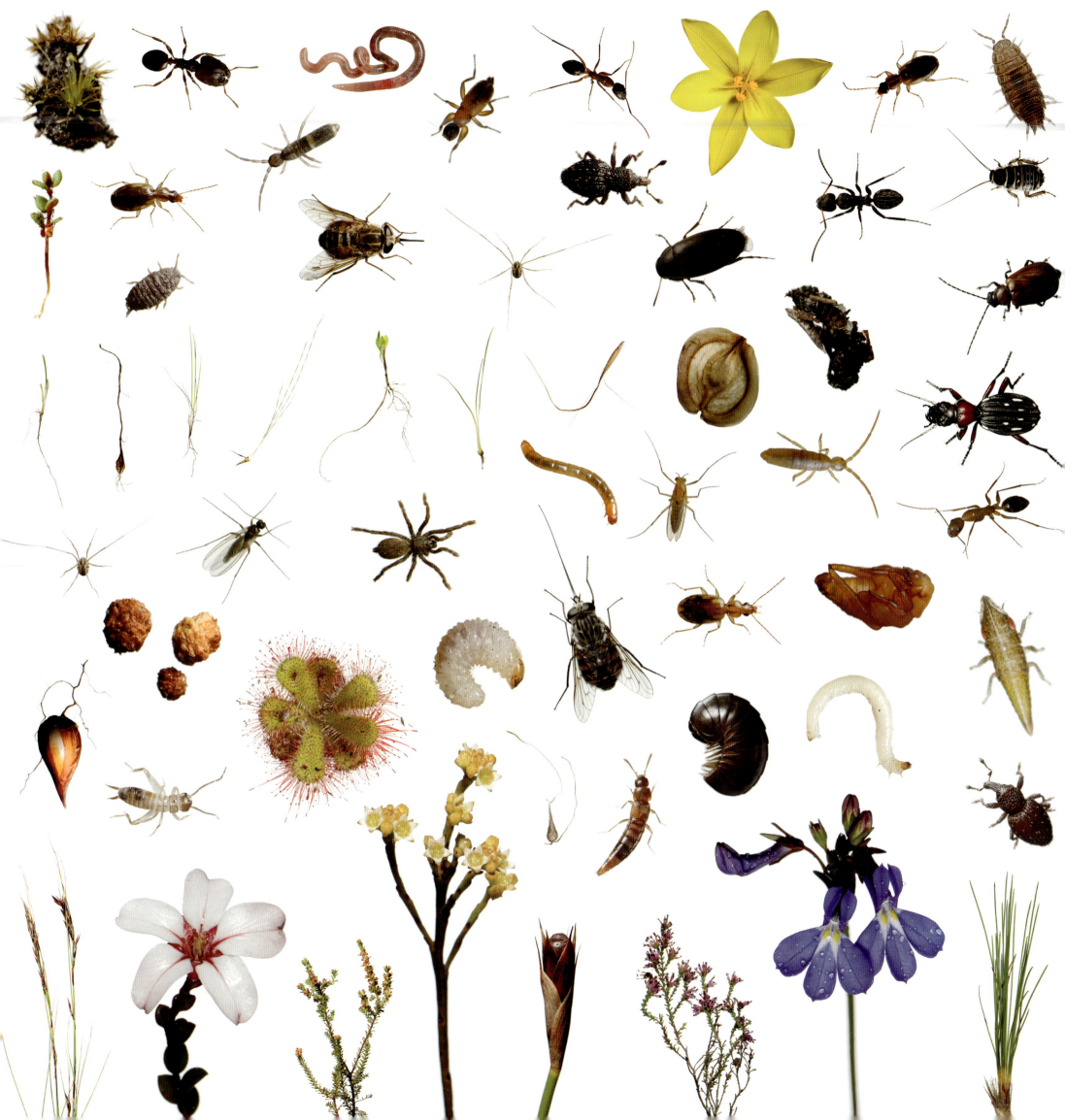

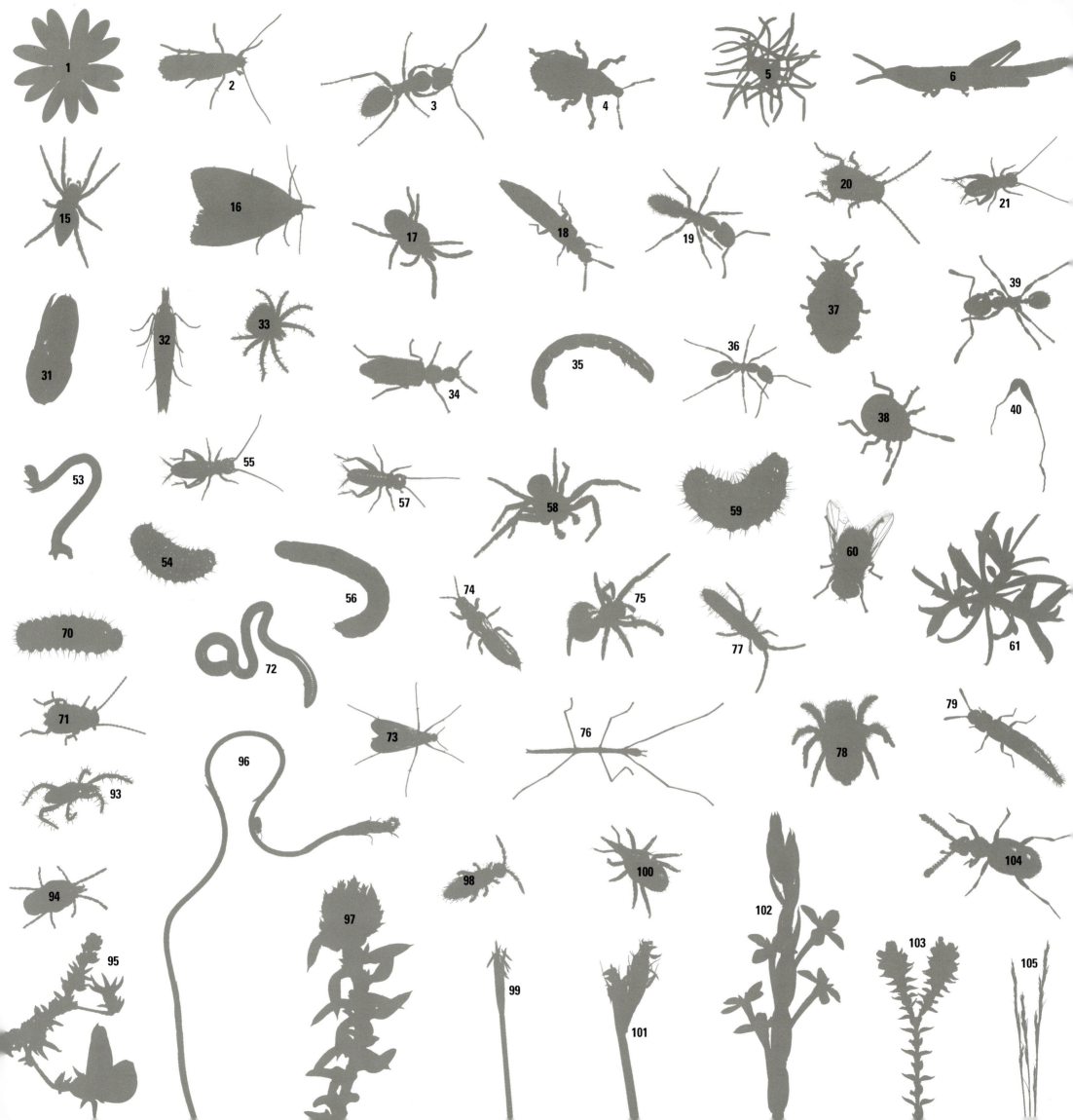

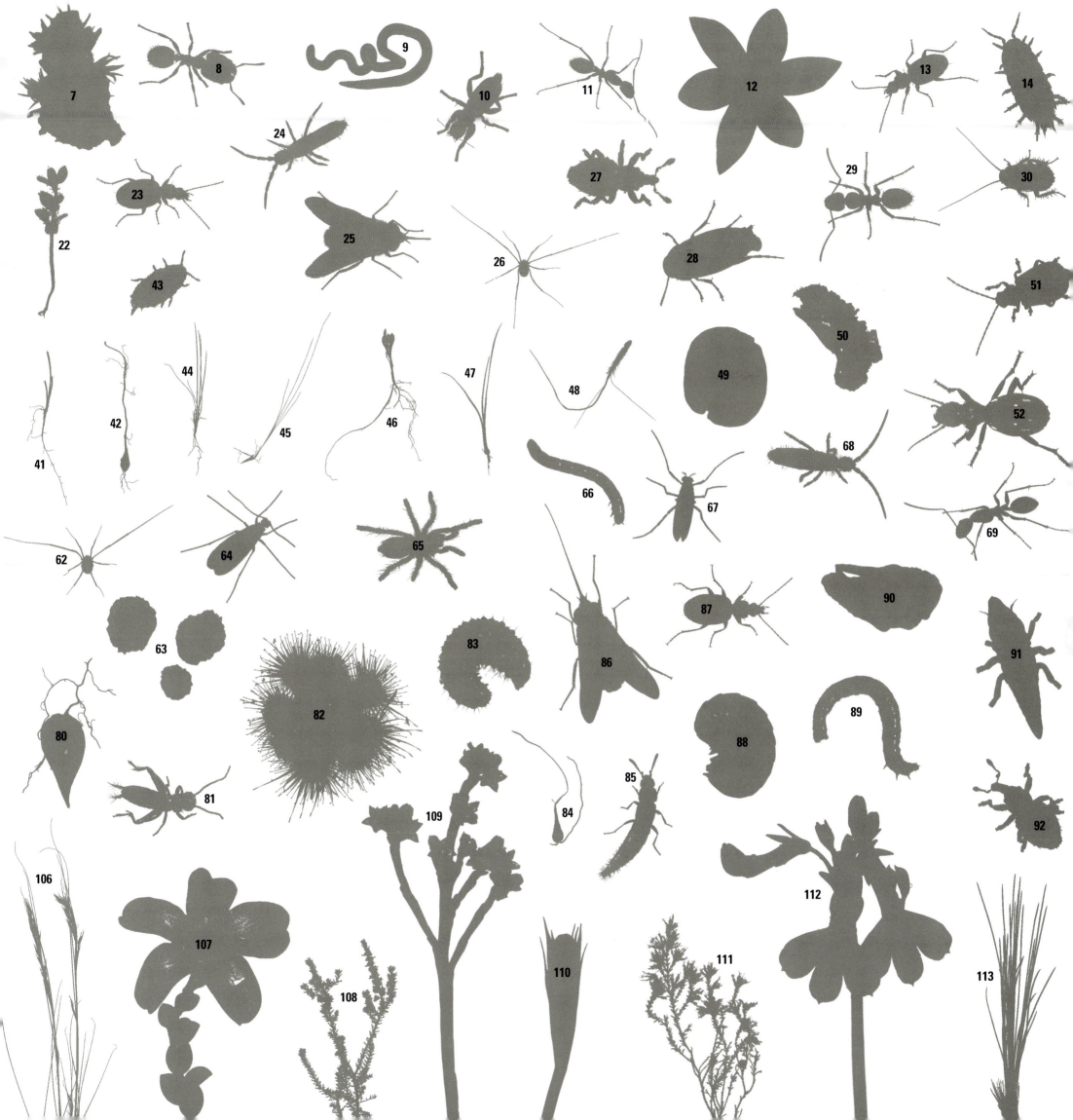

SPECIES KEY

1. Daisy, *Ursinia paleacea*
2. Moth, order Lepidoptera
3. Sugar ant, *Camponotus niveosetosus*
4. Beaded weevil, *Oosomus* sp.
5. Wood sorrel, *Oxalis polyphylla*
6. Grasshopper, family Acrididae
7. Moss, *Campylopus introflexus*
8. Nutcracker ant, *Pheidole* sp.
9. Earthworm, order Annelida
10. Balloon fly, family Empididae
11. Spotted sugar ant, *Camponotus* sp.
12. Sedge-like iris, *Bobartia filiformis*
13. Ground beetle, family Carabidae
14. Woodlouse, order Isopoda
15. Sac spider, *Clubiona* sp.
16. Moth, order Lepidoptera
17. Velvet mite, family Parasitengona
18. Rove beetle, family Staphylinidae
19. Rugged ponerine ant, *Pachycondyla pumicosa*
20. Cockroach nymph, order Blattaria
21. Cricket, *Cophogryllus* sp.
22. Buchu seedling, *Adenandra villosa* subsp. *sonderi*
23. Beetle, family Carabidae
24. Springtail, order Collembola
25. Proboscid fly, *Philoliche lateralis*
26. Harvestman, order Opiliones
27. Weevil, family Curculionidae
28. False flower beetle, family Scraptiidae
29. Sugar ant, *Camponotus niveosetosus*
30. Cape zebra cockroach, *Temnopteryx* sp.
31. Restiad seed, *Hypodiscus aristatus*
32. Moth, order Lepidoptera
33. Mite, *Tencateia villosa*
34. Beetle, *Pagurodactylus* sp.
35. Beetle larva, family Tenebrionidae
36. Ponerine ant, *Pachycondyla peringueyi*
37. Beetle, family Bruchidae
38. Stink bug, family Pentatomidae
39. Ant, *Pheidole* sp.
40. Bulb
41. Iris seedling, *Watsonia* sp.
42. Wood sorrel bulb, *Oxalis polyphylla*
43. Mealy bug, order Isopoda
44. Seedling
45. Iris seedling, *Watsonia* sp.
46. Daisy seedling, *Othonna coronopifolia*
47. Iris seedling, *Watsonia* sp.
48. Grass seed, *Pentaschistis colorata*
49. Daisy seed, *Othonna* sp.
50. Bagworm moth caterpillar, family Psychidae
51. Leaf beetle, *Exosoma* sp.
52. Ten-spotted ground beetle, *Thermophilum decemguttatum*
53. Inchworm caterpillar, order Lepidoptera
54. Fly larva, order Diptera
55. Cricket, *Cophogryllus* sp.
56. Unidentified insect larva
57. Cricket, *Cophogryllus* sp.

58. Crab spider, *Xysticus urbensis*
59. Beetle larva, order Coleoptera
60. Fly, family Muscidae
61. Golden sunshinebush, *Leucadendron laureolum*
62. Harvestman, order Opiliones
63. Rat fecal pellets, from *Otomys* sp.
64. Midge, family Dixidae
65. Spider, order Araneae
66. Beetle larva, family Tenebrionidae
67. Midge, family Dixidae
68. Springtail, order Collembola
69. Spotted sugar ant, *Camponotus* sp.
70. Beetle larva, order Coleoptera
71. Cockroach nymph, order Blattinae
72. Earthworm, order Annelida
73. Midge, family Dixidae
74. Thrip, family Thripidae
75. Spotted orbweaver spider, *Neoscona blondeli*
76. Stick insect, family Bacillidae
77. Springtail, order Collembola
78. Jumping spider, *Aelurillus* sp.
79. Rove beetle, family Staphylinidae
80. Wood sorrel bulb, *Oxalis polyphylla*
81. Cricket, *Cophogryllus* sp.
82. Alice sundew, *Drosera aliciae*
83. Beetle larva, order Coleoptera
84. Scented geranium bulb, *Pelargonium* sp.
85. Rove beetle, family Staphylinidae
86. Proboscid fly, *Philoliche rostrata*
87. Ground beetle, family Carabidae
88. Pill millipede, *Sphaerotherium* sp.
89. Flea beetle larva, family Chrysomelidae

90. Beetle pupa, order Coleoptera
91. Leafhopper, *Cephalelus* sp.
92. Weevil, family Curculionidae
93. Mite, order Araneae
94. Mite, *Mypongia* sp.
95. Cape gorse, *Aspalathus serpens*
96. Restiad with small bug, *Ischyrolepis cincinnata*
97. Bristle bush, *Metalasia cephalotes*
98. Springtail, order Collembola
99. Restiad, *Hypodiscus willdenowia*
100. Mite, *Biscirus* sp.
101. Restiad, *Ischyrolepis capensis*
102. Thyme, *Struthiola ciliata*
103. Shrub, *Penaea mucronata*
104. Beetle, order Coleoptera
105. Sedge, *Tetraria flexuosa*
106. Sedge, *Tetraria fasciata*
107. Buchu, *Adenandra villosa* subsp. *sonderi*
108. Heath, *Erica muscosa*
109. Flower, *Thesium densiflorum*
110. Restiad, *Hypodiscus willdenowia*
111. Heath, *Erica labialis*
112. Lobelia, *Lobelia comosa*
113. Sedge, *Corymbium africanum*

Restiad seed

Hypodiscus aristatus

0.4" (1 cm) long

Restiad

Ischyrolepis capensis

0.8″ (2 cm) long
(portion shown)

SPECIES INDEX